P9-CJJ-852

DATE DUE

AP 4			
DE 12			
DE 2			

NB
1098
S44
1975

Segy, Ladislas.

African sculpture
speaks

RIVERSIDE COMMUNITY COLLEGE
LIBRARY
Riverside, California

FEB 09 DEMCO

PABLO PICASSO: ". . . when the form is realized, it is there to live its own life."

HENRY MOORE: "The sculpture which moves me most is full-blooded and self-supporting, fully in the round; giving out something of an energy and power of great mountains, it has a life of its own independent of the object it represents."

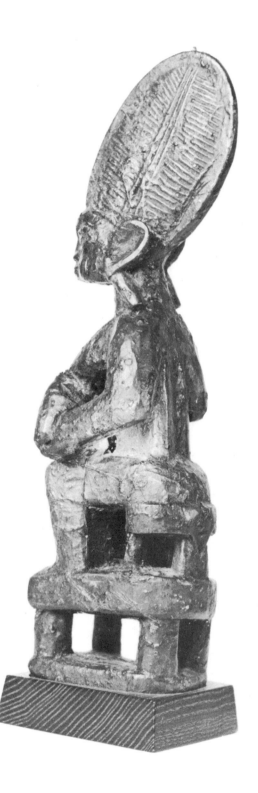

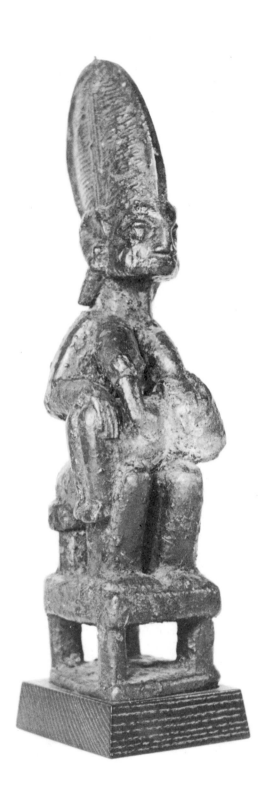

Frontispiece. Maternity statue, Yoruba, Nigeria. 14"

AFRICAN SCULPTURE SPEAKS

Ladislas Segy

Fourth Edition, enlarged

A DA CAPO PAPERBACK

Riverside Community College
Library
4800 Magnolia Avenue
Riverside, CA 92506

NB1098 .S44 1975
Segy, Ladislas.
African sculpture speaks

Library of Congress Cataloging in Publication Data

Segy, Ladislas.
 African sculpture speaks.

 Bibliography: p.
 Includes index.
 1. Sculpture, African. 2. Sculpture, Primitive—
Africa, West. I. Title.
NB1098.S44 1975 732′.2′0966 75-14323
 ISBN 0-306-80018-7

This edition of *African Sculpture Speaks* is an enlarged
version of the Third Edition, revised and enlarged, published
in New York in 1969. It is published with the permission of
Farrar, Straus & Giroux, Inc.

First Edition 1952
Second Printing 1952
Second Edition 1961
Third Edition (Revised and Enlarged) 1969
First paperback printing (Fourth Edition, Enlarged) 1975
Second paperback printing 1978
Third paperback printing 1983

Copyright © 1969, 1975 by Ladislas Segy.
ISBN: 0-306-80018-7

Published by Da Capo Press, Inc.
A subsidiary of Plenum Publishing Corporation
233 Spring Street, New York, N.Y. 10013

All rights reserved.

Manufactured in the U.S.A.

A Note on the Fourth Edition

It is greatly gratifying to know that my book, after twenty-three years in circulation, and in spite of the large number of new books on the same subject, is still in such demand here and abroad that a fourth edition is being undertaken.

Since finishing the third edition in 1968, I made four trips to Africa, visiting Senegal, the Ivory Coast, Upper Volta, Mali, Ghana, Dahomey, Nigeria, and Ethiopia, and I have revisited the major ethnological museums of Europe.

Furthermore, a large body of new documentation has appeared.

Since space limitations were imposed upon me in revising the third edition, and are now even more restrictive limiting me to a few pages, the present material is only an addition to Part IV—STYLE REGIONS. No change has been made in the original text.

L.S.

A Note on the Third Edition

IN 1933 I published an essay on the "Style Regions of the Ivory Coast," which was followed by other studies on different aesthetic approaches to African sculpture and on the classifications of stylistic characteristics of various tribes (see Bibliography). This dual trend of my interest was further developed in the first printing of this book in 1952, with additional material in the second edition of 1961.

For the last few years this book has been out of print. In spite of numerous new books on African art, there has been a persistent and continuous demand for this volume. This time an extensive revision was undertaken in view of the new information that has been made available in the past seventeen years, including my own phenomenological studies. I have also endeavored to develop further the encyclopedic classifications of the first edition by adding over 175 new illustrations, bringing the total to 436. Some illustrations have been eliminated from the earlier editions to avoid duplication of prototypes. It was necessary to reduce the size of the illustrations in Part IV, the Style Regions section, in order to include the largest possible number of the most typical prototypes. This material, not readily available in other publications, was added to increase the effectiveness of this book as a *reference handbook*, within the given limitations of its present scope.

I must express my appreciation and thanks to Miss Elisabeth Corddry for her extraordinarily careful and efficient editorial assistance in the preparation of this edition.

New York, 1969

LADISLAS SEGY

AUTHOR'S NOTE. The main subject of this book is the so-called primitive Negro art of West Africa that flourished up to a generation ago, as distinguished from contemporary West African art, and from North, East, and South African art. When, for simplicity, we use the expressions "African," "native," or "African Negro," we generally mean the West African Negro of past generations.

To assure fluent reading, we have avoided footnotes, names of authors, titles of books, and quotations except where these were deemed essential.

Contents

Part I. The Meaning and Sources of African Art

Part II. The Content of African Art

Part III. African Art and Western Civilization

Contents

Part IV. Style Regions*

* Not all variant spellings of tribe names are in-
cluded in the Contents; the Index, however, does list
the variant spellings mentioned in this book.

Contents

Contents

Part V. Addenda to Style Regions

THE MEANING
AND SOURCES
OF AFRICAN ART

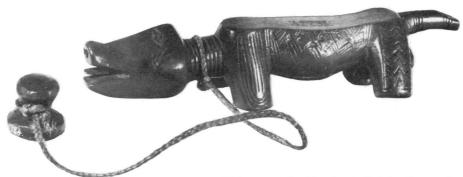

1. *Divination statue* (itombwa), *Bakuba, Congo. 2"*
SEE PAGE 230

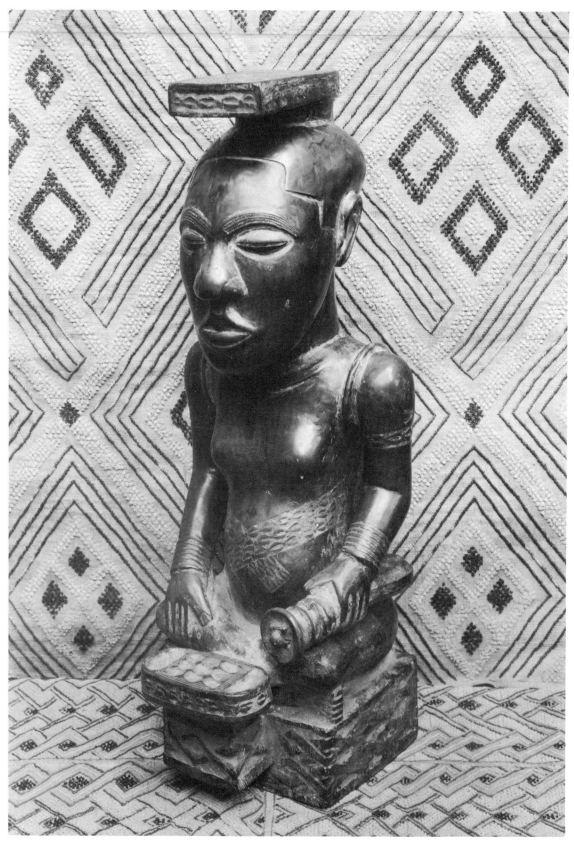

2. *Statue of Shamba Bolongongo, 93rd king of the Bushongo (Bakuba), Congo. 21½"*
SEE PAGES 127–128, 230

1. THE APPROACH

I AM often asked how my interest in African art began.

It must have been nearly forty-eight years ago when I visited an ethnological museum in Paris. In the African room I approached a showcase in which wooden statues were displayed. As I looked at the statues, I felt a strange excitement mixed with anxiety.

This sensation, which combined pleasure and pain, I have never forgotten. Although I did not know then what had happened to me, I recognized it as a powerful, even an overwhelming experience. I felt impelled to see and know more of African art. I wanted to possess such a statue for my own, so as to renew this experience, the quality of which I could not define.

From one of the museum publications on the subject, I selected an illustration as my model and tried to whittle a figure. But this did not satisfy my craving to live with and possess authentic African sculpture. Only after settling in Paris in 1922 was I able to obtain a few pieces. In these not only did I recapture my first excitement, but my involvement deepened. It has lasted to the present time, growing always.

What moved me so deeply in those days, I did not know. I had no knowledge or information about the background of African art. I did not know that before the time of my experience artists in Paris had already discovered in African sculpture works of art of high quality. The plastic aspect of African works "spoke" to me, without my knowing about the co-ordination of those exciting shapes. It took me many years of continued observation and analysis to find a tentative answer, and only now do I realize that I approached these art works from the phenomenological point of view, that is, without any presuppositions or information *about* them. I faced them, I was exposed to them as they appeared in my field of vision. This book, although its scope is limited, reflects my search for a possible answer to African art's mysterious power.

In the first quarter of this century African sculpture was for the most part a body of artifacts stored away in the dusty showcases of ethnological museums, though here and there its plastic qualities were recognized. As I became more acquainted with modern art, I learned that around 1905 and thereafter African and South Sea sculpture created a flurry of interest in Parisian art circles. Artists in Paris discovered the power of these works of primitive man. Books and articles appeared. Some dealt with the subject from an ethnological

standpoint; others confined themselves to the works' aesthetic merits; still others, by means of comparative illustrations, demonstrated its influence on modern art.

In approaching this field, the Westerner is often misled by what he brings from his own cultural background.

Divesting himself of the standards of his own civilization, there are several frames of reference he can adopt. One is to consider African art in its own setting, from the ethnological and *anthropological* point of view, learning about the ethnic backgrounds of the works and the specific sociocultural functions of each of them. Another is to consider the work as art without any reference to its origin, facing it as any work of art and apprehending only the co-ordinations of shapes that result in a coherent whole. This is the *phenomenological* point of view by which the work reveals what it *is,* by its presence, and not what we know about it. Both of these points of view cannot operate at the same time and in that sense they are mutually exclusive. The anthropological point of view enables a student of African works to relate them to their cultural setting and, in looking at them with an "African eye," to understand better their reason for being, their original function, and thus to find what is universally human in the African.

It must be clearly understood, however, that to learn what the objects were used for becomes significant or meaningful only if we are able to integrate this accumulation of information with our true self. Such integration will help to enlarge our scope of awareness of that which exists. In other words, one's sensitivity may be heightened, but ultimately this sensibility is the only instrument which makes the apprehension, perception, and appreciation of the work possible.

We shall also explore another category of apprehension: the *psychological,* which is entirely different, working on another level of consciousness. One of the purposes of this book will be to show parallels between what the African projects freely in his art and what is buried in our own psychological roots. These parallels make possible our emotional identification with the content of African art. Such identification should then lead to a certain self-recognition, to personal rediscovery and renewed contact with our deeper instincts, now overlaid by "civilized" manners and conventions. By learning to understand the African sculptor's motivations and his relationship to his art, we can increase our understanding of ourselves and of our relationship to art.

Our age has been called by Auden "the age of anxiety," and by Camus "the age of fear." This anxiety and fear arise from the split or conflict between the intellect and the emotions in our lives.

In our emotional need we respond to African sculpture because it embodies an intense emotional life. To the extent that we *feel* its reality, that we sense the radiations of its emotional vigor, we gain the sensation of fulfillment, of nourishing something starved in ourselves.

This is a major value African art has for us. Although we will not entirely discard the traditional highway of anthropology, our main emphasis in these pages will be on African sculpture as pure sculpture, speaking the language of plastic forms. We shall deal also with its emotional content, and the way in which its inner reality communicates with the beholder.

THE BACKGROUND OF AFRICAN ART

In describing the life out of which African art arose, we work with uncertain data. Even the reports of ethnological field studies conflict. Their contradictions originate sometimes in differences of method, sometimes in differences of personality. Moreover, some studies were too hasty, or made by researchers whose command of the native tongues was insufficient, who were too unfamiliar with native customs to make correct interpretations or too unskillful to cope with the evasions of natives anxious to protect tribal secrets. It is even possible, according to one scientist, to accept divergences as facts, since the phenomena observed were themselves

variable. Finally, natives sometimes could not make intelligible reports where they were merely carrying on long-established traditions whose reasons or origins had been lost.

From the data which is available we can make some generalizations about the sculpture-producing African. His habitations lined the west and Guinea coasts, extended through what is now the Mali Republic and northern Angola, and reached eastward, across the Democratic Republic of Congo, to the lake region—a territory about twelve hundred miles square, including about half of equatorial Africa.

He was predominantly of Bantu stock and appears to have migrated to Africa from Asia. The date is unknown, but approximate indications would place the main influx around 3000 B.C. By the fourth century A.D., Negro states were well established, and their history showed noteworthy political achievements.

We must bear in mind, however, that *Negro* is neither an African concept nor an African word. It is of Portuguese and Spanish derivation from words meaning "black," and was first used about 1550. In Africa each tribe has its own name and each individual identifies himself by membership in a tribe. The prefix *Ba* (meaning "people"), in most African languages, signifies the tribe; the prefix *Ma* signifies the individual tribesman. Thus, in a typical Congo* group, the tribe is called "Baluba," the tribesman "Maluba."

Being mainly farmers, these African tribes under consideration were often bound to the region where they were settled; this factor promoted the cultural continuity so useful in the development of art. A tribe's social structure was marked by a complex of authority—king, secret societies, medicine men, etc. Virtu-

ally all social functions had the character of religio-magical ceremonies, in each of which sculptured images were employed.

Lacking writing, the African carried his mythology—his literature—in his head, transmitting the legends orally from generation to generation. Sculpture was an additional language through which he expressed his inner life and communicated with the invisible world, a language of emotional communication, used from birth to death. Virtually every act in the life of the African had its ritual, and every rite had its appropriate image.

And the African came under the auspices of these statues even before birth. His mother, during her pregnancy, prayed to an image which functioned as the unborn child's protector. An image assisted her through the delivery, and another stood outside her hut, with an alms bowl before it, to secure help for her in the period when she could not work. Still another image watched over the child at birth and, if he was a twin, special sculptures guarded him against the hazards to which this exposed him.

Every subsequent contingency of his life was provided for by images. In farming, hunting, fishing, in sickness, in litigation, he followed a specific rite employing a specific image. Such decisive periods as puberty, marriage, and death called for a whole gallery of sculptures.

AFRICAN ART STYLES

Inevitably an astonishing wealth of sculptures was produced, the intensity of whose carving reflects the importance of the functions they served. If we now add that each tribe developed an art style of its own, we begin to understand how extensive this material is. Since the creation of an art style is a major cultural achievement, the remarkable diversity of styles is in itself a testimony to the African's artistic inventiveness.

We shall trace here the primary ideas that provided the impetus for new styles. For those who are enthusiastic over this art, it is hoped a highroad to an aesthetic and emotional adven-

* When the term "Congo" is used in text and captions, it refers to the area now called the Democratic Republic of Congo (formerly the Belgian Congo); when the Republic of Congo (formerly a part of French Equatorial Africa) is meant, the full name will be used. The name "Republic of the Ivory Coast" will also be used to distinguish it from the larger territory covered by the old name "Ivory Coast." Similarly the full names "Republic of Guinea" and "Portuguese Guinea" will be used for the areas now included under those names, "Guinea" referring to the ancient, large territory.

ture will be opened. At first African sculpture may represent only an aesthetic pleasure. But another function will begin when we communicate with it, when what it touches in our inner selves is projected back into the sculpture itself.

THE AFRICAN CONCEPT

African sculpture springs from a specific concept of the world. It is the product of primitive mentality or primitive reason. This does not signify any basic differences, however, between the mind of primitive man and that of civilized man.

According to Franz Boas, the chief differences between primitive and civilized man lie in their types of association with reality. Tradition and institutions are more compelling for the primitive; his associations with the community are more emotional and less intellectual than ours.

In our society the goal is individual development, whereas in primitive society it is membership in the community. In both societies, however, the pressures for conformity are so great that in practice this difference proves to be less than it appears. When we examine our own behavior psychologically, we find that even the apparent intellectual differences are not so great. Our behavior is less rational than we think.

With the discoveries of depth psychology has come the realization of the extent and power of our unconscious life, of the emotional content of many of our actions and reactions. With this in mind, the mental and emotional attitudes of the African cannot long continue to be regarded as intellectual absurdities. We shall see here how many African beliefs and habits are analogous to residues deeply imbedded in our own lives—how many, in fact, survive among us in deviated forms.

3. Mask, Bakuba, Congo. 13″
SEE PAGE 232

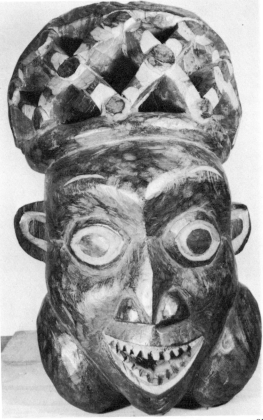

4. Mask, Bekom, Cameroon. 18″
SEE PAGE 205

Primitive thinking is homogeneous because primitive life is conducted in small and relatively isolated groups held to rigid traditional patterns of behavior. The thought of the primitive therefore tends to be communal. The primitive man and his fellow tribesmen are inclined to think the same way that their forefathers did.

Primitive perception relates all objects emotionally. The primitive's attention was intuitively directed to inner reality; he achieved effortlessly the type of penetration Western man has to work to acquire when he faces a work of art. Western man must use outer reality to reach the inner reality, the real content of a work of art.

This emotional reaction is quite utilitarian. The African separated the world and its manifestations into what was good or bad, not in a moral sense but according to what was to his advantage or disadvantage, what was permitted and what was taboo. And he not only sought the good and avoided the evil; he sought to change the evil into good, or annihilate it. Toward this end he built up a magico-religious belief characterized by rituals which were, for the most part, centered on a magical use of sculpture.

We put such emphasis on the emotional tone of primitive man's reactions because this tone also characterizes his art creation. At the same time the primitive shows rudiments of the scientific mind in his observation of nature. His activities follow closely observed seasonal changes, for example. In his canoe-building, in his fishing and hunting, and above all in his farming, he uses his observations to secure the best results. He resorts to magic to influence nature only where his own labors seem to have no effect. Drought or flood can ruin the best-cultivated fields; storms can overwhelm the best fisherman. Here magic comes in—to influence the element of chance in the petitioner's favor.

Malinowski points out that, when fishing in the safe lagoons, the Trobriand Islander dispenses with magic. But for fishing on the dangerous open sea, an extensive magical ritual is performed to insure safety and a good catch.

The school of thought headed by the French scholar Lévy-Bruhl seeks to explain primitive mental processes as aversion to the rational, as follows: Not recognizing or comprehending any laws of nature, the primitive does not connect cause and effect, or distinguish between identity and contradiction. The primitive mind is prelogical, and its behavior patterns are largely inexplicable to Western man. Other schools, however, hold that since the brains of primitive peoples have the same structure as ours and the same potential, and since all civilizations have developed out of the primitive, we must assume at least the groundwork of the rational among the primitives. This, indeed, is to be discerned in the African concept, which is a composite of many interlocking beliefs. The majority of these are magico-religious. As Delafosse expressed it in *Les Nègres,* the Africans "are among the most religious people of the world."

2. BASIC CONCEPTS

A STUDY of the art forms of any people must essentially take into consideration the cultural background from which the art springs. So for a better understanding and deeper appreciation of African art it would be well to examine the basic concepts underlying it. We must therefore concern ourselves with the manifestations of *animism, fetishism, magic,* and *mythology* in the tribal civilization.

Animism

This is the belief that all objects—both "inanimate" and "animate," according to Western terminology—possess vitality or are endowed with indwelling souls. Thus animals as well as men—and earth, water, vegetation, and minerals as well as animals—are invested with souls. The indwelling soul, moreover, is nonmaterial; it has its own thought and will.

Animism was carried over into the African's attitude toward sculpture. Both the creation of a piece of sculpture and its use in tribal rituals were based upon animism. The *power* of a statue or a mask was believed to be more real than that of a living being. Those who possessed the sculpture felt that they could depend on this power to protect them and promote their welfare.

The sculpture did not *represent* an idea, as a statue of Christ may be said to symbolize divine grace. The African sculpture *is* the spirit itself.

This concept, alien as it is to the rational mind, must be grasped if we are to understand and feel the force that African art radiates. An African sculptor's belief that he created life was incomparably greater in its assurance than the "symbolic" or "representational" approach of the Western artist to his work.

For centuries African animism proved durable enough to resist the religious influence and other cultural-social pressures of invaders. Islam, for example, despite its intimate contact with the Sudanese states, left no impress on African art. The Christian missionaries, despite the effects of their medical work, similarly made little impression on animism, though political and economic change, brought about by Western rule, did initiate a breakup of African social structures.

The vitality of animism is all the more striking in that, through centuries of external pressures, it did without the aid of organized religious institutions and the teachings of great re-

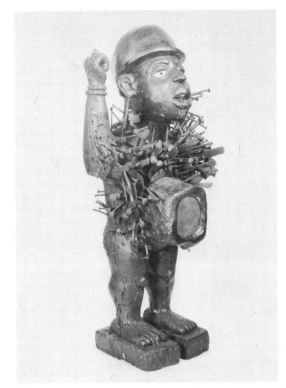

5. Magical statue, Bakongo, Congo. 24"
SEE PAGES 11, 58

ligious leaders, such as have sustained nearly all other religions. Moreover, the African's religion lacked writing and could therefore not preserve itself in records. Traditions were handed down orally with all the consequent risks of change and loss.

The lack of writing, however, resulted in the focusing of creative energies upon sculpture making, which preserved the African's most important concepts about the world and man's relationship to it. Powerful shapes are the result, "speaking" in plastic language. A limitation in one field thus brought about a rare achievement in another.

THE RANGE OF ANIMISM

Animism is not exclusively an African concept. It is found in varying degrees in nearly all religions. We find survivals in many highly developed religions despite the opposition of leaders. The occurrence of animism in the cultures of the Egyptians, Babylonians, and Greeks will be dealt with when we trace their possible influence on African art. We can easily detect animistic survivals in Hinduism, despite the Buddhist, Jain, and Sikh reformations, in the objects which fill Hindu temples and in the Hindu pilgrimages to sacred mountains and rivers.

Again, in the pre-Mosaic religion of the Hebrews, *telphim,* or "idols," apparently made of wood, were adored. The cumbersome wooden Ark of the Covenant that the Hebrews trundled over the desert is another example of the animistic belief in the inner life of inanimate objects.

Before Mahomet, the Arabs worshiped sacred trees, stones, and springs. The guardian spirit of each was later personified in a god or goddess. Despite Mahomet's opposition to animistic beliefs, he had to permit adoration of the black meteorite housed in the Kaaba, and of the Zemzem spring. Belief in them has persisted to this day.

Various Roman and Greek pantheons also showed a development from animism to animistic polytheism. The Teutonic-Scandinavian religions showed a similar development. A chief object of their worship was the "world tree," Yggdrasill.

In Mexico the culture of the Toltecs, Aztecs, and other tribes of the Nahuatlan stock was animistic and resembled that of the Africans. They, too, were noted for their sculpture, and their forms of human sacrifice and their cult of skulls showed similarities to ancient African practices.

An animistic survival may even be found among us in our nurseries.

DOLLS

When a little girl plays with a doll, she talks to it, handles it like a living being, takes it to bed with her. The doll is alive to the child. And experiment has shown that an expressionless doll is more stimulating to the child than a naturalistic one.

The word "doll" itself is a shortened form of the Greek word for image or idol—*eidolon.*

The use of the doll as a toy is a comparatively late development in history.

The doll idea—that an inanimate figure has life—often occurs among neurotic adults. In the year of Catherine de Médicis' seclusion, dolls which she fed and cared for were her only companions. The Duchesse d'Enghien treated dolls like her children, dressed them, fed them, and gave them medicine.

This behavior, a neurotic disorder called "doll fetishism," is a regression to an earlier, primitive state of mind.

A similar fetish is connected with the mandrake or mandragora (also called "gallows man"), a plant in whose forked root men saw a resemblance to the human form. The plant was extensively used in magic rituals in Europe.

Thus we can see that all of us have been under the influence of a sort of animism in childhood. In some the influence retains sufficient power to be reactivated as neurotic behavior under some emotional stress.

Generally speaking, childhood patterns are only pushed down deep in the unconscious; they do not disappear completely. Knowingly or unknowingly, we carry remnants of them all through life. In addition, Jung's and Neumann's investigations into the collective or transpersonal unconscious and the existence of archetypes may provide further explanation for our response to the primary forms of African sculpture—evoking in us both our early, actually lived-through animistic experiences and the inherited psychic form-constellations. Thus, what we experience in reality is our own becoming aware of an emergence of an archetypal feeling.

Generally speaking, primitive arts were practiced in the service of animistic religions. The rituals were basically petitionary, though a distinction must be made between religious and magical practices—of which more will be said.

Fetishism

The word "fetish," which describes the most widely used of magical objects, is not of West African origin. It is an invention of the French scholar Charles de Brosses, who used it in his essay, "Du Culte des Dieux Fétiches," to designate West African statues when compared with the ritual objects of the Egyptians. He derived the word from *phatah,* the Egyptian term for their smaller idols. A similar, earlier coinage by the Greeks was *pataic,* for the figureheads on Phoenician vessels.

Another derivation may be the Portuguese word *feitiço* or *fetiçao,* meaning "fabricated" or "false," and derived in turn from the Latin verb *facere,* from which come such words as "factitious." The connotation for the Portuguese, who were the first to see African carvings, was probably that of false gods. It must be noted, however, that the Africans themselves never thought of these images as gods.

As it has since come to be used, the word "fetish" is applied mainly to statues, but it categorizes *any* object credited with magical power. The African feared evil spirits more than wild animals. Against the latter he could defend himself, but against the spirits his only defense was magic or spirit power, mainly as incorporated in the fetish.

Any object over which the proper magical rites have been performed becomes a fetish. It need not be a statue; it may be a piece of wood, bone, feather, stone, animal tooth, an animal skin, a bird's head, an herb, or a string of beads. In Africa each fetish served a specialized function. A warrior, for example, needed separate fetishes to protect him against death by bullet, by club, by drowning, by crocodiles encountered at river crossings, etc. Consequently the African wore a number of fetishes, usually in a small bag hung around his neck. Fetishes were also used in cures of the sick.

Attempts have been made to classify fetishes as defensive or offensive. It is true that the fetish worn on the body was supposed to be a protection against evil spirits and was thus defensive; and a fetish into which nails were driven was functionally offensive. Yet the nail fetish also had defensive functions, as indicated by the inset mirror, which was supposed to

blind hostile spirits, and the dagger in the upraised hand (Fig. 5).

One may broadly differentiate the fetish from the ancestor statue by considering the first an article of everyday use with a specific function and the latter as reserved for the rituals of the ancestor cult.

There was, however, a diversity in the use of ancestor figures. Offerings to them (in the form of food) varied in purpose: to appease the vengeful spirit; to seek a cure for sickness (believed to be caused by the wrathful ancestor); to solicit the ancestor's aid in an enterprise; or merely to secure peace of mind through relief from guilt feelings.

The word "fetish" is interchangeable with "charm," "talisman," or "amulet." These objects were as numerous in Africa as human desires or fears. They were used to conjure away evil and propitiate chance. The idea of hope was attached to such objects but not a passive hope; use of a fetish was an active way of attempting to influence destiny. Because a definite result was expected, the belief in the fetish became *faith*.

Modern Survivals of Charms

It is interesting to note the magical concept in our word "charm" even when used, not to denote a fetish or a spell, but to describe the characteristics of a person who fascinates *as if he had cast a spell*. Surviving magical beliefs, intermingled with animism, are manifested by us in the use of such objects as lucky coins, rabbits' feet, elks' teeth, rings, lockets, and necklaces; they induce us to hang horseshoes over our doors, to touch wood in order to avert harm, and so on. The Catholic Church uses magical rituals when it pronounces blessings over ordinary water, making it holy, or sells protective medallions and amulets with sacred images or inscriptions.

The cross itself, as used and worn, is endowed with magical power. Incidentally, the cross was readily accepted by the Congolese when Portuguese missionaries, in the fifteenth century, brought it to São Salvador. The natives reproduced crucifixes and images of Saint Anthony in the native manner, called them *kangi*, vested magical power in them, and incorporated them into their own store of fetishes (Fig. 6).

A remarkable transformation occurred at this time. We know that the fifteenth- and sixteenth-century Portuguese crucifixes were made in a rather naturalistic style, indicating a decadence in religious fervor and its expression. This was the type of work given to the Bakongo people to imitate. But the African, being deeply religious, could not tolerate a naturalistic image of a spiritual symbol (they were told that Christ was similar to their own deity concepts), so they transformed a decadent style into a highly abstracted one, giving the impression of having been produced by By-

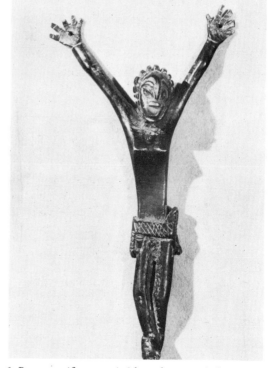

6. *Brass crucifix statue (16th–17th century), Congo. 11″*

zantine or Romanesque artists, who in the ninth or eleventh century possessed true religious fervor.

Magic

In magic, certain gestures, words, or acts, separately or together, are believed to invoke the direct assistance of supernatural powers in human affairs, or to give men control over the secret powers of Nature. In another sense, magic may be defined as the art of living in intimate union with Nature and sharing and using her secrets through ritual, or "doing." The Greek word for rite, as Jane Harrison has observed, is *dromenon*—"a thing done." Thus, a rite is a feeling or reaction expressed in an *act*. Moreover, since, in magic, spirits are influenced by appealing, cajoling, reconciling, conjuring, or subjugating them, magic may also be regarded as the *strategy* of animism. Freud remarked on the correspondence between the thing desired and the thing done in ritual; and magic may further be defined as wish fulfillment through ritual. By means of offerings and sacrifices, the practitioner of magic is assured in advance that his wish will be granted.

THE SCOPE OF MAGIC

Although in the broadest sense the field of magic might be said to include sorcery, or black magic, we shall make a distinction here. For the sake of simplicity we shall call magic that which is intended to have beneficial effects, and sorcery that which is intended to do harm. The magician mainly serves the community; he performs rites to promote fertility and avert misfortune. The sorcerer, on the other hand, is employed privately, serving one man in order to harm an enemy. Sorcery was desperately feared by the African, despite the remedy of counterspells worked by another sorcerer.

The profession of magician was held in es-

teem. It was passed on from father to son. As priest the magician promoted the welfare of the community; as medicine man he healed the ailing.

The sorcerer's profession, on the other hand, was often an underground one. The sorcerer was not only ill regarded but might be persecuted by the magician. His role was to procure somebody's injury or death by poison or by the prostrating fear he instilled. Among the Nyamsi of western Tanganyika the sorcerer was called *lozi* (or "poisoner"), a name derived from a poison root.

Sorcery was regarded as beneficial, however, by the one employing it. Rightly or wrongly, he laid the blame for a misfortune he had suffered on another, an enemy. To retaliate gave him a feeling of justice and restored power.

A third type of practitioner was the diviner, whose "science" was exclusively focused on divination.

If we analyze our own behavior, we will find that we, too, often act on assumptions close to those of magic. Much of what we do is an acting out of what we desire. And we, too, may seek to evade responsibility for the misfortunes that befall us by transferring the blame to others.

MAGIC AND RELIGION

In the ancient Negro states, the ruler was the religious head. But after the white conquests the natives had to dispense with religious leaders other than the local magicians, whose status and function varied from tribe to tribe.

The only African institution comparable to the hierarchy of organized religions was *patriarchy*. Thus, it was the oldest man in the tribe who had authority in religious matters and in the division of land. His authority was backed by the secret societies, which will be discussed later.

The African himself recognized a distinction between his religious and his magical practices. The former were connected with events—such

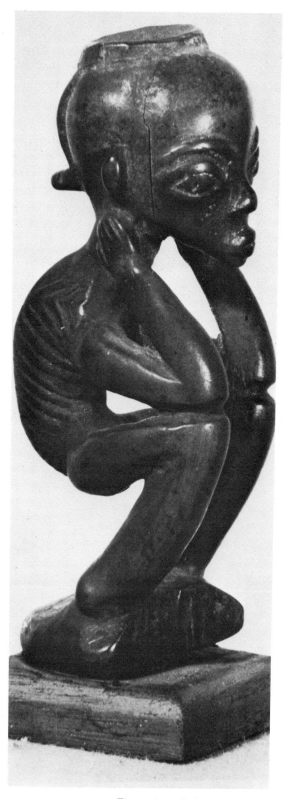

7. Figure, Bena Lulua, Congo. 10"
SEE PAGE 257

as birth, puberty, marriage, death—for which we too prescribe certain rituals. The province of magic, on the other hand, took in unforeseen events of life—sickness, drought, accidents, battle risks.

Magic differs from what we hold to be religion in its lack of a hierarchical priesthood, of scriptures, of authoritarian heads such as a Pope, and of revered founders such as Moses, Jesus, Mahomet, or Buddha. Nor are its practices carried out in large sacred edifices such as churches, temples, synagogues, or mosques; nor does it have a principal center of worship and place of pilgrimage, such as Jerusalem, Rome, or Mecca.

Virtually all these characteristics of other religions were missing in African animistic cults, though the mythology was somewhat analogous to the scriptures of other cultures and unquestioning adherence to the precedents established by the mythology was obligatory, as in religious groups everywhere. In the African cults any infraction, even when accidental, was severely punished. Any lapse was believed to destroy the effectiveness of the rite.

The huts set aside for the storage of religious masks and ancestor sculptures cannot be compared with the edifices raised for worship in other religions. Nor did the same sanctity attach to them. Where the buildings consecrated to other religions are believed to contain emanations of the deity, in Africa no such sanctity was ascribed to the hut containing the magic statues. The African was not connected with any universal God, although in many tribal myths one cosmological God was postulated. The African was concerned with spirits or powers, whether of natural forces, of tribal or family ancestors, or spirits wanting to do harm. Through the medium of the sculptor's art, the various spirits were localized, concretized in carvings, hence brought among the living solely to enable the petitioner to approach and influence them for his benefit.

In other religions the believer trusts in prayer to a forgiving and protecting higher

being. The African, on the other hand, believed that by magic he could directly control the forces of nature and make the spirits work for his advantage. He was so confident of his rights to this—given the proper magic—that a sculpture that failed to produce results was often destroyed and replaced by another. Thus, the worshiper's attitude in the magic cults was active, not passive. Through his positive assertion against fear and despair, the African attempted to arrive at mental assurance and balance.

Another difference between religion and magic is that in the former abstract ethical principles are stressed; in the latter only results count. The magic rites have a clearly defined, practical aim: to satisfy physical or instinctual needs and desires.

Furthermore, religions are usually evangelistic. They hold themselves open to all comers, to everyone willing to believe. In the animistic cults the rites are restricted to the initiated.

In the African cults themselves, certain distinctions might be pointed out between what might be termed their religious and their magical practices. Where the ritual was collective, it might be termed religious; where it was restricted and private, it might be termed magic. Again, where the ritual was founded on family life, it tended to have a religious character; magic was founded on the individual as a member of a secret society. Burials, which were connected with ancestor worship, involved the whole tribe and had a communal religious significance. Many other rites were secret and exclusive, at least of the opposite sex, as in the ceremonies held by the men's or women's secret societies.

THE MAGICAL ACT

The magical act protects one against mischance. When magic is used against the unforeseen, the future loses its dread. Magic helps to transform the uncertain into certainty. It derives from the instinct for self-preservation, but it fulfills other instinctual needs besides.

Recent psychological discoveries throw a new light on the magical act. We now know that if deeply rooted impulses are unfulfilled, they create inner tensions. In the magical act, the African attempted to deal with his neurotic tensions.

The magical act assigns an important role to the expression of emotions. The magician or sorcerer acts out the emotion of his client. This emotional identification gives validity to the wish the magical act is to fulfill. The sorcerer works himself into a rage, which is actually supposed to terrify the object of his maledictions.

Malinowski offers an interesting speculation on the origin of such spells. When one is faced with an overwhelming difficulty, he may blurt out curse words remarkably similar to the words used in spells. This often tranquilizes the person by discharging his emotional tension and gives him a curious feeling of confidence, as if he has done something to bring his desires a little nearer to fulfillment.

This may help to explain the importance of oral expression in the magical act. Though a ritual carving has had magical substances added to it, it assumes its magic power only when some qualified person—the chief, the magician, or the sculptor—pronounces that power to have entered into the carving. Among the Dogon a ritual rock painting incorporated the spirit it was assumed to represent only after the artist's pronouncement. Consecration rites included sacrifices, a dance, and an invocation setting forth the thought or wish the ritual was to embody. The word, we see, was as important in primitive ritual as in organized religion.

Of course the user of magic does not thereby change the course of outer events. But the belief (or faith) in the efficiency of the act reflects in an autosuggestive manner upon the believer. The increase in his self-confidence in turn helps to fulfill that which originally was only a wish. As an example, we may cite the fact that when an arrow was placed on an arrow quiver (Fig. 353), it was believed that the arrow acquired special power from being in

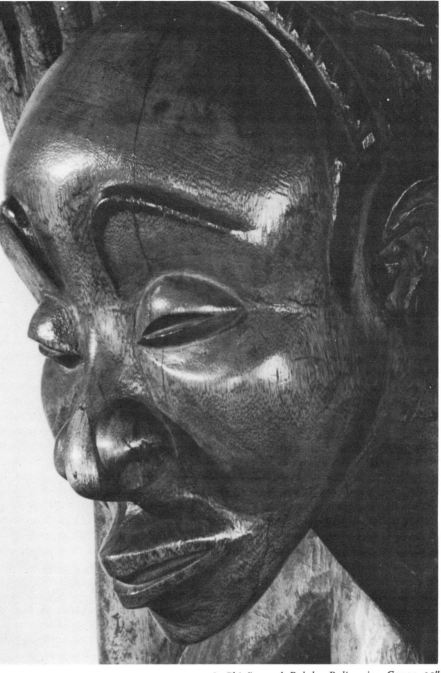

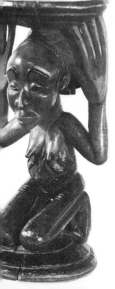

8. *Chief's stool, Baluba, Buli region, Congo. 21"*
SEE PAGE 241

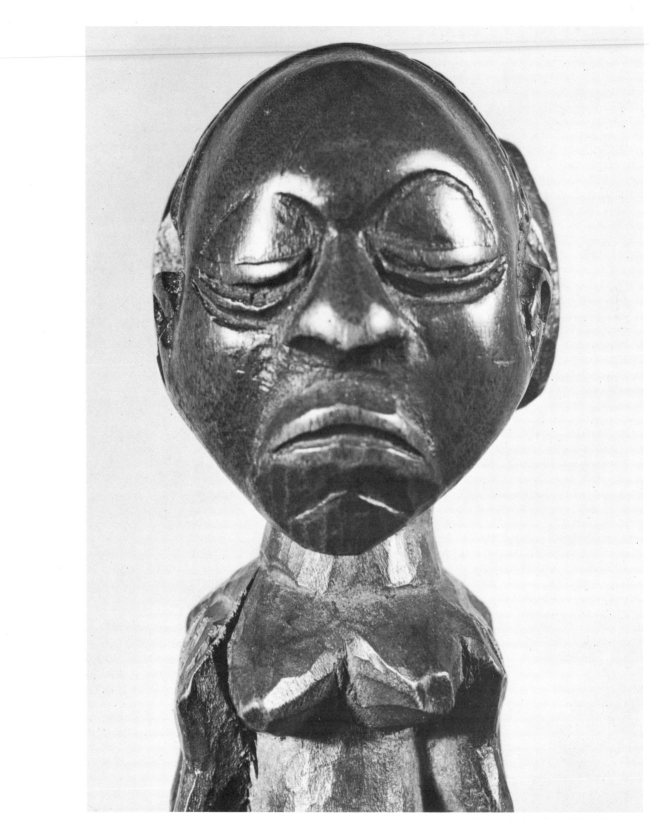

9. *Staff's head (detail), Baluba, Congo. 2″*
SEE PAGE 242

contact with a carved figure that contained a spirit. The hunter then used the arrow with such self-confidence that, in fact, the efficiency of his aim increased remarkably.

The magical act is one of two basic kinds. One is an act with a ritual object such as a statue or a carved mask, the other without. In the former case the ritual object is believed to have the power to bring about the desired end; in the latter the spoken words and the imitative gestures are believed to suffice. But in most African rituals both types of magical acts were performed.

WHY MAGIC SUCCEEDS

Whatever the forms may be, they rest on a common base, the user's faith in their potency. This faith in "the omnipotence of the thought," as Freud called it, was particularly powerful in African ritual because both the spirits and the statues they were believed to inhabit reflected the African's inner world. In this inner world he craved fatherly protection, and this was supplied in the ancestor spirit as concretized in the statues. In our search for security, we in the West build analogous image formations in our minds.

African ritual claimed to be rigid and traditional. The oldest myths affirmed that these rituals, in the forms in which they had been practiced ever since, began with the very genesis of the tribe. Unquestioning and undeviating observance was demanded of and willingly given by the natives, who were convinced that it was in their interest to do so. Observance gave them a comforting sense of belonging and relieved them of difficult personal decisions. The African knew no other way to assure success in his undertakings than magic; and he felt that without the ancestor cult there would be no safe haven for his soul after death.

We can see much the same process in the relation of the Catholic to his church. He is similarly relieved of anxiety and doubt, and many vital personal decisions are made for him.

SYMPATHETIC MAGIC

The anthropologist Frobenius describes in *Und Afrika Sprach* a form of magic he witnessed in the Congo. A hunter traced a picture of an antelope in the dust with his finger and then shot an arrow into its neck. He returned from the hunt with an antelope killed in that manner. For Frobenius this was a living survival of the magic used by the Magdalenian cavemen who, some fifteen thousand years ago, drew pictures of the animals they hunted on the walls of their caves and shot arrows—as marks on the drawings indicate—at vulnerable places on the animal. There is no doubt but that the assurance gained in this symbolic killing gave the primitive hunter a surer eye and a steadier hand.

This is a variant of one of the most widespread of magical procedures: sympathetic, or contagious, magic. What is done to the image of an animal or a man is believed to be done, magically, to the original. It is the chief form of sorcery. Often the sorcerer does without an image or an effigy and makes use of a lock of hair or a nail paring or a piece of a garment worn by the victim. Where a statue is used, it is turned or broken up. Numbers of valuable works of art have been lost in this manner. A similar function is served by the "nail fetishes" into which nails are driven.

Magical thought is very much a part of our mental processes during infancy. The fantasy of killing his father may appear to the infant to be so real (and this is the very nature of "the omnipotence of thought") and sinful an act that psychoanalytic investigation in adulthood may trace his sense of guilt and culpability to this early, fleeting, magical wish-projection.

MAGIC WITHOUT RITUAL OBJECTS

The French anthropologist Feuilloley witnessed the following exorcism. A man said to be possessed by an evil spirit chewed a mixture of seeds and chicken blood given to him by the

magician. He then spat into a dish the masticated matter, which a condemned youth was forced to swallow. The youth immediately howled like an animal. This was taken to mean that the evil spirit had left the older man for the younger, and the exorcism had succeeded.

We can find versions of such a belief in possession by evil spirits in fantasies and in private rituals of compulsion neurotics. The transfer of the possessing spirit effected by a magician is similar to the transference which occurs when the psychoanalyst is accepted as a substitute for the patient's father or any other person in regard to whom the patient is in emotional conflict.

In such exorcism cures an analogy of another sort may be seen. The cure here is the result of the patient's faith, just as are the cures at the miracle shrines of Lourdes or St. Anne de Beaupré, where the walls are lined with the crutches of hysterical paralytics who walked away "cured." This condition is realized at the ministrations of African medicine men, and we may assume a certain proportion of cures where illnesses were psychogenic. Unfortunately, Africans suffering from organic diseases had only the magicians to go to, and millions died prematurely for lack of scientific medicine.

This does not mean, however, that the African medicine man worked with nothing other than faith. Actually he had command of a fairly extensive pharmacopoeia accumulated through centuries of observation of the effects of herbs and minerals and transmitted orally from generation to generation. The value of a number of these remedies has been confirmed by Western scientists. Indeed, the African healer's apprenticeship called for many years of study, beginning at the age of twelve.

Positive and Negative Aspects

In their positive aspect, magical rites provide a man with the assurance necessary to carry out some undertaking with success. In their negative aspect such rites, when the victim knows about them, weaken his capacity to resist. Many instances are known of such victims apathetically resigning themselves to death by inanition. In psychiatric terms, paranoid fear of powerful persecutors or intense guilt feelings have thus been activated in the victim to induce self-destruction. Similar psychic mechanisms are observed in psychotics and neurotics in the West.

Negative Magic—Taboo

A manifestation of negative magic is the operation of restrictions or taboos. The psychologist Wundt called taboo (or tabu, derived from the Polynesian word *tapu*) "the oldest unwritten law of humanity." Freud defined it as the "objectified fear of demonic powers" and, in another connection, as "a command of the conscience, the violation of which causes terrible guilt feeling." Taboo is a series of socially and psychically sanctioned restrictions on behavior. He who violates a taboo faces not only the wrath of the community but his own horrified conscience.

How powerful this can be is shown in episodes reported by French missionaries. After eating a meal at the mission, one child learned that a banana, a food taboo of his tribe, was one of the ingredients. The resulting terror produced a paralysis of the respiratory muscles, and the child died before the missionary's eyes. Another child's taboo was being slapped, which was supposed to be fatal to him. Receiving a slap during a scuffle, the child fainted, and his life was saved only because a magician who could perform the necessary purification rites happened to be available.

The Meaning of Sacrifice

Sacrifice is as old as taboo, as old as the feelings of guilt and fear, as old as humanity. Essentially sacrifice is an appeasement of a higher power by one who fears hostility. It may be connected with taboos, violation of which involves guilt feelings and dread of punishment. In African terms, the superior life force (called

nyama among the Dogon of Mali) of a chief, a priest, or a spirit would destroy the taboo-breaker's life force unless appeased by a sacrifice. This higher power or stronger life force was connected with the image of the parent, from whom everybody experienced punishment as a child. Human sacrifice was rare. Usually animals, fruits, or cereals were offered. The vital force of the offering was believed to be absorbed by the person or image to whom the sacrifice was made.

Sacrifice is also thought of as expiation and is thus a direct expression of the sense of guilt. Since the sacrificial offering is something valuable, it is understood that the petitioner "buys" (or "bribes") the spirit for absolution. Among the Egyptians, this process became a legal matter when the petitioner simply gave a deed of land to the priest. Among the ancient Hebrews sacrifice became so mechanical, omitting any humble confession, that the prophets protested against it in the name of God. God spoke to them and asked them to stop the practice of burnt offerings without the admission of sin, saying also that He did not want His laws engraved on stone tablets but written in their heart.

Although relief and inner peace could be gained through the sacrificial rituals by appeasing the spirit, those who invented these rituals knew also that the sense of guilt (the greatest curse of humanity) could not be erased by a single act. Thus, the sacrificial acts were continuous and repeated (sometimes daily), providing a cumulative effect that was beneficial.

Analogies may be seen in the Catholic institution of confession of sin which produces a temporary relief from guilt through penance and absolution. Psychoanalytic practice shows, however, that until the root of a guilt feeling is found, no real easing of this burden can be achieved.

MODERN SURVIVALS OF MAGICAL BELIEFS

Though in a weakened state, much of our social behavior resembles the code of taboo. Our consciences are deep reservoirs of taboo. These may be so strong as to lead us to punish ourselves by neurotic symptoms for unconscious impulses that transgress against the taboos. Actual survivals of magic in the West include superstitious beliefs in the evil eye, unlucky days and numbers (how many of our modern skyscrapers do without a thirteenth floor!), fears of black cats, an open penknife, a broken mirror, etc. Figures like Superman allow us, like the primitive in his ritual identifications with ancestor heroes, to identify ourselves with fantasy figures through whom we may fulfill infantile wishes for omnipotence.

By extension, social conventions, codes of behavior, the very structure and unexamined usage and acceptance of our language, the "babble" of meaningless conversations, act as taboos, often frustrating the free realization of the true self. The re-examination of all that is handed down, of all that has been said, the asking of the questions "Is it so?" or "Is it for me?" constitute one of the aims of the modern phenomenological approach to reality.

DOGMA AND ART

Our concern here, of course, is with the effect of what we may call African dogmas on African art. Dogmas narrow the scope of the artist, but they also concentrate his emotions and thus intensify their power. The result may be likened to the concentration of sun's rays by a focusing lens, which imparts a burning heat to rays that when diffused are hardly felt.

The limitations of the dogmas are manifest in the rigidity of the African style traditions. The concentration is to be seen in the intense expressiveness of the sculptures. We may note here that early Christian art and the great Khmer Buddhist art show a similar rigidity and intensity.

According to Gide, a work of art is the product of selection and discipline. In African sculpture the selection was imposed by a unified, religio-magical, animist idea, the discipline

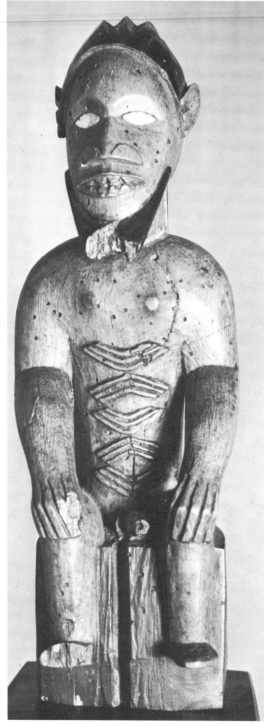

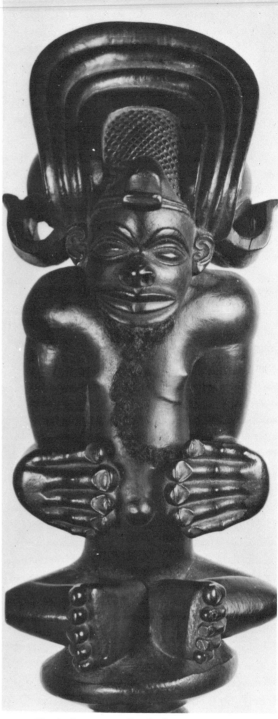

10. *Sitting figure, Babembe, Rep. of Congo. 7"*
SEE PAGE 211

11. *Head of a scepter, Batshioko, Congo, Angola. 14"*
SEE PAGE 270

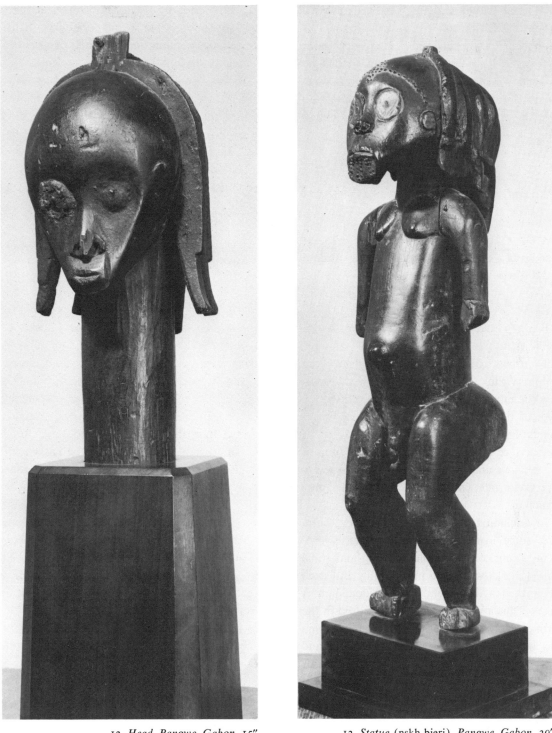

12. *Head, Pangwe, Gabon. 15"*
SEE PAGE 220

13. *Statue* (nskh bieri), *Pangwe, Gabon. 29"*
SEE PAGE 220

by a strong, though limiting, tribal art tradition.

Too much freedom results in chaos. As much as the new inventions of modern Western abstract art have liberated the artists from the conventional means, permitting them unprecedented freedom of expression, only those who have imposed discipline on themselves within their chosen medium have been able to produce authentic, valid works.

AFRICAN SCULPTURE AND MAGIC

Most African sculptures are of a magico-religious character. Seldom have they been the product of a purely aesthetic intention. African sculptures have become works of art only to us. To Africans they were objects of use necessary to the successful performance of rituals.

It is reported that in recent times in the Republic of the Ivory Coast, the Baule and the Guro tribes experienced aesthetic pleasure in sculpture and produced pieces with that purpose in mind. But even among these tribes, most of the sculpture was made upon recommendation of the magician and consecrated by the sacrifice of a cock. Thus the separation of the religious and the aesthetic in African sculpture was a late, incomplete, and isolated phenomenon.

In addition to magical and religious sculpture, some figures served as personal adornment, armor, or household utensils; and some carved masks were used in clowning. But even where the magic element is not predominant, it exists. Thus a pot may have a carved lid in the form of a totem or a mythological animal which was believed to safeguard both the food and those who ate it. Sculptured figures on weapons similarly protected the weapon itself and therefore the wielder.

Some writers hold that the famous statues of the Bushongo (Bakuba) kings should be classified as secular monuments, products of a court culture (Fig. 2). However, since the king (*Nyimi*) was considered of divine origin, his statue was also a religious representation. A division into religious and nonreligious African sculpture is hardly feasible. Its magical function is apparent even in the etymology of the words. Perier points out that the Bantu word *ngangu* means both "talent" and "magician."

African sculpture includes statues and masks, used separately, but both were believed to have magic power. Some statues were used for healing and some were commemorative figures. In the West African term, statues and masks were "spirit- or god-traps," embodying the spirits, providing homes for ancestors, containing their vital force and that of mythical and totemistic animals.

DIVINATION

Another magical procedure, widely practiced in Africa, is "throwing the bones." As reported from Gabon, the practitioner used a basket of small "bones"—*ngombo,* as the apparatus is called. The "bones," numbering about ninety, are small objects, each with its own meaning. A small carving of a crouching dog represents the soul of the dead; a human figurine represents a child; a long sliver of bone represents a traveler; etc. From their position in the basket, the diviner interpreted a person's fate. (Another important divination process, the Ifa ceremony, is described under Yoruba on pages 190 and 193.)

All the African methods of divination resemble our fortunetellers, who predict from the fall of cards, the lines on a palm, the shapes taken by tea leaves, etc. Indeed, another African form of divination directly resembles the last, the dropping of small sticks into a bowl of water and the reading of the "fortune" from the positions they assume. The earliest reports of divination in the Western world describe prognostication from the entrails of sacrificed animals, a practice of the ancient Babylonians, Egyptians, and Romans.

Special small animal sculptures, used by the Bakuba, and called *itombwa,* mainly crocodiles, pigs, and dogs, some with human and some with animal heads, were used in divination (Fig. 1). The back of each was flat, and

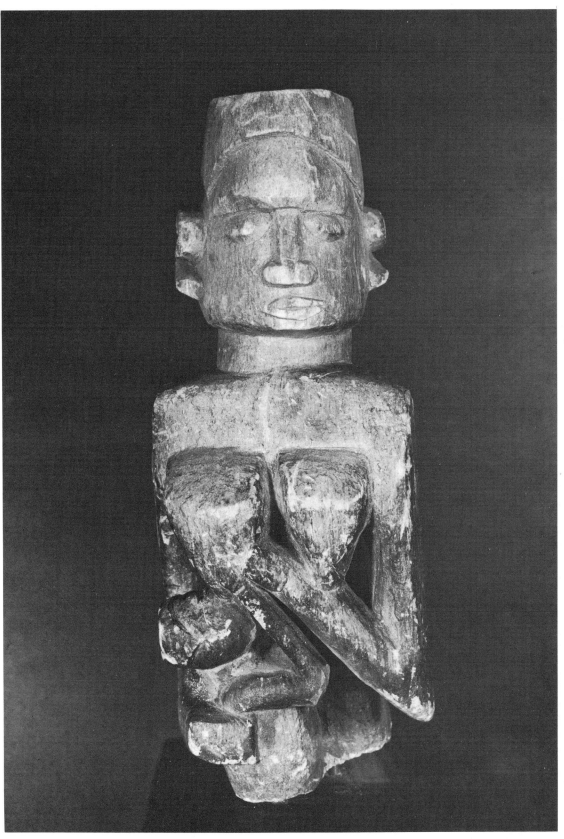

14. *Steatite maternity statue* (mintadi), *Bamboma, Bakongo region, Congo. 9″*
SEE PAGE 229

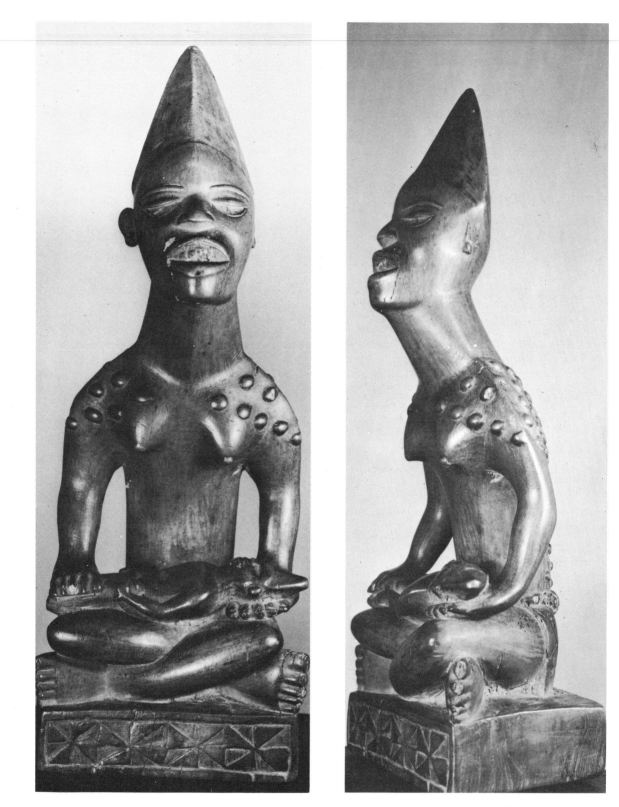

15. *Maternity statue, Bakongo, Congo. 12"*
SEE PAGE 229

during the divination this surface was moistened and a wooden disk rubbed on it. If the disk stuck, it was supposed to be an affirmative answer to a question asked at that moment. Torday reported that the adhesion was so strong that the disk did not fall off when the statue was turned upside down. It seems probable that the *itombwa* was not moistened with water but some mixture that became viscid with rubbing, and that the diviner let the disk stick when he thought he had a clue. For example, in using this magic to catch a thief, the diviner might call out the names of suspects. Nervous behavior on the part of a person on hearing his name might decide the diviner to let the disk stick at that point. Similarly a medicine man using this method to hit on a remedy might call out, "Do not smoke," "Do not eat meat," etc., and let the disk stick at what he considered the right prescription. The client believed that the disk stuck, not through any decision of the medicine man, but through the will of a supernatural spirit. Hence, the psychological effect upon the client was achieved, since the statement of an all-powerful spirit had more validity than the statement of a mortal.

If we study each case involving magical objects, we find sound psychological reasons for the techniques.

Mythology

The historical past of the natives has dissolved in their myths which, while of little documentary value, served a major cultural purpose in providing subjects for symbolic sculptures.

The number of African tribal myths cannot be estimated. Each of the more than a thousand tribes had its own vast store, which took the place of written literature and survived for centuries in oral tradition. The French writer Blaise Cendrars, in his *Anthologie Nègre,* has offered a sampling of these myths, about a hundred legends selected from material in 591 African languages and dialects. He subdivides them into myths concerned with cosmology, fetishism, totemism, fantasy, tales, and poetry.

ORIGIN OF MYTHS

It is possible that some myths began with the recital of a chieftain's dreams. Since primitive people consider dreams a part of their everyday life (seeking guidance for future action in their dreams), the recital might have been accepted both by the narrator and his audience as real, and repeated in future recitals as actual occurrences. Succeeding narrators quite possibly selected and emphasized those features which corresponded with their own desires. Thus the original dream might have grown into a communal fantasy or myth. It is also likely that the chief, as the responsible moral authority of the community, edited his dreams here and there to carry a moral lesson, thus incorporating an ideological statement into the myth.

Most important, perhaps, are the creation myths and the myths of the origin of the tribes and of their institutions. Myths are always "stories," whose characters include human beings (either similar to those presently alive, or ancestor and cultural heroes) and the spirits of natural forces and animals. The characters are not symbolic figures; they act out events from tribal history, and their speech and behavior are those of contemporaries. To the African it was perfectly natural for animals or spirits to behave and talk like living people.

MYTHS IN EVERYDAY LIFE

Myths played an active part in the African's everyday life. They were a vital social force. They not only supplied accounts of the tribe's origin but, as Malinowski pointed out, related *precedents* to present-day beliefs, actions, and codes of behavior. It was taken for granted that beliefs and practices had existed unchanged since their adoption. Thus the reference to a precedent codified and sanctified the beliefs and placed them beyond question or change. According to the myth, magical or religious

ceremonies or actions produced results for the forefather; therefore the efficiency of the ritual was assured.

The faith in myths is comparable to the faith in scriptures. Because myths also lay down laws of ownership, of behavior, etc., they are comparable to our legal codes, which also accord a high place to precedent.

The sacred myths were preserved in Africa by the secret societies and recited in a special language understood only by the members. The impressiveness of these myths was enhanced by the fact that they were revealed to the member for the first time at his initiation, the turning point in his life, when his fears had been excited, when he had been subjected to ordeals of pain and endurance, and when his tribal identification had been dramatized to the utmost.

Thus every subsequent repetition of the myth was bound to evoke strong emotional resonances.

Myths as Art Sources

Myths are peculiarily accessible to the psychoanalytical approach, their symbols showing strong similarities to dream symbols and expressing similar repressed desires, fears, and compulsions. But the mythological symbols, although originating from the unconscious, carry ideological and spiritual concepts as well.

Like dreams, myths are inexhaustible sources of creative impulses. This is exemplified in African art works. Entire masks, and sometimes ornamental details on African art, have their origin in a mythological belief.

For an interesting parallel, dreams have also been used as inspirations in contemporary Surrealist painting and sculpture. Physical reality seemed so precarious that Surrealist artists sought attachment to something more secure, something in their own inner world not dependent on the ever-changing outside world, and they turned to the images in their unconscious.

Mythological precedents, as we have seen, also helped to establish a strong *art-style tradition*. In African mythology, invisible forces, the spirits of nature, the genii, were pictured as the ancestors of the Africans, who believed that the territories they occupied were previously held by the local genii. When a tribe moved to a new territory, rituals were performed asking permission from the spirits of the former inhabitants to occupy the new grounds.

The Dogon, in Mali, have a creation myth eight hundred verses long. Local genii, animals, and mythical "redmen" are their joint ancestors. In their recitals of the myth they refer to certain masks (discussed on pages 155 and 157). The Yoruba, in Nigeria, made a number of carvings representing the *orisha* (demigods), whose existence is based upon the tribe's mythology (described on pages 187, 190, and 193).

The Baule, of the Republic of the Ivory Coast, start their creation myth with an immaterial god (Aluru). No cult, however, was devoted to him; therefore no sculptural representation exists. But Nyama, their spirit, genius, or demon of the sky, who ruled over the future life of people, is represented by a ram mask. A bull mask with two or three horns represents another spirit, Kaka-Huie, and his wife, Ago, who supervised burials. The demon of agriculture, Kuamanbo, is also represented by a ram mask. Zambie and Frete, second-grade genii, are represented by an antelope head with long horns. Obekre, another second-grade spirit, has a monkey mask with a doglike head. Bgogro-Kofi has a hyena mask.

One could continue an endless enumeration of spirits, demigods, and second-grade genii. Sometimes the same mask served two different spirits. To determine whether a mask refers to a myth, a totem, or a supernatural being, whether it embodies the protective spirit of a tribe or a secret society, requires long and careful study.

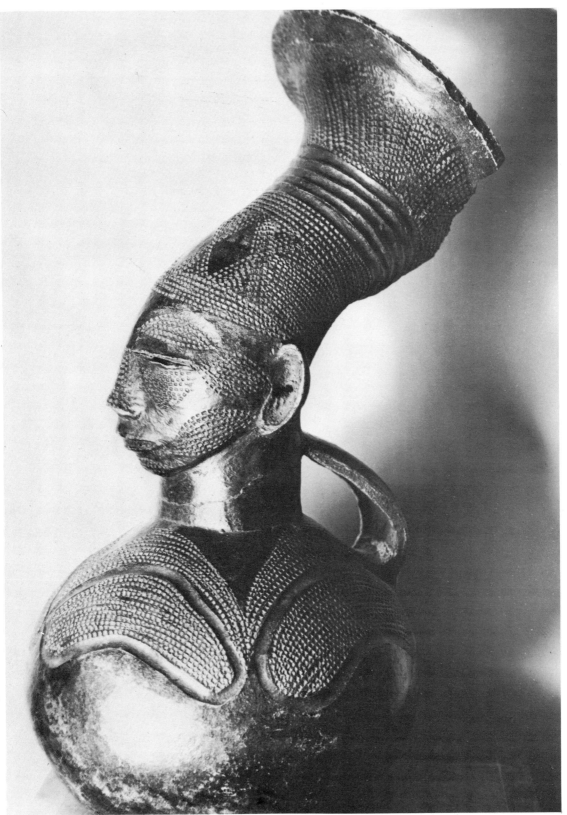

16. *Ceremonial pottery jar, Mangbetu, Congo. 13"*
SEE PAGE 258

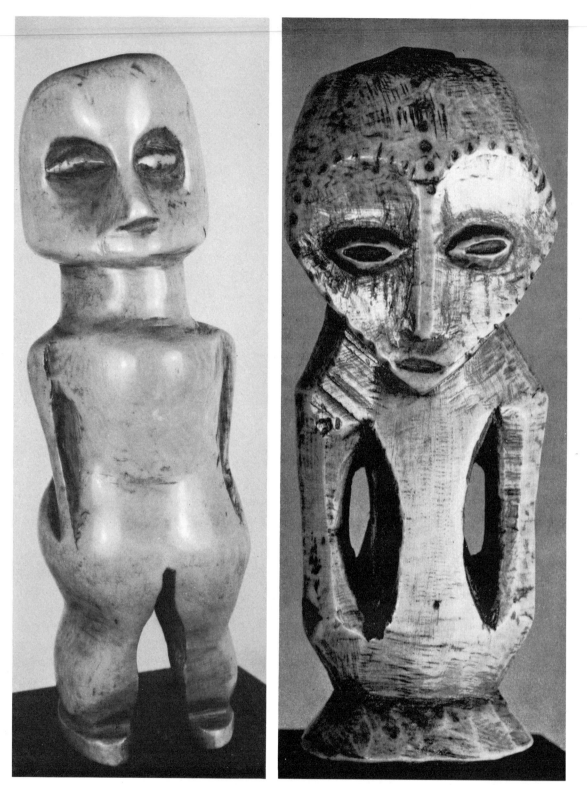

17. *Ivory statue, Warega (?), Congo. 6"*
SEE PAGE 263

18. *Ivory statue, Warega, Congo. 5½"*
SEE PAGE 263

3. AFRICAN CULTS EMPLOYING SCULPTURE

THE HIGH DEGREE of expressiveness of artwork from Africa is based upon the intense emotionalism connected with their deeply experienced religio-magico-social ceremonies, all based upon a rich tradition which survived in unquestioned, basically unaltered form from generation to generation. Sculptured objects were used in all aspects of daily life, since African religiosity was not a simple adherence to set dogmas, or only practiced in special ceremonies, but was a *way of life*. Of the large number of cults that existed, we have selected only three types: the cults of the dead and of ancestors, the cults of what is called for simplicity's sake totemism, and the cults promulgated and maintained by secret societies.

The Cult of the Dead and Ancestor Worship

The cult of the dead, of which ancestor worship is an outgrowth, is one of mankind's oldest religious observances. Remains of the Neolithic period in western Europe (New Stone Age, 10,000 to 3000 B.C.), such as the dolmens (table stones), cromlechs (stone circles), and passage graves found in France, England, and Scandinavia, indicate communal burial sites which were used over long periods. Nowhere was this cult so highly developed as in Egypt, where traces from as far back as 6000 B.C. have been found, and where the world's vastest tombs, the pyramids, arose.

According to Freud, ceremonial burial derives from a deeply rooted instinct in man to return to the womb, to be laid in Mother Earth. Many primitive peoples still bury their dead crouched in the fetal position (Fig. 7).

When an African king or chief died in ancient times, his companions, wives, relatives, slaves, and others connected with him were killed to keep him company in the other world. Only exceptional people were then believed to have immortal souls; therefore only those were sacrificed who were deemed worthy of sharing the dead ruler's immortality.

In some regions the custom survived into the last century. According to Torday, when the Bushongo (Bakuba) king Bope Mobinji died in 1884, two thousand people were killed, not counting wives and personal servants. Similar human hecatombs in the Benin Kingdom showed certain variations. The trunks were buried in a common grave while the severed heads were raised on poles around it. Photo-

graphs of this grisly palisade were brought back by explorers. Elsewhere it became customary to bury sculptured heads or figures of the royal companions instead of killing them and interring their bodies.

Heads were frequently dried and the skulls used for ceremonial drinking cups. Because the vital force (or soul) resided in the head, by drinking from the skull the user appropriated the strength of the dead man. Most treasured of all was the skull of a powerful enemy, for this meant not only the acquisition of his vital force, but his complete extinction. The Bakuba cups carved in the form of human heads appear to be survivals of this custom (Figs. 318, 321, 325).

Subsequently, a carving of the dead man became an ancestor figure. So, instead of providing company for the dead man by slaughtering his former companions, a sculptured body was provided in which he could rejoin the living. Thus, in Africa there evolved from burial rituals a system of worship of the spirits of ancestors. These were believed to retain their vital power after death.

Universal Energy

The concept of one God existed among most Africans, but to them He was more a cosmological idea than a religious, anthropomorphic one. God was believed to be self-begotten and to have created the world, but He was indifferent to human beings and therefore no cults, statues, or symbols were consecrated to Him. His name, however, was mentioned in wishful statements or in blessings. The care of human beings was delegated to secondary demigods or spirits, each with a special function, and many of the rituals and carvings served one of these spirits. *African Ideas of God,* edited by E. W. Smith, enumerates a great number of names for the gods, the most recurrent among West African tribes being Nzambi, which was also spelled Nzami, Nzamba, Nzame, Zambe, Zamba—probably from the same root word although no etymological explanation is available. Other frequently occurring names were Nyamba, Ngombe, Imana, Ngala. On the East Coast another series of names were used, based on a root word: Murungu, Mlungu, Mluku, Mungu, Mbgu.

Among the Akan-speaking people (Ashanti) the Supreme Being was called Nyame, but another derivation, *nyama* (as described by Griaule in *Masques Dogon*), is connected with the concept of vital force or vital breath (*élan vital*). The African had a strong sense of being part of the natural order and by extension of the cosmic order. Everything derived its "energy" from the same source, the force of Nature. Man, animals, even inanimate objects had a share of the Universal Energy, which, though invisible, was omnipresent. The Universal Energy could see and hear everything and had volition; therefore a man's ever-present guilt feelings caused it to be feared, and attempts were made to appease it with flattering offerings and prayers.

Universal Energy was thought of as being distributed through all matter. It is remarkable how close this concept comes to the most modern understanding of matter and energy as different aspects of the same entity.

Vital Force

The vital force (or *nyama,* as we shall call it from now on) existed only in animated beings —men, animals, and plants. It differed from the rest of Universal Energy in that it could pass from man to man, from animal to man, and from plant to man or animal, etc. This transfer could be effected, as desired, by the use of the proper magic. The *nyama* was indestructible. After death it reincarnated itself in other human beings, generally those of the same family.

The idea of *nyama* comes closest to our concept of the soul. Unlike our soul, however, which is indivisible, the *nyama* was transmissible in whole or in part. Our soul is specifically human, and after death goes off to the afterworld to receive divine justice. But *nyama* ex-

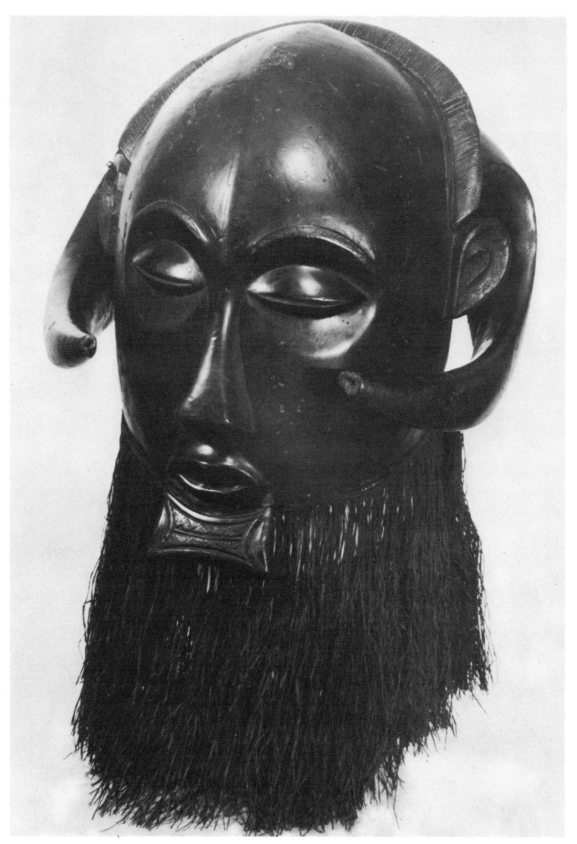

19. Mask with horns, Baluba, Congo. 18"
SEE PAGE 238

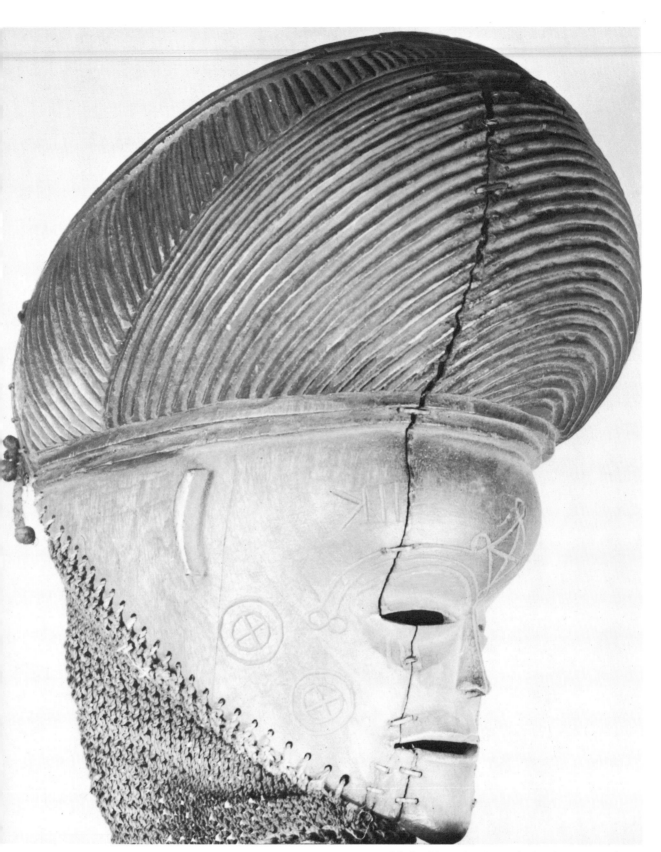

20. *Mask with net (pwo), Batshioko, Congo, Angola. 14"*
SEE PAGE 270

isted in all animate creations. A man's *nyama* remained on earth after his death and exerted power over living beings, with whom it maintained intimate connection. It could be augmented with additions of the *nyama* of others; it could be appropriated by others; and it was not subject to divine justice. As part of Universal Energy, the *nyama* could fuse with it.

Since masks were considered the abodes of various spirits, often the *nyama* of a dead person was attributed to a mask—or to an ancestor statue—and thus *nyama* must be considered in any discussion of African art. The mask was regarded as the support or container of *nyama;* by wearing it the masker augmented his own *nyama*. It was necessary to trap *nyama*, which might work harm when on the loose. In the consecration of the mask the blood of a sacrificed animal was poured over it, thus adding to its *nyama* the *nyama* of the animal. A human being might lose part of his *nyama* by bleeding and add to it by eating. When he consumed a vegetable he acquired not only its *nyama*, but the *nyama* of the earth, rain, and sun which the vegetable had absorbed. Animistic ritual was mainly a matter of transference of *nyama* from one organism to another.

The Polynesian concept of *mana* is so strikingly similar as to suggest the possibility, despite the great geographical distance between the two peoples, of a common cultural origin.

We find this concept throughout the African continent. In Ghana the Ashanti word for it is *kra* (how similar to the Egyptian *ka* for the same concept!). As reported by Eva L. R. Meyerowitz in *The Sacred State of Akan*, the Ashanti defined it as the overriding vital force, which maintained an independent existence in the body and was the source of uncontrollable human impulses, dreams, and fantasies (how close to our concept of the unconscious!). Further, we find the design ◉ on Ashanti gold weights and on the ivories of the Baluba (Fig. 343), Bapende (Fig. 363), Basonge (Figs. 369, 370, 371), and Warega (Figs. 408, 415, 418). This symbol can also be found on some Egyptian carvings. According to Ashanti expla-

nations, the circle enclosing a dot represented the sun, upon which Nyame (the Ashanti supreme being) deposited her *kra* after giving birth to the universe. Subsequently this symbol was restricted to the *kra* or to Universal Energy. (For further study on the circle-dot symbolism, see the author's essay on this subject.)

THE ANCESTOR CULT

To the African, death meant that the *nyama* left the body at the command of Universal Energy. Death, consequently, was not destruction but a transformation or transfiguration.

This belief in the *nyama* may be seen as another primitive solution of a psychic problem. Death was terrifying and repugnant to the African, who had frequent occasion to see putrefying corpses. Had his horror and fear led to flight from the place defiled by the putrefaction, it might have resulted in a disintegration

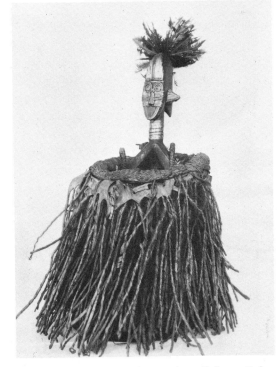

21. *Reliquary figure with container, Bakota, Gabon*
22″
SEE PAGE 213

of his social structure through the continuous disestablishment of its centers. In addition, fear of death would have become a crippling obsession.

Here faith in the survival of his *nyama,* his vital force, came to his rescue. Instead of flight he chose to confront and overcome his fear. He minimized physical death and emphasized the continuity of life. He knew that the *nyama* of his ancestors survived. It was worshiped and venerated. Believing in this procedure, a man need not fear death. His *nyama,* too, would survive to occupy an honored place in the family.

He was assisted in the development of this concept by his dreams of visions, in which dead persons returned. Dreams being as actual to him as reality, this was concrete evidence to him of the survival of the dead. The belief was dramatized by making every death and burial a communal event, and faith was concretized in the ancestor statue.

ANCESTOR STATUES

Among the Pangwe and Bakota and other tribes, ancestor worship involved preserving the skull of the dead in a container mounted with a sculptured head or figure (Figs. 21, 287). Other observances included visits to the grave, where food was offered. But the commonest form of ancestor worship was the use of an ancestor statue (Fig. 155), or mask. The figure was kept in the house on an earthen altar or in a small adjoining hut erected for this purpose. Thus it was immediately accessible any time the ancestor's help was needed.

As we have seen, the soul of the deceased was believed to consist of two components: its *nyama,* with which the worshiper sought to reinforce his own *nyama,* and the powerful Universal Energy, whose good will it was important to have. The concept of Universal Energy and *nyama* was not always clear-cut. Versions varied from tribe to tribe. In some form, however, the concept has been found in every tribe.

The ancestor statue contained this composite force but not until certain rites had been performed to induce the spirit to take up his residence in it. After the spirit had thus been ritually inducted into it, the statue became a very important object. Up to then the spirit was believed to have led a homeless existence, which embittered it against the living and made it dangerous to them.

There are two types of ancestor figures—one serving a family, the other serving the whole tribe. The latter is a representation of a tribal chief. It was kept in the custody of the magician of the village. So real were the spirits to the African that he considered the spirit—and the image in which it was embodied—to be literally alive, to function as an active member of the family, and, indeed, to have more potent vitality than the living.

Residues of similar attitudes may be observed here and there in Europe. For example, in Germany there have been instances in modern times of the place of the dead at the table being left unoccupied and the food set there at family meals.

Most common among the variety of pleas made to the ancestor figure were appeals for the use of his *nyama* to strengthen the petitioner's *nyama,* intervention in his favor with the spirits of Nature, protection against harm to him, and aid in his enterprises. The pleas were expected to be granted if the proper sacrifices had been made. The sacrifices also appeased the ancestor's jealousy and resentment toward the living, signs of which were the accidents, misfortunes, and illnesses which the ancestor was asked to avert.

WESTERN ANALOGIES OF ANCESTOR WORSHIP

When we go into a cemetery and invoke the memory of the deceased, we, too, perform an act of ancestor worship. But the African's ritual was based upon animistic concepts. His mortuary figure had life, while our representation is merely symbolic. For this reason, perhaps, his figure is a powerful work of art, while our

tombstones are among the most inartistic carvings man has ever produced. Instead of our occasional trips to the cemetery, the African could turn at will or need immediately to the ancestor figure beside him. Probably for the same reason—that is, to have the savior symbol near at hand—crosses with finely carved Christ figures have been set up on highways in various parts of Europe.

Psychoanalytic Interpretations

As the dependence upon protective parental figures is deeply imbedded in the human soul due to his early infantile helplessness, the death of this figure may cause anxiety and despair, and if stronger neurotic tendencies are present, an actual infantile regression may occur. Seen from this frame of reference, the ancestor figure, which the individual can touch and feel as real, becomes a permanent ideal father present at all times, ready to fulfill all wishes after the sacrificial offering. He is better than an actual living father: he cannot talk back and punish. The statue also takes the role of the superego or conscience and can play an important role as the personification of one or two parts in an internal dialogue.

On a very practical and fully conscious level, when an African had a dubious impulse, he could consult his ancestor statue. After having made his offering, he was sure that he had the good will and sanction of his ancestor and he then carried out his impulse with an easy mind. The guilt feeling, often so restrictive to our actions, was thus,—for the time being—removed.

The attitude toward the father is ambivalent, however. His protection is sought, but his restrictive authority is resented. Awareness of this appears in the Old Testament, in Exodus, where veneration of father and mother (the ancestors of African ritual) is codified: "Honor thy father and thy mother that thy days may be long upon the land which the Lord thy God giveth thee." In Deuteronomy the commandment is repeated with the added words ". . . as the Lord thy God hath commanded thee,"

and "that it may go well with thee." Thus, to the redoubled command rewards are added—the promise of long life and material prosperity.

According to Freud, the revolt against the father among primitive peoples is expressed in the totem feast, when the totem animal, an ancestor image, is killed and eaten.

Fears, including the fear of the vengeful ancestor, were widespread in Africa, as everywhere. To deal with them, the African may be said to have worked out a psychotherapy of his own, of which ancestor worship was only one aspect.

Fears arouse two types of reaction in human beings: *flight* (or evasion) and *fight* (or struggle). In the case of a neurotic who chooses flight (whether the threatening force is a reality or a fantasy does not matter), this choice may end in panic or the collapse of the will to live. The African chose to fight. To master his fear he "objectivized" or "concretized" it in images and rituals. One result has been creation of a great sculpture.

In this sculpture the African has followed natural forms, but he has deformed them, imposing his will upon them. From this have come abstractions, which we shall later discuss in detail.

With his fear unloaded in his sculptures, the African was able to dominate his fear, having captured, and thus vanquished the threatening spirit, and imprisoned it in the wooden figure. This enabled him at the same time to put greater power into the creation—reflecting the intensity of his animistic belief. In this way, too, he mastered himself, for, as Freud has shown us, spirits and demons are man's projections of his own emotional impulses.

The African's positive struggle against fear, and the will to create that it stimulated, constitute a magnificent, wholesome, and epochal achievement.

To the African the spirits supplied *logical answers* to manifold threats in life and Nature. What he could not understand seemed to him obviously the work of spirits. Rain, fecundity,

sickness—each had its spirit and could be caused by the malevolence of the ancestor spirits. And the better to face them, he simplified or objectified them by creating magical objects and rituals.

Forms of Totemism

Totemism, in Frazer's definition, "is an intimate relation . . . which is supposed to exist between a group of kindred people on the one side and a species of natural or artificial objects on the other side, which objects are called the totems." The totem in most cases is an animal, but sometimes a plant, a natural phenomenon, or a physical object of some kind.

It would be safe to define totemism as a formalized human association with objects and symbols which the natives have charged with emotion. Sometimes the clan takes it name from the totem and uses it as a heraldic symbol or develops a system of magical observance around it. Where the totem is an animal, killing it is taboo. As Freud pointed out, totemism and exogamy often existed together. Exogamy (prohibition of intermarriage or sexual relations within the clan) is frequently one of the totem taboos. It defines incest, inbreeding, and adultery. African peoples did not consider the totem animal to be the tribal ancestor, as do totem-observing peoples in other parts of the world.

According to many African myths, the totem animal helped the founding father of the clan or saved his life, and thus became the protector of the clan, which adopted its name. Animals were seldom objects, in any other way, of a religious cult, although the serpent, among the Ouidah in Dahomey and the Dogon in Mali, etc., was considered sacred, primarily as an incarnation or symbol of local genii or ancestor protectors. This belief, however, did not exclude the possibility of the *nyama* being conducted into an animal.

SOURCES OF TOTEMISM

We will use the totem concept here in its relationship to the concept of spirits, of a force operating in the African's world that he could draw upon for his own use or protection.

The African believed in an intimate affinity and relationship between men and animals, to whom he accorded equal status. Each clan had a different protecting totem animal. To some clans the totem animal was sacred and could not be killed because its ancestor was believed to have given service to the clan's ancestor.

The use of animals as symbols for spirits had its origin in the "soul-worm" concept. According to Otto Rank's interpretation, the worm issuing from the decomposing human corpse was thought to be its departing soul. From this first concept grew the idea that other animals —snakes, leopards, etc.—were also "soul animals." There is a strong possibility that the soul-worm idea was the unconscious source of African veneration of animals and their intimate connection with magico-religious ceremonials. Identification with animals, of course, presupposes the belief that animals have souls.

Concern over food provides an additional explanation. To assure an abundance of food animals and plants, the African had to take care of them. To accomplish this and also to overcome his fear of the animals and to assert his control over them, he made use of magical rituals.

In Boas' view, the totem originated as the guardian spirit of an ancestor revealed in a dream. As we observed earlier, dreams were considered real by the Africans and were often the basis of myth creations. Handed down from generation to generation, the dreams formed the mythology; thus, the dreamed power of the animals was considered a real power established by tradition.

While the spirits of ancestors and of natural forces were seen to some extent as abstract manifestations of Universal Energy and were generally connected with the dead, the totem

animal was thought of as a living being. Yet the totem animal served the same primary purpose as the cult of spirits—a release from fear. In the totem animal fear was objectified in a living figure.

Totemism served still another function. It helped primitive people to feel themselves possessed of some enviable quality of an animal —combativeness, strength, speed, endurance, and so on. When an African wore a totem-animal mask, he became the animal itself.

TOTEMISM AND TRIBAL CUSTOMS

Certain social institutions derive from totemism. Because people in the same clan are considered brothers, they acquire a closely knit unity, not fostered by the ancestor cult or magical rites. But while totemism fosters unity within the group, it fosters differentiation from other groups. The system provides dramatic ritual affirmation of the human need for mutual aid. The totem helps to overcome elemental but destructive human emotions, such as hate, dissension, and jealousy, with the aid of a magical social unity sealed by the common bond of the totem animal.

Where a taboo against killing the totem animal exists, a day is set aside when its slaughter is permitted—a day celebrated as a holiday. The animal is butchered but at the same time mourned, and Freud sees in this an analogue of the child's ambivalent emotion toward the father—love and admiration for his power and hatred for standing so threateningly in the way of his sexual demands and his desire for independence. In Freud's interpretation the totem animal is a substitute for the father, and the simultaneous rejoicing and grief when it is killed reflects the conflicting attitudes toward the father.

TOTEMISTIC USAGES IN CIVILIZED SOCIETIES

Residues of totemistic usage may be detected in our everyday language, when we refer, for example, to "foxy," or "pigheaded," or "eagle-eyed," or "lionhearted" people. Similar vestiges are to be seen in the use of animal mascots, in the figures on college rings and pins, in heraldry, and in emblems of all kinds. Our national symbol, the eagle, is such a survival. Of our fifty states, forty-five have animal emblems.

Secret Societies and Initiation Rites

There were a variety of so-called "secret societies." They were not secret in the sense of not being openly known among all members of the tribe, but because a special admission rite was prescribed and what happened in the society could not be divulged. The most important and most widespread role of the secret society was the separate education of the adolescent boy and adolescent girl and the final admission of each into an adult society. The role of such societies was religio-social. Some societies had, in addition, great political power, such as the Poro society in Liberia or the Ogboni society among the Yoruba in Nigeria, the latter having been entrusted with the administration of law. Other secret societies (the Bwami among the Warega, for example) had different social grades; the individual advanced from one grade to the next, hence gaining social and political prestige and power.

In all these different societies a great abundance of carved objects were used (discussed in detail in Part IV).

To undergo the initiation into adulthood, the boy, after having reached puberty at about eleven, entered into the male secret society. The long and complicated ritual was a form of intensified education. The proceedings were carried on in a hidden place. Generally the boy remained there in seclusion for a longer or shorter period, according to the custom of the tribe. Among the Bakongo of the Congo, this was two to four months. Among the Hyondo of the Ubangi-Shari region (now the Central Afri-

can Republic), the ceremonies lasted two years, and continued flagellation was administered to develop the endurance of the initiate. The timing of the ceremonies also differed from tribe to tribe. Some tribal secret societies met every four years; some, like the Poro secret society in Liberia, once every twenty-five years (that is, once in each generation).

The boy's instruction included complicated ritual dances, secret language, secret music, the sacred myths, religion, and magic. Respect for the aged was drilled into him. Among the tests of endurance he underwent were circumcision, scarring the skin in prescribed patterns, and prolonged silence. The boys were also trained to work collectively, giving a hand where urgently needed.

Girls went through a comparable course of initiation. This has been most closely studied in connection with the feminine secret societies called Bundu (or Sande) in Sierra Leone, among the tribes of Sherbro Island, and among the Bijago on the Bissagos Islands.

In rites analogous to circumcision ceremonies, the membrane covering the clitoris was cut or an incision was made into the vaginal lips, facilitating hygiene.* A hoodlike mask was used in these ceremonies (Fig. 145).

SIGNIFICANCE OF THE MASK

If the society was for the initiation of youth, a mask was worn either by the adolescent or by some members of the society. If the society had a hierarchy into which members were admitted by stages, masks were used either by both new members and officers or only as emblems of each grade (as in the Bwami of the Warega).

Basically the role of a mask is threefold: (1) to hide the wearer's identity from others; (2) to free the wearer from the frustration of what he is supposed to be and revert to what he really is—in contemporary terms, get rid of his public "image" and be what he really is; (3) to allow the wearer to become something different, something he is *not* but would like to be, or to acquire the identity that the mask suggests or represents. (To feel the actual role of mask, the reader is asked to imagine going to a masked party, where everyone is unknown and lets his actions follow his own uninhibited impulses.)

In the initiation ceremony, the aim of a masker was to lose his identity. In many other African ceremonies, the mask represented a spirit or a dead person and the dancer not only lost his own identity but took on that of the mask. In the Poro society in Liberia, it was the mask that was recognized, not the individual who wore it. The mask was the spirit, the mask had the power. The person who wore it was depersonalized.

The mask also became the law, since judgments and rulings were pronounced by the masker in the name of ancestors or ancestor spirits who resided in the mask. These pronouncements, like papal bulls, were considered infallible. For the individual this meant that he could confidently attach himself to the protective power of the mask (the ideal father), in place of the human figure who so often caused deep psychic resentments. When the individual wearer of the mask died, the mask was immediately assigned to another high-ranking member of the secret society, thus achieving a continuity of the law and its institutions.

When the adolescent wore the mask for the final initiation ceremony, the mask represented the old (adolescent) life and it was cast away, symbolizing the death or extinction of childhood as the youth assumed manhood and adult responsibilities. Simultaneously the initiate assumed a new name when he returned to his clan. Changes of name meant more to the African than to us, though we too feel certain psychic effects. For the African the name

* According to H. T. Laycock, "Surgical Aspects of Female Circumcision in Somaliland," published in the *East African Medical Journal* (Nov., 1950), the following operations are performed: Clitoridectomy or excision, infibulation (sewing up) to prevent premature and illicit intercourse, and the reverse, defibulation (cutting open). Infibulation consists in cutting away part of the clitoris and in scarifying the *labia minora;* defibulation consists in a short incision made to separate the fused *labia minora.*

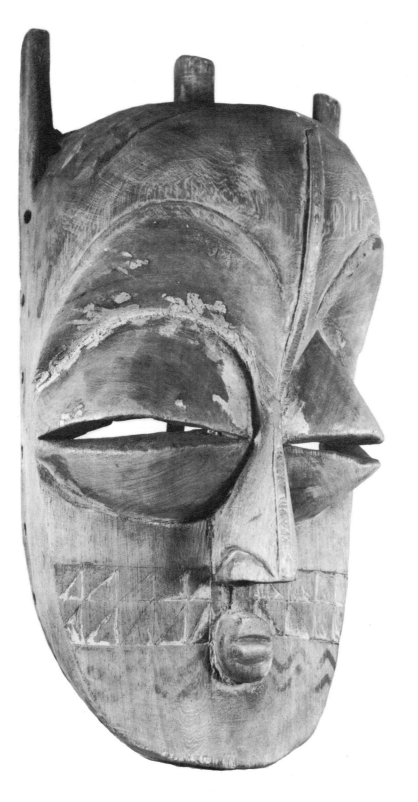

22. *Mask, Bena Biombo, Congo. 15"*
SEE PAGE 257

change involved a change in personality, for the name *is* the person, as his shadow is part of his body.

(Among the Orthodox Jews, when a child is gravely ill, the parents change his name in the hope of giving him a new identity, turning him into a newborn child free of the sickness.)

PSYCHOLOGICAL IMPLICATIONS

Among the Mendi in Sierra Leone, the symbolic death and rebirth was dramatized thus: A "devil" represented by a mask "ate" the candidate, who was painted white, the spirit color, to symbolize his entrance into the world of spirits and the fact that he is not alive now but in communion with the spirits. (This symbolic death is also sought after by adults in trances that enable them to "travel to the country of the spirits.") The devil later "vomited" the candidate, who was thus resurrected from the dead as newly born. The candidate's head was shaven to simulate the hairless scalp of the newborn infant; then he was washed and given a new name.

In the Bakhimba secret society (Mayombe region, Congo) the final ceremony was a baptism of the initiated under water to wash away his past. He ate a morsel of sacred food to acquire part of its *nyama* (which brings the Catholic institution of the Host to mind) and he acquired a new name.

We will realize what sound psychological reasons lie behind the initiation ceremony when we compare it with our own development. The transition from youth to manhood, with its sexual ripening, is accompanied, among us, with prolonged conflicts marked by varying degrees of frustration, guilt, and fears. In his initiation ceremonies, the African dramatized this transition and its associated reactions against the emotional bonds of the child to his parents. The African father did not evade the issue of the coming manhood of his son, and it was made easier for him by having the responsibility for it assumed communally, by the assembly of "all fathers." At the same time, this lessened the psychic resentment against the father, a resentment that sometimes inhibits a boy's sexual development.

Similarly, the problem of the boy's relationship to his mother was dealt with through ceremonies which helped to cut the psychic "umbilical cord." In these rites he was born anew into his tribe. The African youth thus appears to have been spared the agonies and fears that so often (and so tragically) overshadow adolescence in "civilized" countries. The rituals were the African's way of attempting to prevent mother fixations.

The circumcision ceremony, performed at the onset of virility in the youth, was made the occasion for his incarnating the vital force. The ceremonies had the effect of making him feel assured of potency and helping him to avoid the self-doubts that harass so many adolescents and adults in other cultures.

The initiation ceremonies also helped to preserve the traditions handed down by sacred myths, which were the foundation of social unity in Africa. The youth underwent fear, privation, physical pain; for the rest of his life he carried the scars of his ceremonial mutilation. The dramatic rituals impressed deep into his consciousness the traditions of his tribe. The strength of African tradition, thus reinforced, also manifested itself in African art.

SOCIAL ROLE OF THE SECRET SOCIETY

A further word should be said here about the social role of the secret societies. The chiefs and magicians—who were the leaders of the societies—held the tribes together and assured continuity and order. With their influence discredited and their powers shorn after the white intrusion, with the magician largely displaced by the white doctor, with soldier and policeman hired by a remote foreign government as the new embodiments of power, the intimate contact with and participation in traditional religio-magical exercises have been disrupted. The resulting confusion of the African has been augmented by the preachments of missionaries.

Their abstract divinity was alien to him. The idea that all men are equal before God could scarcely be a reality to him when in practice white men, including the missionary himself, treated him as a second-class human being. Material values replaced spiritual ones; the carver who once worked to produce objects of religious significance began to make objects for sale. He still used his hands, but his heart was no longer engaged in his work.

For this reason the present-day art of the African has lost its root in the tradition that was lived through and emotionally experienced by each generation. With few exceptions, it has become—at best—an empty copy of a once-vital art expression.

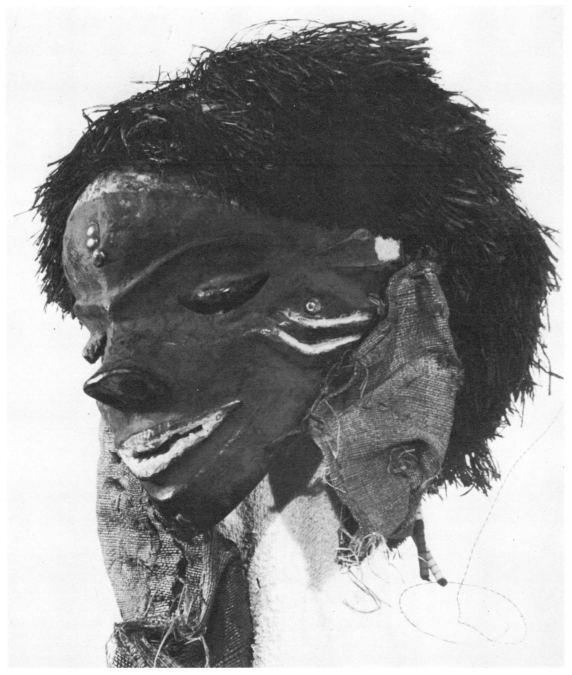

23. *Mask* (mbuya), *Bapende, Congo. 11"*
SEE PAGE 244

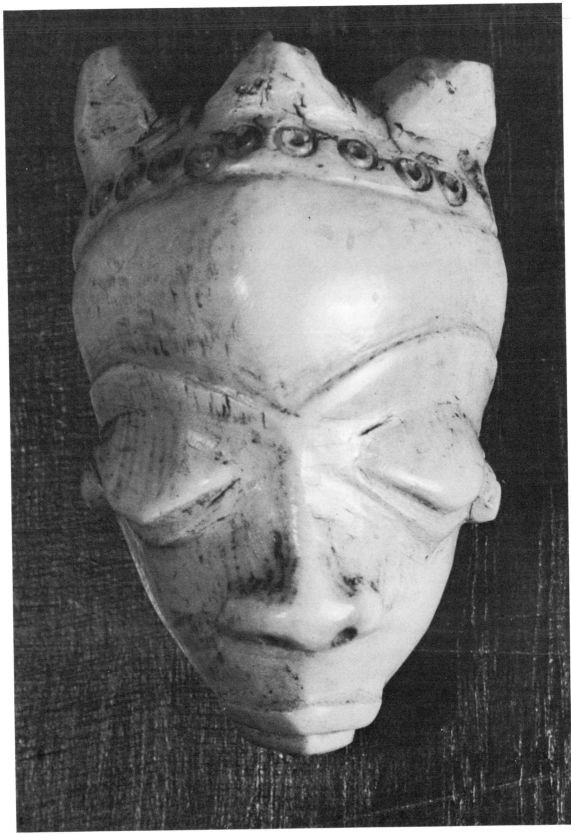

24. *Ivory mask* (ikhoko), *Bapende, Congo. 2½"*
SEE PAGE 246

THE CONTENT
OF AFRICAN ART

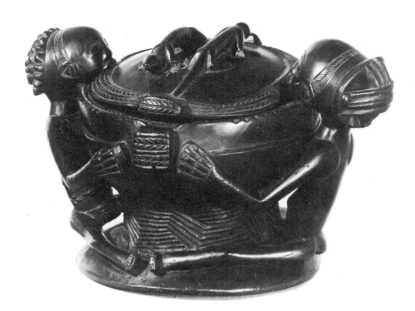

25. *Container with lid, Baluba, Congo. 8" high*
SEE PAGE 236

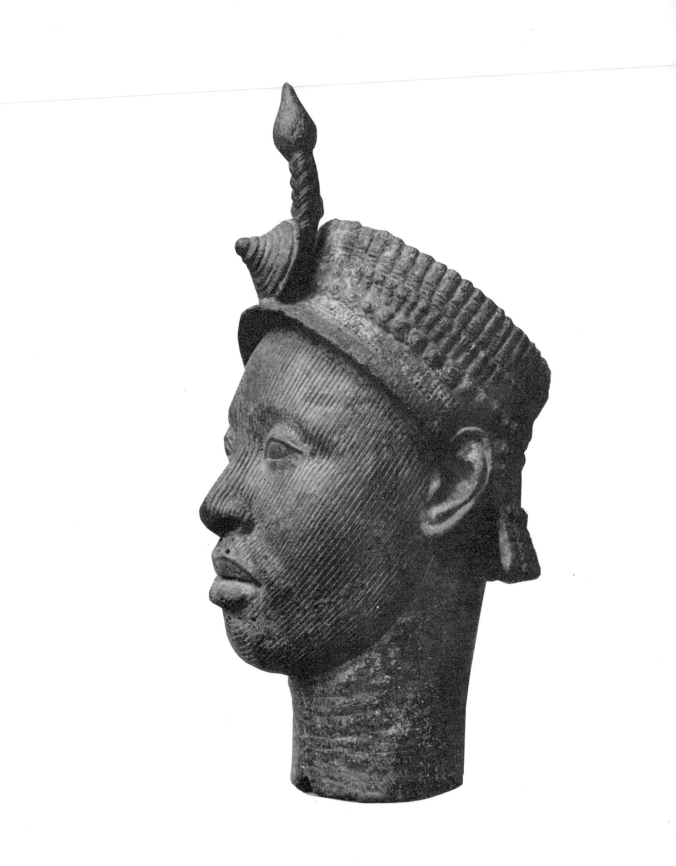

26. Brass head of an Oni of Ife, Ife, Nigeria. 14"
SEE PAGE 188

4. HISTORICAL BACKGROUND

THE BODY OF INFORMATION about the racial antecedents of the African tribes is somewhat sketchy. For example, stone implements of Paleolithic type and celts (primitive chisels) of Neolithic style have been discovered in Africa. This, however, does not prove, even assuming that the tools originated in Africa, that they belong to the same period of time as corresponding tools in Europe, or that they were produced by the ancestors of the present inhabitants of Africa. When the Bube tribe on the island of Fernando Po off West Africa were discovered by Europeans in the late eighteenth century, they were using Neolithic celts, which they considered to be images of the thunderbolt.

The C. G. Seligman excavations in Egypt, however, indicate that Hamitic people, with characteristics similar to those of present-day Negroes, lived there in the last predynastic period, or about 3000 B.C. According to some theories, prehistoric invasions took place in Africa about 6000 B.C., probably from Asia through the Straits of Aden (Bab el Mandeb).

There is, as we have seen, a theory that the invasion route was from Asia through Somaliland or Madagascar. It is to be noted that Madagascar, in spite of its proximity to the African continent, differs in many aspects from Africa;

thus it is possible that Madagascar was long ago connected with Asia.

The theory is advanced that this prehistoric invasion came in three waves: a "white invasion," which occupied, successively, Ethiopia, Egypt, and North Africa; a "black invasion" that mixed neither with the whites of the north nor with the Pygmies, and established itself around the Equator to form the present Bantu people; and a second "black invasion," which reached the Sudanese plains and the Guinea coast, forming the Sudanese and Guinea Negro groups.

Probably the Pygmies now living in the Congo forests were the aborigines of Africa. They are mentioned as court clowns in Egyptian records dating from 3000 B.C. Even today Pygmies are noted for their mimicry. They are isolated from the surrounding Bantu and have no religious cult resembling West African concepts.

Besides the Pygmies, the Bushmen of the Kalahari Desert of southern Africa and the Hamites of the northern part of the continent might have constituted the original inhabitants.

Of the many African stocks, it is the agricultural Negroes (the Bantu, Sudanese, and Guinea) bound to the land, who have devel-

oped an art of high quality. The nomadic Berber herdsmen and Pygmy hunters have produced no art worth mentioning. The Bushmen produced cave paintings.

New archaeological excavations are beginning to enlarge our knowledge of ancient Africa. These excavations have brought amazing achievements to light, among them the bronze and terra-cotta heads of Ife, the stone figures of Esie, the stone heads from Nok, and the bronze figures of Tada and Jebba (all four in Nigeria), the terra cottas of the Chad region, and those found lately in the Congo.

HISTORICAL DOCUMENTS

Fortunately we have also some historical writings from which we can piece together the history of the tribal cultures.

The first historian to mention West Africa was Herodotus. He described the circumnavigation of Africa in the sixth century B.C. by the Phoenicians, who set out from the Red Sea and returned through the Straits of Gibraltar.

Later the Carthaginians, in a naval expedition commanded by Hanno, touched Senegal and Guinea. From the ninth to the nineteenth century A.D., powerful Negro states flourished on the Sudanese plains, along the coastal regions, and in the Congo.

References to these Sudanese states appear in Arabic literature—the reports of ibn-Khaldun, al-Bakri, Yaqut, and Idrisi. Other sources include the *Tarikh Es Sudan* and the *Tarikh El Fettach*, sixteenth-century chronicles compiled in Timbuktu; the fourteenth-century references by the Arab traveler ibn-Batuta, who visited Mali; and the sixteenth-century accounts of Leo Africanus, who visited Gao and Mali.

The history of the indigenous native kingdoms interests us because it proves the existence of well-integrated political units. The basis for the existence of these states was an agreement on fundamental cultural issues and, with the divine power invested in the kings, a great unification took place. Only under such conditions could such an expressive art emerge.

A further contribution to the development of art was the great patronage of the kings, since the art products were necessary implements to maintain the different religious institutions which were the basic foundation of the political organizations in which every member of the community took part.

Prior to the nineteenth century, some reliable geographical information was available concerning the outer rim of the African continent. We now have a map dated 1351, in a museum in Florence, which already gives the coast line in fairly accurate detail. Early in the fifteenth century, cartographers of Majorca (one of the best known of whom was Abraham Cresca) mapped the Senegal and the "Gold" rivers. The information upon which these maps were based probably came from North African traders, who were in contact with the Sudanese Negro states.

More elaborate maps were made in the 1700's by G. Delisle and by Bourguignon d'Anville, but they indicate only coastal towns.

The interior remained unknown. Some mapmakers of the eighteenth century compensated for lack of knowledge by their imagination. They designated Lake Chad as the source of the Niger and sent rivers coursing across the Sahara.

Probably the first published document on the African West Coast was the Venetian Cadamosto's *Account of Voyages along the Western Coast of Africa,* in 1455–57. Some years later, a narrative by Pigafetta appeared in Rome, based on the travels of a Portuguese monk, Fra Duarte Lopez. It was translated into French, English, Dutch, German, and Latin. This book made the first mention of African "idols." In 1599 J. H. van Linschoten's report on the Guinea coast, the Congo, and Angola was published in The Hague. De Rochefort published his *Voyage to the Kingdom of Sénégal* in 1643; and Dr. Olfert Dapper's *Description of Africa* appeared in Amsterdam in 1686. A year later, in 1687, an abundantly illustrated nine-hundred-page volume was published in Bologna by the Franciscan friar Giovanni Antonio

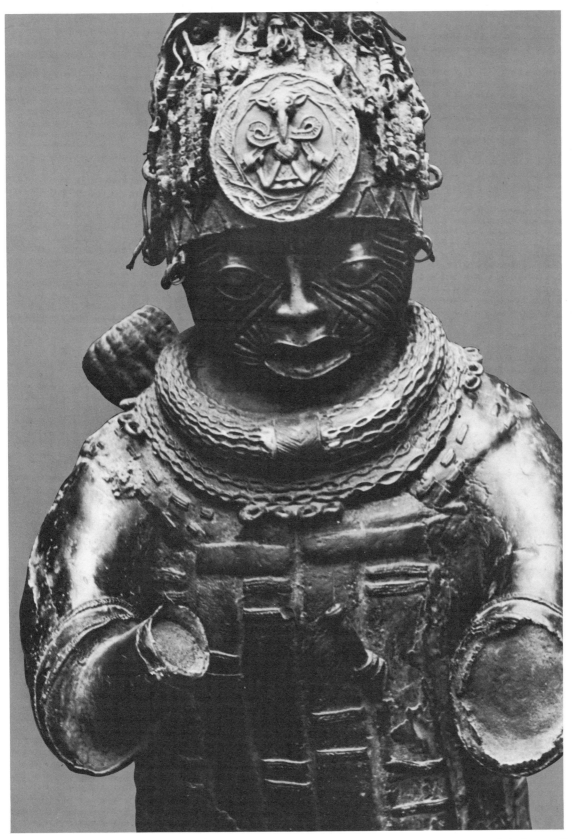

27. *Bronze figure of a warrior (detail), Jebba Island, Nigeria. Whole figure 44"*
SEE PAGE 188

Cavazzi, in which the Portuguese West African colonies were described. Here, too, mention was made of idols and magical rituals. From that time on the literature has become voluminous.

It is believed that the Normans were the first Europeans to reach Guinea, but they left no records. The Portuguese were the first Europeans to circumnavigate Africa after intensified exploration under Prince Henry the Navigator. To this we owe the abundance of reports on West Africa. The first shipment of Negro slaves appeared in Lisbon in 1469, brought in by a dealer named Fernão Gomes, who had received a monopoly for the slave trade from the king.

The Portuguese reached the Gold Coast in 1470 and the Benin Kingdom in 1472. In 1484, under Diogo Cão, Portuguese ships reached the river Congo and sailed up ninety miles to Matadi. In 1490 they had established a small colony in the Congo. In 1508 the son of a Congo king studied theology in Lisbon, and in the year 1520 he was consecrated Bishop of Utica, the first Negro bishop, unless the earlier Coptic prelates may also be regarded as Negroes. In 1574 Portuguese settlement of Angola began.

NEGRO EMPIRES AND KINGDOMS

The northern or inland states (Ghana, Songhay, Manding, and Hausa) came under Islamic influence around the year 1000. Many of their rulers embraced the Moslem religion, but animism was not suppressed; the majority of the people retained the old cults. The court conversions had political motives rather than religious ones.

Flourishing Negro states were in existence even before the Islamic penetration. Their religious life was based on animism, and an abundance of sculpture was produced. Islamic influence waned; the tribes returned to animism, which lasted in a vigorous form until the recent influence of the Christian missionary. This suggests that the natives have been sculpturing as

long as they have lived in Africa, probably some fifteen centuries.

Along the coast flourished independent empires and kingdoms—Ashanti, Dahomey, Fanti, Yoruba, Benin, and, farther south, Loango and the empire of Congo—which were not infiltrated by Islam. Here the art of carving also flourished without interruption and was encouraged by powerful rulers. A very strong, conventional art tradition developed such as that of the Yoruba (Ife) and of the Benin Kingdom. The richness of the Congo sculpture is probably due to this continuity, upon which early European contacts left no effect. Only in the last sixty years did coastal colonization lead to organized exploration of the interior and attendant missionary activities, which threatened and in many cases destroyed the social and religious structures of the Negroes, thus causing the decline of African art.

Under Islamic influence or outright rule, the African art tradition often persisted. The lack of art objects from antiquity (except for the bronzes and terra cottas from the fourteenth to the eighteenth centuries) is due solely to the perishable materials used, which were mostly wood. From our knowledge of the rigid traditional style unity of each tribe and the fact that little perceptible change has occurred in the last century, we may assume that the existing objects are the product of an art developed over many centuries.

Why Islamic influence failed to reach Equatorial West Africa has been tentatively answered by Messrs. Haardt and Andouin-Dubreuil, leaders of the Citroën expedition in 1926. They observed that the limits of Islamic penetration stopped with the areas infested by the tsetse fly, carrier of the fatal bacteria of sleeping sickness.

THE AFRICAN STATES

The history of the African states is evidence of the Negro's ability to organize empires, to install systems of jurisprudence, and to produce powerful leaders.

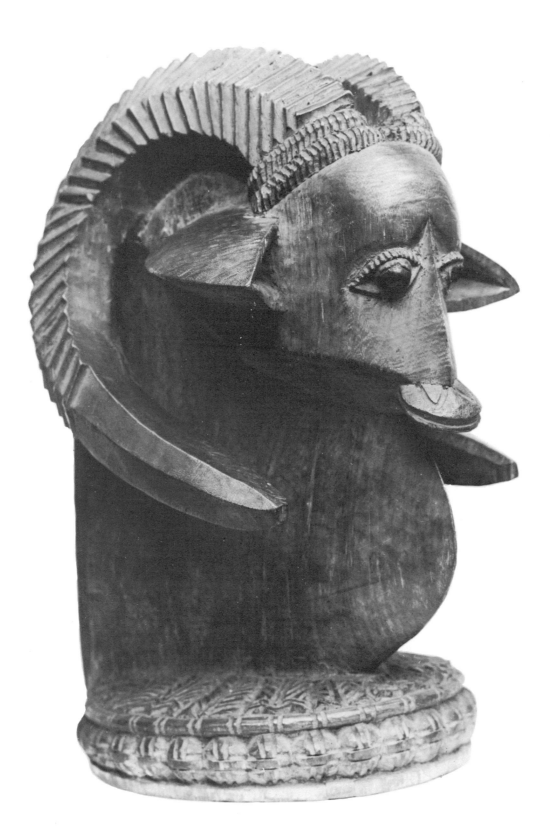

28. *Head of a ram, Yoruba, Owo region, Nigeria. 20"*
SEE PAGE 195

Ghana (also called Kumbi), probably the first of the Negro empires, was founded possibly around 300 A.D., on the Sudanese plains. In the ninth century, Ghana had large cities and an army of 200,000. Many houses in the capital, Kumbi, were built of stone. The empire traded with caravans from beyond the Sahara in ivory and gold dust or gold worked into wire. But Ghana weakened, was defeated in war, and in 1203 became part of the Soso Empire.

The Empire of Manding developed in the eleventh century on the left bank of the Niger (above the northern borders of the present Republic of Guinea) with its capital at Kangaba, and lasted into the fifteenth century. The first time the outside world learned about the Mandingos was in 1050, when one of their kings, converted to Islam, made a pilgrimage to Mecca and startled the East by the wealth and splendor of his retinue. Under Gongo Musa, about 1320, the Mandingo Empire was at its height. It then comprised nearly the whole of what used to be French West Africa. Gongo Musa also made a pilgrimage to Mecca in 1324, leading what was probably the greatest procession ever to leave Africa on such a mission. His caravan numbered sixty thousand and carried more than a ton of gold.

The Songhay Empire, with its capital at Gao, was probably founded in the seventh century along the bend of the Niger River. In 1325 it fell under the sway of the Mandingo Empire for a time, but later turned the tables under the leadership of Sonni Ali. The latter, though a Moslem convert, was not a zealot. He allowed religious freedom to his people, most of whom remained animists. He was perhaps the first ruler to separate church and state. After his death in 1492, Askia, a devout Moslem and a great organizer, consolidated the Songhay Empire, whose prosperity continued for about a century, when Moroccan troops, including three thousand Spanish renegades equipped with firearms, invaded the country.

The Mossi states, a cluster of principalities with two important capital cities, developed south of the Niger in the present Upper Volta regions. They resisted Moslem influence and clung to animism. They developed a highly mature judiciary system.

The Hausa city states developed east of Songhay, in what is now northern Nigeria. They flourished about the fifteenth century under Moslem kings, and their cities, Zinder, Gober, Kano, and Zaria, became famous.

On both sides of Lake Chad, the Bornu Kingdom existed until the end of the eleventh century under an animistic state religion. Under native kings converted to Islam it lasted until the twentieth century.

Other kingdoms, such as the Fula of Massina, the Bambara (Bannama) of Segu, and those of Bagirmi, Wadai, and Kanem, existed in the eighteenth and nineteenth centuries but never reached the importance of the earlier Negro states.

Along the Guinea coast, independent kingdoms developed, such as Ashanti, Dahomey, Benin, and Yoruba, maintaining, for unknown periods, the institution of animism. This was reflected not only in the strength of their art tradition but also in the surprising tenacity of their resistance to the European occupation, which began in earnest about sixty years ago.

We do not know much about the Ashanti Kingdom, except that it successfully resisted the English invasion until 1894. About the year 1700, during the reign of King Osai Tutu, the institution of a wooden throne of heavenly origin began and the carving of such thrones and stools spread toward the Cameroons.

Dahomey (also called Danhome) was noted as early as 1507 by Leo Africanus and was charted on maps published in Amsterdam in 1627. This kingdom had a rich art tradition. It became known for its Amazon regiment, established by the fourth king of Dahomey, Agasa, who used one thousand of his superfluous wives first as bodyguard and later as soldiers. Their chastity was enforced by enormous penalties. Dahomey grew very rich on the slave trade. Its last king, Behanzin, resisted the French until 1894.

Nigeria includes several old native states: in

the north, the kingdoms of Hausa and Bornu; in the south, the kingdoms of Lagos, Nupe, Ife, Yoruba, and Benin.

Ife came into prominence in 1936 when highly sophisticated bronze heads were excavated there (Fig. 26). With regard to these and the bronze figures found at Tada (Fig. 29), Sir Richmond Palmer suggests that possibly between 600 and 950 A.D. an important casting industry had been established at Kaukau on the Niger which spread to Nupe (where Tada was located) and was carried by the Yoruba first to Ife and then to Benin. Another possibility is that Persians, Jews, or Greeks introduced the method in the Nile Valley, whence it made its way westward. In either case, the discovery of the Ife heads forced revisions of our estimates of Benin art. It may now be assumed that the art of bronze casting traveled to Benin by way of Ife, where a highly developed state must have existed.

About the Benin Kingdom we have abundant information. The Portuguese reached it under Ruy de Sequeira in 1472, and thirteen years later sent to it their first missionary, Alfonso d'Aveiro, who persuaded the *Oba* (king) to send an ambassador to the King of Portugal. The ambassador returned with missionaries and presents. The mission, founded in 1530, built three churches, but was abandoned in 1699. We know of a line of thirty-three *Oba,* or Benin kings, among them Oguola (c. 1280), who built the great city wall and imported the Ife technique of bronze casting. Benin's pioneer smith, Egueigha, is still venerated as the patron saint of the craft.

Dutch visitors to Benin included Dapper and Nyedael, who published their accounts in 1686 and 1702 respectively. The British first reached Benin in 1553. In 1897 a British expedition numbering two hundred fifty men disregarded the *Oba*'s warnings and entered the city of Benin during secret religious ceremonies. The entire troop was massacred. A month later, a British punitive expedition took out some three thousand objects, which were immediately purchased by English and German museums.

We have little information of the Negro states which might have existed between the Bight of Biafra and the Congo River. We know of the kingdom of Loango and of the empire of Congo, the latter comprising several kingdoms, among them the Bushongo (Bakuba), Ansika (Bateka and Bayaka), Lunda (Balunda), and Bachimba. A Portuguese ship first sailed up the Congo in 1484 (under Diogo Cão) and established a colony christened São Salvador. But the Congo Empire and the other Negro states in this region kept expanding under native dynasties until the nineteenth century.

ANTIQUITY OF AFRICAN ART WORKS

For the majority of African sculptures (except Ife and Benin) we have no historical data. The older objects have disintegrated because of their perishable materials (wood, clay, straw, etc.). The only exceptions, to our knowledge, are certain objects collected before 1600, now in the museum at Ulm, Germany.

Here we must reiterate our belief that, although the majority of the objects are the products of the last century, they are representative of older periods as well, the forms remaining unchanged through the rigid adherence to tradition.

ORIGIN OF AFRICAN ART

The question now arises, Is African art indigenous or is it derivative? Leo Frobenius was the first to advance the theory that Negro art may have been influenced by Mediterranean cultures, and in addition by a civilization from beyond the Sahara Desert. The origins of West African art may lie in the Fezzan, Atlas, and Libyan Desert regions of North Africa. In Fezzan, Frobenius saw four rock pictures similar to the Egyptian images of their god Bes. In the Saharan Atlas Mountains were found pictures of rams with disks between their horns, resembling images of the Egyptian ram god, Jupiter Ammon (Amen). In the Libyan Desert, rock

pictures similar in appearance to representations of the Egyptian god Set were found. The theory has been advanced that the images in these rock pictures spread to Egypt.

Thus we see how early in human history art influences traveled from one country to another.

As we have seen, between the ninth and nineteenth centuries, contact was maintained between West Africa, the western Sudanese empires, and the Arabic world. This contact was commercial and intellectual as well as military. Islam, however, left no influence on West African art. One reason is undoubtedly the Koran's prohibition of the use of human figures, which limited artistic expression among the Arabs to geometric decorations and calligraphy. This had no attraction to the vigorous African artists.

In the great epochs of the African empires, Egyptian caravans, traveling through the Sahara, established trade with the Negro states, exchanging goods for slaves. Egyptian navigators are reported to have steered their ships into the Bight of Benin.

Another direction of Egyptian infiltration and possible influence was across the equatorial region. Egyptian vessels could have sailed to Rejaf on the Nile near Lake Albert in northeastern Belgian Congo. From Rejaf the River Uele, a tributary of the Congo, is only a little more than a hundred miles. Through the Congo tributaries the Egyptians could easily have reached into West Africa.

The practice of the Mangbetu people (living between the Nile and Uele) of pressing the craniums of their females into an elongated form shows startling resemblances to the head forms in Egyptian art. And according to an interesting study made by Jeanne Tercafs, certain dialects in the Uele region show words and pronunciations resembling those of ancient Egypt.

Thus in the north the Egyptians reached the Sudanese people through caravans, and in the south there is a possibility that they may have reached the Bantu people by boats. There is an astonishing unity in the plastic creations of the different African tribes, although we know of no direct contact between north and south. The Egyptians' infiltration might explain this unity.

When people of common cultural background meet, their artistic products are subject to mutual influence. Because Islam was alien to the Africans, it left no imprint on their works. Egypt and the Mediterranean countries, though farther removed geographically than the territories ruled by Islam, appear to have exercised some influence on West African art.

COMPARISON BETWEEN EGYPTIAN AND AFRICAN RELIGIONS

Early Egyptian religion was animistic, with fetishes and magic. Its polytheism was a later development. Sculpture was used in a religious or magical manner, as in West Africa. The Egyptian believed in the survival of the soul and incorporated it into statues. The Egyptian Soul Bird is comparable to the totem animal. The statues which the Egyptians placed in the tombs are analogous in meaning to the ancestor figures of the Africans, which were kept on display and used in everyday rituals. For a parallel to the Egyptian custom of putting statues into the earth for eternity, we may note the West African practice of placing funerary figures in the baskets of ancestral bones in the "burial" huts to keep eternal guard over the ancestral spirits. The Egyptian idea of *ka*, as the surviving substance of the personality, is similar to the West African *nyama* (called *kra* by the Ashanti). The shadow as a part of the personality was a concept common to both Egypt and West Africa. Sculpture in both Egypt and West Africa had a similar religious role.*

In Babylon also, demons and animal gods were worshiped; prayers were incantations and divinations. That country's religion was also

* For further study of Egyptian influence, see the author's paper "The Ashanti Akua'ba Statues as Archetype, and the Egyptian Ankh" (1963).

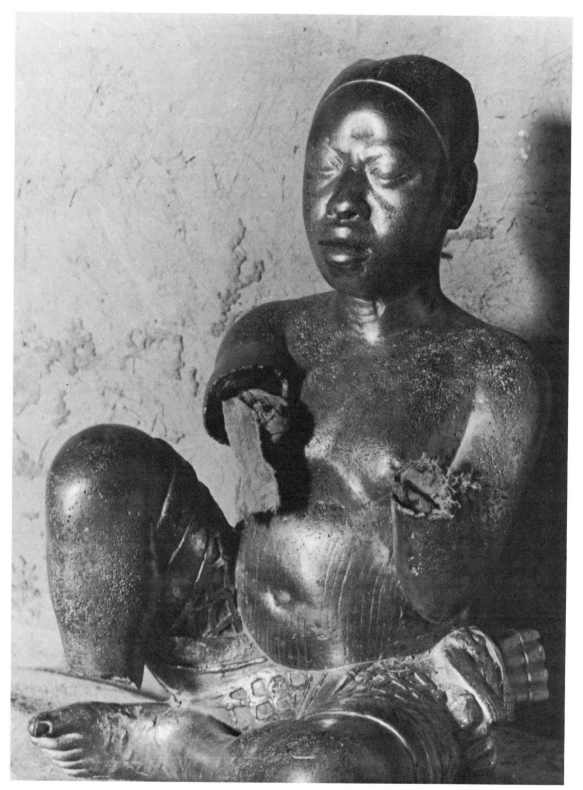

29. Bronze sitting figure, Tada region, Nigeria. 22"
SEE PAGE 188

animistic; for it, too, polytheism was a later development.

In Greece, similarly, fetishism, animism, and even traces of totemism were found, as well as intimacies between gods and men such as the Africans knew between their totem animals and men. Potter remarks that "a very old statue of a goddess in the Parthenon itself was comparable to the crudest idols of African tribes."

COMPARISON OF ART FORMS

The most striking characteristics of African art are its architectonic quality, the sobriety and closeness of its forms, its feeling for the material, and the fact that its carving is done out of the mass. The same characteristics hold true for Egyptian art.

In their decorative schemes, some Egyptian vases and utensils resemble Congo pottery and utensils of Africa. Portraits of Egyptian kings, especially those of certain Pharaohs of the fourth dynasty, became cult objects, and the figures were portrayed in attitudes similar to the portraits of the Bakuba (Bushongo) kings (Fig. 2). Statues of the first dynasty resemble West African ancestor figures. A bronze statue found in Tada, Nigeria (Fig. 29), is comparable to the famous early Egyptian "scribe" statue. The Egyptians also regarded the head as the abode of spirit power, and many of their sculptures exaggerate the head, as do West African sculptures. Negro headrests are similar to those of the third to eleventh dynasties; and some musical instruments found in West Africa are of the same design as the Egyptian.

30. *Group of stone figures, near Esie, Nigeria*
SEE PAGES 188–189

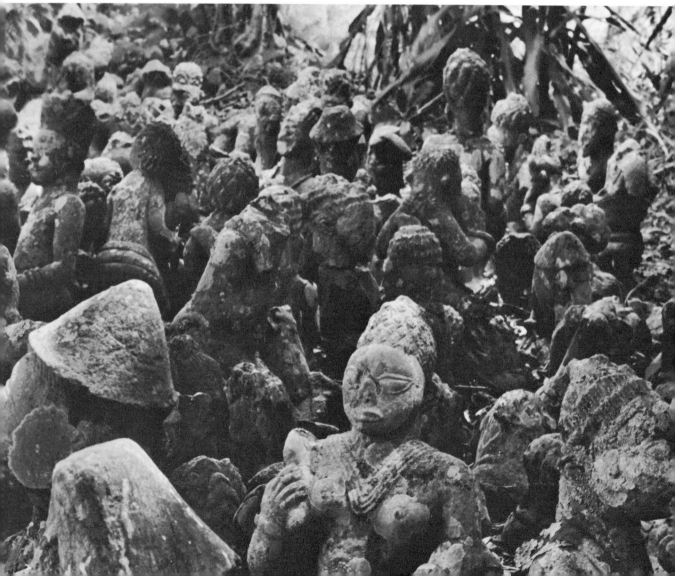

There is also a possibility that the lost-wax casting technique was imported from Egypt.

Cylindrical beads of the African natives (especially in the Benin Kingdom) resemble those found in Phoenician graves.

The astonishing Ife bronze heads (Fig. 26) may also indicate a Mediterranean influence. These heads have a classical Greco-Roman cast. The Yoruba, original inhabitants of this territory, never created any such works. The purity of the style could have been achieved only by artists already at the height of their development, artists for whom the style was an established tradition. We know that Greek sculptors wandered as far as Afghanistan to create the Gandhara style. Is it then not possible that some accompanied caravans to Ife? The nineteen heads found there might be the products of one master caster, or two or three, since certain signs indicate uniformity of handling. However, as soon as these heads were used as models by the Bini people, the Ife style was altered. Even the early Bini heads, although of portrait type, have the freedom typical of the Negro carving style. This would point to foreign influence in the Ife heads. As soon as the Negro influence became dominant, it imposed the West African style.

The artist was anonymous in Egypt, as he was in Africa. The objects which he fashioned were used exclusively in religio-magical rituals. There is uniformity in dimension and attitude and unchanging stylistic unity in both Egypt and Africa.

If, as this evidence suggests, African art was not indigenous, how is it that this art has such a dynamic liveliness, such a force of expression, and such a unity of style? The so-called "derivative" arts generally show signs of decadence: borrowed forms "perfected," then exaggerated, and finally drained of living content.

It appears that the African was able to absorb influences without succumbing to them. The strength and energy of his own outlook on the world, combined with the intensity of his religious feeling, proved stronger than any formal influence. He digested the imported forms and made something new out of them. African sculpture stood on its own, and continues to radiate life.

5. CHARACTERISTIC FORMS

As WE HAVE SEEN in earlier chapters, the entire body of African art includes a wide range of material, from the object which is almost strictly utilitarian to that which possesses a highly religious or magical significance. In the latter category are statues and masks with human features and animal carvings.

Statues

African animism recognized two major groups of activities: religious and magical. In the first group were the spirits connected with birth, puberty, marriage, and death including both the ancestor spirits and the genii of Nature. In the magical group belonged spirits whose benevolence was desired for the attainment of practical results.

The spirits of Nature were connected with the earth, sky, rain, sun, thunder, fecundity of the earth and of humans, also with mountains, trees, stones, rivers, the sea, and so forth.

The distinction between what was religious and what was magical is not always clear. If, for instance, sickness was attributed to the wrath of an ancestor, an appeasing offering was made to the ancestor-cult statue and hence was a religious act. If, on the other hand, a malevo-

lent spirit or a spell cast by an enemy was thought to be responsible, magical ceremonies took place.

Among the great variety of ancestor-cult statues we may perhaps state that they usualy have a closed form with no additional material like horn, nails, or shells added to them (Figs. 119, 155, and 165, for example). The composition and frequently the facial expression manifest calm and dignity. They give an impression of other-worldly detachment. The magical statues, although also architectonic in their sculptural concept, are more aggressive in their facial expressions. Often their attitudes suggest latent movement.

MAGICAL SUBSTANCE

Usually magical statues did not acquire their power until after the addition of a magical substance whose ingredients might be anything —particles of earth, dead flies, a hair, a nail paring, or merely grease rubbed into the statue. In many of the statues, cavities were hollowed out in the abdomen (Fig. 31), breast, back, or head, to be filled with magical substance and sometimes sealed with a mirror (Fig. 32).

The use of a mirror was one of the first ob-

servations made by Europeans as early as the fifteenth century. Malfante wrote that the African "worshiped mirrors which reflected their faces . . . worship statues with which, they say, they commune by incantations." As to the interpretation of the use of mirrors on statues we have two statements: Bastian supposes that the purpose of the mirror was to reflect the image of, and thus identify, the person who caused a sickness; Peschuel-Loesche and Nuoffer think that its purpose was to repel evil spirits, who were believed to be unable to withstand strong light. In a tropical country like Africa, mirrors reflect the sun with blinding brilliance, and this may have suggested the use of mirrors to the image makers. Possibly, too, the African might have felt that through the reflected rays he could use the power of the sun against evil spirits. Incrustations of glass, shell, or mirror in the eyes of many magical statues had a similar purpose.

Magical substance was not essential to endow a statue with magic power. With or without the substance, such power was believed to be invoked by the magical words spoken by the magician at the consecration of the statue.

In most of the statues in Western collections, the magical substance is missing. It has been removed to get rid of decaying organic matter or in the process of deconsecration by the native, to make the statue safe as a lay object.

It may be noted that deconsecration, as well as consecration, is also a practice of the Catholic ritual. And the power attributed to "relics" is analogous to magic power.

CLASSIFICATION OF MAGICAL STATUES

The variety, number, and uses of magical statues are great. The statues may have been family possessions, communal property in the custody of the tribal magician, or professional

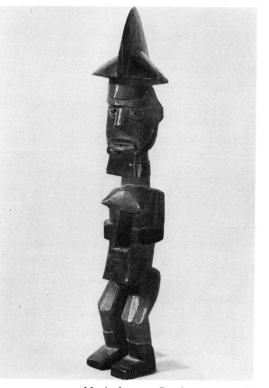

31. *Magical statue, Bateke, Congo. 18"*
SEE PAGE 250

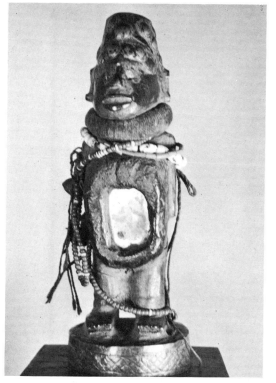

32. *Magical statue, Bakongo, Congo. 8"*

instruments of the medicine man. The last group is the most numerous. The African did not attribute sickness or death to natural causes but to spirits—the wrathful spirit of an ancestor or the hostile spirit summoned by a sorcerer. The remedy was appeasement through sacrifices, or the summoning of a more powerful spirit with the aid of the medicine man, who knew how to handle the magical statues.

In the following section we shall enumerate only the best-known types of magical statues to illustrate how African animism used sculpture.

Although the use of magical statues is a common feature of animism everywhere, we shall begin with the Bakongo tribe in the Congo, where such statues are especially abundant and have been most extensively studied by Maes and others. The statues in this region are used in a continuous warfare between the good spirit Nkisi and the evil spirit Ndoki.

(1) The *konde* or nail fetish. One of the best-known types of statue in this region is the *konde*, or nail fetish, the abode of the evil spirit Ndoki. The statues are large, erect wooden figures, the legs and trunks roughly carved and often without sex indications, and the feet flat on the base. In some figures one hand is on the hip while the other hand brandishes a dagger. Magical substance, here called *bilongo*, is applied to both the abdomen and the head. In other statues both hands are on the hips, and the *bilongo* is applied only to the abdomen. In both, the carving of the head is artistic. The expression is menacing, often with mouth half open as if the sickness was to be exorcised from it. Sometimes the tongue protrudes. The eyes are splinters of mirror. The cavity in the abdomen containing the *bilongo* is square and is sealed with a mirror (Fig. 5). The nail fetish may also be in the form of an animal statue. (Fig. 33.)

Nails, pieces of metal, amulets, etc., stud the body. The head, emerging from the mass of metal, has an impressive effect. With the nails removed, the statue looks "naked" (Fig. 34.)

The *konde* housed extremely dangerous spirits, which could inflict diseases and "eat up"

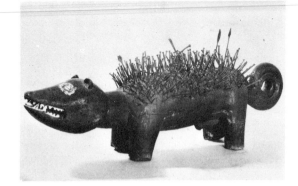

33. *Animal carving with nails, Bakongo, Congo. 13"*

those whom they were set upon. Each *konde* was kept in a special hut.

(2) The *pezu* or *panzu mbongo*. These were similar in function to the *konde* but served only for minor ailments. The figures, painted red and white, are smaller; their expression is less terrifying; and they are more likely to be hung with bags and amulets than studded with nails (Fig. 35).

(3) The *na moganga* or *noganga*. These are healing fetishes which belonged to the *noganga*, or village medicine man. They were the abode of the good spirit Nkisi. Their expressions are benevolent, and they helped the medicine man to recognize the plant whose potent spirit was the right one to cast out the evil spirit from the patient's body. In such cases, the medicine man actually relied upon a store of folk knowledge of the curative effects of herbs and minerals. The African, however, did not attribute these effects to the chemical properties of the plants, but to the spirits that resided in them.

The *na moganga* statues also contained magical substance, but they were carved with greater care than the nail fetishes. In some, however, the arms are mere stumps. Others are in squatting attitudes with chin in one or both hands.

The Basundi and Babuende tribes also had stump-armed statues; and seated figures are also to be found among the Mussurongo. Similar statues among the Bateke have filed teeth and scar patterns on the skin.

(4) The *Mbula* or fire fetish. This belonged to the tribal chief and protected him against enemy medicine men. The fetish can be recognized by a tube protruding from the magical substance. Through this tube were inserted gunpowder and metal slugs, which exploded when enemy magicians tampered with the image. Many are known to have been killed by these homemade "magic" grenades.

(5) The *makonda* and *simbu*. These minor magical statues of the Bakongo were designed for the protection of children. Pregnant women dedicated their unborn children to the *makonda* and invoked its protection for the child after birth. The *simbu* was placed in the hut

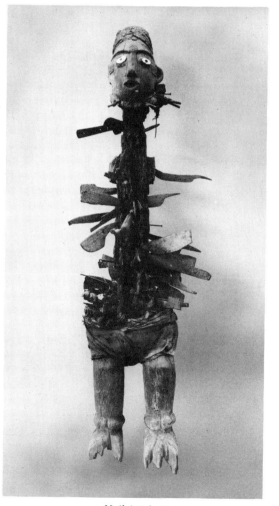

34. *Nail fetish, Bakongo, Congo. 20"*

after labor began in order to facilitate the birth.

(6) The guardian of the home. A special type of fetish was placed at the door to guard a house. It was supposed to contain spirits of the dead. The distinguishing marks are an oblong face and a protruding chin. The eyes are inset cowrie shells, and horns frequently crown the head. Similar figures were placed in the fields to protect crops against marauders.

(7) The healing fetish. These statues, which were placed beside the sick, occur in nearly all regions. Among the best-known are the Bateke statues (Fig. 31), which were also used for the child's protection until he attained adulthood.

(8) The fertility fetish. Figures with outstretched arms and disklike heads were made by the Ashanti of Ghana. These were given to expectant mothers to facilitate childbirth and to young girls to render them fertile (Figs. 195–201).

(9) The *ibeji* or twin fetish. This figure was produced by the Yoruba in Nigeria (Fig. 36). The statue was carved upon the death of one of a pair of twins. The mother cared for the statue and made offerings to it to assure the welfare of the surviving twin until the latter reached maturity, at which time he took over the care of the statue, continuing to make offerings to it for the rest of his life. This was done in the belief that twins shared one spirit, and therefore the survivor must be protected against the effort of the dead twin to seize the rest of his *nyama*. Twins were also believed to be able to communicate more readily with ancestor spirits than other people.

In this case, as in so many others, magical practice was founded on acute psychological insight. Twins brought up together are known to have a compulsive sense of belonging to each other which may lead to neurotic behavior. For this reason it has been found advisable in our armed forces to separate twins.

(10) The *bieri* statues (Fig. 75). These fetishes of the Pangwe tribe of Gabon were not restricted to guarding the barrel containing the bones of the dead, as is generally stated. They

also served as healing statues and were brought into the huts of the sick.

PREPARATION OF NAIL FETISHES

To assure the power of the nail fetish, certain rituals were required. Formerly, we are told, many slaves were killed at the felling of the tree used for the sculpture and their blood was mixed with the sap, thus combining their *nyama* with that of the tree. According to another version, the name of a man was called out when the tree was felled, and he died in a day or two as his *nyama* entered the log. The explorer Visser relates that an African who sought to own a nail fetish had to procure a human corpse, which he carried to a tree that he himself cut down. A sculptor then carved the figure under the future owner's personal supervision, which established his future mastery over the fetish. The corpse, meanwhile, was fumigated and rubbed with red wood powder. When the carving was finished, the same red powder was rubbed into it.

THE CONCEPT OF NAIL FETISHES

The nail fetish was a composite of varied forces, or rather desires, of the Africans. First, it was imbued with power by the deposit of magical substance in the cavity cut into the abdomen. The teeth of powerful animals, such as the leopard, were often included in the magical substance to impart the power of the animal. Second, the statue was endowed with outward powers: the mirror to reflect blinding sunlight against hostile spirits, the danger in the upraised arm, the defiant, protruding tongue. A third power was exerted by the user when he drove a nail into the body of the fetish at the moment of conjuration. All these powers were invoked by the user in order to have his particular wish granted. When the wish was expressed, the nail or piece of metal driven into the image drove the desire in deeply, thus concretizing it.

Probably the most widely known use of the nail fetish was for the purpose of having a sickness inflicted in turn upon whoever had caused it in the current victim. The good offices of the medicine man and the persuasion of a proper sacrifice were used to induce the statue to act against the perpetrator, whom it was believed to know. Another purpose of the nail-driving was to injure thereby the evil spirit which caused the illness, and by thus reducing his power, to lessen the virulence of the disease.

The use of fetishes and other magical statues varied from tribe to tribe.

Peschuel-Loesche describes how a heated nail driven into a fetish caused an accused person to fall ill. After he had cleared himself, a process including payment of a fee to the magician, the nail was extracted and a cure followed. Nails were similarly driven into fetishes to bring about the destruction of enemies and also to kill the slaves of enemy tribes and thus weaken their power. Some nail fetishes were used only in the treatment of specific illnesses. Among other odd functions of nail fetishes were the tracking down of thieves and providing protection against dangers of travel and other perils.

Sometimes the fetish was put to an entirely positive use. A nail might be driven into a fetish to solemnize an obligation undertaken toward another person. This is similar to our signing a contract, or "nailing" someone to a deal. According to Vatter, the Loango tribesmen believed that driving the nail in stimulated the fetish to the desired action. (Conversely, the nail could be driven in to punish inaction.)

In the Bakhimba secret society of the Mayombe region in the Congo, the mirror inset in a statue was also used in taking an oath, the person who made the pledge licking the mirror.

ANALOGIES IN THE WEST

As in other primitive practices, parallels of the nail fetish may be found in the West. In the Hainaut Province of Belgium one may see a statue of Saint Catherine studded with needles driven in by girls seeking marriage. In

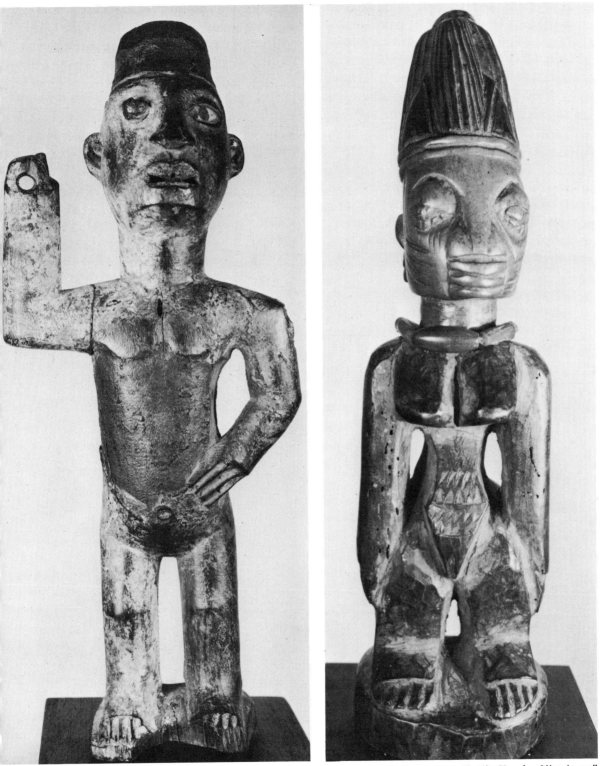

35. *Magical statue, Bakongo, Congo. 8"*

36. *Twin statue* (ibeji), *Yoruba, Nigeria. 10"*
SEE PAGE 193

Germany during World War I, people paid to drive nails into a huge statue of Marshal von Hindenburg, as a means of protecting a soldier at the front, or assuring the safe return of a prisoner. And a practice widespread in Europe in the Middle Ages was that of driving nails and needles into wax figures to injure enemies.

Animal Carvings

When we consider the religious and cultural significance of the totem or mythological animal, plus the African tribesman's dependence upon animals for food, it is understandable that animal representation is evident in much of his art.

As mentioned earlier, the African practiced sympathetic magic on drawings of animals which he wished to kill in the hunt. Often, too, he tattooed his body with the images of his totem animal. However, the outstanding examples of this subject matter exist in the field of animal sculpture, where his subjects were either mythological or totem animals.

Ritual Objects Using Animals

Perhaps the most extensive use of mythological animals occurs among the Dogon of Mali (pages 152–158). Another good example is the combination of animal and human features done among the Bambara (Fig. 114). The Senufo not only have masks combining human and animal features but also those incorporating the features of several animals in one mask (Fig. 173). Remarkable are the large birds (*porpianong*) of the Senufo (Fig. 168). There are also numerous utensils in animal form or ornamented with animal figures in three dimensions or carved in bas-relief.

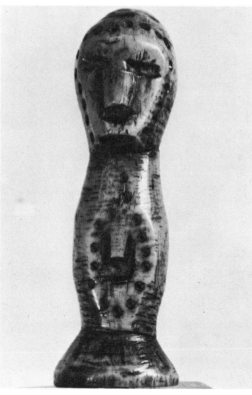

37. Ivory statue, Warega, Congo. 5"
SEE PAGE 263

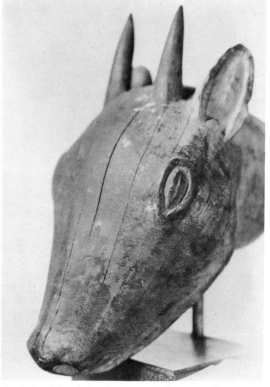

38. Animal head, Baule, Rep. of the Ivory Coast. 10"
SEE PAGE 167

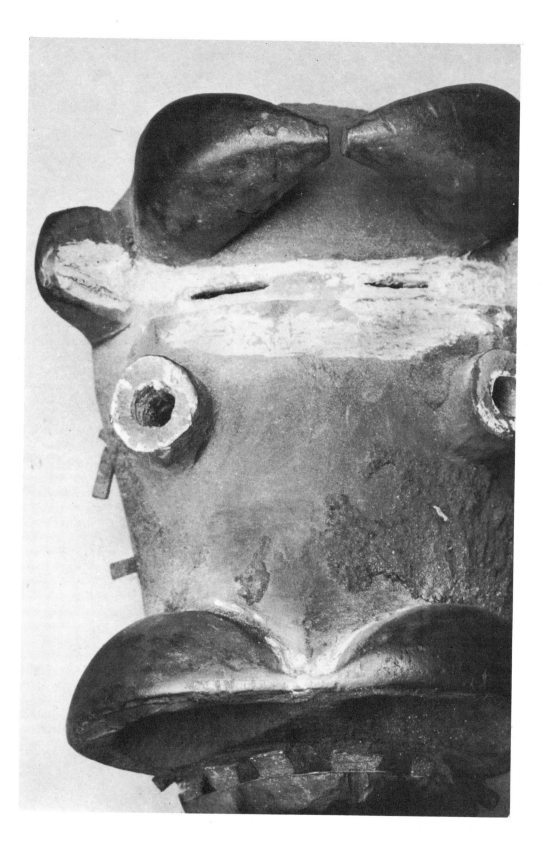

39. *Animal head, Guere-Ouobe, Rep. of the Ivory Coast. 10"*

Masks

The use of masks as magical objects is universal, extending over all six continents and from prehistoric times to the present. They are to be found in the Swiss Tyrol, the Upper Rhineland, Ireland, and other European countries; in Tibet, China, Indonesia, Ceylon, Japan, and other Asiatic countries; in nearly all the islands of the South Seas; and in many sites on the North and South American continents.

In Africa, all territories covered in this book produced masks. They can be classified according to:

(1) Usage—cults (ancestor, initiation, magical, etc.), war, play, and nearly always prescribed ritual dance.

(2) Forms—varying from the crude to portraitlike naturalism to geometric or abstract stylizations, invoking specific emotions such as fear; and based on animal and human features, either singly or in combination.

(3) Apparel—perforated masks, intended to be worn with a raffia, straw, or knitted costume, often including gloves; masklike objects to be worn above or below the face; masklike objects not to be worn; hoodlike masks completely covering the head; objects resembling headdresses; masks worn on ritual occasions, as badges of membership in a secret society or participation in a certain rite.

Certain masks, used for the dance, have holes on the rim for tying around the face but have no eye openings. These have been interpreted as masks for a dance symbolizing possession by a spirit. The staggering, sightless dancer would be unable to direct his movements, which for the African was a sign of being possessed by a spirit. In this case the spirit would be indicated by the mask.

FUNCTION OF THE MASK

Most masks were attached to a raffia, straw, or knitted costume which covered the dancer's whole body (Figs. 45 and 46). From this capelike garment the mask stood out with dramatic

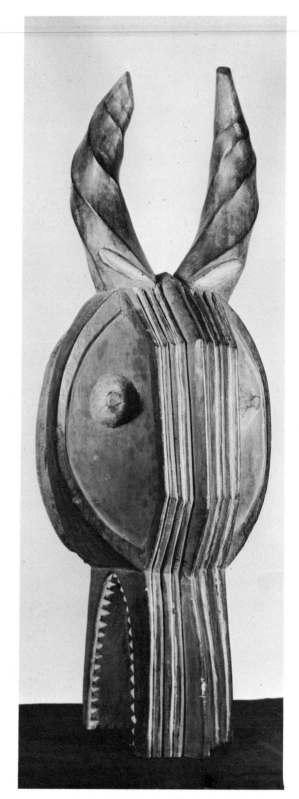

40. *Animal mask* (goli), *Baule, Rep. of the Ivory Coast. 30"*
SEE PAGE 167

power. Without it the mask looked "nude" to the African. Instead of the complete costume, the dancer might use a shirtlike dress with a high neck, a hair net, ornaments on the chest, and arm and ankle brackelets, the latter often in the form of small bands.

In our exhibits the mask usually hangs on the wall or is mounted on a stand, static and isolated from its function. To the native, however, it was an inspiring object, inseparable from movement, whether used in public or in rituals of a secret society. It was worn in a dance where gesture, rhythm, and singing held significance and excitement for participants and spectators. Thus the mask had an intensity of radiation upon the African masses to which our reaction cannot compare.

The dancer, by his skill in carrying out the prescribed movements, evoked the spirit which the mask represented. Even without the mask, the dance afforded physical release of emotional tensions. To this day in Africa dances are performed with strict and detailed adherence to precedent, which assures the desired effect.

To this physical release through motion should be added the effects of the dancer's song, another release of tension. The singing in accompaniment and the clapping approval of the audience gave the act and the catharsis a communal feeling. This was intensified by the powerful tones and vibrations of the musical instruments, mainly drums, and the curious annihilation of personal identity and substitution of a traditional identity in the wearing of the masks. All these elements combined to produce an exhilarating, ecstatic effect: unconscious powers were released, reality was obliterated, and what the African felt to be spirit power was assumed.

Different masks were used for different dances, depending on the aims of the dance. Some dances served as the ritual for a boy's initiation into the tribe; some for the exorcism of evil spirits; some to invoke rain and fertility; some to communicate with the spirit of the dead and draw off his *nyama*. Thus the function of the mask was close to that of the ances-

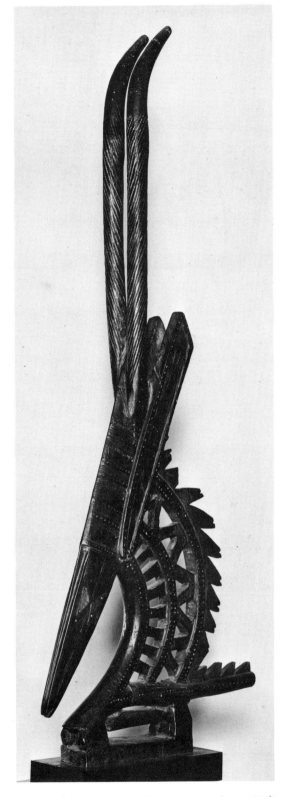

41. *Antelope headgear* (tji wara), *Bambara, Mali*
30"
SEE PAGE 148

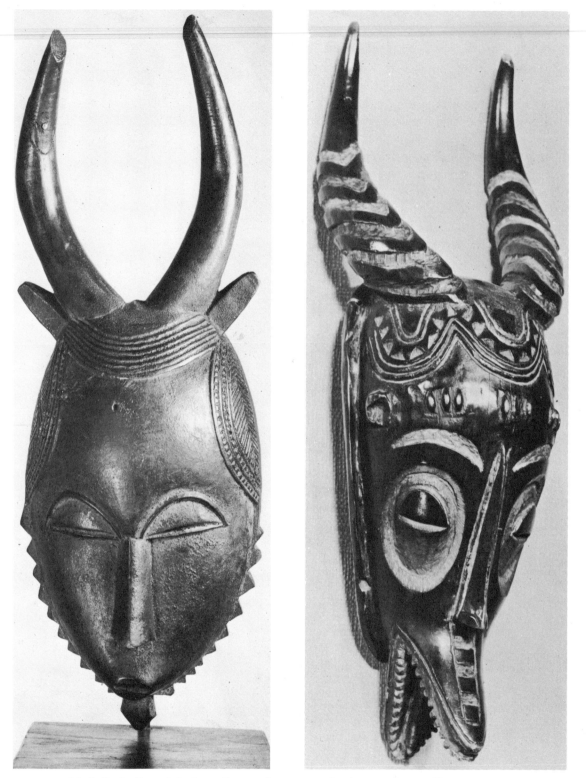

42. *Mask, Baule, Rep. of the Ivory Coast. 14"*
SEE PAGE 167

43. *Antelope mask, Zamble society, Guro, Rep. of
the Ivory Coast. 12"*
SEE PAGE 177

tor figure, though the motives may have differed. The masker might seek to instill fear into enemies, raise his own courage, or repel evil spirits. For these purposes wild-animal masks were sometimes used.

PHYSICAL ASPECT OF MASKS

Because the head represented the seat of wisdom, it was believed to be the last refuge of the *nyama* before it was emitted from the body at the moment of death. Therefore most attention was paid to the face mask, which stood for the body as a whole and the spirit as well. Like the ancestor figures, a mask did not merely represent the spirit, it was the spirit.

This emphasis on the spiritual aspect of the face gives the masks rich expressiveness. They are masterpieces of facial sculpture rendered in stylized, abstract images. They have greater intensity than the faces of statues, where the emotion is distributed to all parts of the figure— the posture, the proportions of the limbs, etc. In the mask, all is concentrated on one surface. The mask is an *enlarged face,* dramatized to the utmost. Through forceful exaggeration the sculptor achieves an effect of spiritual intensity. As von Sydow (1923) expressed it, the masks are "loaded" with spiritual energy. And another German art critic, Carl Einstein (1921), called it "the fixation of an ecstasy." This ecstasy is the result of a suspension of the rational faculties and ego controls. The sculptor was possessed (or obsessed) by an emotion so powerful that reality disappeared, and with it fear. For this release from anxiety the African willingly yielded submission to the spirits.

Another reason for the enlargement of the face was the outdoor use of the mask, which had to be visible at a distance and to a multitude of people. The statues, on the other hand, were kept in sanctuaries and used in close contact. The mask provoked excitement; the statue called for contemplation. Because the mask was used as a "tool" in communal ceremonies, it possessed greater suggestive power.

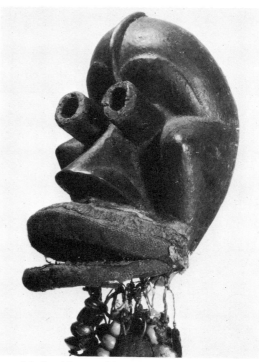

44. *Mask with movable jaw, Guere-Ouobe, Rep. of the Ivory Coast. 10"*
SEE PAGE 176

PSYCHOLOGICAL SIGNIFICANCE OF MASKS

Through the ancestor figure the dead returned to the family, which thereby gained reassurance and peace. The ancestor statues have an air of calm and repose.

Through the mask, worn in an ecstatic dance, the African sought active communion with the spirit, in order to combat evil forces or to compel the spirit of the dead to act in his favor. Released from the limitation of everyday life, the masker and his audience were lifted into the superhuman and charged with fresh springs of vital energy.

The masker became the spirit itself, whether it was that of the protective animal whose qualities he coveted or the spirit which would heal sickness. He underwent a complete change, a *transfiguration.* He lost his own identity and became the spirit. He fulfilled his wishes for omnipotence.

In this the African achieved a simple and direct escape from oppressive reality—from the taboos and other tribal conventions.

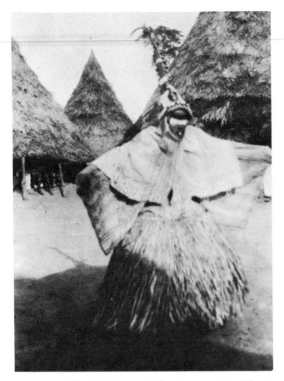

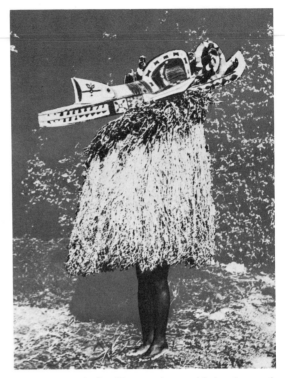

45. *Masked dancer of the Poro society, Liberia*
SEE PAGE 163

46. *Dancer of the Simo society, with* banda *mask,*
Baga, Rep. of Guinea
SEE PAGE 159

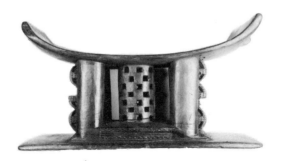

47. *Ceremonial stool, Ashanti, Ghana. 8"*
SEE PAGE 183

6. STYLISTIC FEATURES

WHAT we usually call primitive art includes sculptures from Africa and the South Seas, pre-Columbian art of Central and South America, and works of the American Indian and the Eskimos. The term does not include the art of early civilizations such as those of Mesopotamia or the Aegean, although in style much of this work is very close to what is known as primitive art. The unifying principle of primitive art works is animism: they were not created as "works of art" in the Western sense; they were used in magico-religio-social functions and not produced for sale.

The primitive style of expression shows great variety, but the major trend is toward nonnaturalism, with a greater or lesser degree of semiabstraction.

The term "primitive" is often misused and misunderstood. It is too often used synonymously with crudity, although the root of the word "primitive" means "original, primary, not derived." It is in this sense of an original, underivative art form that African sculpture may be called "primitive."

African sculpture is a sophisticated art—as Alain Locke (1946) put it, "culturally and technically so mature that it must be rated as classic in the best sense of the word," exhibit-ing a "completely successful harmony between the idea and its material embodiment." Its best examples can be rated with sculpture of the great periods in art history.

Each example of so-called primitive art, which at first glance seems so like the rest, exhibits marked stylistic individuality when carefully examined. On investigation we shall then have no difficulty in immediately distinguishing a piece of African sculpture from a South Sea or a Central American figure. Further acquaintance with African art will show that each part of West Africa and even each tribe and subsequent subtribes produced a quite typical and identifiable tribal style. Sustained observation, however, will also permit us to distinguish in each sculpture the individual talent of each carver and hence establish the all-important artistic quality of each piece.

It is important to remember that when we speak of African, South Sea, or pre-Columbian art, we speak of conglomerations of various cultures. Yet if we take the Bateke mask (Fig. 377) and compare with a statue of the same tribe (Fig. 376), we see that they represent two entirely different styles. If we take a mask from New Ireland in the South Seas and compare with an Easter Island figure, we have two

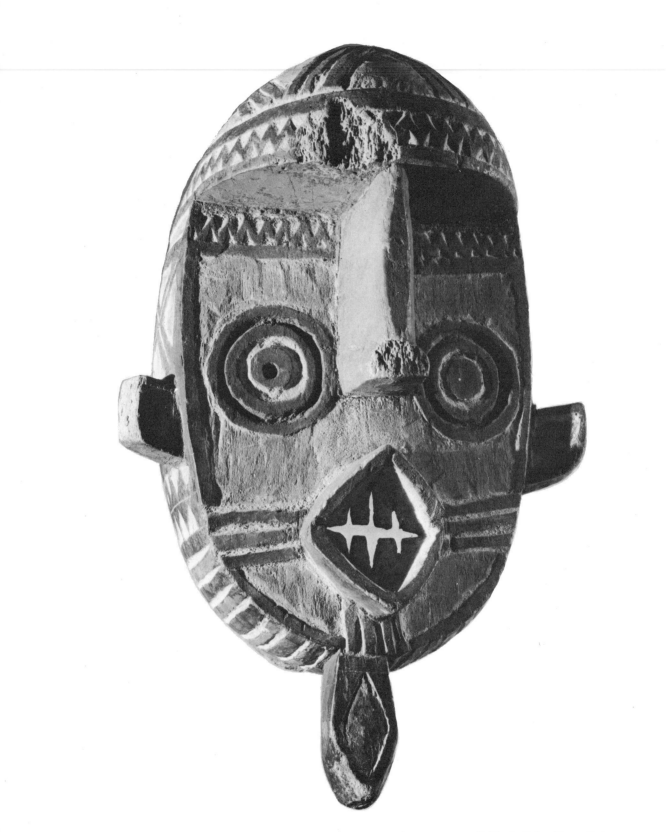

48. *Mask, Bobo, Upper Volta. 10"*
SEE PAGE 180

different styles. Of if we take a Colima or a Maya pottery and compare with a stone statue of the Mezcala River region of the State of Guerrero, we have two entirely different art styles, although we speak in general terms of pre-Columbian art of Mexico. Hence, when we speak in general about African sculpture, it should be taken as a means of orientation.

What distinguishes African art is its combination of architectonic immobility with calm serenity. By "architectonic" we mean that the masses of the sculpture are structural; the figure has a columnar effect. This architectonic quality characterizes most of the African statues. It gives even the masks a solid and sober quality markedly different from those of the South Seas. This serenity suggests that the African had found peace in the world and within himself through cultural catharsis. In contrast, the art of the South Seas seems agitated and fantastic. (Perhaps it's worth noting that the Cubist artists in Paris collected African material and the Surrealist group preferred the art of the South Seas.)

The Force of Tradition

In African sculpture, traditional stylistic characteristics are repeated in the work of each tribe. This enables us to chart what might be called a dictionary of style regions, defining the particularities of each.

TRADITION

We can speak of a tribal style which has a marked unity. But further study will show, in our section on Style Regions (Part IV), that one tribe has many different styles, sometimes astonishingly at variance with each other. Thus, among the Baule tribe in masks alone we have three different styles (Figs. 40, 42, 159).

As to the origin of each style we have no knowledge at all. We lack written documentation since the exploration of most of the Afri-

can regions is less than a century old and the African had no writing. But there are strong indications that styles were handed down from generation to generation for centuries. The African was a conservative, conformist member of his collective society; he had to adhere without deviation to precedents; he had to "copy" in an unaltered manner the prototypes of his sculptures because this was the very basis of his religio-social order.

The anonymous sculptors who, at the genesis of African art, invented and produced the original styles which have since influenced many generations must have had a creative genius comparable to the greatest personalities of art history. In the primary reproductive sense of the word "genius," these creative masters were able to reproduce vital formulations of the life of their community, similar in power to the achievements of religious and political leaders.

RELIGIOUS UNITY

How was it possible for such a strong style tradition to be produced by the African Negro? One answer is the overwhelming unity of *religious feeling and purpose* through the centuries. The sculptor shared the religious feelings handed down from the tribal ancestors. His art made him the spokesman of the tribe; through him the fears and desires of his people found expression. This made the expression more valid and intense than if it had conveyed only his individual feelings.

Imbued with the authority and conviction of a whole people, he acquired a sense of infallibility. This in turn produced the sure touch which gives African art its calm strength and certainty. There is no hesitancy; the sculpture radiates serenity and fulfillment.

DISCIPLINE

The style was handed down from father to son. The student spent many years acquiring this tradition, precept by precept.

This rigid adherence to tradition had another, a psychic, reason. The African was convinced that the traditional manner was good because it was effective in magical rites—it worked. Therefore it must be continued. If there had been any change, who knows what the consequences might be? This fear of the consequences of change was behind his rigid traditionalism.

Moreover, he had to consider his fellow believers. Each sculpture represented a well-known spirit, totem, or mythological personality, and its appearance had to be fixed for direct and immediate recognition. This imposed a powerful discipline on the artist.

The rewards for such conformity, however, were substantial. They were assurance and security, reflecting social stability. Conformity was part of the artist's whole life pattern, as in his adherence to taboos and the other clan conventions. The tribal myths strengthened the hold of tradition. Precedent was regarded as having passed the test of efficiency. Thus everything in the artist's culture strengthened the force of tradition.

As soon as the social stability from which a tradition derives is disturbed, as occurred with the irruption of the Europeans into Africa, an indigenous art, deprived of its tradition, degenerates and frequently disappears.

Effect of Discipline

Lack of creative liberty does not necessarily work to the detriment of art. Frequently it promotes intensity. In early Christian art, when painters followed strict prescriptions by the Church, their works achieved an unparalleled concentration of feeling. Similarly, the Buddhist sculptors of the Khmers, who established a powerful empire and a rich culture at Angkor in Cambodia c. 900 A.D., were also under a very rigid canonic discipline. The figures had to have a uniform dressing of the hair; the ear lobes were elongated in a certain way; and the head was held in a prescribed attitude. Nevertheless—and perhaps because of these limita-

tions—Khmer sculpture is the most sublime manifestation of Buddhist art.

The reverse can be seen in a case where foreign influence resulted in greater liberty for sculpture. At Gandhara in ancient Afghanistan, then a Buddhist land, Greek sculptors, not Buddhists themselves, were employed to carve figures of Buddha. Their work was refined and graceful but lacked the force, the penetration, the purity, and the simplicity of the later Khmer Buddhist sculpture.

Individual Differences

It must not be thought, however, that African sculpture is without diversity and individuality. As we have seen, the traditional forms differ from region to region. And even in the separate style regions, the individuality of the sculptor breaks through the conventional form. This appears in the details where he has ventured improvisations of his own. Thus most of the Bambara antelopes or Bakota reliquary figures will have a common style and form, but each individual piece differs in details of design and execution.

As indicated earlier, it is of great importance to distinguish in each work the individuality of the artist (as if detecting his fingerprint), since upon this distinction will depend the artistic quality of each piece. It is a tribute to the creative talent of man as a unique person that in spite of a communal and traditional way of thinking and carving, the marks of individuality change a common object of definable tribal style into a masterpiece.

Inner Mechanism of Creation

A work of art may be considered in terms of its content or in terms of its form.

The emotion with which the content is charged originates in an experience of the artist, gained from external impulses (or inputs) integrated and co-ordinated with his memory traces, partly cultural, partly individual residual material. He may arrive at a perception of what

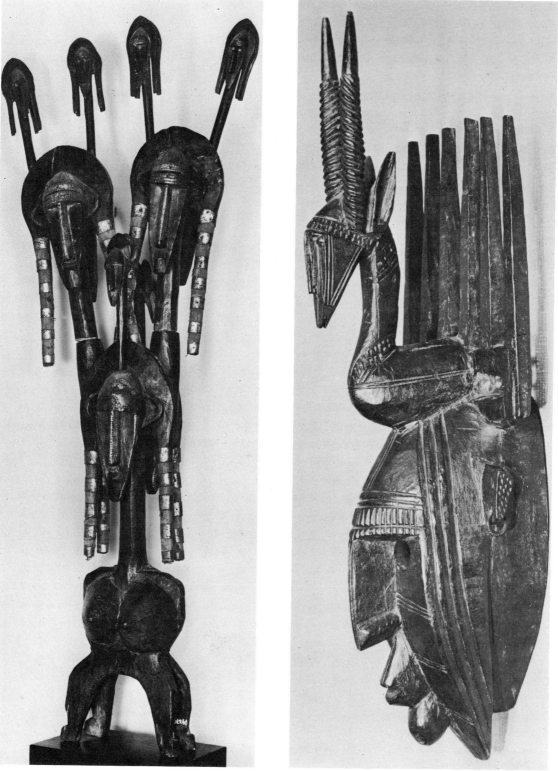

49. *Dance headdress, Bambara, Mali. 39"*
SEE PAGE 150

50. *Mask with antelope head and horns, N'tomo society, Bambara, Mali. 15"*
SEE PAGE 150

his inner self (or state of being) is, and may develop a conception of his relationship to reality and form a world view (*Weltanschauung*) or simply an attitude or posture toward the outside world. Between his approach to reality and the conception formed of it and the work of art that springs from it, occurs a series of neural processes, of which he may be only partially aware. He may only be aware of the symptoms, such as irritation or frustration of his desires; anxiety for his inability to crystalize his own concept may be repressed into the unconscious. It has to be emphasized that although he may not be conscious of what drives him to creation, the creative energy takes over and often the work becomes a revelation to the artist himself.

What the artist "has to say" is very important since the creative process gets into motion only because there is an inner need to "say something." But this is nonverbal; it may be formed from ideas and feeling and the resulting conception may not be defined. What is important is that the initial experience should have a high degree of intensity, so strong that no intellectual deliberation can distract the creator, and he co-ordinates directly those mediums of expression which alone will carry his emotion. When creation takes place in this manner, the medium of expression is chosen with spontaneous insight.

Picasso once told the writer that the act of creation is an overflow. Just as when too much water is poured in a glass, it overflows, so when one has experienced too much, there is an overflow which becomes the content of the work of art.

Creation is thus a co-ordination of this *inner* emotional reality with the *artistic medium*. If the emotion is strong, the artist's skill may become secondary. Even where little skill is involved, a forceful work of art may be produced. With an excess of skill, the artist may concentrate on virtuosity, and his work will lack forceful content.

African art at its best shows a rare co-ordination of skill and emotional tension.

Form and Expression

An inquiry into the form of African sculpture must concern itself with the materials, traditions, and techniques because of the limitations which each of these factors places upon the finished art work.

MATERIALS

Knowledge of the material used in a sculpture is important to its understanding. In many ways the material determines the nature of the statue. The sculptor knows that he cannot do anything *to* a particular material; he can do only that which is *in the nature of the material.* This the African intuitively recognized. Where the material was bronze, the objects were given a form not to be duplicated in wood. And when it was wood it attained that freedom of expression so characteristic of African art—greater than would have been possible in stone.

The actual selection of a material and the use made of it depend upon its availability. In Mexico, for instance, stone and clay predominate; in Alaska, bone. Mexican carving, therefore, is mainly in clay and stone; Alaskan carving in bone. African sculpture uses a great variety of materials, the most common being wood and the least common stone. We know of stone sculptures in Sierra Leone by the Mendi and in the Republic of Guinea by the Kissi tribes, some stone figures by the Bakongo in the Congo, some stone heads in the northern Congo in the region of the Uele River, and the stone figures discovered at Esie in Nigeria.

Of ivory carvings, the best-known are the elephant tusks, armbands, a few statues, and the goblets from the Benin Kingdom. They are most abundant in the Congo (among the Warega, Wazimba, Baluba, Mossendjo, Basonge, Bakuba and Bapende tribes). Some new ivory and bone carvings are produced in Loango and also in Dahomey.

Because of its rarity, ivory was always highly appreciated, and constituted one of the chief exchange items traded to the Arabs. Most of

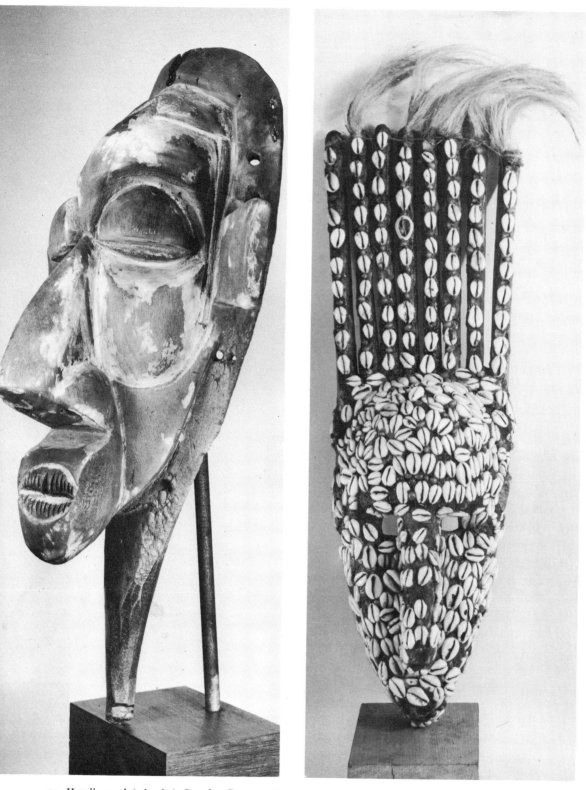

51. *Handle mask* (ndemba), *Bayaka, Congo. 17"*
SEE PAGE 254

52. *Mask with cowrie shells, N'tomo society,
Bambara, Mali. 15"*
SEE PAGE 150

the ivory pieces (armbands, amuletlike masks, figurines, etc.) were worn on the body, which contributed to the beautiful reddish-brown patina and smooth surface of old pieces.

As to metal, gold was used by the Ashanti, Aitutu, and Baule tribes, mostly in Ghana, the Republic of the Ivory Coast, and in Dahomey.

Of the bronzes, the most famous are those of Ife and Benin and the Ashanti gold weights. In Nigeria other tribes such as the Yoruba, Edo, and Igala made bronze casts, as did the Dan and Kra in Liberia; the Tikar, Bali, Bagam, and Bamum tribes in Cameroon; the Lobi and Bobo in the Upper Volta; and the Ewe and Ga in Togo. In Ghana and the Republic of the Ivory Coast, in addition to the Ashanti, the Baule, Agni, and Akan tribes made bronze casts. The *cire-perdue*, or lost-wax, casting technique was mainly used.

The last consists of making a model in wax over an earthen core. This is covered with fine-grained potter's clay, and when several layers have dried, the whole is enveloped in earth and baked. As the melted wax drains away through vents, it is replaced by molten bronze. When the cast has cooled the mold is broken. The emerging bronze cast exactly reproduces the original wax model. In the Benin Kingdom, extremely complicated plates, heads, etc., were cast in this technique, as skillfully executed, according to experts, as the Cellini casts.

We cannot say whether the West Africans discovered this technique or whether they borrowed it. It was used in ancient Egypt, Greece, and Rome, in India, and in pre-Columbian America. The fact remains, however, that the bronze castings achieved by the West African in the thirteenth to seventeenth centuries were never surpassed in technical perfection. If we presume an Egyptian origin, the learning must have fallen on very fertile ground; an amazing bronze art developed from it.

Other materials used in Africa were terra cotta, hammered-metal sheets to cover objects, clay, raffia and straw, palm fiber, and cotton thread, often combined into a real "assemblage" (Fig. 310).

Wood, which is available almost everywhere in Africa, was most commonly used. Another important reason for its use was its magico-religious significance.

The Meaning of Wood to the African

Africans worshiped the tree as the abode of supernatural forces. In Nigeria the tree was connected with human life. If a man fell sick or a woman wanted a child, offerings were made to a particular tree. Some tribes believed that trees were their ancestors. Trees were sometimes worshiped as mother symbols, since they produce and bear fruits.

The sacredness of trees associated them with the ancestor cult. The dead were buried in the holy forest; consequently the spirits of the deceased lived there. Where the dead were buried near the village, a tree might be planted over the graves.

Belief in the sancity of trees is found in all parts of the world. According to the Bible, God made his appearance to Moses in a bush. Zoroastrians held all plants sacred; the Greeks venerated Zeus at the oak of Dodona; Buddha found peace under the Bo tree. The instances could be endlessly tallied.

Vestiges of this animistic belief in the life power of trees have been carried over in the present-day use by "dowsers" of hazel twigs to locate water. When we "knock on wood," we perpetuate an animistic belief: we summon the spirit of the tree to protect us.

Significance of Poles

The next development in tree worship is trimming the tree trunk into a pole. Early African explorers found large, roughly carved posts used as tribal fetishes. In recent times more elaborately sculptured houseposts served as guardian spirits of dwellings or commemorative statues of the deceased.

The word "pole" or "pale" in English is derived from the Latin word *palus*, the primordial symbol for phallus or *penis erectus*.

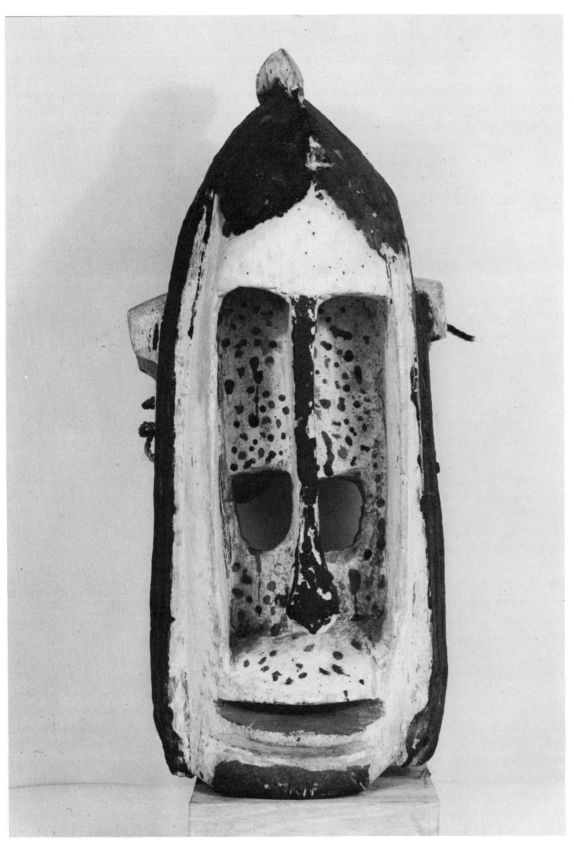

53. *Mask* (samana), *Dogon, Mali. 15"*
SEE PAGE 157

According to the Freudian system of dream interpretation, any long, hard object may serve as a symbol of the male genital. (The male connotation of angularity in the writer's Theory of Tension is partly based upon this observation.) The Maypole dance (with the pole substituting for the tree) once had a phallic significance. This symbol is the elemental representation of vital force, of creation and fertility. The African columnar statue derives from the pale, or post, the primary form of the symbol. It has all the phallic characteristics: the erect position, symmetry, etc.

African phallic symbolism (the subject of a 1955 essay by the author) is seen most clearly in the soapstone figures of the Kissi tribe in the Republic of Guinea (Fig. 141) or in Warega ivory carvings (Fig. 37). The oversized head of African statues is proportionate to the head of the penis. This is probably one of the reasons why masks, which are representations of the head, are also oversized.

A similar use of the pole to represent the human figure appears in Greek architecture. The early Doric column is the trunk of the male, abstracted into an aesthetic columnar unity, with the capital as an abstraction of the head (the word "capital" is in fact derived from the Latin *caput,* "head"). This symbolism was carried so far that the column had a standard measure of one foot (human-foot size) in diameter, and a height of six times this diameter, corresponding to the average male proportions. Later, for aesthetic considerations, the height was changed to seven times the diameter, and the height of Ionic columns was nine times the diameter.

The caryatid is a decadent form of the same idea—a naturalistic illustration used to replace a forceful abstraction.

The Baluba stools with their supporting figures only apparently suggest the same caryatid idea. These stools might be representations of the ancient custom prescribing that the king sit on the back of a crouching slave to symbolize his power (Fig. 56).

THE SPIRIT OF WOOD

Tree worship, intermingled with phallic symbolism, accounted for the African's deep attachment to wood. The ritual preparations for the sculpture reflected the mystical feeling toward the tree.

The part to be carved was carefully selected from either trunk or limb. When the tree was cut down, a magical ceremony was performed to cope with its spirit. This was pacified by prayer or sacrifices, or more powerful spirits were invoked to provide protection against the spirit of the tree. Usually the log was left lying in the forest to give the spirit time to leave it, but sometimes it was immediately hauled to a secluded place, where the sculptor gave it a crude preliminary shaping. Among certain of the Congo tribes the man who ordered the sculpture from the magician had to participate in this ritual.

The feeling that the wood to be carved contained a spirit and had life contributed to the sculptor's deep feeling for his material. For him it was already endowed with power before he even began shaping it into a magic figure.

OTHER MATERIALS

For the African, metals too had symbolic power. In Mali, copper signified water itself and the rays of light reflected in water; it was also considered the brother of gold. Even unshaped rocks were adored as manifestations of natural forces.

DOMINANT FORMS

An African sculpture was carved or hewn out of a single block of wood. The sculpture seems to emerge out of the mass of the material. The magical life that the block of wood was supposed to have seems to show in the massiveness of the wood and its beautiful grain, which the sculptor kept intact. The contours follow the cylindrical form of the log, to which all parts are kept subordinate. Another, though

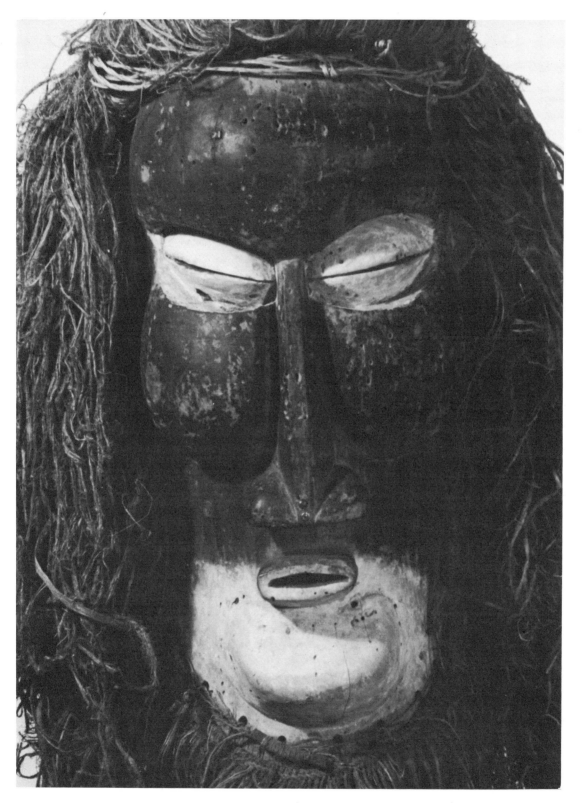

54. *Mask* (kakunga), *Bayaka, Congo. 12"*
SEE PAGE 254

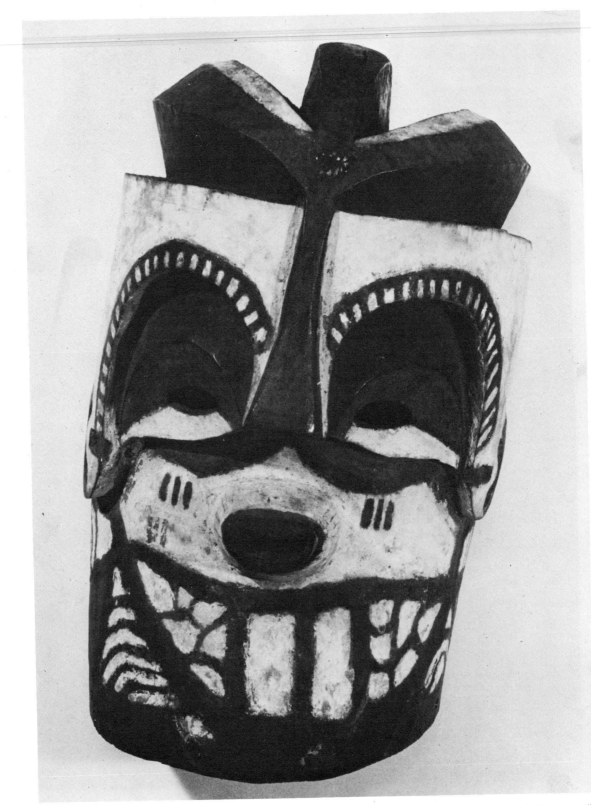

55. Hood mask, Bena Kosh, Congo. 15"
SEE PAGE 257

subconscious, reason for retaining the natural outlines of the wood was probably to preserve its phallic suggestion.

This emphasis on the *vertical line* gives each statue a vertical *axis*, to which the different parts of the sculpture have an organic connection. If divided along this vertical axis, many African statues would separate into two symmetrical halves, an effect also to be observed in Babylonian, Egyptian, Archaic Greek, and Romanesque statues. It creates an impression of serenity and repose. Another example of this vertical symmetry lies in the deep, peaceful lines of the Gothic arch, as of two hands closed in prayer and raised toward heaven.

The majesty and serenity of African sculpture is also due to the wonderful co-ordination of the emotional and ideological attitudes of the African with structural principles. In its lack of bodily movement, Maillol compared Negro sculpture to the Egyptian, observing that the more immobile it is, the more it appears about to move. This latent movement, this anticipation of action, is an important element in its attraction for us. In our imagination we complete the indicated action. Maillol added that "Negro sculpture has reduced (synthesized) twenty forms into one." African sculpture is architectonic in the equilibrium of its masses.

TECHNIQUE OF CARVING AND ITS INFLUENCE ON FORM

In all works of art there is rhythm of forms, but it is so pronounced in African art as to become, in Élie Faure's words, "rhythmic reality."

Rhythm is elemental in all human beings, whose organic functions are carried on in regular pulsations; but this is truest, perhaps, of the African. His walk is markedly rhythmic. And rhythm is so important to the African that he even works to song. The sculptor swings his adze to cadences.

This rhythm, as Boas points out, becomes a "motor habit." Because tradition imposed on

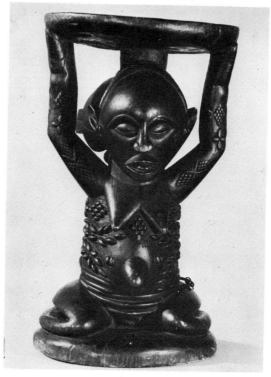

56. Chief's stool, Baluba, Congo. 19"
SEE PAGE 241

the African a rigid manner of carving, his technique tended toward uniform, almost mechanical, operation. Although his tools varied according to region—axes, knives, and awls being used—the most common resembles an adze. The use of such a tool calls for chopping rather than carving. (The tool is used elsewhere for rough carving by ship carpenters, coopers, etc.) Since the blade is set at a right angle to the handle, the adze is swung from such a distance that precision is virtually impossible. Not creation of form but intensity of feeling was the sculptor's main concern. Like the violin virtuoso who transcends all kinds of technical difficulties and concentrates all his energies on forceful rendition, the African sculptor, sure of his form, concentrated on expression. That so many of the extremely fine carvings of Africa were done with this rough tool is a tribute to the skill of the sculptors, the sureness of their vision, and the co-ordination between tool and concept. As Mrs. Esther Warner put it: "The tool seemed a part of the

artist's own body, an artery through which his soul flowed into the wood he was shaping."

The African sculptor acquired this rhythmical carving skill in many ways. To begin with, only one with a gift for carving became a sculptor. Usually he had a high standing in the community. Often magician and sculptor were one. In many instances the skill was handed down from father to son in a long and rigorous training.

The African sculptor possessed a vast amount of that commodity so essential to artistic creation—*leisure*. He could work on his statue until he was satisfied; and he got great satisfaction out of a well-made piece of sculpture. Love of the work is one of the reasons for its high artistic standard. Certain of his technical problems were difficult to solve, and he could have skimped or evaded the solution had his aim been merely to finish the sculpture quickly. Many statues have scarification marks in relief, which meant the chopping or carving of the whole block of wood to make these marks stand out in relief. Or, to provide for a small protrusion, an extremely large area of wood was cut away. The African sculptor would not think of omitting a detail to save time and work. Thus the Bambara sculptor, for instance, carving the *tji wara* in Fig. 110 out of a block of wood, painstakingly conserved the forms of the anteleope's horns and ears and the tail of the lower animal, although with the grain of the wood running horizontally there was great danger the wood might break off. Had he shortened the horns or reduced their arc, he would have simplified his task—but at a sacrifice of impressiveness and aesthetic values.

The surface of the completed statue appears to breathe its own life. The surface has a function in terms of light, gaining cadence from the reflection.

The sculptor identified himself with the whole work. He participated in the ceremonies when the tree was felled, when dyes were applied, etc. Often he was the one who gave the magical substance to the statue in the ritual that consecrated it as a magic-working image.

ABSTRACTION

As a general observation we can state that African sculpture is nonnaturalistic with a trend toward abstracting into geometric forms parts of the human body. In the great periods, this abstract trend was combined with semi-abstract features. Decadence came into African art when it turned to naturalism.

The majority of African sculptures show an *interplay of round and angular forms* (Figs. 57 and 58, for example). In a paper published in 1957, "Plastic Aspects of African Sculpture," this observation was further developed into a Theory of Tension, maintaining that round forms (female) and angular shapes (male) create between them a tensional situation, and that the excitement that good African carvings convey to us is due to this latent, not apparent, inner tension between the forms. Exclusively angular shapes are rather rare, the best example being the Dogon mask in Fig. 128.

Although the detection of interplay of forms often needs sustained observation and analysis, this is one of the qualities of African art which places an individual work into the realm of a structured organization, a configuration of shapes that from the phenomenological point of view "gives" what it is, in its "isness" (to use an Eckhart expression), without any descriptive element.

Here we may also add that many drawings made by Cézanne in preparation for his painting "The Bathers," many of Picasso's sketches and the finished painting "Les Demoiselles d'Avignon" as well other analytic Cubistic works of Picasso and Braque and the contrast of forms in Leger (1914) show the interplay of round and angular forms; in this respect, again the African sculptor's and the Western artist's plastic searches met.

Abstract Forms. The most striking facet of African sculpture is exaggeration. Because the content of his work was spiritual, the sculptor chose those forms which he felt intuitively. Since the culture in which the African sculptor's creative impulse had its source was

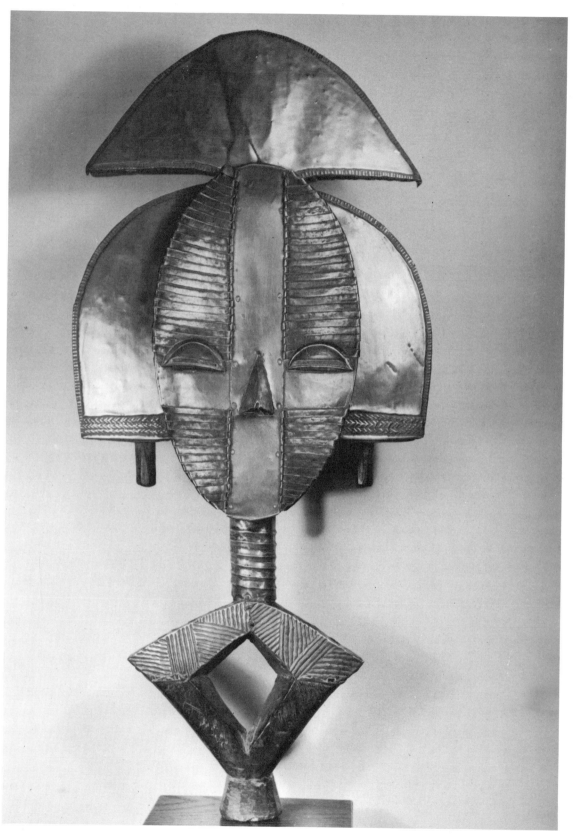

57. *Reliquary figure* (mbulu ngulu), *Bakota, Gabon. 24″*
SEE PAGES 213, 216

marked by powerful abstractions, his work followed the same path. His objectivization of abstract ideas made use of analogous abstract forms.

We know that all African sculptures, including ancestor figures, magical figures, and masks, had a magical meaning. All held potential mastery over the secret forces of Nature, to be worked at man's command.

But it was more than that. The invisible idea of the ancestor spirit or the magic power was rendered visible through image making. The formless acquired form and because of the force of the materialization of the invisible power, that which was unspeakable for the African was able to speak to us. This is because the plastic language transcends what is verbal, breaks time and space. The image was the message. Leonardo da Vinci was right when he wrote, "Inscribe in any place the name of God and set opposite it His image. You will then see which will be held in greater reverence."

Animate nature, whether embodied in human, animal, or plant life, is manifested in visible forms. To order and subjugate them to his will, man deformed or transformed them into *invented* forms, products of his creative volition. This "will-to-form" (a phrase coined by Alois Riegl) turned to "denaturalized" forms as an assertion of man's dominance and independence, and as an expression of his individual personality. The forms became truly *new creations,* symbolizing man's presence on earth and his mastery over Nature.

From the African point of view, however, the "new creation" or "inventive" form needed neither to be new nor invented, but to render an imitation not of *visual* reality, but of *conceptual* reality. This primitive art provided images—indeed, true copies—of an intuitive concept, objectifications of an emotional reality. This emotional reality was a struggle against fear of the spirit forces. By overcoming his fear, he attained a feeling of superiority, controlling forces which hitherto had controlled him. Rank points out that first man felt himself a *creature* of Nature and religious beliefs, eventually to emerge as a *creator* in his art.

Man's emergence as a self-asserting being developed another important attitude in him. Because of his inner ruling forces (which today we call the unconscious), he questioned the independent existence of visual reality. Natural forces, thunderstorms, fecundity, illness became real to him when he attributed their action to a spirit. Thus natural phenomena were converted into imaginary forces to fit them into his inner reality.

The Revolt Against Nature. From this *doubt* in the validity of reality came his revolt against Nature's established order and his creation of the new order imposed by his will and conforming to his inner or conceptual reality. When he rendered something that in nature was short and round as something long and angular, this *symptomatic* action asserted opposition to Nature's order.

It is rather interesting to note that according to the latest discoveries in the realm of physics (expressed by Schrödinger, von Weizsacher, Heisenberg, etc.) reality is nothing but a construct of the mind. The very cosmic order (as Einstein stated) is nothing but man's theoretical invention into which we coerce our observations. And we are not speaking now of the whole question of *meaning,* which is the only measure of man's individual relationship to reality, and which is the most subjective act that man can achieve.

In addition to the reasons given above, the African might have conceived his abstract or unnaturalistic form and realizations for a simpler reason. Let us turn from the mask in Fig. 59, which has all the Negroid features of naturalistic portraiture—short broad nose, thick lips, square head form—to a Baule mask (Fig. 42). Here the nose is thin and long, the mouth small, the head oblong. Every feature contradicts visual reality, has become an abstraction. This mask has been made the abode of a spirit. The ancestor spirit is obviously not a visual but a conceptual reality. It is abstract.

But being a true artist and understanding, or rather feeling, the inner mechanism of form within the creation, the sculptor did more than merely contradict. All forms are round, and

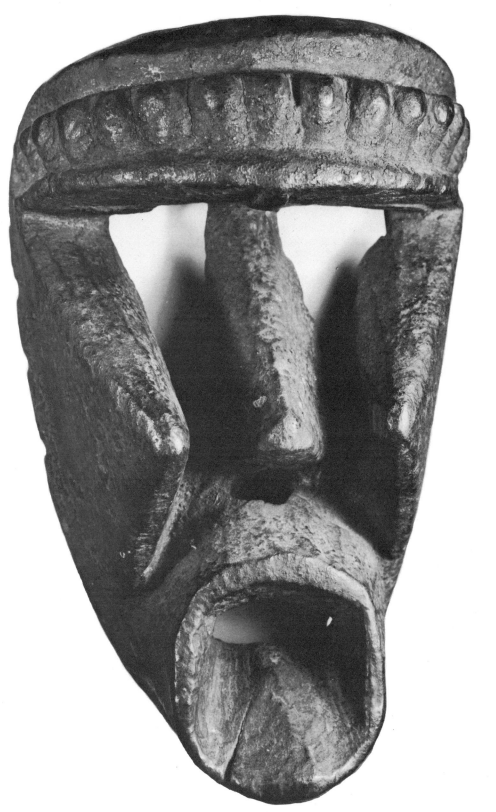

58. Mask, Poro society, Geh, Liberia. 8"
SEE PAGES 163, 176

their interplay creates a rhythm made more intense by the introduction of the unexpected, strong, angular, straight line. There is tension, but it has balance and therefore gives an impression of serenity and detachment.

All this, however, is on the unconscious level. When a natural form is transformed into an abstract one, it is the psychic *intent*—the drive—which counts. Because man's innate drives to power, to self-assertion, are so basic, the performance of this act, the creation of new forms, is carried on with great absorption and excitement, but governed by the strong, rhythmic design in which these impulses are co-ordinated.

To self-assertion is added the drive to assert an idea or fulfill a specific purpose; and this becomes the content of the work of art. Here the aim is man's protection. In African art the idea was animism; the purpose was to protect the beholder against malevolent spirits.

Abstract, exaggerated, stylized, unnaturalistic, or distorted forms occur in art whenever a dynamic expression of an idea takes place. When the pressure behind a dam becomes excessive the water breaks through; so, too, will the emotional pressure of a new and unified idea break through naturalistic forms.

Art, or style in art, is the expression of an ideology. Ideologies are subject to change; consequently art styles—resultants of such changes—are also subject to change.

CLASSIFICATION OF CREATIVE ART ACTIVITIES

In Élie Faure's theory, the idea which is the content of a work of art should be projected or exteriorized in *expression*. When expression aims at *perfection* it uses the skill of the artist to attain maximum truth to nature—the hallmark of decadence.

When the Greek idea was strong and virile in its Archaic period, it achieved the most balanced, tightly formed statues, from which the idea radiated with great power. When the idea weakened and its emotional excitement died down, the artist—now having no deeply felt emotional need for expression—took the forms

of his predecessors and tried to refine them and to do better, to achieve *perfection*.

Observing details and comparing them with nature, he arrived at the satisfaction of being more perfect (compared to nature) than his creative, explosive forerunner.

Thus *feeling,* the creative force, was replaced by *knowledge.* Maillol once remarked that Praxiteles had learned to make such fine, polished sculptures that they no longer possessed any character.

The Christian idea also produced unnaturalistic sculpture in the Byzantine and Romanesque periods, when it expressed a deep religious feeling. Later, especially in the fifteenth century in Germany, heads of Christ were done with anatomical perfection and sculptured with tortured facial expressions, even with color to reproduce blood. In the early Romanesque sculptures the head of Christ, however,

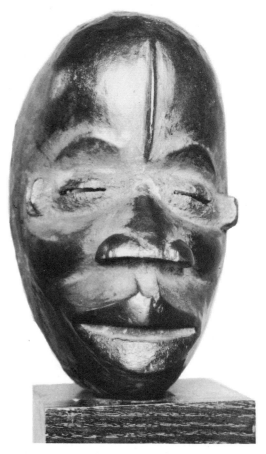

59. Mask, Dan-Guere, Rep. of the Ivory Coast. 8″
SEE PAGE 176

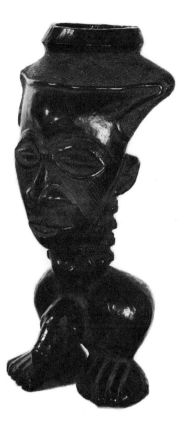

60. *Ceremonial cup, Bakuba, Congo. 12″*
SEE PAGE 232

is serene, as if saying, "Forgive them, for they know not what they do." This is the Christian spirit; the imitation of physical suffering is not.

Our period, too, has its ideology, although it is more complex than any of the past. Whether based on individualism, anxiety, or any other elemental feeling, this ideology is vigorously expressed by great personalities, such as Picasso, who synthesized the spirit of the time and expressed it in forceful new forms. But their imitators, often quite unconscious of the influences they were responding to, did not understand the spirit and never felt the excitement of creative improvisations. They merely elaborated upon the already created forms, perfecting some (according to their own criteria); but their work was lifeless.

This can happen when an artist begins to imitate himself, as in the case of Utrillo. His early paintings were an expression of his loneliness. When his need to unload his intensity ceased,

he turned back to his own early inventions, repeated them, and they became lifeless.

The conflicting trends in art—the creative and emotional aspect as against the refining and intellectual aspect—have been given many different formulations. In Nietzsche they appear as the "Dionysian," or inspired and ecstatic expression, as against the "Apollonian," or intellectually controlled expression. Scheltama called the two directions "organic," when the drive stems from the inner need of the creator, and "mechanical," when the expression merely uses and refines existing forms. Herbert Kühn's terms for the two trends are "imaginative" and "sensory," with the imaginative leading to invented and, ultimately, abstract forms, and the sensory, deriving its inspiration from the visual, tending to become naturalistic. Max Verworn's terms are "ideoplastic" as against "physioplastic," one creative tendency working with ideas, the other with physical reality. E. von Sydow, in his psychoanalytical studies (*Primitive Kunst und Psychoanalyse*), called the two directions "Eros dominated" and "Eros dominating"—one dominated by libidinal (emotional) forces and the other dominating those forces.

Elaborating this, Otto Rank divides the directions into two groups:

I	II
Transformation of life into a personal experience	Makes use of other life experiences
Total participation of the artist	Partial participation of the artist
Self-justification of the individual, raised above the crowd	Justification by way of general recognition
Creating new forms to express his personality	Perfecting forms, using traditional materials
Driving to express an individual truth	Accepting generally adopted truth
Subjective; individual; personal	Objective; collective; social

Further divisions may be suggested, such as:

Psychological	Materialistic
Conceptual reality	Visual reality
Inventive	Imitative

Or they may be summed up as the expression of an inner reality, as opposed to the rendering of external reality.

Maillol said, "I use form to arrive at what is without form." The African, with innate artistic facility, found forms to express his inner feeling and, in this way, to put order into his ideas—a process which may be called also the *spiritualization* of a work of art. The author gained a sense of this in a small church in Toledo, Spain, where hang several of El Greco's paintings. A priest who acted as guide was startled by the question, "What did El Greco's paintings mean to him personally?" After a while he answered, "They represent for me spiritualized reality."

Such spiritual realities are not confined to individual revelations. Animism for African art or Christianity for the Romanesque are collective ideologies for which the artist served as the expressive agent.

The individual artist expressing an ideology also has his own problem and inner realities. The formation of a style is thus the expression of ideologies through the "will-to-form" of the individual.

African art is similar to Egyptian or Romanesque art, simple and unified in idea as in individual expression. Like the idea of the cult of spirits, personal problems were universal to Africans—fear, dependence on natural forces, and so on. The uniqueness of a personality such as Michelangelo or Cézanne could not have developed in Africa because the personal problems were not unique but general.

DISTORTION OF THE BODY

In most African sculpture we find an overlarge head and a trunk too long for the legs (Figs. 69, 73, and 74). The same disproportion appears in the costumes of the maskers. Emphasis is placed on the head because in it the spirit powers are believed to reside (Fig. 61).

This is one phase of the soul concept. The soul has been variously located in the stomach, the liver, and other organs of the body cavity, a

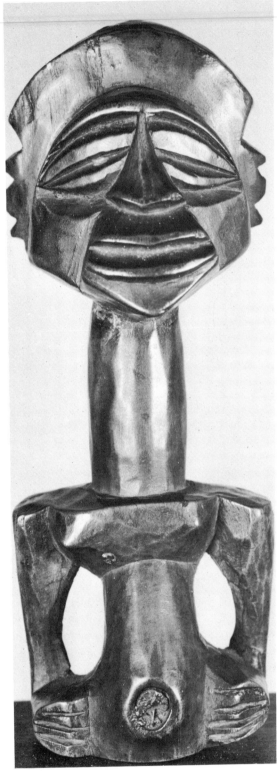

61. *Statue, Basonge, Congo.* 5"
SEE PAGE 247

variation of the concept of the womb as the origin of life.

The exaggeration of the head to the neglect of other parts of the body is best illustrated by the Bakota funerary statue (Fig. 57). The natives called such a figure *mbulu ngulu*, or "picture of the spirit of the dead." There is general agreement that these fetishes were placed in baskets containing ancestral bones (Fig. 21), but there is disagreement as to their function, some writers maintaining that it was to serve as watchman over the remains, others that these fetishes merely marked where the deceased lay.

The distortion of the head is not limited to its relative size. Often the forehead bulges out for further emphasis of mental power. Or emanations of the spirit are indicated by a nimbus of rays around the head. To the African this was no mere ornament or symbol—it was the spirit itself pulsing from the head (Fig. 57). As if to give a personal sense of each person whose spirit the fetish represented the design of this radiation varies from figure to figure, a testimony to the sculptors' ingenuity.

The body of an African statue never appears "fleshy" but has a feeling of austerity and serenity. Although male and female genitals are often exaggerated, the purpose is never to evoke sensuous emotions, but rather to suggest the power of the procreative force (Figs. 60 and 70).

As to the length of the trunk of the body, we shall study this question from the plastic point of view on pages 99–100. From the psychological point of view it is possible that the subordination of the body to the spirit may have resulted in the simplification of the body structure, often reduced to a columnlike trunk.

The legs, too, receive little attention, and often the feet are missing entirely. Arms are often attached in such a way as to accentuate the vertical. Exaggerated rendering of individual parts of the body in African sculpture may perhaps be better understood from this anecdote. An African, shown a photograph of a human being, had this reaction: "This is the nose"—pause—"This is the mouth. . . ." Hav-

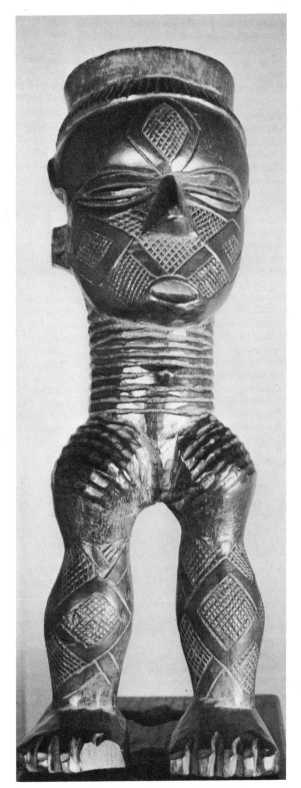

62. *Ceremonial cup, Bakuba, Congo. 11"*
SEE PAGE 232

ing enumerated the separate features, he said, as if in surprise, "This is a figure."

COMPARISON WITH CHILDREN'S DRAWINGS

The design aspect of African art has been compared to that of children's drawings. This can be of value only if we investigate whether the inner point of departure of the child's creative drive is close to that of the primitive African adult.

We find that children do not draw actual appearances. They reproduce a mental image. A typical child's drawing of a human being is a large head with large eyes, with the body frequently omitted and the limbs attached to the head. The child selects what seem to him the significant parts of the thing to be represented. With no concern for realistic appearance he expresses his symbolized concept. On this ground the child's concept meets that of the African.

The African, too, began with an idea (a

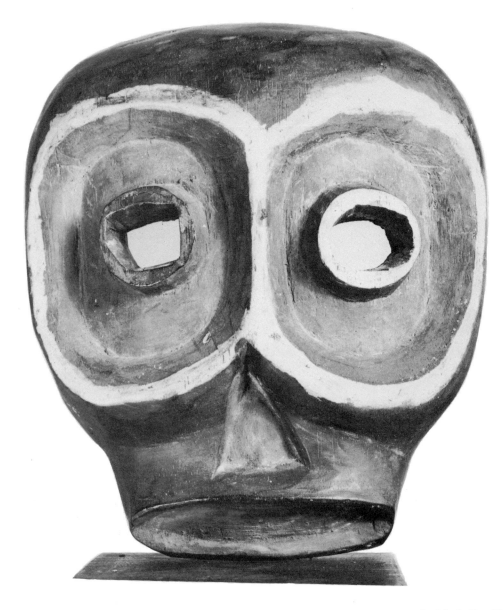

63. Mask, Ibo, Nigeria. 8"

This would indicate that conceptual vision is inherent in man. Modern art—the expression of contemporary consciousness—is its latest demonstration.

The exaggerations in African sculpture touch upon and reveal in us, through the mechanism of identification, our own primary conceptualism, stored deep in us along with other values of our childhood. African sculpture reawakens early habits and sensations, plunges us again into the miraculous world of imagination.

64. *Stone fragment of a figure* (pombo), *Kissi, Rep. of Guinea. 3½"*
SEE PAGE 159

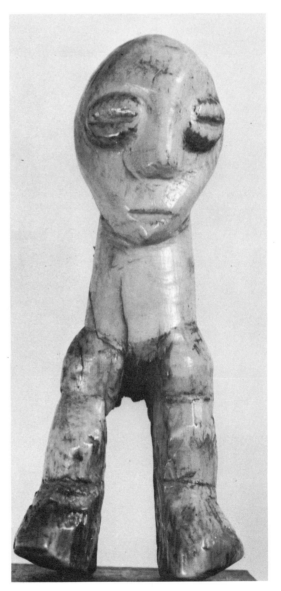

65. *Ivory statue, Warega, Congo. 4½"*
SEE PAGE 263

composite concept of feeling and mental image), whether it was of a spirit or a healing force. His conceptual image of this idea became his reality, which disregarded visual sensations or realistic proportions. The sculptural forms with which he expressed it became conceptual symbols of his inner reality, his mental image.

To be specific, let us consider two examples from the Congo, Fig. 62, a Bakuba cup, and Fig. 65, a Warega ivory statue. Here we have the typical vision of the child—head with legs attached. The mask in Fig. 63, from the Ibo tribe in Nigeria, shows similar striking resemblances to the child's creation.

How basic is this instinct to present the essential is demonstrated by the oldest existing sculpture of the human body, the abstract, non-naturalistic Paleolithic "Venus of Willendorf." Its exaggerated breasts and buttocks are virtual ideograms of maternity, comparable to a Kissi stone figure (Fig. 64).

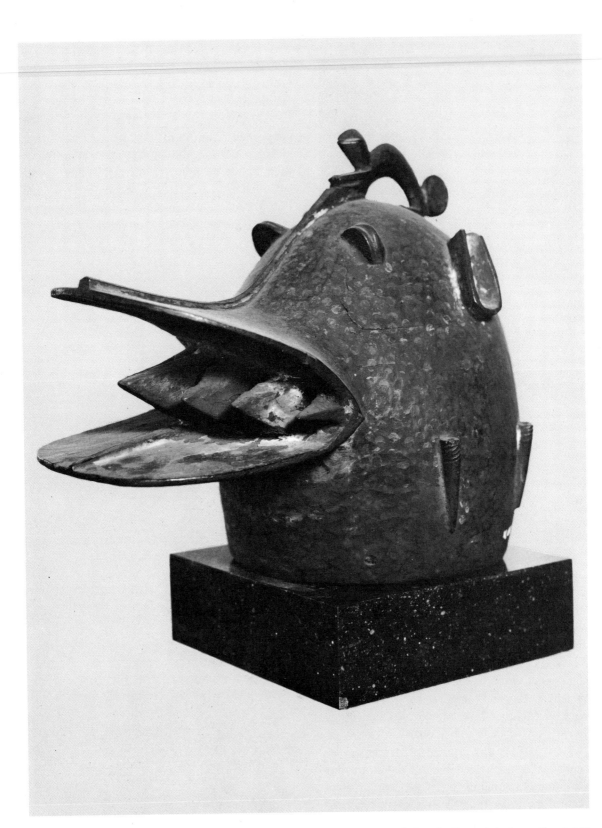

66. *Hyena helmet mask, Senufo, Rep. of the Ivory Coast. 14"*
SEE PAGE 173

AFRICAN ART AND WESTERN CIVILIZATION

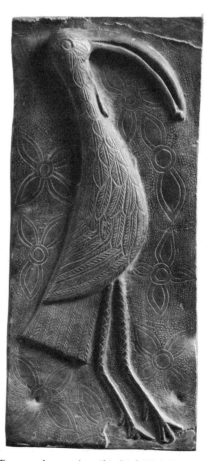

67. *Bronze plaque of an ibis bird, Bini (Benin Kingdom), Nigeria. 17"*
SEE PAGES 135, 189–190

7. OUR APPROACH TO AFRICAN ART

WHAT we perceive in any work of art is the co-ordination of forms into a configuration or a coherent whole. In African art the forms themselves and their co-ordination into a whole are so strong and suggestive that our reaction has a meaningful emotional impact. But this plastic structure could not evoke in us such a strong reaction if the work itself had not been the expression of a deeply felt emotional experience on the part of the carver. This is the emotional content of the work. The greatness of any authentic work of art is—and African art fits into this category—that it is not *about* an emotional idea (it does not describe, illustrate, or represent), but it *is* the idea in immediate, uninhibited expression. It does not want to evoke image associations by being analogous to something else, it wants to hit at the essential part of man, giving an impact in its "suchness," as the Hindus would say. And in this respect it comes close to the essential quality of abstract art. It *is*, it does not look *like* something else. The emotional impact is direct, although, for lack of imagery, indefinable.

It may be said that the effect which African sculpture has upon us comes from its economy —every part being essential—or from the efficient co-ordination and functioning of its parts. It must now be clear that in our relationship with African art, we should not look for beauty in any conventional sense connoting naturalistic reality.

If we take the classical definition of beauty —namely, that which causes an immediate, disinterested pleasure or delight for its own sake, and not for the use or benefit derived from it—we come to the conclusion that beauty belongs to the category of personal and subjective experience. Hence it does not belong to the category of concepts or ideas and for this reason cannot be defined. If concepts are attached to beauty, there are only rationalizations for an undefined subjective experience. But since individuals are conditioned by conventional ideas which change with time, there are periodic "tastes" upon which a group of people agree at that time. Taste is not constant, even in circles of the same class and background.

To show the change in taste concerning African sculpture, it might be worth quoting some early African travelers: Nyedael wrote about a "wretchedly carved" tusk of the Bini. Ling Roth, who contributed so much to our knowledge of Benin, described the figures on an ivory tusk as "grotesque." In the nineteenth

94

century Mary Kingsley wrote about "large, grotesque images carved in wood," Burton about "very hideous efforts of native art," adding, "His statuary are like his person, ungraceful and grotesque." Jacques and Stroms characterized the art of the African as "naive art, provoking laughter." A new frame of reference in the twentieth century has made us aware that these "grotesque" statues are works of art of high quality.

As to the African's own concept of beauty, we know that in his religio-magical carvings he was so much concerned with the direct expression of his religious feeling that no beauty concept was involved. (There is a great difference between an organic configuration that by means of its own inner tension "works" and one that illustrates a preset idea of what is beautiful.) In minor matters, however, the African did have a sense of personal beautification, although very much different from ours. For beauty's sake Africans underwent physical deformations that may seem monstrous to us. The Maganja women distended their lips with large rings and disks. Others used pressure to produce unnatural skull shapes, pierced the nose, from which they hung rings, tattooed the body, cut the skin to produce raised scars, filed their teeth to points, and so on. Usually these marks of beauty were acquired at the cost of great physical pain. In some cases the marks had another use: tribal or secret-society identifications.

INTUITIVE APPROACH

Because what we look for lies in the realm of the emotions, we must be intuitive in our approach if we are to respond to it. In Schopenhauer's view, it is only through our intuition that a work of art can speak to us, or rather, that we can comprehend its speech, which is untranslatable into the language of reason. Bergson adds that we must revive the feeling of reality obliterated by habits. Re-feeling, or *Einfühlung*, as Worringer called it, suggests *empathy*, or sympathetic identification. We prefer Otto Rank's more literal translation of the word, "feeling oneself into" a work of art. We propose, as even more accurate, the expressions "intuitive projection" or "introjection" of ourselves to convey the idea of active participation in, and even projection of ourselves into, the emotion expressed by a work of art.

Such a personal projection occurs when a creative artist, using a communal concept, projects his own feeling into the work of art he bases on that concept. By projecting his own individualistic yet animistic feeling into the statue, the African artist achieved union with the communal animistic concept.

One might ask which came first, the community's or the individual's concept? The writer would attribute precedence to the communal philosophy, observing, however, that it fits into the artist's personal spiritual attitude. Otherwise the artist would not be in sympathy with it and would not be able to project himself into the work; hence he could not create it.

If the observer adopts the *psychological* approach, by feeling-himself-into-the work he will translate the visible into an invisible emotional reaction, in which his own personality is projected back into the work. In this process he tries to seize the object.

The *phenomenological* approach endeavors to reduce this too-personal projective method. It professes that the object should seize the observer rather than the other way around. As Maurice Merleau-Ponty suggests, the object-subject dualism should be removed as much as possible.

Both approaches are possible by the same person, but not simultaneously; this is why we state that the two categories are mutually exclusive.

HOW TO SEE ANY WORK OF ART

Whether we adopt one or the other of these approaches in looking at a work of art, the first condition is to be open-minded and to suspend all expectations, all previous knowledge about the work. We must focus the whole power of

our mind on *observation,* surrendering ourselves to contemplation of the object, thus opening our entire capacity for the advent of something new, achieving a readiness to experience what we have perceived. It is a process of depersonalization (Worringer terms it "self-renunciation"). A complete "opening" of our inner selves is necessary, but after we have captured the "input" a very complex process takes place by which we form a *perception* of what was apprehended. Depending upon the level of consciousness on which we form this perception, we project our own feeling back into the work (the psychological approach), or we arrest it on preconscious, prereflective level and are content with an awareness of what has happened without the need to conceptualize it. On the psychological level the perception discloses within us a pent-up emotion (often existing on an unconscious level) which we project back into the work. Within this level of consciousness, occurs our projection of repressed animistic feelings into the work, which have been awakened by the contemplation of the work. Because the process is nonverbal and unconscious, it can affect the deepest reaches of our minds, again without our being conscious of what has happened, however. As Élie Faure put it, the subject of any work of art is only the means (or the catalytic agent) of fixing, first, our attention upon appearances and, second, inducing us to penetrate these appearances so as to penetrate to the essential quality that the artist has incorporated into his work—also without conscious intent on his part.

What actually we apprehend when we look at any piece of reality (a work of art being one) can be—in its general outline, and only from an orientational point of view—compared to the working of the camera. Our eyes can be compared to the camera lens which has been found to the required precision. They can be worked to comparable precision by looking at works of art and by applying basic viewpoints out of art books.

The image captured by the lens is deposited on the negative inside the camera. Good light, properly timed exposure, and especially the "speed," or refinement of the emulsion on the film, are necessary to get a satisfactory negative. This "speed" is comparable to our own inner sensitivity and the extent to which it has been cultivated to absorb emotional reactions. The negative is then developed, printed, and "fixed" with the proper chemicals.

We similarly capture an image with our eyes and transfer it to our inner selves; the print is our emotional concept, which may be very vague unless we have trained ourselves in each step of the process.

Those who can transform the first visual sensation into an emotional experience are rather few. Usually man works with the conventional symbolic associations and tries to understand what he has seen, since any vague sensation would cause him anxiety. This is the result of a classical education about artwork which has definable subject matter or is actually meant to be symbolic. But our education in listening and reacting to music has been different. We have transformed our sensory perception (hearing) into emotional reaction without trying to understand what we have experienced. The experience of seeing painting or sculpture can be as immediate as hearing music, and an effort has to be made to adapt our vision to the same approach.

Picasso once said that he uses his strong and startling forms and colors to give the onlooker such an emotional punch that intellectual deliberation has no chance to intervene. We should not merely look at a piece of sculpture (or any work of art), but learn to see it, which is far from simple. Bergson points out that the more preoccupied we are with our practical life (rather, our mechanical life), the less we are inclined to see.

We may learn to see, to find the proper viewpoints, but our emotional enjoyment of a work of art will still depend upon our own inner life, upon the degree of sensitivity our psychological make-up has achieved and the life experience it has absorbed.

PHENOMENOLOGICAL APPROACH

As valid as the psychological approach is, the fact remains that what we experience is very subjective; hence, we are aware not what the object in view *is*, but how we feel *about* it. We make a confession about ourselves and not a statement about what the work is. Although subjective projection cannot be eliminated, it can be reduced by adopting a new frame of reference or method of observation.

This is the phenomenological method, which consists in an attempt to focus our attention—as much as humanly possible—as if impersonally, to observe with abandon, with suspension of presuppositions, to describe as minutely and accurately as possible what is immediately present. If we can "undress" reality from its assumed meaning, its sheer presence will impose itself upon us (valid also for interpersonal relationships and for seeing patterns of events). We should bear witness, as if impartially, to what is *given* as actual evidence and not project our wish of how it should be, what it is supposed to be, what it looks like, or whether we like it or not. The aim is "eidetic reduction" (as Husserl called it), namely, to reduce that which can be observed to its essential qualities. It is to isolate the present without relating to past or future, avoiding the compulsive need (often conditioned by convention) to understand or to explain what we have experienced. It is to accept the validity of prereflective awareness, to register what is and to avoid any symbolic interpretations, any personal meaning-giving action, and to center our attention to *what is there.* Because of the very limitations of man's power of observation, a sustained, repeated focusing of our attention is necessary so as to accumulate as much as possible such observations as are beyond personal preferences, beyond analogies and allegories, beyond interpretation, to arrive at a description upon whic' other persons can agree. It is to state what *is as is,* or more precisely what it appears to be, and not what we think it to be.

Since it is the writer's contention that we have an affinity with the sculptures of the African not because they come from Africa, not because we know about the ethnic use of the works, but because they are of high artistic quality, the application of phenomenological observation to the specific carvings will liberate the objects from any knowledge we have about them. By pointing out what is "given" or actually observable we shall try to purify the input (visual apprehension) into the neurological process upon which our experience is based. The aim is not to understand but to live through the very process of having experienced a new input into our nervous system.

Thus, in the true process of reduction, we must discard or suspend any conventional description of forms, or what appears in the field of vision. We will not speak of the "eyes" of a specific mask, but rather describe them as two round shapes within an oval shape, or whatever the forms are. If we call these forms "eyes," we are relying upon knowledge and convention to which we have been conditioned and not upon a primary exposure to what is *manifest.*

Ultimately we cannot escape from a fundamental personal projection and interpretation. But once we become aware that such a subjective method can falsify what reality is, we can endeavor—to the degree we are able—to reduce what we see to what is observable and not be bound by what we imagine or think it to be.

In the following descriptions of three statues, which according to conventional description represent human figures, we shall refer to anatomical parts only in order to locate the shapes being discussed. This is only for the sake of convenience, since the aim is to consider them as plastic structures and focus our attention on the component parts, their interrelationship to each other, resulting in a coherent whole.

The statue in Figs. 68–70 (a Bambara female figure) at first glance shows a very bold interplay of round and angular shapes in an amazing and monumental plastic structure. If we experience a sense of wonder and astonishment at the daring structure, this may be caused either by comparison of the statue with

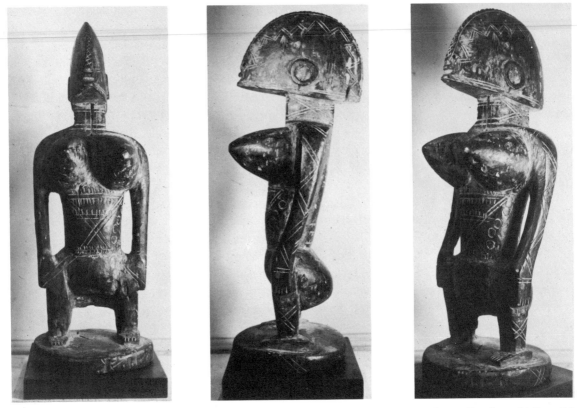

68, 69, 70. Statue, Bambara, Mali. 14½"
SEE PAGE 150

conventional knowledge of how a female body is formed—or, on a phenomenological level, by admiration of the sheer inventiveness of the plastic structure.

Looking at the front (Fig. 68), we can observe three basic round shapes: the shoulders, the breasts, and the hemispherical, crested head with crosshatched incisions on the ridge of the crest. The head is connected with the body by a square neck with chevron incisions. Following the line of the arms, we see that the hands against the thighs form right angles, the horizontal sides corresponding with the short horizontal lines of the mouth and the nose.

The angularity of the hands is further extended by the position of the legs. The broad distance between the legs and feet (against all anatomical observation), the shortness of the feet and their square form, give the statue a solid, unmovable *presence*, as if of great weight.

From the side view (Fig. 69), this statue becomes surprisingly dramatic as the hemispherical head, a great abstraction, comes into view. If we follow the round line of the head from back to the front, we come at the end to two small incisions interrupting with an understatement the continuity of the hemispherical line. This basic half-round shape is given an unexpected thrust by the fact that the straight line at the bottom is not horizontal but slants. At the chin, where the small incisions occur, two small round holes are drilled, forming small circles. For further accent this is repeated on both sides by the stylized ears carved as raised circles. The two conic shapes, prominently pointed breasts, jut out with force, being one of the most dramatic features of this carving, reaching about the same point in space as the head. (In spite of the very strong female attributes, no sex is indicated on the statue, seen from the front.) As a counterpoint to the

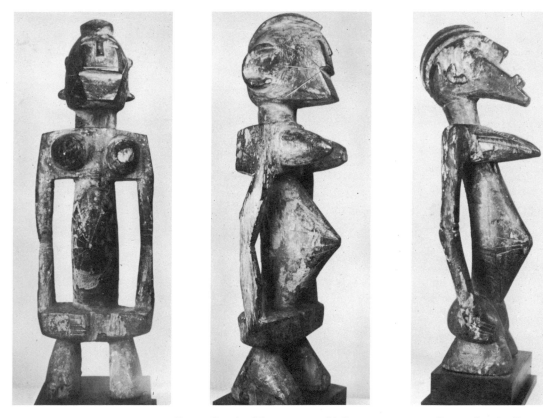

71, 72. *Statue, Senufo, Sikasso region, Mali. 12"*
SEE PAGE 171

73. *Statue, Senufo, Rep. of the
Ivory Coast. 11"*
SEE PAGE 171

breasts are the buttocks, the roundness of which becomes more evident because of the straight line of the back and the front. The arms, having at the shoulders the same width as the neck, do not descend in a straight line (as on the Senufo statue in Fig. 71) but swing toward the front to meet the wide hips, the hands having the same width as the foreshortened legs.

It is as if the artist had concentrated with great care upon the upper part of the statue, neglecting the lower part. The lower part measures 4 inches from the feet to the waistline, and the rest of the body measures nearly 10 inches, more than double the height of the lower part. Since the lower part of the adult human body from the waist down usually measures about 40 inches when the part above the waist is about 25 inches, the proportions of this statue reverse those of nature. Because the figure is not "sexual" but has an exaggerated

rendition of breasts, it appears that what the carver wanted to give was a symbolic representation for the concept of maternity as if divorced from the sexuality.

From the over-all design or *Gestalt* point of view (best shown in Fig. 69), two basic plastic elements are interacting: the round shapes of the head, breasts, and buttocks against the horizontal-vertical lines of the head, neck, back, and front. The circular base, acting as an integral part of the configuration, adds a line parallel, though slightly divergent to the nearly horizontal line of the head.

Accentuating further the difference between the round and the straight lines, another contrast was added. The whole body, the arms, the back, the legs, and the neck are covered with incisions, but there is no such ornamentation on the breasts, the buttocks, or the pubic region (from the frontal view); hence, more light is reflected from those parts than from those

where engravings break the light reflection.

There is a basic similarity in the plastic structures of the Bambara figure and the Senufo statue in Figs. 71 and 72, and hence in the underlying concept, although in the Senufo example the basic unity is formed by the interplay of horizontal and vertical lines.

From the front (Fig. 71), the following horizontal lines are apparent: the eyes, the mouth, the jaw, the shoulders, and the hands. The basic vertical lines are: the two sides of the face, the body, the arms, the legs, and the spaces between the arms and the body and between the legs. The interplay of vertical and horizontal shapes, in which the three negative spaces play an important role, result in an over-all rectangularity that is more prominent than in Fig. 69, in which the interplay of round and angular shapes was more important.

From the side (Fig. 72), the following straight lines and forms can be noticed: the nose, the face, the jaw, the shoulders, the arms, the hands, the very bold triangular shape of the belly, the smaller triangles of the legs and feet. The round shapes are: the hairdo, the ears, the neck, and the breasts. The pointedness of the breasts also corresponds with the angularity of the belly. The back is completely flat. Six incised lines radiate on the face and similar lines radiate from the point of the belly. Incisions are also used for the mouth and for the fingers and toes.

Once again the proportions of the human body have been reversed. From foot to waistline the statue measures 2¾ inches, from waist to head 9 inches, the upper part being over three times as long as the lower. (Aside from the breasts, no indication of female sex can be observed.)

On the third example, the Senufo statue in Fig. 73, the exaggeration of the upper part of the body appears even more accentuated. The distance from foot to waistline is 2½ inches, from waistline to the top of the head 8½ inches. (On this statue the sex is slightly indicated.) The side view reveals the main structural elements of this statue. There are three important protrusions: the square jaw, the cone-shaped breasts ending in points, and the belly, its triangular shape more obtuse than in Fig. 72. Serving as a counterpoint are the arms which form a slight triangular shape, opposing that of the belly. Against these angularities is a bold curving line starting from the hairdo, the back of the neck, the back of the whole body, and ending at the buttocks. The round buttocks follow this basic round line, dramatized by the contrast with the angularity of the legs. From the front (not illustrated) we have a design similar to Fig. 71—namely, the arms are parallel to the body, and the space between the arms and the body is about the same width as the whole body. The hips are at a 45-degree angle to the body, repeated in the design of the armpits and shoulders. If we follow the basic circular line of the hairdo, we find that the jaw, starting from the neck, also has a curved line, which is paralleled by the top line of the breast, while the lower part of the breast is a straight line. If we follow the line of the hairdo forward, we see three dramatic angularities: the nose, the mouth, and the chin.

If we look at these carvings as structures of plastic forms, the factual evidence shows that they are highly successful co-ordinations of shaped forms resulting in a coherent unity, as if the carver had executed them in a disciplined manner planned in advance. On the other hand, we know that the style traditions were handed down in a rather unaltered form from generation to generation and that the carver had to repeat these tribal stylistic features so that the carving would "work" as a container of some spiritual force. A third point of view is that of comparative study, which indicates that these particular pieces differ from other work known to be from the same tribes since these pieces are unusually bold in their concept. Hence, we must assume that their unknown creators must have been carvers of exceptional talent and individual inventiveness, who within the tradition were able to achieve outstanding works by their own individual talents.

Knowing that the African carver was tradition-bound, that he aimed at rendering not the visual but the conceptual reality, and hence that all his creative energies were centered around giving form to a formless or abstract idea (such as the survival of a spirit), the question may be posed, What accounts for the exceptional plastic solutions manifest in these three carvings?

The simple answer is that since each individual is genetically different, the individual talent of a carver accounts for differences in his work. Individual talent, however, is also subjected to environmental conditions. We know that individuality was suppressed in the collectivity of the African tribal system. Under the imposition of the tribal style a degree of repression of what was uniquely personal in the sculptors did occur. This accounts for the large number of carvings having uniform solutions and artistic merit. Our contention is that if a strong and exceptional individual, being endowed with a great creative force, is subjected to such a tribal discipline, he has the force to break through. By an inner necessity he steps out from the conformist form-tradition, as if unwillingly, and creates a unique and very personal work—although within the over-all tribal tradition.

Among the many thousands of art works from Africa, products of thousands of nameless artists, there are a number that have a particular suggestive power. It is only by phenomenological observation of what is evident in terms of plastic structure that we can distinguish between those which are of good *Gestalt*, representing masterpieces of their kind, and those which are formal repetitions of a great tradition.

Most of those who have been conditioned to apprehend works of art do not follow this process of analysis. They have an immediate over-all "impression," perceiving only the striking features without penetrating deeper into what caused their spontaneous experience. They feel whether a work or art is of good *Gestalt* or not without being aware that their split-

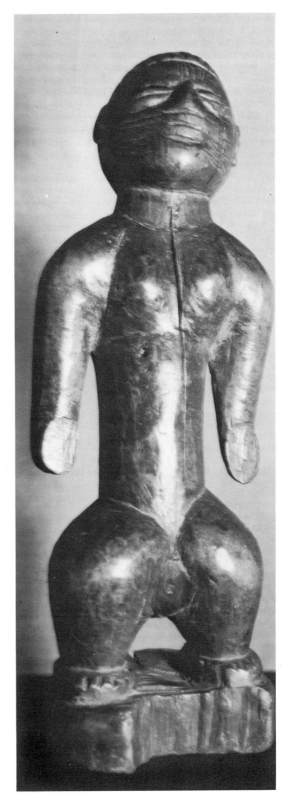

74. *Statue, Yoruba, Nigeria. 12"*

second observation has apprehended only the most apparent component parts of the whole. With a reaction akin to that of a computer, this visual input at lightning speed produces a quick analysis and synthesis resulting simultaneously in a statement as to the artistic quality of an object.

Experience has shown, however, that the human power of observation and perception is very limited. As important as the first experience is, sustained attention, observation, and analysis can open up new avenues of discovery, revealing what is latently *there* within the work under contemplation. New surprises are often in store; that a new aspect of a work reveals itself at each viewing of it is a sign of the survival value of the object. A high-quality work of art can withstand innumerable inspections and concentrated observation. In colloquial terms, it "wears well."*

How to See Sculpture

We have attempted to show how different a statue looks from different angles. This means that each aspect of the work has its own life, intense energy manifested in the tensional situation of its parts. The only evidence we have is what is in our field of vision; the fact that we know that a human figure also has a back must be considered as a presupposition.

A piece of African sculpture, however, is such a well-coordinated plastic structure, all parts function in such unity, each side flows into the other with such fluidity, each side suggests a continuity with the sides not seen, that the sensation of *expectation* becomes inherent in our experiencing the work, from whatever angle we see it. To be more specific, if we look at the front view in Fig. 68, we are interested not in how the "breasts" may look from the side but in seeing whether our expectation of how the conic shapes might look from the side is confirmed.

*The author has applied the phenomenological approach in two essays, "The Phenomenological Approach to the Perception of Artworks" (1965) and "Geometric Art and Aspects of Reality" (1967).

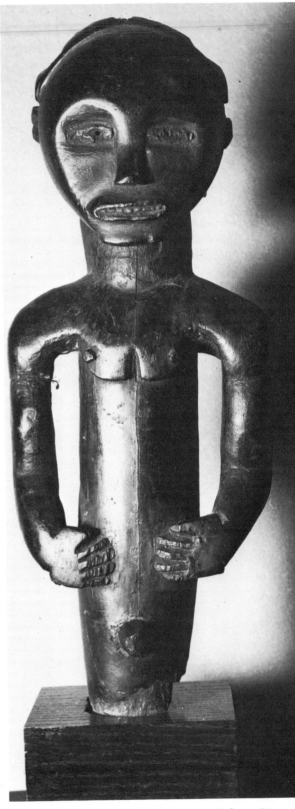

75. *Half figure* (nskh bieri), *Pangwe, Gabon. 18"*
SEE PAGE 220

Touching an African sculpture provides an additional and unusual sensation. Closing our eyes and concentrating on the sensations in our fingers is likely to evoke a new impression of delight. Lines, planes, and volumes in African sculpture have so smooth a flow that our touch records a living harmony.

This suggestion opens a new field of intersensory relationships, one aspect of the Gestalt psychology. Our simple vision is not a "simple sensation itself" (William James); "the totals themselves [in our case the sculpture] are different entities than the sums of their parts" (G. Hartmann). The experience of using one of our senses by touching the sculpture and adding this sensation to our visual perception is comparable to other sensory interrelations, such as "warm" (red, yellow, etc.) and "cool" (blue, green, etc.) colors, also "weights" of colors and the "colors" of musical compositions. (A color piano has been constructed on the basis of the color sensations evoked by musical tones.) When we see a form, its perception will depend upon our position. And that which we see can be intensified by different stimuli—touch, smell, and so on.

According to recent investigations of the phenomena of perception at Princeton, vision (mechanical reception of images) gives only cues to perception; the evaluation is made in terms of past experiences. Because perception is such a subjective experience, varying in each individual, the adoption of the phenomenological approach becomes more significant.

Unconsciously, then, a long process of integration takes place within our brain. All our senses produce inputs (electric in reality) which are co-ordinated, integrated with the memory traces imprinted on the tissues of nerves. The transformation of this integrated perception into an emotional experience, combined with whatever personal distortions and falsifications, is actually the key to the "feel" of any work of art. Whether we remain on the psychological level, with its "I like it" or "I don't like it" subjective statements, or whether we adopt the phenomenological attitude of detachment will depend entirely on how much effort we are willing to put into achieving a perspective on ourselves.

To sum up, it is not the art work which we experience, we experience our own experience. In order to undergo such an experience, we have to be exposed to an outside impetus, in our case the work of art. But—and here we repeat what has been said—first the work must have a suggestive, hitting quality formed into a coherent unity that is able to evoke in us an emotional reaction, and second we must be able to observe and really see those qualities that are inherent in the work. Hence, the work of art becomes a catalytic agent which starts the experience, but the quality and depth of our experience will depend not only on the artistic quality of the work but on our ability to observe with great concentration, without expectations, what *is* in view and to undergo with less ego-centeredness a more purified, hence more truly lived-through, experience derived from the plastic qualities of the work and not from what we project into it. This is the essence of the phenomenological approach.

8. THE PLASTIC LANGUAGE

IF WE START by considering a piece of sculpture as a plastic structure, we are already able to suspend such previous knowledge as who made it or why. Since the forms of such a structure are expressive, in other words able to suggest or initiate an emotional experience, they may be referred to as idioms of a plastic language.

There is a difference between the plastic language of sculpture and verbal language. For we have a dictionary to define the meaning of each word in verbal language; there is general agreement as to what each word means. But we have no accepted definitions of the psychological properties of the shapes which are the elements of plastic language. Yet we unconsciously associate certain emotional reactions with certain shapes or combinations of shapes. The sculpture that contains and integrates them imposes certain feelings upon us.

Our analysis of the interplay of round and angular shapes may be recalled here. In addition, a flat surface may connote calmness, a symmetrical composition balance. Many shapes and their combinations are so complex, however, that no definition of their connotative quality can be offered. Although we may not be able to pinpoint the meaning of every shape, they can be extremely effective. It will be clear from this that the interplay of sculptural forms sets up complex emotional reactions in us. And our response to the sculpture is the sum of the emotional responses it evokes from us.

The same principle applies in painting. Colors, too, have inherent emotional values; and our reaction to the interplay of colors in painting produces reactions resembling our responses to sculpture. Wall colors for modern hospitals and other places where emotional tensions have to be given special consideration are carefully planned.

To use the plastic language effectively, the artist must be possessed by a vital experience and, depending upon the depth of it, an urgency to *unload* this will be manifest. But urgent as the need to create might be, the individual must also possess the artistic, *creative* talent in order to find the corresponding combination of plastic forms that will convey the power and intensity of the experience. If such a co-ordination does occur, the plastic language will display a unity marked by simplicity, coherence, and vigor.

Forms and their co-ordination do not lie.

They stem from the depth of human experience. If one produces deliberate forms, the forms will show their lack of authenticity.

INVENTED FORMS

The matter becomes more complex in objectifying an inner reality when the artist *invents* forms outside the conventional patterns. It is this that causes many artists to be misunderstood in their day. Only when the new form invented by him becomes conventional does his unique personal concretization of an inner process become intelligible to the public. A further reason for difficulties in understanding is that the personal inner reality from which the urge to create originates may be very deeply buried in the artist's unconscious.

THE EXPRESSION OF THE UNCONSCIOUS

The phrase "The artist must have something to say" should not be understood as calling for anything analogous to a spoken or written statement. Artistic creation is the expression mainly of nonformulated ideas and unconscious feelings—the crystallization of an emotion.

Picasso once told the writer that if he knew, if he were conscious of, what he intended to express in his work, he would not create it. It is the tension of expressing what is as yet unknown to him, but astir within his inner self, which drives the creator to action. The existence and importance of the artistic impulse are measurable only by the pressure within the artist and the urgency of the need to free himself of it in the work of art.

This statement does not mean that all the artist has to start with is this vague though pressing need. He will be conscious of a great variety of emotions: enraged protest, a desire for escape, the love for his fellow man, religious fervor. Such emotional concepts fill him to such an extent that the need to express them in a work of art becomes imperative. But often subject matter serves as a vehicle, symbol, or occasion for introducing or concealing the real

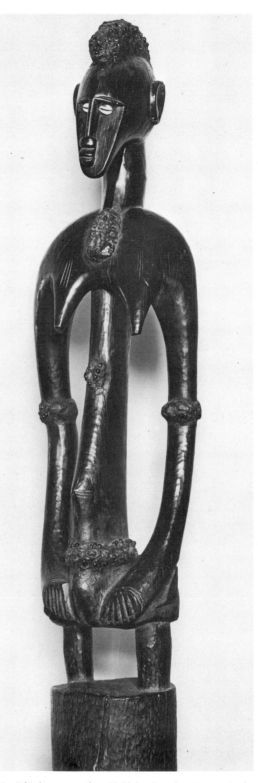

76. *Rhythm pounder* (deble), *Senufo, Rep. of the Ivory Coast. 22"*
SEE PAGE 171

content: his unconscious feelings. The artist selects among innumerable available subjects the one which he feels can best carry his message. Soutine, for instance, chose gladioli to express his persecution complex; Picasso chose a bull's head to express brutality.

Not every artist, of course, has emotions of equal depth or complexity. Only *vital* artists—those who seek to do more than copy, who are moved to express basic human emotions—will plunge deep into themselves for the material of their art.

The process has certain similarities to psychoanalysis. The analysand may start with a dream, but more significant are the free associations produced by pursuing the dream symbols. In the same manner, the "subject vehicle" is the artist's starting point, but the rhythm of creation introduces associations through which drives and impulses, hidden in his unconscious, slip into his works. We may say that the artist works with his fingers and the real content *slips* into his work *between* his fingers; just as in slips of the tongue or of the pen repressed truths slip into consciousness.

Much of art is *sublimation*. When the artist is unable to live out deeply rooted desires and drives, they are repressed. They can be permitted entry into consciousness in another, or sublimated, form, which may be the work of art. This sublimation will acquire a figurative, symbolic meaning. In the fantasy of his creation the artist frees himself, at least temporarily, from his conflict. Freudian investigation appears to show that most symbolic creations stem from repressed sex drives.

The African lived in fear; he was the prisoner of taboos; he had to repress desires that conflicted with the restrictions. He had all the characteristics of a neurotic. The mystery and power of the African artist's work come from the fact that during the rhythm of creation shaped by his animistic beliefs, he projected his unconscious into his work, thus freeing himself from his conflict.

We come now to the question, How can we recognize whether the work of art is a sublimation or a "straight" living-out of the artist's impulses, if such can actually occur?

It is only our own sensitivity that can tell us. From viewing the work of art we can get the excitement, the conflict, the feeling that during the creation something new was discovered by the artist and incorporated into his work.

Whether the point of departure was a sublimation or a direct statement, the sign of a genuine work of art is that it can stir us. It is not what the intent was, but what the result is. It is not important what we know about the artist or the particular work, but what the concrete evidence is that we can be witness to. But this evidence, the end result of all endeavors, will be authentic only if the creative person succeeded in extending into the work his true state of being, without any premeditation.

INTERPRETATION OF PLASTIC LANGUAGE

The French sculptor Maillol, asked by the writer to explain the intent of a certain piece of sculpture in his studio at Marly, replied that he was more interested in knowing how the interviewer "deciphered" the very difficult language which is sculpture. We know that this deciphering must be done intuitively, through emotional associations. We know also that sometimes the subject hides the real meaning of the work. We know that our own unconscious may provide clues to the real content of the work. We know also that we have to learn how to see, how to open ourselves up, how to make ourselves receptive to forms of the plastic language so that they will speak to us. Only if these conditions are fulfilled shall we have an emotional reaction.

EMOTIONAL CONTENT AND
OUR REACTION TO WORKS OF ART

When we described the peculiarities of the African concept, we pointed out its similarity to our inner psychological make-up. We can experience only those emotions which at bottom are our own. We have an inner reserve of

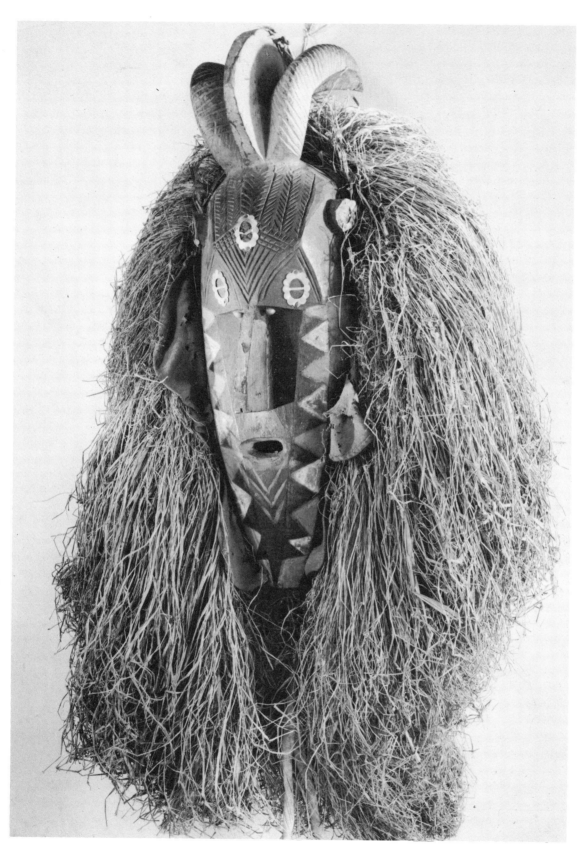

77. *Mask* (banda), *Simo society, Baga, Rep. of Guinea. 25"*
SEE PAGE 159

emotional experiences with which the work of art will react, permitting our participation, through their re-creation within ourselves, in the experiences which the work expresses. This participation is important in our artistic experience. In such manner we become ourselves the *creator* of the work, within ourselves.

We have produced a resonance or vibration in our inner selves with the content of the work of art. The participation, or resonance, is an *identification*. This identification is, however, possible only because the emotion expressed is one basic to all human beings (often on an unconscious level); and this feeling is not merely individual but universal.

African sculpture comes from an alien civilization; other art works were produced two or three thousand years ago, from very early cultures. Why can they move us and stir us emotionally? Because the content of the works is an experience based upon man being a human being and because the plastic language used is also universal, to be "read" or to be refelt by those who are able to see what is present. Those art works which reflect the uniquely personal do not have survival value.

FREE ASSOCIATION

The artist often expresses hidden, unconscious feelings, sometimes in a sublimated fashion, as in an uncontrollable, slip-of-the-finger manner. This is true not only for the artist in his creative activity, but for the observer in his re-creative activity.

The observer of a work of art, too, will receive initial stimuli, and through *free association* a chain reaction of emotional associations will take place. Past emotional experiences, sometimes on an unconscious level—images of the forgotten past—will erupt within his inner self. The emotions thus evoked will be projected into the work of art. This is "feeling oneself into" the work of art.

But when the phenomenological approach is adopted, a change occurs. The experience does not take place on ego-projection or on image-association levels, but an immediate and spontaneous reaction occurs on the preconscious level, on the threshold of consciousness. The awareness of this experience is rather vague, indefinable. The experience has to be arrested on this level before any conceptualization or personal identification can take place.

Man has the innate endowment to be in the presence of what reality *is*; he can sense it, but he cannot *know* it. It is "mystic" in the true sense of the word: it is a closed, noncommunicable experience.

EMOTIONAL CONCEPT OF AFRICAN SCULPTURE

As the majority of our reactions do occur on the psychological level, we may ask, What are the emotions that are expressed in African sculpture and resonate in us? Primarily, an expression of the compulsion to unload an intense feeling.

What we feel intensely may be fear or flight from reality, and not only fear and escape into the unreal, but fear of the unknown as well—of the panic and anxiety that can paralyze our faculties. Just as fear elsewhere has created the concept of the protecting God, it may well have created the African statues and masks as objectifications or concretizations of fear. Our own search for communion, a relaxation within a unified faith that relieves us of panic and the terror of the unknown and the responsibility of action, might have been the same as the search which produced African sculpture.

It may be that African sculpture awakens some primeval fantasies in us, not only those which we have experienced in infancy and childhood, but those to which we have already referred as *archetypes*, which are connected with our human beginnings, murmurs from an ancestral background, a longing to revert to the primitive and escape from the complexities of civilization, or a response to elemental rhythms felt in all of us. When we talk about what is universally human (rather than what is uniquely personal), when we indicate that there are patterns of thought and patterns of

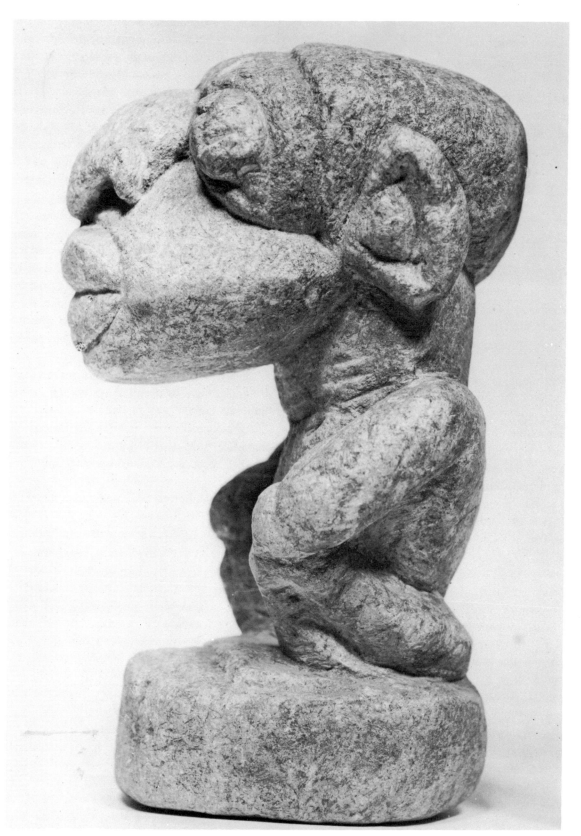

78. *Steatite figure* (nomori), *Mendi, Sierra Leone. 7"*
SEE PAGE 160

forms that we have inherited in our transpersonal unconscious, we refer to those preconscious, vague awarenesses, which might be touched by forms that are familiar to us although buried deep in our unconscious. But—and here we must repeat—these reactions can take place only if the forms have the forceful, suggestive power.

When we talk about primary, elemental drives and images, we talk about those which are at the ground of one's soul, and not about the complicated civilized or intellectual problems of a Michelangelo, Cézanne, or Picasso. It is true that all great artists tried to reduce the complex to a synthesis, but this is on a different level from those ancient impulses and preconscious emotions that still live in us, although repressed or dormant. As psychoanalysis has shown, we recognize their power only when we are unable to cope with them and they produce deep emotional disturbance (neurosis).

The deep significance of African art lies in its incorporation and expression of the emotional states of man at the stage of his awakening as individual. Through them we can rediscover and set in vibration, with an organic, emotional shock, our own dawning impulses as a human being.

It is not important to be conscious of what we feel; it is enough just to feel, to feel with intensity. If we do, we may experience an urge to express these feelings which, unless we can live them out, demand the creativity of an artist. Therefore our real interest in a work of art is often that we relive and somehow re-create or complete the work. This is not a process of imagination; it is a process of which we are not aware at all, except that it may result in a very subtle and sublime feeling of delight, as if we had accomplished a set purpose. Great contemplative artistic experiences have a tone that could be called religious.

We know that African sculpture was religious and its significance for the natives was that they had *faith* in it. Whether they be one or many, the common denominator in the worship of all gods and spirits everywhere is faith.

This is the universal constant. It is within us and it can be reached by a work of art. This explains why works of art, even though they are five thousand years old, still stir us. It is this that assures immortality to genuine works of art of all ages. It is thus that African sculpture becomes our own, as if we might have created it; we relive it on our own terms.

A valid question is whether or not we respond to the same emotion that the Africans expressed. If we keep the enjoyment of any work of art within the category of experience, this question becomes nonsensical, as Wittgenstein called it. Knowledge about a thing and experiencing the thing are two mutually exclusive categories. Hence, in principle knowing the intent of the African is very unimportant, since with the best, with the most simple, or with the most complex intent an artist can produce a work of no merit whatsoever.

Nevertheless, the cognitive and intuitive capacities of man do often interact, within the set limitations of the two categories. Knowing the African concepts may help us to localize or channel or somewhat define (as much as possible) our reactions. This can give us only a directional sign, into which we shall try to fit, *post factum,* after we have undergone the experience, our present bewildered emotional reaction. For example if we know that animism was the basic root of African art, and we know that we underwent animistic experiences, traces of which are very much alive in us, we can postulate the question, Is it possible that the vague undefined feeling we experience may be an animistic one or connected with our archetypal images? If the very question "hits," and we feel that if might be right, we can explore not knowledge, but our own experience guided by this hypothesis.

Experience has shown that individuals with approximately the same artistic and intellectual background, with a refined inner sensitivity accumulated through experience, have this in common: they have learned how to *see.* They have developed a "code" that organizes their educated reactions in a similar way. Spectators

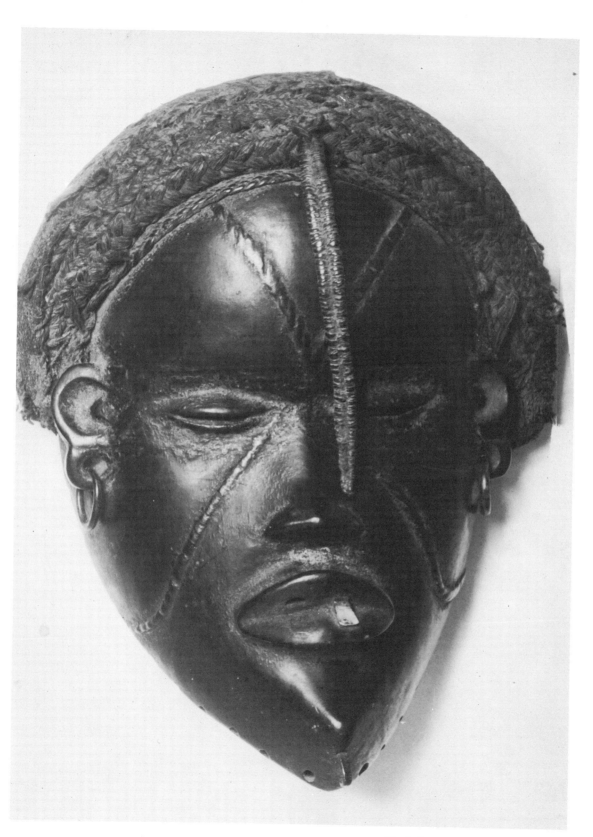

79. Mask, Poro society, Mano, Liberia. 8"
SEE PAGE 163

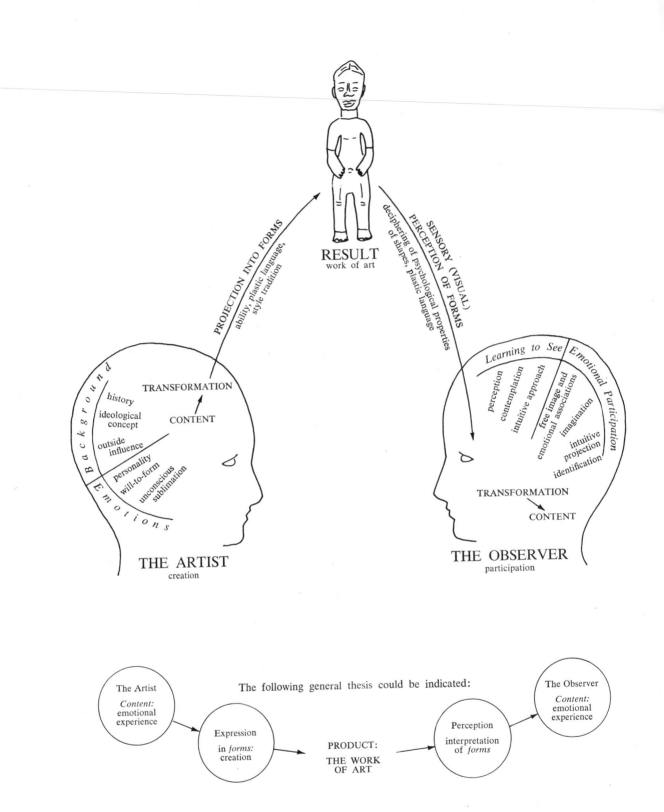

RESULT
work of art

PROJECTION INTO FORMS
ability, plastic language,
style tradition

SENSORY (VISUAL)
PERCEPTION OF FORMS
deciphering of psychological properties
of shapes, plastic language

Background

TRANSFORMATION

history

ideological
concept

CONTENT

outside
influence

personality
will-to-form

unconscious
sublimation

Emotions

THE ARTIST
creation

Learning to See *Emotional Participation*

perception
contemplation
intuitive approach

free image and
emotional associations

imagination

intuitive
projection

identification

TRANSFORMATION

CONTENT

THE OBSERVER
participation

The following general thesis could be indicated:

The Artist

Content:
emotional
experience

Expression
in *forms:*
creation

PRODUCT:
THE WORK
OF ART

Perception

interpretation
of *forms*

The Observer

Content:
emotional
experience

of this type will all find a Braque still life "subdued and poetically calm," a particular Picasso painting "emotionally explosive."

Because African sculpture speaks such a suggestive plastic language, the same standards of inner reaction will apply for those who have learned how to see. That means not only that they have the power of contemplation, observation, description, and classification of that which was observed, but that through conditioning (having seen art works for many years, having received points of view from art books) the minutely observed physical evidence of the work can be co-ordinated with the residue of this experience, plus, and this is important, with that special part in us that is the universally human. Because the channeling of the input often tends to be uniquely personal, differences in reaction, in principle, are as varied, as there are genetically different people. We only speak of the over-all orientation in which an agreement may be reached.

The most important fact remains that even where our reactions differ from others (and we must expect that they will differ), what we live through in contact with a work of art, what we experience, remains a subtle feeling, very much our own, beyond any verbalization. The fact that African sculpture at its best can provoke multiple and varied reactions, from the most primary to the most sophisticated, is proof of its richness.

AFRICAN AND WESTERN ART

African art at its best is aesthetically comparable to the products of the best periods in the history of art. Where African and Western art differ is in the level of their emotional content and in their form of expression.

The greatness of Negro art is that it ex-

presses basic human emotions—fear, faith, etc. —and may evoke in us the same emotions, though sometimes on a subconscious level.

Western art at its best may also go back to basic compulsions, but the emotional content will be more complex because the inner life of the Western artist is under more control. The artist is less able to "let himself go" and express himself intuitively; he must consult his intellect, must resort to artistic discipline to arrive at artistic creation. In an analogous but simpler process, the African artist submits to the dogmas of the African concept and to the forms of tribal style.

Although the content of the African work is more direct than the complex work of a Maillol, for instance, appreciation of the latter will be easier for the Western art lover. For the plastic language of a Maillol is more *conventional* than the daring, "strange," semiabstract African forms. We have to overcome a *resistance* against them; we have to forget the naturalistic-conventional-symbolic associations to which we have become accustomed and take the forms of African art at their intrinsic worth.

But it takes strict concentration to capture the meaning of purely plastic language and thus penetrate to the content of a work of art.

The forms of African art are not symbolic, or descriptive, or comparable to other forms. They are direct, intense statements of the emotions of their creators.

CHART OF CREATION AND PARTICIPATION

As we have seen, the emotional participation of the viewer in a work of art resembles, and is as complex as, the creative activity of the artist. To summarize this resemblance and simplify its understanding, the reader may find the chart on the opposite page helpful.

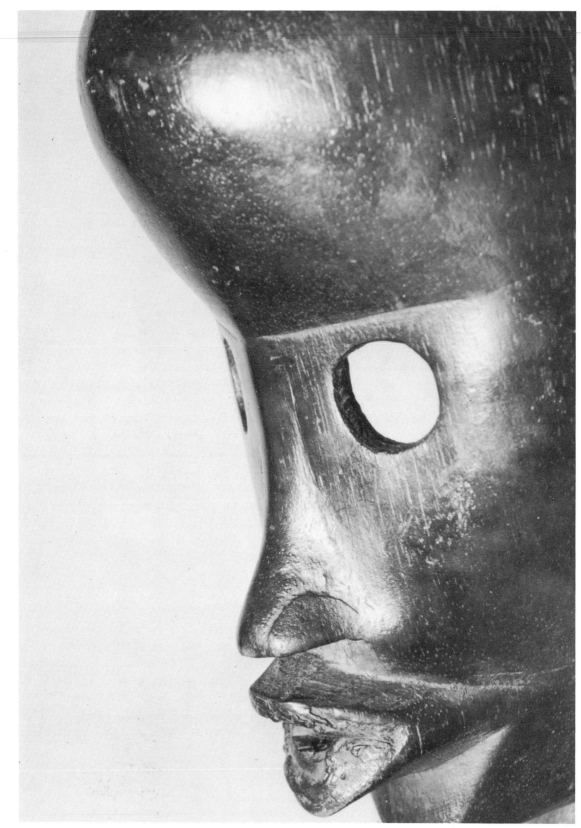

80. *Mask, Dan, Rep. of the Ivory Coast. 9"*
SEE PAGE 176

9. AFRICAN ART AND MODERN EUROPEAN ART

DURING the late nineteenth and early twentieth centuries, so-called "intellectual" circles in Europe, especially in Germany, developed a passion for exotic objects and started indiscriminate collecting of curios. Their interest was neither ethnographic nor aesthetic but romantic. They were chiefly motivated by flight from reality.

This pull toward the exotic was evident also in late nineteenth-century painting. It was part of the general aesthetic revolt against academicism. We are familiar with the influence of Japanese prints on the impressionists. Gauguin went to Tahiti, Pechstein to the Peleliu Islands; Barlach carved copies of African statues. Exotic objects were also used as subject matter by many German artists, but were treated academically, with little understanding of what they stood for.

Gauguin's and Pechstein's stays in the South Sea Islands enriched their palettes, but their work shows no inward grasp of primitive arts. A more direct influence appears in the work of James Ensor, the Belgian artist, who was inspired by Congolese masks. Also, certain masks with a distinctive polychrome design element exhibit characteristics similar to those found in the works of Paul Klee. Although when Klee lived in Munich he had several African masks of this type in his studio, it is by no means certain that these parallels indicate an African inspiration. In neither Ensor nor Klee was there any profound contact with the spiritual qualities of African art.

In the early years of this century primitive sculptures, especially from Africa, began to evoke responsive understanding in other Western artists.

Cézanne, who was probably unfamiliar with African art, once wrote to his son that what he wanted was to treat nature in terms of cylinders, spheres, and cones, in such a perspective that all sides of the objects would be oriented toward a central point. Cézanne's idea was to decompose the elements of nature into simple forms with which to create a pictorial architecture. A painting was to be a construction with simplified forms taken from nature, not a copy of nature.

This, actually, was the approach of the African artist. He made use only of the elements of nature (mostly the human body) and created a true *sculptural architecture*.

Cézanne's ideas, as realized in his canvases, were a great inspiration to modern artists. These ideas germinated and reached full

bloom in Cubism. A further development in-
spired the creation of abstract art.

When painters like Modigliani, Picasso,
Braque, Vlaminck, and the German *Brücke*
and *Blaue Reiter* groups began, about 1907, to
collect the works of primitive peoples, mainly
African objects, they felt an instinctual affinity
with those works.

The French Cubists and the German Expres-
sionists differed, however, in their approach.
The former were concerned with forms; they
recognized the architectonic character of Afri-
can art; they were chiefly interested in *how* the
expression took place. The Expressionists were
attracted toward the emotional content, the
what, mixing romantic-mystic notions of their
own into their interpretation.

If we look at Picasso's "Les Demoiselles
d'Avignon," we can say that the face of the
fourth figure is very similar, or rather has great
stylistic affinity with the mask in Fig. 81. The
anonymous African sculptors, modeling a face,
used perfect triangular shapes to indicate nose
and cheeks, and formed mouth and chin in
cubist planes.

This was at the opposite pole from natural-
ism. It was Cubism in spirit and rendition.

But before analyzing the daring artistic crea-
tions of the African and their relationship to
modern art, let us examine the reasons why Af-
rican sculpture was rediscovered as art at that
particular time, after having been ignored for
many years.

THE SPIRIT OF THE AGE

The beginning of the twentieth century was a
period of insurgence. Artists were open-minded
and disposed to accept new ideas. The École
de Paris united artists of different nationali-
ties: the Spaniards Picasso, Gris, Miró, Pica-
bia, Gargallo, Dali, etc.; the Russians Chagall,
Zadkine, Kandinsky, and the Lithuanians Sou-
tine and Lipchitz; the Pole Kisling; the Italians
Modigliani, Chirico, de Pisis, Severini, and
others; the Dutch Mondrian and Van Dongen;
the Romanian Brancusi; the German Ernst; the

Bulgarian Pascin; the Swiss Klee. All contrib-
uted to the most vital art movements of the
century. Some artists continued to use subject
matter as a vehicle to express emotional expe-
riences; some, starting with Cubism, estab-
lished the basic principles of the nonobjective
(or pure abstract art) in both the spontaneous
lyric and the hard-edge geometric directions;
others experimented with collage and as-
semblage methods, a small group with Surreal-
ism. In a few years, between 1905 and 1914,
most of the great tendencies of modern art
were invented and if we scrutinize many of the
present-day art movements, we find antece-
dents in those early years of modern art.

The French, traditionally conservative, ac-
cepted these artists because this was a period
of search, of renovation, of mixing and amalga-
mating new ideas and artistic styles. Paris was
also the place of many movements in the other
arts (literature, music, dance), again with a
great number of foreigners participating. Here
also was the easygoing way of life so favorable
for the freedom of individualism. Such was the
public's participation that more contemporary
art was bought in Paris than in any previous
period in the history of art.

The open-mindedness of the artists, influenc-
ing a small group of art lovers, and the search
for plastic constructions initiated by Cézanne
made possible the welcome of the anonymous
African artist into the family of the École de
Paris; his contribution was merged into the dy-
namic art forms of the creative evolution.

FORMALISTIC "INFLUENCE"

Little attention has been paid heretofore to
what actually happened in this contact between
modern artists and African art. Because certain
simplifications similar to those of African art
appeared in a few of Picasso's paintings, this
was described as "African influence."

It was the Grenoble Museum which first had
the daring and the imagination to show African
art side by side with modern art. The Museum
of Modern Art in New York exhibited Negro

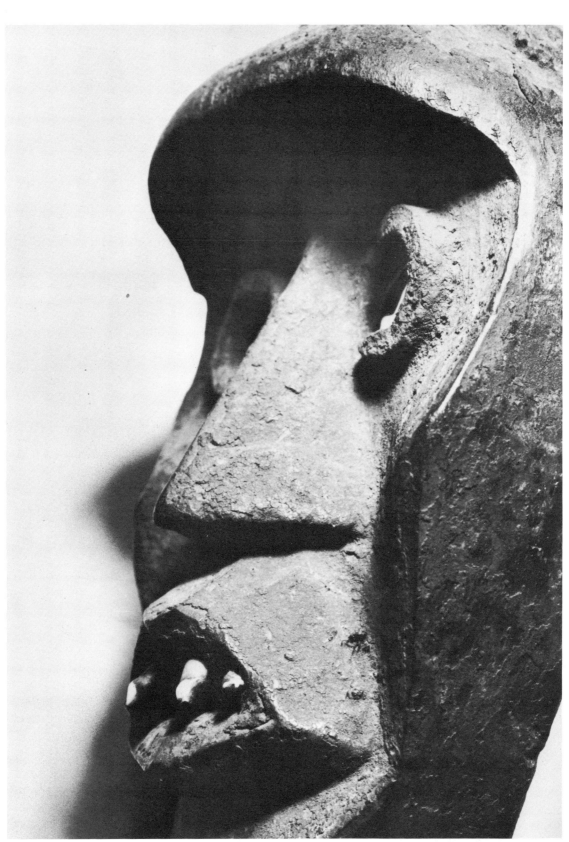

81. Mask, Dan-Guere, Rep. of the Ivory Coast. 8"
SEE PAGE 176

sculpture in their show "Cubism and Abstract Art" in 1936; and this was followed by the 1939 exhibition at the Institute of Contemporary Art in Boston, "The Sources of Modern Painting." In 1948 the Institute of Contemporary Arts in London organized a comparative exhibition entitled "40,000 Years of Modern Art."

If African sculpture is placed next to Cubistic paintings, an obvious formal affinity appears. But it would be misleading to imply that the very profound effect of African art was limited to such accidental similarity of forms.

If the plastic solution—the very concept that a work of art is a plastic structure—was the first and most prevailing aspect of the rediscovery of African art as truly great, nevertheless it was the *spirit,* the underlying ideology, not merely African but universal, which was truly captured by the modern Cubist artists. The fact that they collected African sculptures meant that these moderns lived with them sufficiently to absorb the sculptures' radiance, and not merely to "borrow" forms. They did not divide the form from the content, any more than the human body can be separated from the mind. It was an "influence," if one wishes to use the word; but an influence of the *content* which was first digested in its essence by the artists, and then re-created by them.

THE INNER CONTACT

The artists, naturally, considered African sculptures only as works of art and not as ethnological objects. They felt that, by its very presence, African sculpture had an existence in space, independent of conventional comparisons. The sculpture had validity not because it did look like, but because it did *not* look like, an object or model known to us. It was *itself,* a creation in a sculptural medium. This was the very essence of what the Cubist painters were aiming at. Picasso defined Cubism as an art dealing primarily with forms; when the form is realized, it is there *to live its own life.*

Both African and Cubist works exist through their own invented and co-ordinated forms, used for their own meaning and not to copy natural objects. The resulting interplay of forms (the sculpture) has its own inner life. By "invented" we mean that each form was something new, never seen before, something particular to the artist, his own. If the forms were new, never seen before, if their interplay was new, the results also became new. The work of art had a new existence.

There are different realities; one we can see, another we can feel, and still another is the inner life of an art creation. The fact that it carries a message of the artist makes this reality the more exciting. But without the suggestive power of the plastic co-ordination we could not perceive what the artist wanted to convey.

Unlike the signs in other languages, there is no general agreement on the meanings of signs in the language of art. Yet each has its strong, suggestive power for us to feel and grasp.

The discovery that each artistic object can have its own plastic and emotional reality helped the understanding of African art. It also helps to explain why we admire, why we can "feel," African art products. This discovery brought a new influence into modern art.

AFFINITY OF IDEAS

First: We have to recall here that the transformation of natural forms into abstract forms is a symptomatic action of man's basic unconscious compulsion—his self-assertion, his drive for power, his revolt against and control over natural forces. Since on basic human issues and compulsions there is no difference between primitive man and civilized man, the same psychological compulsion is behind the endeavors of the modern artists to abstract nature.

The will-to-form, the desire to express a personal experience, to search for individual truth, and to create imaginative, inventive works, motivated modern art to a much larger extent than African art. Because this age has been dominated by the cult of the individual, all art activ-

ity, with full cognizance of the role of the unconscious impulses, became a glorification of individuality.

The creative will-to-form has another dramatic significance today in the age of anxiety. The will to assert oneself, to invent new forms, is an unconscious reaction to the fear of life; it seeks to prove, to justify, one's own presence and existence in the world.

The aspect of *doubt of reality* should here be emphasized. If the African questioned reality, so did the modern artist. Their respective points of departure, however, were different. This was the time of Freud, who introduced a new concept for evaluating human behavior; of the Curies, who produced new values in terms of the elements; of Einstein, whose theory of relativity revolutionized our viewpoint of the universe; it was the time when prophecies of changes were confirmed by world wars and revolutions. All this was reflected in art. The artist's doubts were translated into Cubistic painting. A bottle (representing reality) was decomposed into parts which lost their identity with the bottle, and were used by the artist as new elements in paintings that became a new reality, the product of the artist's invention. Later, in this inventive creative process, forms were no longer borrowed from naturalistic reality but were purely the products of the artist's imagination. The result was independent, abstract works of art.

Second: Throughout history, artists of great personality and imagination have reacted against the prevailing schools. Giotto freed himself from the rigidity of Byzantine art; El Greco invented pure designs in revolt against Renaissance formalism; the Impressionists revolted against the classicism of David; the *Fauves* (literally "Wild Beasts") rebelled against the established patterns of Impressionism, "inventing" realities by the use of bold, unnaturalistic colors and brush strokes.

Our modern artists have carried this process further. In addition to the revolt against the accepted, conventional art styles, they have sought expression of the *inner self*—not only liberation from conventional art forms but from inhibitions as well. This search coincided with the recognition of the fact that African artists had already produced works in such complete freedom.

Third: Modern art, like African art, sought to "express" an idea or an emotion instead of "perfecting" the medium through which this expression takes place. The African has the same urgency of expression as the modern. In his case, too, the object, or the subject matter, is only a vehicle for the idea. Cézanne said that the subject is only a pretext for expressing a sensation or a vision.

Fourth: The African and the modern artist both aimed to express a conceptual image, instead of a visual image.

Fifth: Modern artists abandoned representational ideas or symbolic imagery for direct statement. The work of their art seeks to be *itself*, to move us directly, rather than merely to *look like* something. From this aim of avoiding conventional associations comes the invention of abstract forms.

The very concept that the work of art is nothing but itself, introduced about sixty years ago into the contemporary consciousness, had two important effects: (1) to foster the idea that the work being nothing but itself, any meaning-giving action is subjective; (2) to herald the present-day phenomenological approach, which also aims *"zum Sachen selbst"* ("to the things themselves"), as Husserl said it —to grasp intuitively the essential qualities of things (or artwork) without any presuppositions, analogies, associations, etc.

Picasso's idea that when a painting is achieved, it is there "to live its own life" is comparable to the African's belief that an inanimate object, through animism, had its own life.

RELATION BETWEEN THE ARTIST AND HIS WORK

Thus we can see that the creations of both the African and the modern artists were logical outcomes of viewpoints and volitions differing

from each other but reducible to common denominators. The criterion for the moderns was whether or not the work was a genuine expression of the artist's personality. This means *his state of being* in its mysterious complexity, not the fact that he has a specific message to communicate. He did not want to communicate, he wanted to give a document of his presence. In this sense the work became organically related to his inner self, just as African sculpture was a functional concretization of the African concept. A very new concept had come into contemporary thought: the work is not the *expression* of the artist's thought, but it is the *extension* of his being. It is from heart to hand, excluding the mind.

This very organic aspect of the work's relationship to its creator was also expressed by the African. A piece of sculpture for him was "good" not because of any aesthetic consideration but because it fulfilled the role for which it had been produced, because it was effective in a particular ritual. For the Western artist, a work was "good" if it came about by its own necessity, if it was the authentic and true extension of his state of being.

When the question concerns such indefinable matters as what one is, or what a spirit is, the obvious choice of the means for making such a statement is abstract forms, with their indefinable meaning.

This whole trend corresponds also with Cézanne's aim in his work: "the realization of the sensations." Thus the very aim of the African and the Western artist, independent of each other, met, and if we say that it was a coincidence, this should be extended by saying that without the "new" eye, or frame of reference, that Cézanne and early Cubist artists inaugurated, we could not have apprehended the plastic qualities of African sculpture.

Further research has shown* that the genetic idea of geometric forms stems from Cézanne. All the preliminary sketches that Picasso did

* See the author's essay "African Sculpture and Cubism" (1962).

for his "Les Demoiselles d'Avignon"—after he had done landscapes in Gosol in the summer of 1906 under the direct influence of Cézanne—bear witness to this fact. The fourth face in "Les Demoiselles" shows African characteristics, but the face of the fifth figure is a direct indication of a trend toward purer abstraction. We can say, then, that Cubism came about under the influence of Cézanne, but that the discovery of African art as art of high quality served as a confirmation, an encouragement for Picasso, and at the same time helped to make bolder the initial forms invented under Cézanne's influence.

Considering the unconscious to be the real source of inspiration, some modern artists practiced "automatic drawing" (drawing with closed eyes). Other artists, experimenting in direct, spontaneous expression, sought other ways to exclude intellectual control and create from "soul to hand" or "from unconscious to conscious action." (This method was carried on by the post-World War II "abstract expressionists," the group who have also been called "action painters.")

It is understood that only the intent is indicated by the expression "soul to hand." The African was disciplined by his tradition and his unconscious compulsions, yet in direct expression of primary emotions he had the advantage of living in them. They constituted his habitual level of feeling and acting. And he had the added advantage of *not* being self-conscious about being an artist.

The modern creative artist, on the other hand, is conscious of being an artist. He has to overcome this self-consciousness to produce a state of mind in which he will be free to "let himself go." He must use an intellectual effort not to be intellectual. To overcome this handicap, he has to produce such an intensity of emotion or conviction that the urgency to express it will "blind" him and force him to disregard (or rather overcome) imbedded, established tradition.

From the viewpoint of the public to whom the work of art is addressed, the African artist

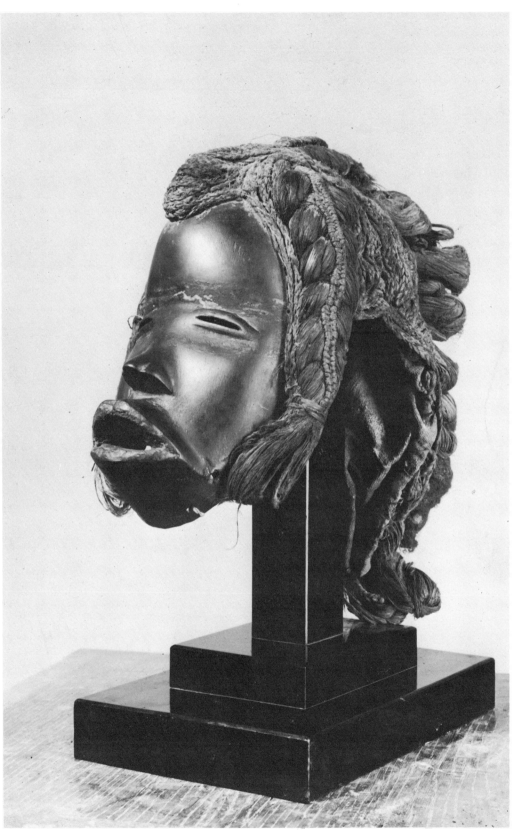

82. *Mask, Dan, Rep. of the Ivory Coast. 10″*
SEE PAGE 176

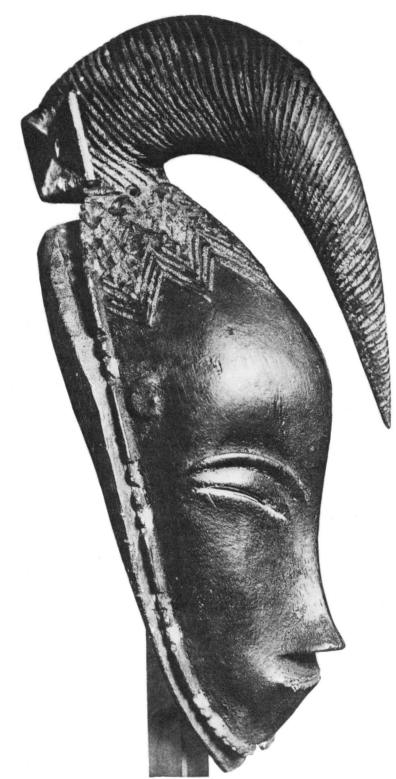

83. *Mask, Guro, Rep. of the Ivory Coast. 9"*
SEE PAGE 177

used traditional symbolic forms, simplified abstractions known to all the natives. Thus the meaning of his work was clear. His audience shared the same background and beliefs. The forms were not created for aesthetic quality, but for direct emotional communication. Because emotion was felt deeply and communicated directly, it proved aesthetically acceptable everywhere.

In contrast, the contemporary Western artist is too much of an individualist, being the product of his atomistic time, as the African was the product of a communal ideology. The Western artist's "abstract language" is his own, and often alien to his public. This is why the interpretation of a modern abstraction varies with each beholder. In Africa, artist and audience were in rapport. The outlook of the artist and that of his public was the same.

There is a difference, too, in the basic intent, the need to create, of the African and the modern Western artist. The latter seeks new forms and artistic values as a *revolt* against tradition, while the African artist is in accord with his tradition.

The need to change, the drama of "becoming," to quote Bergson, is felt in all modern art. But, at the same time, there is perceptible a struggle to be one with the product, to make it integrally, organically, an expression of the artist. In this, however, he has too often been handicapped by the emphasis on "individuality" and by the intellect that could not be excluded from his work, which often reflected theories and "isms."

With the greatest ease the African artist "arrived" at a realization which radiates serenity. He was able to reduce a multitude of complex feelings, fears, and dogmatic or stylistic limitations into a synthesis exhibiting calmness and fulfillment.

Unity and Fragmentation

When an idea or emotion projected under uniform social conditions has been so universally accepted and imbedded in the soul of a people for a long time, it can be realized aesthetically with an astonishing unity of form. A similar fulfillment was seen in Egyptian, Greek, and Romanesque art. The Cathedral of Chartres is a magnificent work, produced by several generations and by many thousands of individuals. Yet it shows a unified style and radiates a sober dignity.

If we knew nothing of the history of any of those people, if we were to excavate their works out of the earth, we would at once be struck by their tremendous unity and we would conclude that that particular period must have had an all-embracing unity of idea. If, after a thousand years, works of art of our period were to be unearthed, our descendants would be struck by their difference; their common denominator would be their *lack of unity*, or perhaps a different unity in each of them, according to the individual personality of each artist. Of course, if our observation extended to a very large number of works, we would be able to detect "schools" of different trends such as Cubism, Surrealism, and so forth as well as we can detect different tribal styles in Africa.

From the over-all point of view African art has a great unity, against which modern art shows a different type of over-all unity, namely that of fragmentation, reflecting the alienation of the individual from his own society. In many of the great periods of art history, including African art, the unifying factor was religion, which is missing in our period of time. And no compensating over-all spiritual idea has appeared. The whole twentieth century is characterized by doubt, requestioning old answers, re-examining every convention, and in this trend modern science, especially physics, leads the way. It is only now that philosophy attempts not to give an answer but rather a line of conduct, stating that the answer does not lie in any statement of truth or in any ready-made precept but rather in the *process of striving* for an answer. Life has no meaning; human existence is as meaningful as what we give to it— not what we get, but what we put into it.

The emergence of modern art was first the

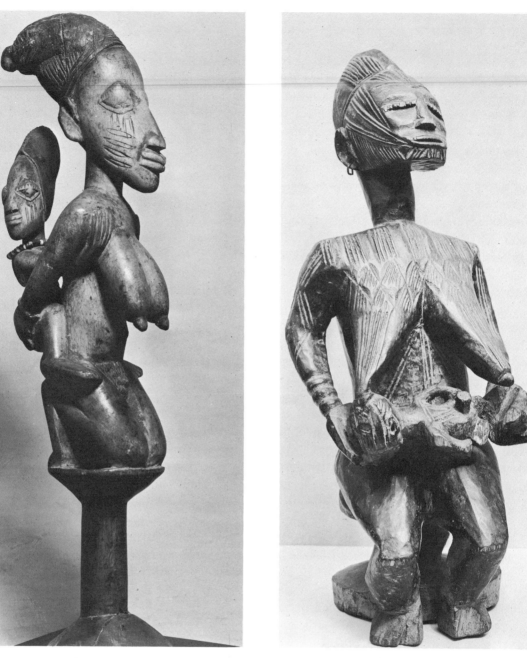

84. *Mother and child, Yoruba, Nigeria. 15"*
SEE PAGE 190

85. *Mother and child, Yoruba (also Afo), Nigeria.*
20"

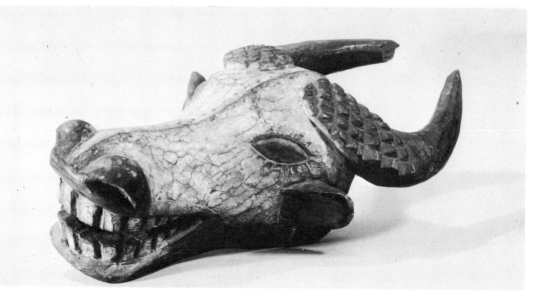

revolt against accepted values, in the name of re-evaluating them. By the very nature of this evolving process, however, no synthesis or unification of the problem was possible. For that matter—and this is the inspiring excitement of the present scene—the search still continues, within various art movements, each trying to liberate man more and more from conventional means of artistic expression, giving greater freedom for anyone who has the urge to express himself.

From the historical point of view, the whole new trend is about sixty years old (only two generations), which is a very short period in the history of mankind, especially when we consider that it began with a startling revolutionary innovation: the abandonment of visual reality and the substitution of various trends in pure abstraction. It takes time to resolve new trends; man has to transform his own posture toward reality and life in order for a new art, the product of this unification, to emerge. It took probably several thousands of years before African art, based upon a unifying ideology of religion, was able to produce resolutions, conclusions. For this reason we feel a harmonious balance of the parts in the over-all aspect of the work, in spite of the exciting interaction to be noted between the parts. Modern art, in the over-all, has one strong trend: away from visual reality—which is disappointing and frustrating, and the nature of which we do not know—back to what we feel, to what our reaction to the world is, and to express this in perhaps the only language that can carry this unspeakable level of being, since it does not need any definition. But the means of this over-all trend is diversified, showing search in various directions, experimentations, and heroic efforts to assert the individuality against the steamroller of conformism. Perhaps those over-man-sized canvases are the expression, in an overcompensatory manner, of this desperate need to assert oneself.

But if the only experience man is able to be aware of is the continuous striving, the process of becoming, and the search for the answer (and not the finding of it), if this is the only vital reality one can be conscious of, modern art has translated this search into a search for new means of expression. If the vitality of modern art is precisely in this excitement of searching, the passionate commitment to this endeavor to extend one's state of being into one's own work, each individual African carving (as shown on pages 97–99) manifests the same type of passionate engrossment, the excitement with which an individual has tried to find the means of expression that fits his unique personality, in spite of the conformism of the over-all discipline. Both the African and the modern have searched to leave something concretely real on this earth, to change existing forms (the "will to form") by inventing new ones through sheer inner necessity and often inescapable inner volition; hence the works of both become the unwritten documents of man's search for resolution. In this respect both the African and the modern are before all human beings, whose destiny is—if he wishes to fulfill his role in the evolutionary process, as Teilhard de Chardin stated it—to advance in the search, knowing that there is no answer. Perhaps in this lies the dignity and greatness of man.

5. Animal mask, Bamum, Cameroon. 10"
SEE PAGE 205

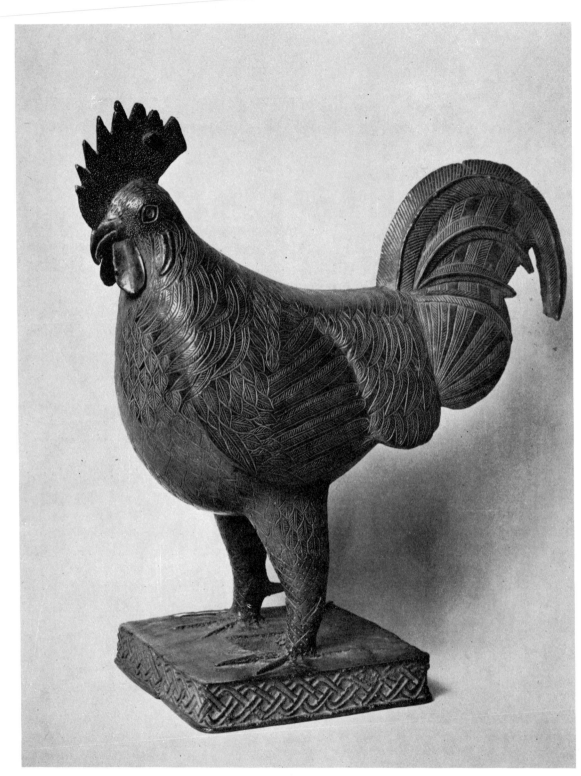

87. Bronze cock, Bini (Benin Kingdom), Nigeria. 8"
SEE PAGES 135, 189–190

10. THE COLLECTOR'S POINT OF VIEW

ETHNOLOGICAL museums or museums of natural history collect African objects to illustrate the life of particular ethnic groups. The art collector's viewpoint is aesthetic. Most collectors of African art are drawn to it by its similarity of feeling to modern art. Additions to their collections are sought in order to renew the emotional experience of the first acquisition. They seek in it aesthetic and emotional satisfactions.

The collector's interest grows as his knowledge of African art develops, and he is soon eager to form a comprehensive and representative collection. In a short time he becomes aware of the rarity of certain objects. He learns that Ife heads have become virtually unobtainable; that the Benin ivory tusk is more unusual than the Benin bell, a Warega ivory mask less common than a Warega ivory statue, a Pangwe head rarer than a Pangwe full figure; that there is a greater variety of Dan masks in other styles than in the cubist style from Liberia; and so on.

Those collectors who content themselves with a few pieces as shelf ornaments or other décor use them for their astonishing harmony with modern paintings, furniture, and interiors.

The largest collections are in the museums.

In Europe many of these collections have been assembled for the study of the use of African sculptures in the dance, religion, magic, medicine, and psychology. Of course, not all of these objects satisfy aesthetic standards; not all were used in religious rites or produced by carvers of talent.

AGE OF AFRICAN SCULPTURES

It is probable that, from the beginning of their occupation of West Africa, the Negroes there carved sculpture for their religious rites. Documents of the fifteenth and sixteenth centuries mention their idols.

In only a few instances can we set the date of African objects. The Ife terra-cotta and bronze heads and the Benin bronzes and ivory sculptures can be safely dated from the fifteenth century on. We can date the famous Bushongo king statues to the reign of Shamba Bolongongo (the ninety-third *Nyimi*, or sovereign of divine origin), around 1600, who instituted the custom of carving a wooden image of the ruler (Fig. 2). We know of seventeen such king statues, of which twelve can be dated and identi-

fied. The survival of the Ife and Benin objects is due to their material, which was not wood but bronze, pottery, and ivory. The wooden Bushongo king statues survived because they were preserved in the palace.

Other objects may be three to four hundred years old; but there is no data to guide us. The majority of African wood carvings are not older than 150 years. Moist heat and termites and other insects have destroyed the wood of which most were made.

Furthermore, objects were protected only as long as they were used. Having fulfilled a certain function, they were discarded or destroyed. A magic statue that failed to "give results" was destroyed. We have reports of statues burned on pyres; and the traditions of certain secret societies called for the destruction of masks after their use.

The destruction of what must have amounted to millions of sculptural objects is a great loss. Yet this very fact must have contributed to the dynamic quality of the work, to the continuity of a strong sculptural tradition, and to the honorable and socially integrated role of the sculptor, for whose work there was a constant demand, since the destroyed work was continually being replaced.

Although we cannot date the sculptures, we may safely make a distinction between objects produced *before* and *since* the European penetration of Africa. The *pre-European period* was the intensely religious period, when refined tools were missing, when outside influence had not yet corrupted the vision of the African.

Distinction must be made, however, between the period, lasting more than four hundred years, when the Europeans maintained trading-ing posts (mainly for the slave trade) without interfering in the internal life of the Africans and the period of colonization, which can be dated at the end of last century. (The Congo Free State was established in 1885; Benin City was destroyed by the English in 1897). The real decline of African art took place during this later period.

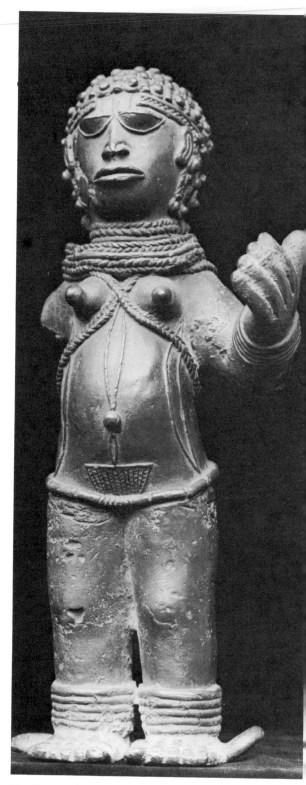

88. *Bronze figure, Bini (Benin Kingdom), Nigeria*
14"
SEE PAGES 135, 189–190

The *post-European period* is marked by the loosening of the deep belief in the power of the spirits. The missionaries warred upon the animistic cults. While the native concept still flourishes in many regions, new social conditions, including certain features of industrialism, are eroding the old way of life, and the African's religio-magical faith is losing its intensity.

European influence was strongest in the coastal regions, where art activity was very high. Consequently, the isolation necessary for the continuity of the African art tradition was impossible to maintain. Finally, appreciation of this type of art has become quite undiscriminating. Virtual sweatshops have been set up in Africa to produce wood sculptures for the tourist trade.

Some governmental agencies have established schools to encourage the native handicrafts, but they have concentrated on objects of decorative use. Because the former emotional content is lacking, these objects are lifeless. In Nigeria a well-known native sculptor was engaged to teach in one of the schools. It was not long after he became an "artist" that his work declined to the level of tourist-trade objects.

PRESENT-DAY PRODUCTION

Most present-day production can be classified as: (1) useful decorative objects for the tourist trade: bookends, ashtrays, bowls, animal figures, small statuettes, ivory letter openers, etc.; (2) copies of traditional masks and sculptures; (3) new creations.

The useful objects are generally of good execution, applied art forms without aesthetic pretense.

Between masks and statues in the traditional style a distinction must be made. There are regions where the secret societies maintain a strong foothold, as in the Liberian hinterland, and the masks used there are of great artistic merit. Elsewhere, particularly among the Northeast Yoruba, the Ibibio and Ijaw of Nigeria, the Baule and Guro of the Republic of the Ivory Coast, and the Dogon of Mali, very talented carvers continue the tradition, and their work is of excellent quality. Here it is the talent of the individual sculptor that counts, and the works are to be judged in that sense. But work done under European influence is extremely ugly—figures in European garb, painted with commercial colors, with hats, sticks, or guns in their hands, etc.

Concerning contemporary copies of objects of traditional designs, we have a firsthand account in *Negerkünstler* by Himmelheber, who interviewed some native sculptors in the Ivory Coast in 1933. Now, he said, they carve to make money. They seek to become famous because this will bring higher prices. They consider carving hard work (harder than agricultural labor) because it demands thinking. They feel no pleasure in the act of creation. They win their place by training rather than by talent. They copy old models over and over.

But the magician often still prescribes a fetish for a client, and the image is still intended for magic use; certain woods are still avoided because their spirits are evil; other woods are still preferred as enhancing the power of the statue; a cock may still be killed to consecrate an object.

The anthropologist Herskovits reported in 1938 that to obtain a sculpture in Dahomey required the following procedure: The collector had to propose an exchange to the owner, who then consulted the diviner. If the auspices were favorable, the wood carver was commissioned to make a copy. A sacrifice was offered at the shrine when the old image was removed and again when the new one was installed. The collector paid all the costs plus a gift to compensate the owner.

The old objects have been collected for the past century by different expeditions. Even at the beginning these perishable statues were few, and it is now extremely difficult to find genuine old pieces.

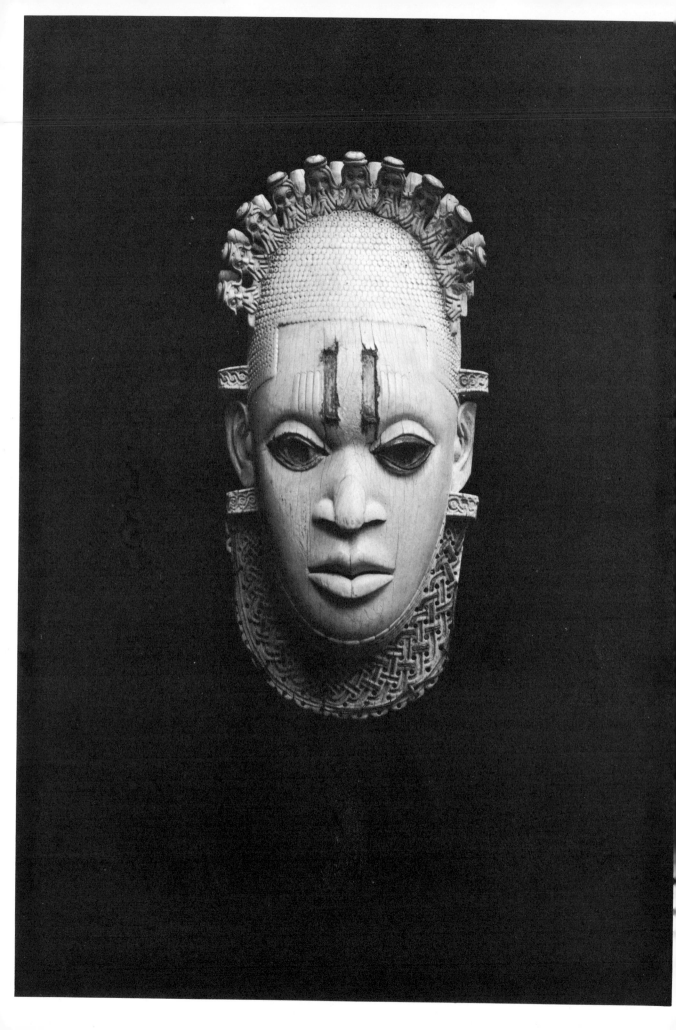

SO-CALLED "ANTIQUE" SCULPTURES*

The "antiquity" of a work of art generally connotes an object of great age, such as the works of ancient Egypt or Greece. If we use the word "antique," it must be understood in its original sense, namely to describe an object executed in a bygone style, a style that is no longer practiced.

The rarity of an object is a consideration that belongs in an entirely different category than its plastic merit. We can state that an object is rare by the extensive knowledge of what exists in the various public and private collections. We know, for instance, the number of Bushongo king statues, the number of Ife bronze or terra-cotta heads. The fact that they are rare and command high prices has nothing to do with their age or their aesthetic merit.

The age of a piece of African sculpture cannot be determined. If we consider its physical condition, we also have to consider under what conditions it was used. If, for instance, masks (like those of the Dogon) were left on the ground after use, subjected to termites and humidity, they acquired overnight an "old" appearance. In contrast, ancestor-cult objects (like the Baule statues) which were kept in huts and houses have a "newer" appearance, although, in fact, they are much older. Objects that were held in the hand will have a "used" appearance, but again this does not indicate the age. We have not yet developed a wood-dating technique (such as carbon 14) to measure objects fifty or a hundred years old. On the other hand, such a technique would be meaningless in terms of establishing the quality of art.

It is inaccurate to call authentic African carvings "fake" because they are of more re-

* The author has explored this question in detail in "The Artistic Quality of African Sculpture" published in *Tribus* in 1956, considering all possible evidence—background material (written documentation from the fifteenth century on), physical conditions—and concluding with a consideration of what constitutes artistic quality.

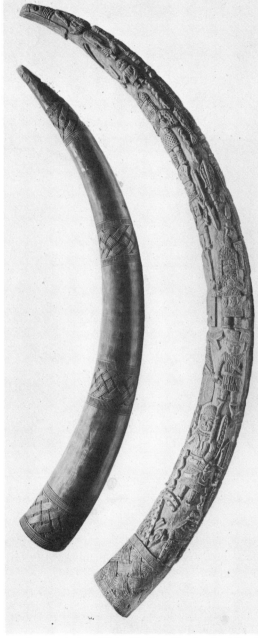

90. *Ivory tusks, Bini (Benin Kingdom), Nigeria*
Larger tusk, 48"
SEE PAGES 135, 189–190

Ivory pendant mask, Bini (Benin Kingdom),
Nigeria. 9½"
SEE PAGES 135, 189–190

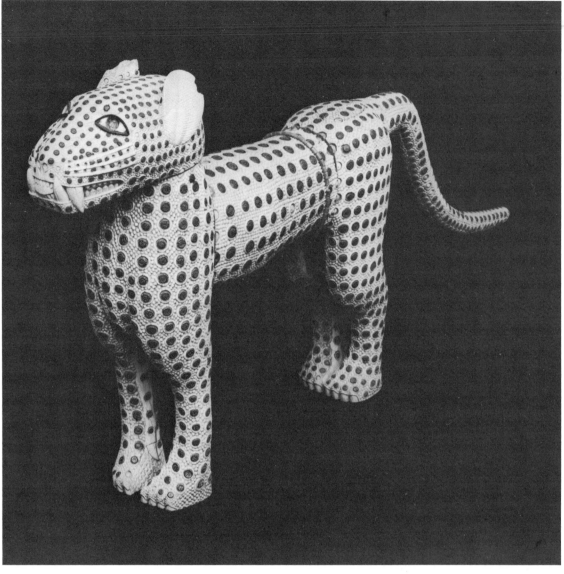

91. *Ivory leopard, Bini (Benin Kingdom), Nigeria. 33″ high*
SEE PAGES 135, 189–190

cent origin or because they are copies of old pieces. Not that there are no actual "fakes" of higher-quality objects, made expressly to give the impression of an old authentic object, but the majority in circulation are not fakes but simply bad work, done with little care or talent for the export trade.

The dates of exportation of some objects in various European museums have been ascertained. Some are over 150 years old, but they look like new because they were acquired shortly after the carver had finished and then kept in showcases.

There are surface conditions, such as patina, which of course indicate extensive use, very often giving to an object a high degree of light reflection. This, however, becomes of aesthetic value only if the work in itself is successful. A marble cover on a bad building does not make it a good architectural structure. It is the plastic structure of the carving which is the main consideration.

Even though the plastic quality is the only criterion by which a collector interested in art would look at an African statue, the phrase "a good old piece" is common usage. This should be understood in the light of the following: It is not the oldness of the piece that is the first consideration (this, in fact, cannot be determined), but the fact that the carver created this piece during the period before African carvers were subjected to outside influence. Such carvers had a better chance to be imbued with deeply felt religious ideas; they had more time and patience for producing works to their entire satisfaction than the later carvers who worked for sale. Our statement should be qualified further: As old as a piece may appear, ultimately it is the *talent* of the carver that gives artistic quality to an object and makes a piece desirable to an art lover.

How to Recognize a Genuine Old Carving

First, an antique carving can be recognized by its artistic unity, apart from purity of style. Artistic unity is a universal quality of good art. The artistic sensitivity of the collector will tell him immediately whether or not an object has it, by its power to stir him. That indicates whether the co-ordination of the inner emotional tension has been expressed forcefully. Mrs. Esther Warner commented on her impressions of a sculpture she saw in Africa: "I felt infected with its implications, as though the emotions of the carver were readily contagious. I had 'caught' them by looking and running my fingertips over his work." This quality is self-evident in a genuine piece, not only attesting to the authenticity of its African origin but also to the authenticity of the individual who carved it.

Provided that the over-all plastic structure is a successful one, the surface quality, or the condition of the wood or ivory, may play a role. Most frequently the wood is white and is stained in different colors, letting the grain of the wood be sensed. If the edges of the cutting or incision are worn off, this indicates greater

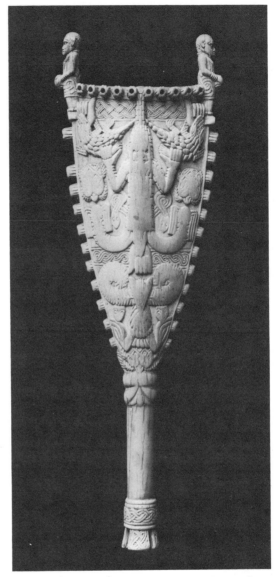

92. *Ivory double gong, Bini (Benin Kingdom), Nigeria. 14″*
SEE PAGES 135, 189–190

use of course, but from the aesthetic point of view it contributes to the smooth flow of the shapes. Often magical substance has been added to the object or red earth rubbed on it, adding to the surface quality of the object and enhancing its artistic merit. Often we look into the inside of a mask to see how much care the carver took in "finishing" his work; the thickness of a Dan mask, for instance, may be a fac-

tor, a thinner mask taking precedence. Actually these details have nothing to do with the plastic quality of a mask, which appears in our field of vision from the front and the side. Such examinations are merely technical, supporting our reaction to the whole. When the front view is satisfactory, for example, but the back lacks expression, this indicates a lack of wholeness of the work. In such a case it is obvious that the carver did not take enough pride in his work, since a strong three-dimensional quality is the very essence of a good African carving. When the front aspect is not satisfactory, in the great majority of cases the back or side view is just as unsatisfactory. A good piece of sculpture must be "alive" from all sides (meaning that the co-ordination of all shapes must be resolved); otherwise we do not have a satisfactory work.

RECOGNITION OF QUALITY

Ultimately, the criteria for a collector of African art, as works of art, are artistic ones. We have to look at African sculpture as at any artwork—and what was said previously in this book tries to show the various points of view from which such an appreciation can be developed. The question is, Is it of good quality or not? Is it a good *Gestalt* (configuration) or not? Although the ability to recognize a strict tribal style may help, and often such pure-style objects have their own artistic merit, this is not enough. An unusually talented carver may break the rules and produce a masterpiece. We have to repeat again: It is the talent of the individual carver that makes a work good or bad.

But it is the observer who must be able to recognize this fact. There is no yardstick or ready-made measuring rod which can be offered and applied to any artwork, including African sculpture. Rarity, value, tribal classification are all categories which have nothing to do with high quality. It is man ultimately who has to give meaning to what he apprehends or what he experiences.

Inasmuch as man is a unique person, his

reaction to any aspect of reality is in fact different (Merleau-Ponty said, "My red is not your red"). We cannot simply say that each person's reaction is widely different, however. If it is the *sensitivity* of the observer that is the recording instrument, this inner mechanism can be cultivated, disciplined, trained to a high degree. It is true that some people have more or less "talent" for visual perception (and this is very important). Nevertheless, a person who has experienced art for several decades, and African art especially, has retained thousands and thousands of images from the past experiences, not only in the field of African art, but in the field of art history. When an "input" (as in a computer) is received, in a split second all those "references" are evoked (they constitute the tape of the programming of the computer),

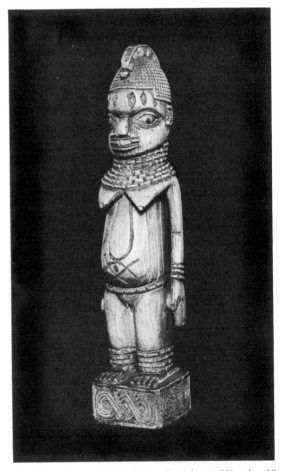

93. *Ivory figure, Bini (Benin Kingdom), Nigeria. 8"*
SEE PAGES 135, 189–190

producing an analysis and a synthesis at the same time. This applies not only to a process that compares examples of art but a process that compares the identities, the qualities, the depths of *personal experiences* undergone when facing good *Gestalt* works. The very content of the present experience is compared with past ones. The difference between individuals that we speak of here is in the stored information, the image references and the experience references (and we postulate the talented eye, not an attribute of any machine). Ultimately, the accumulation of data, of experience integrated with uniquely personal qualities, will result in the *refinement of "inner sensitivity."* We may also add that it is not necessary to be able to verbalize about such an experience; for this, another talent is needed, namely, introspection and the facility to integrate the experience with the appropriate words.

Although many years of experience have shown that this cultivated sensitivity is necessary to achieve the proper perspective on one's immediate experience, it is also true (although rarer) that there are people who have an innate talent to "smell" what is high quality and what is not, who are "right" without any background or training. On the other hand, there are people with a great deal of training who do not know "what they like" or what is of high quality. The ideal is when training and innate talent are combined.

BENIN SCULPTURE

Because of the richness of the material and the abundance of documentation on the works of the Benin Kingdom, attempts have been made to classify them in chronological order and also in the order of rarity.

From a collector's viewpoint, the best objects are of the *Great Period* (1500–75). The works of this period are complex in construction with elaborate chasing and a warm greenish, reddish, or dull black patina. In objects of the *Late* or *Declining Period* (1691–1819), the execution is rough, often without chasing or with the chasing rudimentary. These still have the traditional spirit, but the work has lost the strong yet sophisticated and refined execution of the Great Period.

In the order of rarity of Benin sculptures are: large figures of dwarfs in the round; bronze figures (Fig. 88); richly carved ivory panthers (Fig. 91); ivory tusks (Fig. 90); ivory masks (Fig. 89); ivory rattles (Fig. 92); also ivory figures (Fig. 93), goblets, and armlets; large bronze figures of flute players, dignitaries, etc., in the round; bronze animals (panthers, roosters) (Fig. 87); bronze portrait-like, life-size heads (Figs. 94 and 95); more conventionalized bronze heads larger than life, adorned with necklaces of broad, cylindrical pearls (Fig. 96); large elephant-tusk holders ornamented with numerous figures; branched, so-called "fetish trees"; plaques with bas-reliefs of groups of natives (Fig. 97), warriors, hunters, dignitaries (Fig. 100), etc.; plaques with a single figure of a warrior, dignitary, musician, European, messenger, etc.; ritual plaques; plaques with animals and animal heads (fishes, birds, snakes, crocodiles, panthers) (Fig. 67), and other large pieces. Smaller objects include figurines, often in groups; small animals, ceremonial maces; pendants with figures; small masks worn as buckles or other dress accessories; bracelets and armlets (Fig. 98); bells (Fig. 99), vases; wooden heads; boxes; carved coconut shells; etc. (See also pages 189–190.)

THE MONETARY VALUE OF AFRICAN SCULPTURES

In spite of the high artistic quality of African objects and their place as products of a virtually ended creative period, their market value is not high as compared, for example, to Egyptian sculpture. Thus far, only a minority of connoisseurs are aware of the intrinsic expressive power of African art.

Often it is believed that auction prices are indicative of the value of a particular object. We know, however, that prices depend upon which

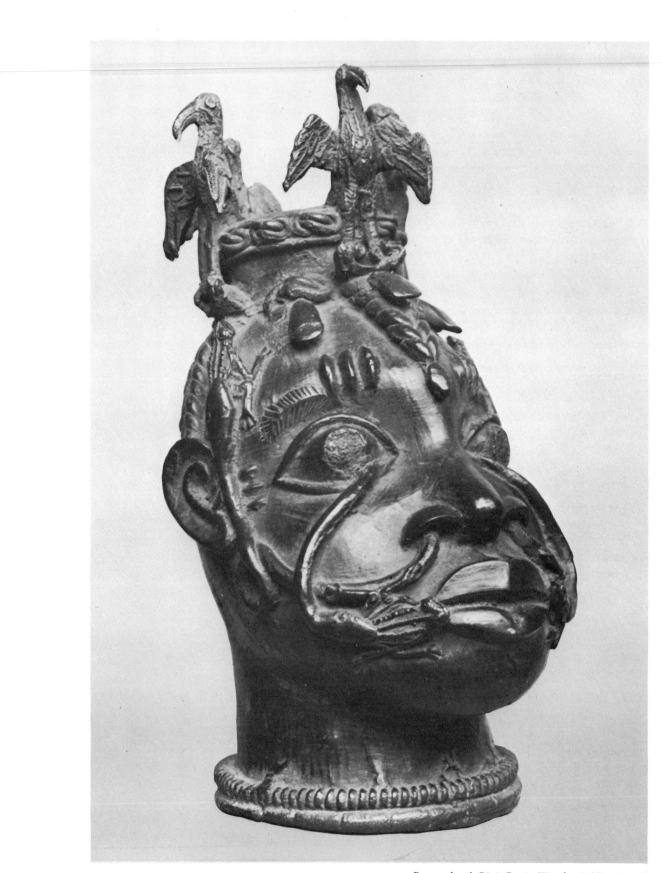

94. Bronze head, Bini (Benin Kingdom), Nigeria. 11″
SEE PAGES 135, 189–190

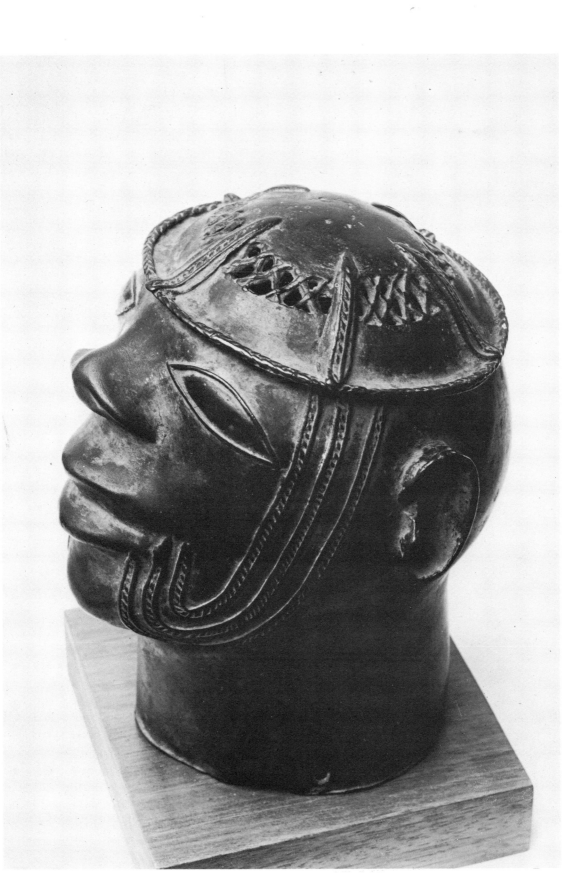

95. *Bronze head, Bini (Benin Kingdom), Nigeria. 6½″*
SEE PAGES 135, 189–190

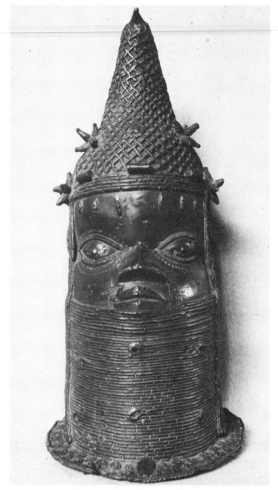

96. *Bronze head, Bini (Benin Kingdom), Nigeria*
14"
SEE PAGES 135, 189–190

is a true experience, no value can be set on it.

There is often a conflict between emotion and intellect when it comes to making a purchase. We have maintained several times in this book that the only true approach to any work of art is the intuitive one, which is a noncognitive channel of apprehending reality in its true nature. To co-ordinate this apprehension with your state of being is a different matter, and to separate it from knowledge is again another matter. It is one thing to appreciate the inherent artistic qualities of a work of art, another to decide to live with it, the assumption that you want to possess it because you have established an intimate fusion and communion with it. Having information about the object may be of intellectual interest, may serve a classificatory purpose, but this belongs in a different category from experiencing its presence.

Suppose that your intuition about art is an instrument consisting of ten bells. Certain artwork (as high as its artistic quality may be) may not ring any bell at all for you, some may ring two or five bells. In my own case, if eight or ten bells ring in unison, an object becomes irresistible *for me*, according to what my state of being is. This intuitive process, being noncognitive, must be kept separate from any interference of the intellect (which includes value judgment), because not only can such an interference influence and falsify the very delicate working of this mechanism, but it can introduce doubts and actually stop its workings.

If your choice has to be made between two or more works and the ringing of the bells has become confused on account of the interference of value judgment, a practical test is to ask yourself, "Which one would I take if I could get any one of them for nothing?"

The value of African sculpture has increased considerably through the years. More people have discovered for themselves the delight of having "great souls" in their homes and maintaining a dialogue with them through the idiom of plastic language. Hence, the demand is greater, more high-quality pieces are absorbed

auction house makes the sale, the amount of publicity, whether two or more people are present wanting the same object and having the means to bid on it, and often whether it's raining on the day of the auction. Auction prices, therefore, are no indication of the prevailing worth of art objects.

There is, however, a base for prices, the result of many years of observation as to the prices quoted by various European dealers. Ultimately it is a very personal matter. If you like something very much, if it gives you such a vital experience that you would like to renew it in your home, and if you can afford it without any great sacrifice to your daily life, buy it. If it

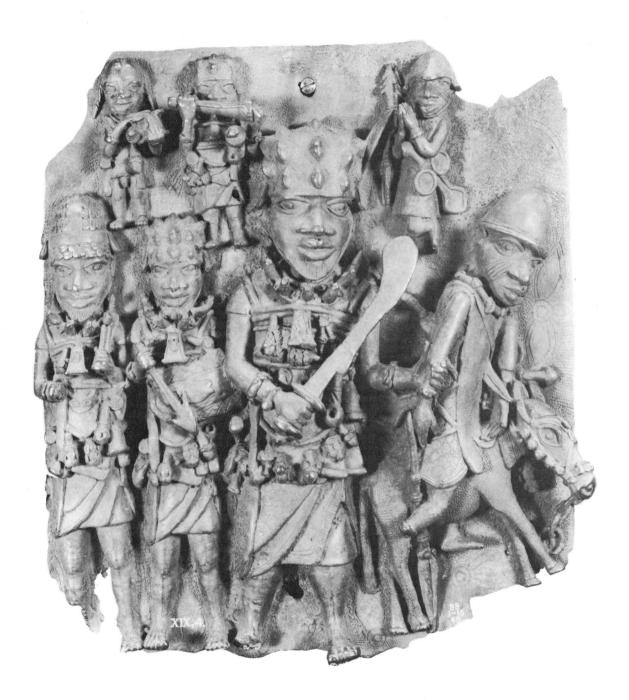

97. *Bronze plaque (warriors), Bini (Benin Kingdom), Nigeria. 17"*
SEE PAGES 135, 189–190

in collections, and less are available. But a distinction must be made between what is said to be of high quality and what offers a lasting emotional experience on a very personal level. The purchase of a Benin bronze because it is a rarity and commands high prices while evoking no emotion is usually motivated by a desire for prestige, or perhaps by an appreciation of its high technical accomplishment, an appreciation entirely outside of the realm of emotional experience. Collecting in general, especially of high-priced art works or those which represent the latest trend on the contemporary scene, is frequently motivated by such considerations as investments, status, and publicity.

HOW TO RECOGNIZE THE STYLE OF AN OBJECT

After having seen a large number of sculptures, the collector will recognize certain stylistic marks (described in Part IV). The beginner will find books on African art helpful when he compares the object with illustrations

and identifications given in their pages. Similar comparative study can be made with objects in museums and private collections. The sculptured forms differ according to the style regions. For example, the Pangwe favored round, refined, smooth shapes; the Bayaka's taste was more rugged. Recognizing tribal style characteristics is a question of keen observation and good memory. It is like keeping up a well-organized file cabinet. Collecting and remembering such information does not, however, guarantee the capacity to "refeel" what the sculptor has said or to sense the sublime differences that distinguish an authentic work from one that is merely repetitive when both belong to a pure style tradition.

Here it should be noted that although we can characterize what the style of a certain tribe is, the concept of pure style cannot be defined. We can talk about the degree to which a work fits into what we consider to be a pure tribal style, but most African sculpture is mixed in style, or approximates a pure style. In some cases the

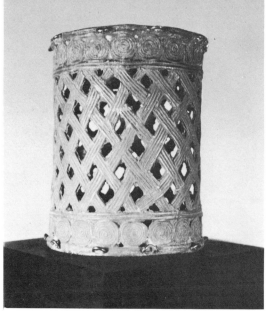

98. *Bronze armlet, Bini (Benin Kingdom), Nigeria*
SEE PAGES 135, 189–190 *5"*

99. *Bronze bell, Bini (Benin Kingdom), Nigeria. 5"*
SEE PAGES 135, 189–190

mixture is the result of migration of a tribe into a new style region or the result of influence by a neighbor tribe with a strongly marked style. Thus the statues of some Batshioko tribes that settled in Bakuba country show the intense Batshioko facial expression and headdress, while the body is in the Bakuba style. We have mentioned several times that a very talented carver was able to produce strong individual work within the tribal style discipline. But when a carver abandoned his tribal style tradition and introduced individual innovations, a "hybrid" style resulted in very bad artwork, utterly without "character."

In estimating the collector-value of an African sculpture, purity of style will carry greater weight with those who look for classical work, boldness of style with those who look for carvings close to modern art.

Color and Patina

The French speak of the "inimitable" surface of a good African carving. This is achieved in different ways. Most carvers avoided seasoned wood, the green wood being easier to carve. To prevent the statue from splitting on drying, the sculpture in some regions was smeared with sesame oil, palm oil, or butter. In Mali, especially among the Bambara, the statue was often finished with a hot iron to give it a slightly carbonized surface, which later was colored and acquired a patina through use.

The color was always vegetable or earth color, often mixed with magical substance or sacrificial blood. Sometimes latex or gum was added to this mixture. As in the carving, the application of the color to the sculpture was accompanied by ceremonies to insure its magical efficiency.

Subsequently, the statue was exposed to dust, earth, and the smoke of the hut in which it was stored. These overlaid the original color and produced an inimitable patina that has the uneven warm tone of bronze.

Some masks and fetishes have a glossy surface because a wax substance was added to the color which, when rubbed, polished to a lacquer-like finish. Vandenhoute mentions the "mud bath" technique used by the Dan tribe, which consisted of burying the mask in a mud substance that contained color. When sculptures were not colored, the wood, especially when hard, sometimes acquired a high polish and a warm brownish tint through use. Some Pangwe figures treated with a certain dressing appear oily, and "sweat" under certain climatic conditions. Ivory fetishes or masks acquired a brownish-red patina from contact with the body. The carving and incisions are worn away, leaving a very smooth surface.

Polychrome objects carry layers of vegetable and earth colors, having been repainted each time they were used. The cracked paint has left an uneven surface. On recent objects with only one layer the color is uniform, and often of imported ready-made oil paints. Despite the evenness of the surface, the effects are usually inartistic.

Preservation of Objects

Many objects are split. If the crack is small, it can be left as it is. If it is large, it may be advisable to plug it with a wood inset cut to fit exactly.

Termites, wood worms, or beetles may still be in the wood. They can be traced by the white wood dust that appears from time to time around the little holes that mark their burrows. Drops of carbon bisulphide in each hole will dispose of them. If not checked, the insects will destroy the sculpture.

The ritual use of the sculpture led to an accumulation of substances which often contribute to the surface texture and appearance but sometimes mar it. This is especially true when sacrificial blood has been poured over the object. When mixed with earth, this blood coats the sculpture with a heavy layer. In such cases, we face the object as a restorer faces a discolored oil painting or a damaged faience. Ex-

treme discrimination should be used to decide how much of the earth-and-dust layer should be removed. Complete removal would give a "new" look that would spoil the effect. Judicious cleaning will restore the original beauty of the piece with no injury to the patina of age and use. This viewpoint guided the cleaning of Benin objects found on the Juju altars in Benin City, which had become unrecognizable under layers of coagulated sacrificial blood and earth.

No wax, varnish, or polishing material should be used, for this would destroy the patina. Metal-plated or bronze objects particularly should not be washed or polished, for their patinas (green, black, red, etc.) are a part of the quality of the objects.

It is advisable to mount objects on stands. This makes for more effective display and for greater safety. Masks are often mounted on walls, but mounting them on stands is preferable. By presenting them as statues we come a little closer to their use as part of a costume. Another advantage is that they can then be turned around or viewed from different angles, allowing the many facets and the three-dimensional quality and richness of forms to emerge. Similarly, Benin plates should be nailed directly on the wall, as was done originally in Benin City.

Exhibitions of African Art

Private ethnological collections of African sculpture began in Germany. The first collec-

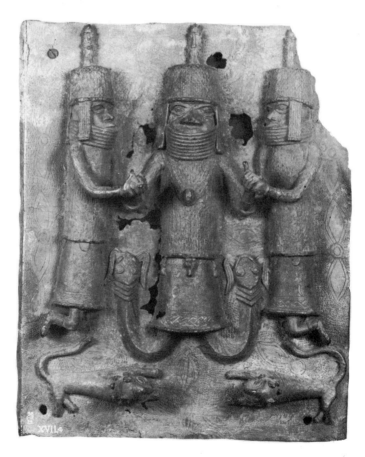

100. *Bronze plaque (middle figure: the* Oba *of Benin), Bini (Benin Kingdom), Nigeria. 18"*
SEE PAGES 135, 189–190

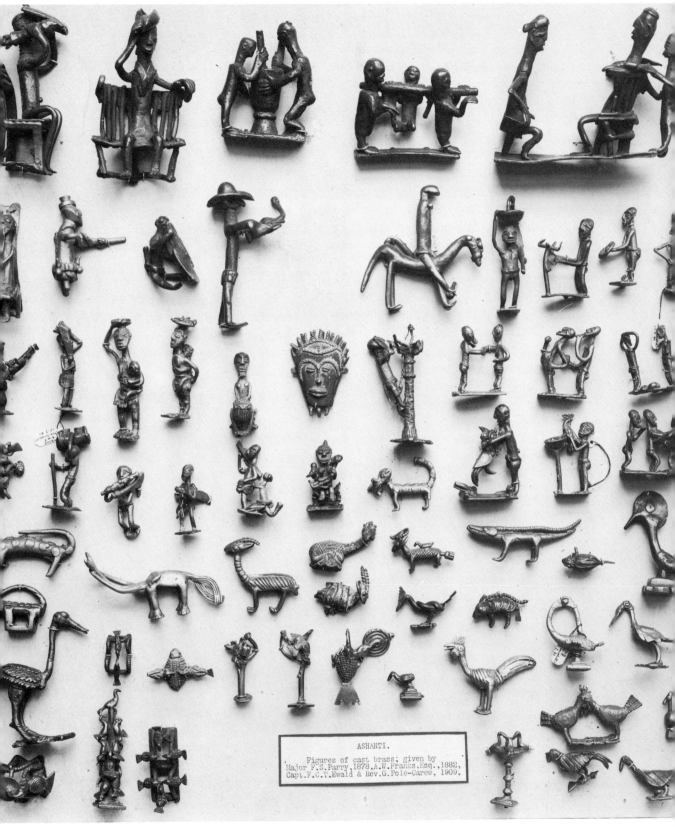

ASHANTI.

Figures of cast brass; given by
Major F.S.Parry,1878,A.W.Franks,Esq.,1882,
Capt.F.C.T.Ewald & Rev.G.Pole-Carew,1909.

101. *Brass gold weights* (mrammuo), *Ashanti, Ghana. 1" to 3"*
SEE PAGE 182

tions as art began in France about forty years ago. This was followed by others in Belgium, England, Holland, and again in Germany.

In the United States, the first exhibition of African art was held in 1914 in Alfred Stieglitz' gallery "291"; in 1916 Marius de Zayas organized a show in the Modern Gallery and published what was probably the first book in America on African art. In 1922 the Brummer Gallery and in 1927 the J. B. Neumann Gallery held special exhibitions on African art.

Many art museums, which are supposed to include the art of *all* ages and cultures, are without African collections. Chaldean, Hittite, Luristan, or Egyptian sculptures are represented, but no Benin or Bakuba examples are shown. This is true also of products of such high cultures as the Maya, Zapotec, or Nahua periods of Mexico and Central America. These, along with African sculpture, suffer from the antiquated notion that their chief interest is ethnological.

This anachronism is disappearing as special exhibits of African sculptures in art museums become more common.* Some art museums, however, continue to ignore African art. Because today no new production in Africa compares in quality with antique works, the available objects are limited to those assembled in the last forty to fifty years in private collections in Europe and the United States. The first large private collection in the United States was formed by the late Dr. Albert Barnes in Merion, Pennsylvania. Dr. Barnes found "African sculptures . . . equal in artistic value to the great Greek, Egyptian, or Chinese sculptures, and as difficult to obtain."

The last twenty years have witnessed an upsurge of interest in African art. Not only museums and educational institutions, but increasing numbers of private collectors as well, have formed collections. They have opened new vistas of art experience with an unlimited range of emotional responses.

* In May, 1969, when this book was about to go to the printer, the Metropolitan Museum of Art opened an exhibit entitled "The Art of Oceania, Africa, and the Americas" consisting of about 2,000 objects chosen from the collection of the Museum of Primitive Art in New York.

STYLE REGIONS

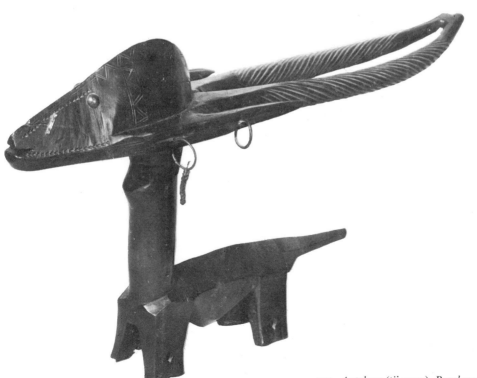

102. *Antelope* (tji wara), *Bambara, Mali. 8"*
SEE PAGES 148, 150

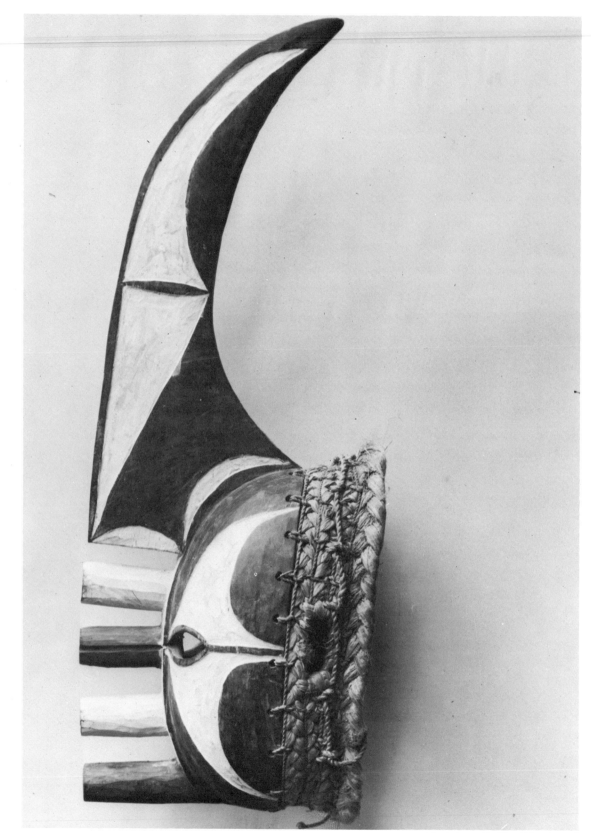

103. *Mask* (mmaji), *Ibo, Nigeria. 19"*
SEE PAGE 199

ASSEMBLING a reference handbook of West African style regions is a challenging and difficult task. Not only are there many hundreds of tribes but each tribe has an amazing variety of styles, as we shall demonstrate in the forthcoming text.

Our concern is with objects which were made in the past to be used in tribal rituals, or which continue traditional styles. We have adopted the past tense when discussing the use of African artwork because the majority of the magico-religious ceremonies are no longer practiced, although there are some regions in which the old rituals, using presently made carvings, are still performed.

The ideal would be to use illustrations for each stylistic difference (and this we have done in a limited way), pointing out the special characteristics of each tribal style and indicating also the varied uses of the objects illustrated. A more complete nomenclature would probably require over a thousand illustrations. At the present we can only attempt to list the best-known prototypes—not aiming to include the rare and unusual—and for this purpose we have increased in this fourth printing the number of illustrations to over four hundred.

Territories

Although the arts of East and South Africa are related to those of West Africa, we have limited our scope to the latter because of its dominant Negro population, its relative unity, and the abundance of its art activities. (We have included, however, at the end of Part IV a brief summary of the artwork of eastern and southern Africa.)

Proceeding from north to south on the West Coast of Africa, we find the territories listed below. The left-hand column gives the pre-1959/60 name, the right-hand column the name since independence.

French Sudan	Republic of Mali
Portuguese Guinea	
French Guinea	Republic of Guinea
Sierra Leone	
Liberia	
Ivory Coast	Republic of the Ivory Coast
	Republic of the Upper Volta
Gold Coast	Republic of Ghana
Togo	Republic of Togo
Dahomey	Republic of Dahomey
Nigeria	Federal Republic of Nigeria
Cameroons	Republic of Cameroon
French Equatorial Africa	Republic of Chad
	Gabon Republic
	Republic of Congo
	Central African Republic
Belgian Congo	Democratic Republic of Congo
Angola	

(To repeat an earlier note, the simplified term "Congo" will designate the Democratic Republic of Congo, not the Republic of Congo. The full names "Republic of the Ivory Coast" and "Republic of Guinea" will be used to distinguish them from the old Ivory Coast and Guinea, which were larger areas.)

It should be noted that boundaries were established by the European conquerors in complete disregard of tribal frontiers. To this handicap in identifying a style region is added the fact that some tribes are found in several geographical areas. Before the European conquests, the tribes were in continual movement. Overpopulation or the search for water and salt produced continual migrations. Each tribe carried its own stylistic tradition into the new location, where it influenced and was influenced by local traditions. Only in the case of a mass migration, or when the tribe occupied a new, uninhabited territory, did it conserve its own tradition intact.

Thus we find the Dan tribe both in the Republic of the Ivory Coast and in Liberia; the Senufo both in the Republic of the Ivory Coast and in Mali; the Yoruba in Nigeria, Dahomey, Togo, and Ghana; the Pangwe in Gabon and in Cameroon; the Ashanti in Ghana and Dahomey, etc.*

REPUBLIC OF MALI (FRENCH SUDAN)

BAMBARA

The Bambara, of western Mali, numbering about a million, excelled in three types of sculpture: stylized antelope headdresses, statues, and masks. The basic characteristic of all their carvings is the use of bold volumes, often in angular interplay, with semiabstract over-all composition.

ANTELOPE HEADDRESSES are called *tji wara,* the word *tji* meaning "work" and *wara* meaning "animal," thus "working animal." When they were worn by the members of the Flanton society at agricultural festivities before the

* English, French, and German spellings of tribal names differ, each transliteration attempting to give a phonetic sound similar to the original language. In the last few years new spellings of tribal names have been adopted, for instance Tshokwe for Batshioko, Yaka for Bayaka, and Fang for Pangwe. The fact is, however, that the majority of basic documentations do use the traditionally adopted spellings and, to avoid confusion, we continue the use of traditional English spellings, indicating occasionally the newly adopted names, especially under Democratic Republic of Congo.

rainy season and when the fields were cleared, they did "work" in the mind of the Bambara, since they were supposed to increase the fertility of the earth. There are male and female antelopes which were attached to basketwork headgear, in turn attached to the heads of dancers. The dancers appeared in pairs (a man and a woman—an association with fertility) holding two sticks in their hands, their leaps imitating the jumps of the antelopes.

Among the large variety of *tji wara* the following distinctions can be made within the two main groups: vertical and horizontal direction of the horns.

In the *vertical* group: (1) Fig. 41 represents the most usual antelope. The body is very small, a rectangular open-box type, with large head, long horns, and an elaborate openwork mane, which indicates a male antelope (some also have a large genital under the upper part of the box). (2) Fig. 109 shows the same type, only here the legs are more marked, and there is a small antelope on the top of the large one, indicating that the figure is female. To be noted are metal rings on the neck and the horn of this antelope. (3) Fig. 104 is a rather compact composition that comes from the Bougouni district. As a base there is a four-legged animal, often a chameleon, which supports the antelope. The only antelope features are the horns and ears, the body and head constituted as a round shape with a zigzag pattern below it. The three prongs are added only for artistic reasons. (4) Fig. 106 is a subgroup of the same style, characterized by having one or two figures standing or sitting on the antelope itself. (5) Fig. 105 is a very simple carving. Nevertheless the legs and body and neck can be recognized, along with a strong head having two horns and two ears. Two pieces within one group can be quite different; the best example is Fig. 107, in which the general elements as outlined in Fig. 105 are present but with a different design. Also within this group are antelopes that consist only of openwork mane, head, and horns without a body, sometimes only neck, head, and horns.

In the *horizontal* group: (1) Fig. 102 has a simple body, although each facet of the planes composing the body is flat and angular. Upon the long neck rests a strongly carved head and

BAMBARA ANTELOPES (TJI WARA), Mali

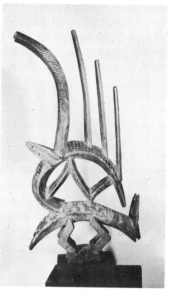

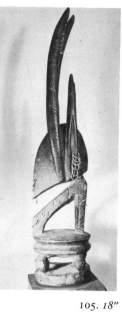

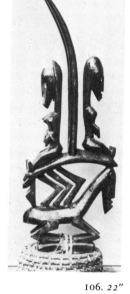

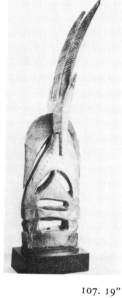

104. *Bougouni district. 18½"* 105. *18"* 106. *22"* 107. *19"*

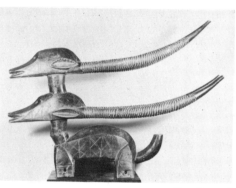

108. *14" x 24"*

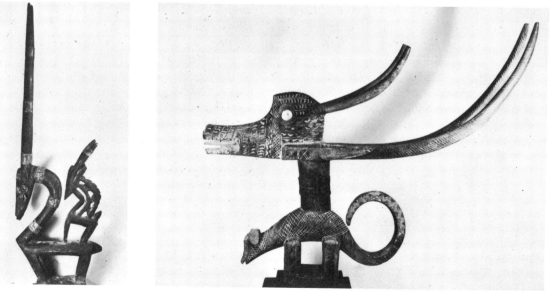

109. *37"* 110. *Bougouni district. 14" x 23"*

long horns joined at the end, the ears following the same direction. (2) Fig. 108 has the same type of strongly carved body, but here we have a bold roundness of body, the tail curved upward. This is a rather rare example, with two heads, one attached to the body, the other attached to the head below it; in both cases the attachment is made with metal clips. (3) Fig. 110 has the same concept as the Bougouni style, namely having a four-legged animal as a base. To this, by a cylindrical neck, the head of the antelope is attached with a metal ring. The horns stretch out horizontally but curve upward; unlike the first example, the ends of the horns are not joined together. (4) In this group there are also very simple examples: one with only a short neck, a head, and two long horizontal horns (no body); another with a very long, straight neck, small head, and small horns, etc. There is one consisting of a head with a beaklike feature and with multiple horns; another has a simplified body with four legs, long neck, and two horns, but no mane.

STATUES. We can distinguish two groups among the Bambara statuary: those of smaller size (12 to 15 inches) and larger carvings measuring up to 4 feet.

The smaller figures are usually standing or sitting females executed in bold forms with prominent cone-shaped, pointed breasts. They function as fertility figures. Some have the arms separated from the body, flat palms facing forward, the hands sometimes attached to the thighs. Fig. 68 is a good example (although coming from the Bougouni district); it has an additional feature: its crestlike head formation, not seen in other Bambara statues. Usually the face is extremely angular, with a convex forehead and an angular, ridged nose against a flat face and often with globular eyes.

The large figures (also from Bougouni) are seated and standing females with a rather dignified air about them, some holding a child. They have crestlike hairdos with several braids falling on their breasts. A very unusual carving is Fig. 49, a dance headdress, which consists in a central figure with Janus head and developed breasts; two detachable Janus heads are appended. These three heads have transverse coiffures with pendants on both sides, deco-

rated with red cloth and metal strips. Two smaller heads in the same style are attached to each of the larger heads. The faces are partly covered with metal sheeting worked in *repoussé* with geometric patterns.

MASKS AND HEADDRESSES. The masks of the Bambara can be classified according to the secret societies in which they were used, namely the N'tomo, Kore, Kono, and Komo.

The N'tomo society was organized for men according to age groups, each member graduating from a lower to a higher grade and finally entering into another society. There are two main style groups. One is characterized by an oval face with four to ten horns in a row on top like a comb (Fig. 52). Often the whole mask and the horn are covered with cowries or dried red berries. The next type has a strong, angular, ridged nose and a protruding mouth, a superstructure of vertical horns, in the middle of which is a standing figure or an animal. Sometimes the standing figure is in front of the comblike arrangement of horns (Fig. 50).

The Kore society functioned at agricultural activities such as supplication for rain. The hyena, the society's guardian animal, is featured most frequently in their masks. Fig. 114 shows one of these masks, with hemispherical forehead, long, angular nose, open jaw, and long, hollowed-out ears. Fig. 111 is a simple animal head.

The Kono masks were also used in agricultural rituals, mostly to petition for a good harvest. They usually represent an animal head with very long open snout (seen from the side) and long ears standing in a V from the head, often covered with mud (Fig. 112). The same type of mask sometimes has a row of long horns. Some have a four-legged animal on the forehead or a small standing figure between the horns.

The Komo society headdress, worn horizontally, consists of an animal, covered with mud or sacrifical material, with open jaw; often horns and feathers are attached.

A rather unusual helmet mask is Fig. 115, reminiscent of some medieval headgear, with square, pierced eyes, nose only indicated by a narrow line, no mouth, two long horns bent so as to form an oval shape between them, two

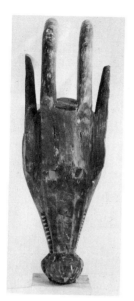

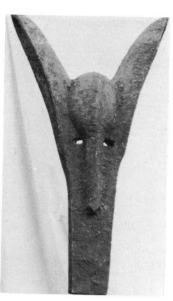

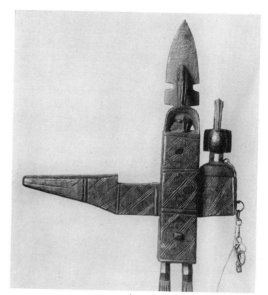

111. *Animal mask,
Kore society. 25"*

112. *Mask, Kono society. 30"*

113. *Crossbolt. 18" x 16"*

ears at obtuse angles. The forehead has a cavity used to hold an ornament. This type of mask comes from the Bamako district.

OTHER SCULPTURE. Reliquary figures in form of a woman, having an oval cavity below the breasts to receive relics, covered with a lid with a face carved on it in high relief, arms detachable. Marionette figures (*merekun*), often consisting only of a handle with a head and highly developed breasts. Crossbolts (or door locks) of great artistic merit; the main body is a boxlike structure with incised ornamentation, having the legs in zigzag formation and either a human or animal head (Fig. 113) or a bird's head with beak. The *boli* figures, which are covered with thick sacrificial material, often animal horns or feathers embedded in them, may also be mentioned. Iron staffs (2 to 3 feet high) with standing or riding figures (some with bells) were used by the chief as insignia.

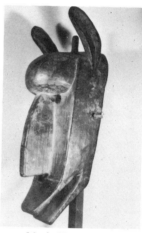

114. *Mask, Kore society. 16"*

MARKA *and* MALINKE

These are two ethnic groups independent from the Bambara but whose styles show a strong Bambara influence.

The Marka have some masks very similar to the N'tomo society masks, with multiple horns, but with metal rings, the face covered with hammered metal and also metal appliqués. An-

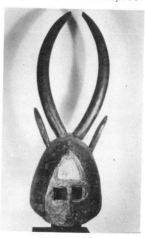

115. *Helmet mask with horns,
Bamako district. 23"*

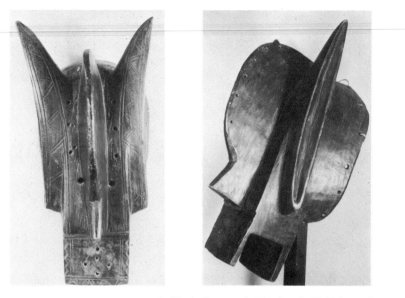

116. *Mask (front and side views), Malinke. 14"*

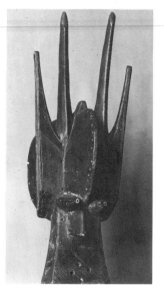

117. *Mask, Malinke. 24"*

other type of mask is similar to the Kore society mask, with large forehead and long nose, but this mask is not only covered with metal sheeting worked in *repoussé* with geometric patterns but has three or four metal bars attached to the forehead, with red cotton at the end of each (Fig. 118).

The Malinke is the other tribe whose style could be characterized as having a vigorous, bold configuration of volumes, some with extremely large hemispherical forehead unified with an angular nose and square mouth (Fig. 116). Others, such as Fig. 117, show more Senufo influence.* If we notice the formation of the forehead on the side view of Fig. 116, we can find the same bold shape on the head of Fig. 69, which we have classified under Bambara, with possible Malinke influence. (Buffalo masks in the Dakar museum, identified as Minianka and Koutiala, have horns that form an incomplete circle and ears that protrude. Metal pieces cover the face of one of these masks.)

DOGON

The Dogon live 180 miles south of Timbuktu on the cliffs of Bandiagara, which dominate the plains for over 150 miles. On their small fields they cultivate their staple diet, millet. The mil-

* A very similar mask in the Musée de l'Université de Dakar is identified as Koutiala.

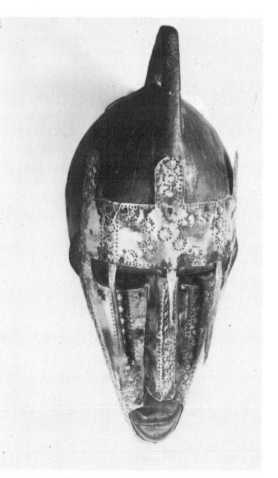

118. *Mask with metal sheeting, Marka. 14"*

let is stored in high quadrangular granaries around which they build their houses. Because of the difficult approach to these regions and the aridity of the climate, the Dogon have been isolated and hence were able to conserve their ancient religious habits and ways of making the necessary implements, their carvings. It is only since about forty years ago that we know about their works (Griaule's book, *Masques Dogon*,* was published in 1938).

The Dogon have a great tradition in both statuary and masks.

STATUES. As a general characterization of Dogon statues, one could say that they render the human body in a simplified way, reducing it to its essentials. Some are extremely elongated with emphasis on geometric forms. The subjective impression is one of immobility with a mysterious sense of serenity, although conveying at the same time a latent movement.

The statuary could be divided into two main groups, according to their appearance: (1) the majority, which appear archaic, and (2) those whose surfaces do not look "old" or "used." Those of the first group have a thick, encrusted, often crackled surface caused by pouring over them sacrificial animal blood, often mixed with dust or millet powder. Others in this group have a weather-beaten appearance, and because of the heavy grain of the wood they look as if they have been sandblasted, a result of having been left outside on the open terraces of the cliffs. We assume that they may be older than the second group, but the differences could derive only from the conditions in which they have been kept and found; we have no evidence as to the actual age. These statues were found in the cliffside sanctuaries. The Dogon themselves refer to them as *tellem* and show special veneration for them. The very complex mythology of the Dogon (which Griaule has collected from oral tradition) refers to a cosmological system and is reflected in the religious, social use of their carvings (including the masks). It contains also a reference to the "little people" (*andumbulu*), the original founders of the tribe, and then to the *tellem* (of normal human proportions), and it is said

that they came from Mande, probably from the old Mandingo empire.

For classification purposes, the *tellem* denomination could be used to label the archaic type of statuary, and by extension it would refer to *tribal* ancestors. A statue of the second type, without this old-surface quality, could be considered a *family* ancestor statue (being the abode of the spirit of the deceased), which actually was placed next to the dead person in the funerary cave.

Among the large number of Dogon statues we have selected eight as the most typical: Fig. 119, a standing figure with bent knees, long arms, hands of angular shape, shoulders following the horizontal line of the hands—one of the most geometrically constructed statues among our examples. Fig. 120 shows a face in archetypal formation, as if emerging from prehistory. Although it has both hands on the hips, two arms are also raised (the right arm is missing). Fig. 121 shows the "sandblasted" effects on the surface. Opposed to the angularity of the first statues, here we have three oval shapes formed by the head, the arms, and the legs. Fig. 122 is a kneeling figure with weatherbeaten surface, strong angularity of the arms, facial expression completely obliterated. It has lip plugs, a usual ornament among the Dogon women. Fig. 123, a standing figure with both hands raised, which indicates supplication for rain, has a crackled surface. Fig. 124 has only one arm raised and the male genital strongly evident. This statue does not have the weathered surface, and on this basis may perhaps belong in the group representing a family rather than a tribal ancestor. Fig. 125 is a kneeling female in which the position of the legs is rather distorted. It has a large, rather naturalistic head, although most of the features are covered with some material, partly worn off. Fig. 126 is a fragment of an equestrian figure. Originally the statue had one arm upraised with a closed fist holding a spear or dagger. The other hand rested on the neck of the horse, the body of which is missing.

There are other statues: a seated female, the seat supported by standing smaller figures; maternity figures, standing or seated, with a child on the woman's lap; and double figures, either two standing figures attached to each other at

* Consult the Bibliography for full references of authors cited.

Dogon Statues, Mali

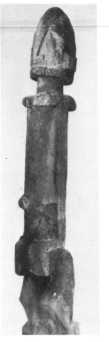

119. *16"*

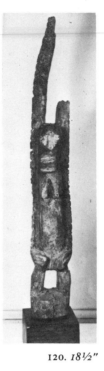

120. *18½"*

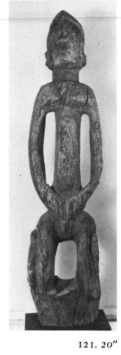

121. *20"*

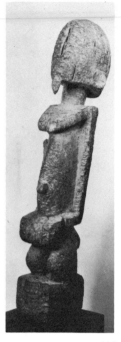

122. *13½"*

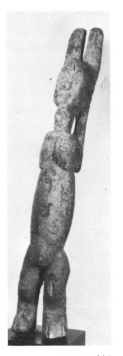

123. *15½"*

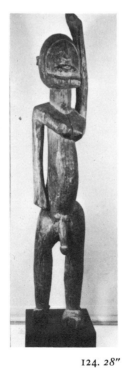

124. *28"*

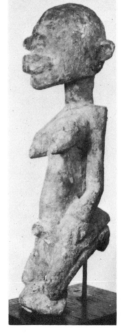

125. *11"*

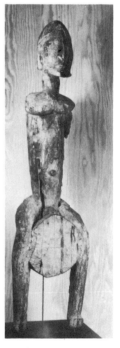

126. *26"*

the thigh or one standing on the top of the other, probably for some decorative purpose. Of great strength and massive volume are Dogon animal figures, such as the mythological horse (Fig. 127) identified as being "the horse leaving the world's first ark."

Although the carving of the Dogon is primarily geometric, the faces of certain statues express great human emotion (Fig. 126), showing a restraint and dignity comparable to some of the Romanesque statuary.

MASKS. There are many styles of masks, but their basic characteristic is great boldness in the use of geometric shapes, independent of the various animals they are supposed to represent. The structure of a large number of masks is based on the interplay of vertical and horizontal lines and shapes (Fig. 128), similar to the neoplastic trend in modern art (Mondrian). Another large group has triangular, conic shapes (Fig. 131). The masks are often polychromed but on many the color is lost; after the ceremonies they were left on the ground and quickly deteriorated because of termites and other conditions.

The names and functions of Dogon masks are all based upon an extensive mythology. One of the fundamental tenets is that both humans and animals have their *nyama* (soul substance) which returns after death into a mask (and of course also into a statue). The masks were used at burial ceremonies to drive away the souls of the deceased who might harm the living and also at the end of mourning and at various other rituals, all of which had their own fixed dates. Newly made masks were put into the sacred sanctuaries on the cliff, either next to the Great Mask or near painted symbolic designs (Fig. 135), both of which were supposed to contain the spirit of the ancestor. The masks are attached to a woven fabric (often red in color) which covered the back of the head. Part of this is made of long red fringes (Fig. 129). The back of the mask has holes to which cords are attached. The cords came back down onto the back of the dancer, fastening to belts at the chest and waist. Sometimes a 25-foot-tall plank was attached to the mask or the mask was carved from such a long log. As one of Huet's photographs illustrates, the dancers wore a blouselike dress made of red fiber, a short skirt of the same material and color, and a long skirt in black covering the legs.

The most commonly known mask styles are: (1) Fig. 128 is one of the best-known types. It is constructed of vertical and rectangular shapes forming a boxlike shape, with pierced eyes and topped by two long, straight, vertical horns. This mask is called *wilu*, "the gazelle." (2) Very close to this mask is the *walu* ("the horse of the bush"), with heavy, shorter horns in V shape. (3) Fig. 129, the *kanaga* mask, uses triangular patterns in its construction, although this mask also exists with a boxlike head. According to one source, the "cross of Lorraine" represents the stretched wings of the *kommondo* bird combined with four feet. The large, triangular shape of the face is supposed to stand for the upper jaw of the bird and the conic form below for the tongue. It is said that this mask was created in ancient times by a hunter who killed the bird, replacing it with its figuration in the mask, which was used in turn for purification ceremonies. Griaule, in his article "Les Symboles des arts africaines," writes that beneath this mythological story lies a very

127. *Carving of a horse, Dogon, Mali. 4½" high*

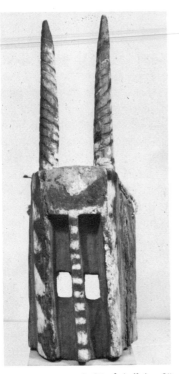

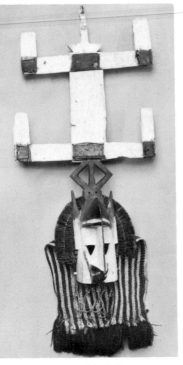

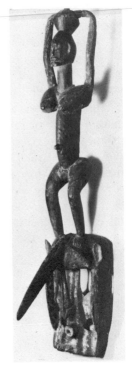

128. *Mask (wilu). 18"*

129. *Mask (kanaga). 40"*

130. *Mask with figure. 37"*

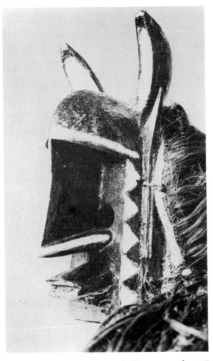

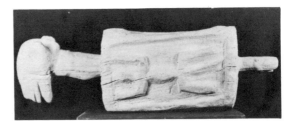

132. *Trough. 4½" x 4"*

131. *Hyena mask. 15"*

complex cosmological concept that is connected with the world-creator demiurge, who raised his hand upward after the creation of the world. It is also said that the superstructure is the transformation of a swastika-like configuration. Often the upper part of the "cross of Lorraine" is called "the hand of god." (4) Fig. 131 is an extremely bold construction of triangular patterns, and although it may look like a human face, it is called "the mask of the hyena." (5) Fig. 130 shows a mask with a boxlike base, a horn protruding forward from the forehead, surmounted by a figure (similar to the Mossi mask in Fig. 184). The mask probably represents a hornbill. (6) A mask called *ireli* (hare) with two big ears. (7) A mask called *kelemo jene* (antelope) with a comblike structure of five horns on the top. (8) The *karanda* mask has two long horns issuing from the top of the mask and curving backward in a horizontal line. (9) The whole face of the *dege* mask represents the white monkey. (10) Another mask represents the black monkey, the figure of the monkey sur-

mounting the mask itself, which has a concave, flat surface. (11) The *satimbe* mask is a box-like face mask surmounted by a large figure, two or three times the size of the mask, whose arms are either in a V shape or in a U shape. (12) There are masks which represent personages, such as "the Hunter" (from the region of Sanga), with an interesting formation of the forehead and mouth resulting in a figure-8 shape (Fig. 133). Another is named *samana*, "the master of the bush" (Fig. 53). Some of these masks have a large degree of expressionistic naturalism. Some are made of cowrie shells, some of knitted material to which occasionally shells and pieces of metal are attached. When these masks represent women of the Peul tribe, dancers use artificial conic breasts (similar to the usage of the Ibo and the Batshioko). (13) There are other masks representing the stork, the ostrich, the lion, the crocodile with big jaw, the antelope with two very long vertical horns and long ears parallel with the horns.

ROCK PICTURES created by the Dogon are unique in West African art (Fig. 135). The style is not in the realistic vein of the prehistoric rock pictures of Altamira in Spain or Dordogne in France, nor does it resemble that of the rock paintings of North Africa (Atlas and the Libyan Desert) or of the Bushmen of South Africa. These pictures are symbols reduced to the most essential concept of an idea or of an object rather than a visual rendition. They show striking resemblances to modern abstract paintings, some being so "abstracted" that they require painstaking research to reveal their meaning. They are painted on rocks and in the caves where the masks were stored or where circumcision ceremonies were performed. Most are multicolored (ocher, red, white, black). Most have a religious significance. It is difficult to estimate their age, since they have been repainted continuously. Subject matter includes masks of different styles and uses, dancers with masks (Fig. 135), animals, genii, and utensils or other objects.

OTHER SCULPTURE. Granary doors of great refinement, having rows of smaller figures representing ancestors (Fig. 134); crossbolts for the doors, usually with two standing figures.

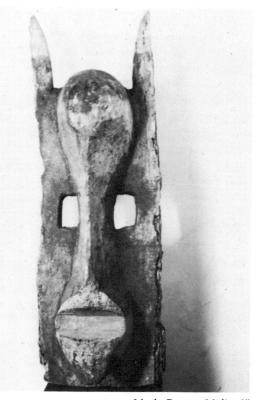

133. *Mask, Dogon, Mali. 18"*

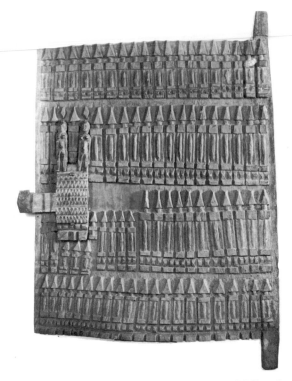

134. Door, Dogon, Mali. 32"

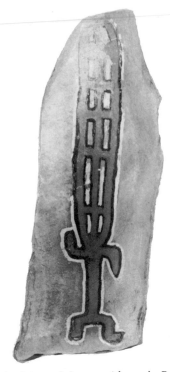

135. Rock picture of dancer with mask, Dogon, Mali.
15"

Houseposts about 7 feet high, with large fe-male figures, heavy breasts carved on the sur-face. Compactly formed, small horses. Carved stools supported by four figures. Richly carved troughs in various sizes (Fig. 132 shows a smaller one), which might have been used for the millet grains and probably was also used on ritual occasions.

PORTUGUESE GUINEA

BISSAGOS ISLANDS (BIJAGO *or* BIDJUGO *tribe*)

Bernatzik describes this very interesting tribe in which the matriarchal order was so strong that the women selected their men and could force divorce on their husbands, the man keep-ing the children. The women wore single or double raffia skirts (like those of the island of Formosa, long skirts hanging down from the shoulders). They wore a pageboy-type hairdo stiffened by the use of ocher-colored clay mixed with palm oil.

STATUES. Fig. 136 shows the above charac-teristics, also a long nose with narins, closed lips, short and thick legs. The feet are missing, the eyes inset with beads. Other statues have short skirts and bare breasts.

OTHER SCULPTURE. Bowls with lids, the han-dle being a carved animal, the bowl held by two or four figures; so-called "soul" figures; a torsolike figure with a lower structure; forklike "dolls," the head of which is a human figure (the women carried these against their hips); animal masks.

REPUBLIC OF GUINEA (FRENCH GUINEA)

BAGA

STATUES on round columns, called *tam-baane, tsakala,* or *kelefa:* extremely large head, compressed on both sides, in angular, stylized construction; jutting nose; arms without hands, or hands resting under the chin (Fig. 142).

They were kept in round huts by the Simo secret society.

Bird heads (*anok*) were used at harvest time and funerary rites, also by the members of the Simo society. Fig. 137 shows one with a beak of rather massive appearance. Fig. 138 has a

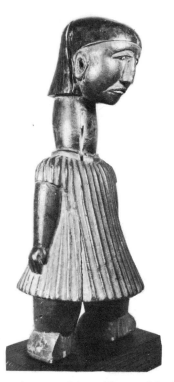

136. Female statue, Bijago, Bissagos Islands. 11"

longer beak and bold design. This head has lozenge forms through which the inside of the head was hollowed out, and it is reported that into these cavities small horns filled with a magical substance were fitted.

Very remarkable for boldness of carving and for size (30 to 45 inches tall) are the fertility figures called *nimba*, which come in two forms —one with a pillarlike body (Fig. 140), the other carved out in the inside so that it may go over the head and on the shoulders of the wearer. They represent the mother of fertility, protector of the pregnant women.

MASKS. The Simo society utilized very large polychromed masks (often 4 to 5 feet tall or more) which are known as *banda* or *boke* and

were used in fertility rituals. Fig. 77 shows one type with basically human features surmounted by three curved horns, a raffia collar attached. More typical, however, is Fig. 46, showing the prominent jaw of the crocodile combined with a large, wedge-shaped nose and an elaborate rendition of the horn of an antelope. This illustration shows also the horizontal postion of the mask when used.

There are also masks combining human and animal features, some with horns. A few are known to have been covered with small polished-copper plates.

Carved DRUMS each supported by four human figures with large heads.

KISSI

Soapstone (steatite) STATUES called *pombo*, meaning "the image of death," are very similar in style to the *nomori* statues of the Mendi tribe in Sierra Leone, so much so that it is difficult to distinguish between them. Most have a round, columnar, phallic form (Fig. 141) with a small head, others have exaggerated breasts (Fig. 64), and some are in crouching position with oversized head. The products of past generations, they were found in the rice fields. This accounts for their similarity to the *nomori*, since in all probability the same population lived on both geographic territories.

According to Paulme (*Les Gens du Riz*), people believed that these statues were the abodes of the spirits of their ancestors. In order to find out which ancestor a statue represented, a man's dreams were analyzed with the help of the diviner. At such festivities the statue was wrapped in cotton upon which sacrificial blood had been poured, so that often the statue became invisible. The owner (the guardian of the statue) placed it on the family altar; hence it was thought to be the family's protector against sickness. It was also consulted before a new undertaking was planned. In S. Brown's view, the statues were believed to have supernatural power and were used in rice cultivation. Rutimeyer states in an early report that the statues, being phallic in form, were stuck headfirst into the earth at sowing festivities, symbolically fertilizing the grain.

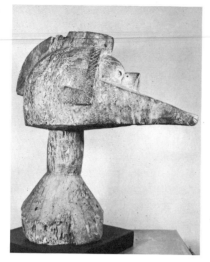

137. *Bird's head* (anok), *Baga. 11"*

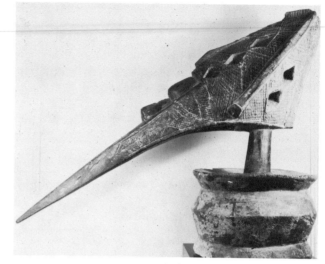

138. *Bird's head* (anok), *Baga. 18" x 26"*

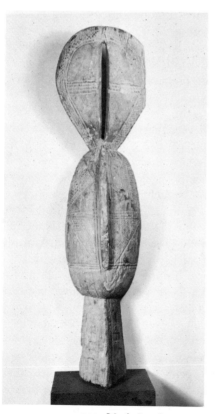

139. *Mask, Landuma. 29"*

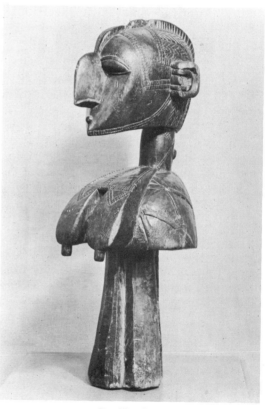

140. *Fertility figure* (nimba), *Baga. 30"*

LANDUMA (LANDOUMAN)

The art of this tribe (often called a substyle of the Baga)* includes two remarkable sculptures. One is a very abstract mask in animal-head form, where the stylized horns and the beak are clearly recognizable but the face represented only by a vertical projection in the middle (Fig. 139). The other is a carving in the shape of a python (measuring 54 and 68 inches), which probably is connected with the snake cult, usually associated with fertility. (Although such a cult is known in West Africa, and especially developed in Dahomey as the Danghbe cult, no sculptural representation was made in that country.)

GUERZE *and* KONO

These tribes, dominated by the Poro secret societies, produced masks of the same type as those discussed under Liberia and the Dan of the Ivory Coast. Fig. 144 is Guerze and Fig. 143 is Kono (both in the museum in Dakar) These illustrations show that a style tradition established by an intertribal secret society was maintained by different tribes over a great expanse—in this case, from Guinea through Sierra Leone and Liberia to the Republic of the Ivory Coast.

SUSU (SOUSOU)

Masks with large foreheads, used in harvest and burial ceremonies.

TOMA

The men's secret society of this tribe produced an unusually free, abstract type of mask called *landa* (Fig. 147), composed of a large flat surface with angular projecting nose, hemispherical domed forehead, circular pierced eyes, and often with hornlike protuberances. Our illustration has two horns and a third projection in the middle with a human face carved in relief.

* Identified as Baga-Boke by the Dakar museum.

SIERRA LEONE

MENDI (MENDE)

STATUES. Fecundity fetishes. The head has a large, domed forehead with face depressed underneath, groovelike line for the eyes, extremely small mouth, chin indicated but not developed, complicated hairdo showing great variety. The neck is long with numerous bulbous, ringlike forms. The body is slender with large breasts, neck thin in proportion to head. The thin legs are straight, arms and hands close to the body. Some are male figures but most are female. Female figures were used as oracles by the Yassi women's secret society (Fig. 146). The figures called *minsereh* were anointed, through which they acquired their magical power. The woman leader (*Ya-Mama*) of the society deposited them beside the secret tribal medicine and then fell into a trance. On awakening, she anointed the statue again, then held it in her hands, and from its motions during a dance the answers to questions were construed.

Stone figures of steatite (soapstone) are called *nomori* (Fig. 78). The style is entirely different from the wood figures. The idiom is free. The large head has a narrow forehead (as opposed to the broad ones of the wood statues), a curved nose, large froglike eyes, large lips, a facial expression often portraitlike. Position is also varied—standing, kneeling, sitting, etc. Statues were found in graves and in the fields. Offerings were brought to them and if they failed to produce the desired results, they were flogged.

MASKS. Hood- or helmet-like heads carved from the full trunk of a large tree were worn over the entire head, with rims resting on the masker's shoulders (Fig. 145). Characteristics similar to the heads of statues but exaggerated. The forehead is more than half the size of the entire head and ends in a point; the face is depressed; eyes, mouth, and chin small; hairdo elaborate. Used by the Bundu (or Sande) women's secret society. Some have one, two, or four faces. The mask is colored black on the outside. A costume of black fiber covering hands and legs was worn with the mask in rituals. This mask, called *min*, or spirit, has been

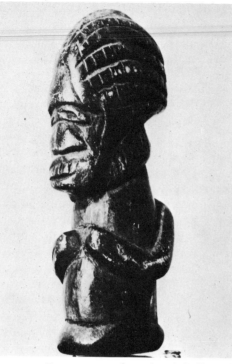

141. *Funerary stone figure (pombo), Kissi. 6"*

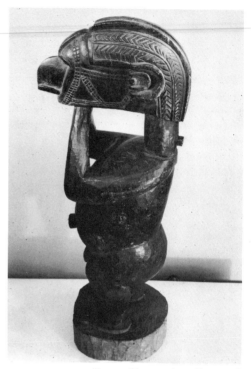

142. *Statue, Simo society, Baga. 31"*

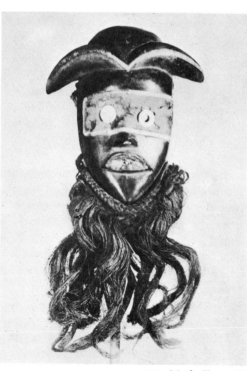

143. *Mask, Kono. 8"*

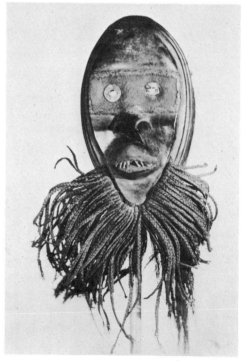

144. *Mask, Guerze. 8"*

written of as a devil mask. Girls were admitted into the society at puberty or after and were educated in marital duties. Prospective husbands often paid the initiation fee. "Fat" rings on the hood masks are thought to be symbolic of the fattening of the girl into a woman. The graduates of this training received a new name.

Another mask, called *nyangbai,* makes a design of the eyes—two small rings—and nose in a straight line; the rest of face is patterned in straight lines, the whole surmounted by a crownlike structure. This type represents a spirit or demon.

(The Poro secret society was also strong in Sierra Leone and was affiliated with local societies. Its art, found also in this area, will be discussed under Liberia.)

TEMNE (TIMNE)

The Temne, who are related to the Baga, have produced steatite figures familiar to this region. Their wood carvings are distinctive, however. The *fema* figure, though it has rings on the neck similar to Mendi statues, has a narrow waist, large hips, and very thin arms completely separate from the body, conveying an impression of fragility.

LIBERIA

Most of the ceremonial MASKS were produced for the powerful men's secret society, Poro, and the women's secret society, Sande. Both were under hierarchical rule and controlled the religious and social life of the tribes, imposing capital punishment and keeping the tribesmen in constant fear. Each mask, being itself the spirit (*ge*), had a special name, the belief being that it was the mask, not the man, which performed the specific ritual function.

The chief tribes, each dominated by a Poro society, are the Mano, Geh, and Gio. There are several minor tribes, among them the Kra and Konor.

Masks fall into six general types: (1) Finely carved masks in simple columnar form, portraitlike, with spiritualized facial expression;

small eye slits; scarifications carved vertically from forehead to nose (Fig. 79). (2) Same type with hair and beard of woven hair or raffia; eyes indicated by red or white paint or colored strips of cloth (Fig. 149).* (3) Masks with protruding tubular eyes; forehead often richly ornamented with carvings (Fig. 150). (4) Beak-mouthed masks (Fig. 152), some with movable lower jaw (Fig. 148). (5) Masks, cubistic in design, eyes in large triangles (Fig. 58). (6) Small replicas of large masks, 2 or 3 inches in size, carried on the owner's person or kept at his home. Descriptions are based on Dr. Harley's publications. Masks similar to those described, found on the Ivory Coast, are attributed to the Dan and Guere-Ouobe tribes.

The Sande women's secret society masks resemble the hoodlike masks of the Bundu women's society masks (Fig. 145). (See Sierra Leone.)

DEY (DE)

Masks similar to the Mendi of Sierra Leone, but eyes indicated in small swellings without openings.

VAI (WEI)

Same masks as Dey, but some are given distinctively masculine features and some are colored white and red; used in initiation ceremonies. Also postlike figures with roughly carved human features.

GOLAH (GOLA)

A few wooden sculptures; some steatite figures. Mendi-style masks, with human teeth inset into the mouth.

BASSA (BASA)

Large-headed statues with face planes and small round forehead meeting at a forty-five degree angle; small, snoutlike, protruding mouth placed under the broad, projecting nose.

Also three-inch masks, replicas of the above.

* Masks made by the Mau in the Republic of the Ivory Coast are very similar (see page 176).

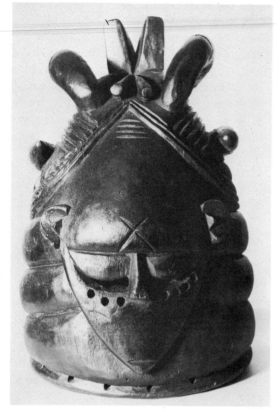

145. *Helmet mask, Bundu society, Mendi, Sierra Leone. 17"*

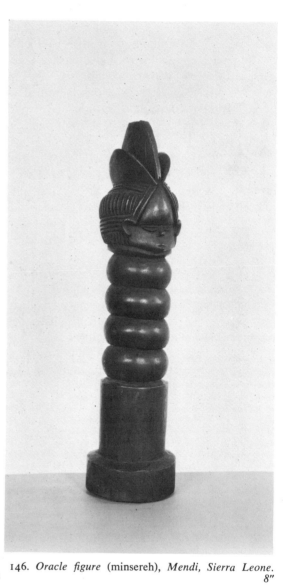

146. *Oracle figure* (minsereh), *Mendi, Sierra Leone. 8"*

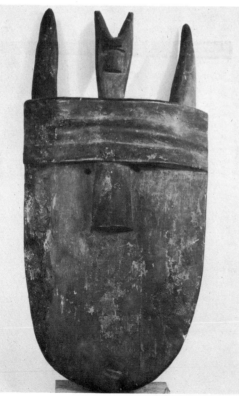

147. *Mask* (landa), *Toma, Rep. of Guinea. 18"*

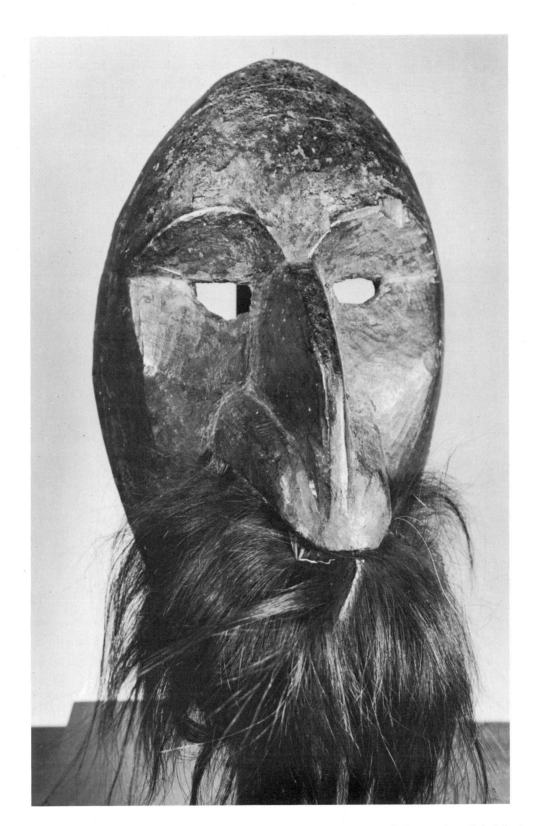

148. *Initiation ceremony mask, Poro society, Geh. Liberia. 9"*

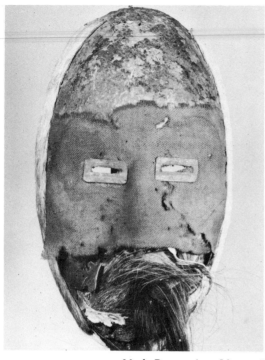

149. *Mask, Poro society, Mano. 9"*

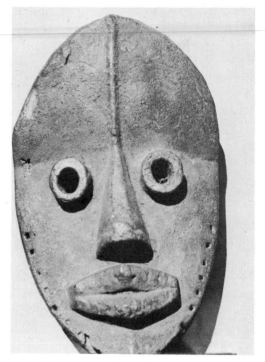

150. *Mask, Poro society, Mano. 9"*

151. *Brass anklet, Gio. 6" wide*

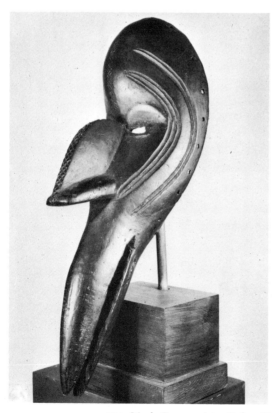

152. *Mask, Poro society, Geh. 16"*

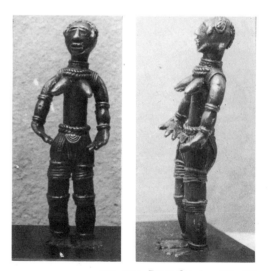

153, 154. *Brass figurine, Gio. 6"*

GIO

The Kra, Geh (Ga), and the Gio tribes produced brass casts in the lost-wax method. Fig. 153 is a type of brass cast, with finely overlaid wax thread, which Schwab attributes to the Gio tribe; similar figurines have also been found among the Guere of the Guiglo region of the Republic of the Ivory Coast. Casts exist also in double figures, figures in various positions and activities. Fig. 151 illustrates a very fine hollow-brass anklet ornamented with precisely laid wax thread. This anklet is also attributed to the Gio, and similar anklets were used by the Bete, Neyo, Bakwe, and other tribes of the Republic of the Ivory Coast.

REPUBLIC OF THE IVORY COAST (IVORY COAST)*

BAULE (BAOULE)

One of the rare tribes where sculpture is produced for aesthetic appreciation as well as for ritualistic purposes. The Baule came to the territory they now occupy in the eighteenth century, an area previously the home of the Guro; traces of the original Guro style can be found in many Baule works, especially in the masks.

Ancestor STATUES, male and female, carved with pedestals, having sophisticated elegance and a strongly marked, traditional style (Fig. 155). The body is usually slender, face delicate, forehead high, nose long and thin, chin rounded, eyes almond shaped with finely carved eyebrows and lashes over half-lidded eyes, mouth broad and finely cut. The tribal hairdo is highly stylized, done with elaborate, fine, parallel, curving incisions, corresponding to the elaborate hairdo still used by Baule women today. Scarification marks on neck, face, and body are skillfully done in relief (Fig. 156). Arms with long fingers, without separation from the body. Legs balanced, finely carved, bulbous in form. Some statues have

long, stylized beards. The name of these statues is *waka sona*, "wooden people." Although their main purpose was to insure the beneficial presence of the ancestor, they had additional uses: to insure fertility, to prevent miscarriages, to bring about good harvests, and generally to promote personal well-being and prosperity. Statues (sometimes of animals) covered with gold foil were used as insignia of the Baule chief and carried on festive occasions. Old seated figures are rare because only persons of high social rank had the right to use the ceremonial stools, which were sacred containers of the power of command, thus serving a function very similar to that of the Ashanti stools.

If the ancestor-cult statues are characterized by highly refined and detailed carving, the wood stained and often highly polished, very different in style are the so-called "mendicant monkey" figures known as *gbekre* (Fig. 157). They are roughly carved in natural, unstained wood, although the position of the legs and their bulbous forms recall the usual figures. The monkey figure symbolizes the son of the god of heaven, his role being to receive offerings for this deity, usually in relation to agricultural activities.

MASKS. Sensitive frontal dome, attenuated face, elongated nose, arched eyes with emphasized lids, small stylized mouth, ornamental patterns around the face (often like sideburns); hairdo in fine ornamental incisions, often in three sections. Some masks combine human and animal features. Some human-face masks are surmounted by stylized horns (Fig. 42) or by an animal or a human figure.* Many have a sophisticated beauty; some, though contemporary products, are in perfect traditional form. Masks also represent animal heads (Fig. 38)—elephant, bull, ram, antelope—the best known being the cow head in rather abstract design (Fig. 40), representing the spirit of the dead and called *kakagye* or *goli*.† Masks of great beauty combine animal and human fea-

* Additional information on the art of Ivory Coast tribes is based on the author's recent visit to the Centre des Sciences Humaines in Abidjan and on B. Holas, *Craft and Culture in the Ivory Coast* (1968).

* According to Holas, this type of mask should be attributed to a small tribe located between the Baule and the Guro around Bouaflé, the Yaoure, whose work has been influenced by both neighboring tribes.

† The Dakar museum labels this type of mask *die yassoa,* stating that it was used in agricultural festivals,

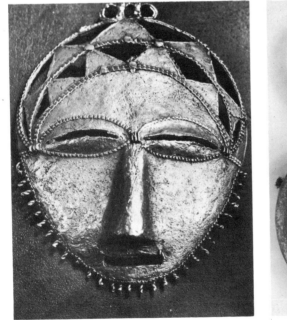

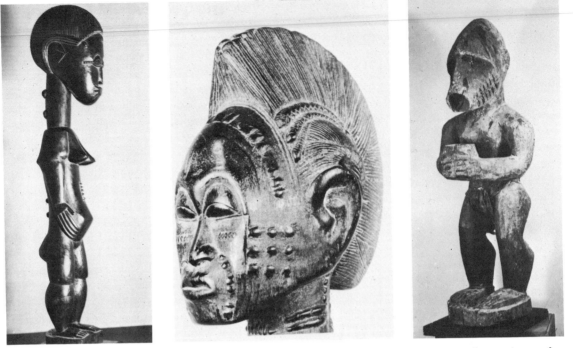

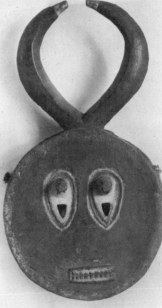

155. *Ancestor statue. 15"*

156. *Head of a statue. 4½"*

157. *Statue of a monkey* (gbekre). *21½"*

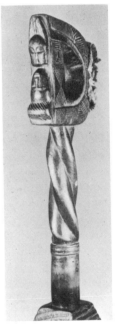

158. *Gold mask. 3½"*

159. *Mask* (kplekple). *17"*

160. *Tambourine beater* (lahoure). *8"*

tures in perfect harmony. Animal heads often represent spirits from the Baule mythology. One Baule mask varies sharply from the traditional style, a round face with eyes shaped like inverted drops, straight mouth, no nose, and arched horn on the head. This mask, known as *kplekple* (Fig. 159), was used in commemorative ceremonies, at burials, and at collective sacrifices in connection with the agricultural seasons. In the Abidjan museum is an example covered with hammered-brass sheeting.

As to the usage of Baule masks and statues, Lindholm distinguished between *religious* and *commemorative* purposes. In the religious context a mask or statue was the abode into which the ancestral spirit was "fixed" with the intent —and this is rather unusual in African art— that the features of the carvings (especially in the case of masks) should resemble the deceased. Daily offerings were made to the spirit residing in the mask or statue. The commemorative purpose was served when a person leaving the village wanted his "portrait" to remain with an intimate. In this case the mask was hung on the wall of the house, divorced from any religious connotation. Note that under European influence a great individualization took place in the Baule society which is also felt in the carved work. The carvers were in competition with each other and each tried to produce some new details on the mask, very often to the detriment of the more classic tribal style.

METALWORK. The brass gold weights attributed to the Baule are very much in the same class as the Ashanti gold weights. Although in the execution of their gold masks (Fig. 158) they were also under Ashanti influence, the Baule were able to produce a great variety of gold pendants. As Bardon reported, in addition to the small human-face gold masks, there are breastplates (pectorals), rams' heads, crocodiles, etc., all covered with extremely fine wax threads, placed next to each other. Cast in the lost-wax method, this work achieved a high degree of thinness and refinement of details, such as in the twined hair and beards of the masks. These gold ornaments were highly praised by chiefs and noblemen. They were worn as pendants on the forehead, attached to a headdress made of animal skins, sometimes worn on the

upper part of the arms or attached to the sword. It was believed that the gold masks represented the spirits of the chiefs killed in war; thus, attaching a mask to a sword transferred the spiritual force of the vanquished to the conqueror's sword.

OTHER SCULPTURE. Among the carved utensils and instruments are heddle pulleys, similar in form to the Guro pulleys (Fig. 161). From pulleys are suspended the frames (heddles) used to separate alternate warps in a horizontal hand loom. They have great variety: single or double Janus heads, animal heads, or sometimes the head of a bull in the *goli* style. Tambourine beaters, called *lahoure,* are executed with great refinement. Fig. 160 shows two types of masks carved in low relief on the upper part of the beater, one a face mask and the other a *goli*-type mask.

They also carve drums and wooden doors with relief carvings, some with masks as ornaments; often a stylized fish motif is used on the doors (Fig. 163). Wooden bowls with a human head or figure on the top of the lid.

In reviewing the various Baule styles we cannot fail to notice the great divergences within this single style region: (1) The rather naturalistic, highly refined ancestor-cult statue (Fig. 155). (2) The highly stylized mask with elongated nose (Fig. 42). (3) In contrast, the roughly carved monkey figure (Fig. 157), which seems to have come from another region. If we add now (4) the very massive, monumental animal mask with its heavy horns (Fig. 40) and we compare with (5) the round, highly abstract *kplekple* mask (Fig. 159), we see again the great differences in style. Of course, we know that a style derives from some ideological concept, based often upon mythological background, but why there is this great variety of styles within one tribe is still an open question.

MARITIME REGION

Earlier masks (Fig. 164) were attributed to the region around Sassandra, but later on similar masks were also found among the Grebo (around Tabou) and among the Kru, in the

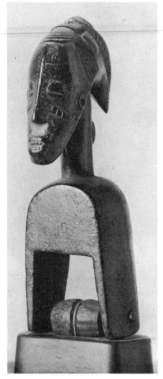

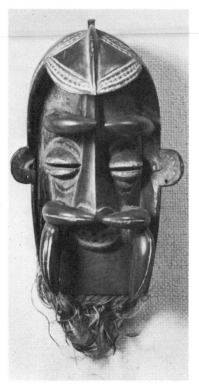

161. *Heddle pulley, Guro, Rep. of the Ivory Coast. 5"*

162. *Mask, Guere-Ouobe, Rep. of the Ivory Coast. 10"*

163. *Carved door, Baule, Rep. of the Ivory Coast*

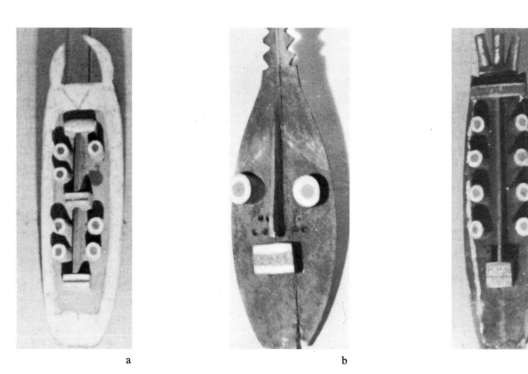

a

b

c

164. *Masks, Grebo or Kru, Maritime regions of Rep. of the Ivory Coast and Liberia*

southern maritime region of Liberia.* These masks are very bold abstractions, characterized by a flat surface for the face and having a number of round protrusions jutting out from this flat plane. In Fig. 164b it is clear that the two round protrusions represent eyes. It is reported that these masks were used as symbols of the chief's authority and hung at the entrance of his hut.

SENUFO

STATUES. There are numerous male and female figures in standing or sitting positions, some representing mother and child, a few equestrian. A large number adhere basically to the conventional proportions of the body, but the exciting ones, with very long arms and foreshortened legs, are more "abstracted." Two interesting examples show the same general trend but differ in details. Fig. 166 has foreshortened legs, body and arms in rounded shapes, pointed breasts, rather heavy arms, and hands without articulation. The crested head has an oval mouth with teeth showing. Fig. 73 also has short legs and pointed breasts, but the jaw is jutting out and the bodily form and the shape of the arms are angular. Most of the statues represent ancestor-cult objects. They were connected with fertility rituals and were also used for divination purposes in the Sandogo society.

The equestrian figures are rather small (about 10 inches high). The rider has a conic headdress and in some examples holds a sword. Such statutes were used as part of the diviner's equipment and represented a mediator spirit.

Rather remarkable are the Senufo figures from the northern region, especially those around Sikasso (in Mali). Their over-all rectangular shape gives them a monumental quality (Figs. 71, 72), with angular, square jaw, face, and shoulders, elongated arms, short legs, conic belly. The incisions symbolize the sun-ray-fertility concept.

Rhythm pounders, called *deble,* stand (with-

out feet) on a circular base, which was part of a long pole used to pound the earth, providing the rhythm for a dance in the Lo society. This implement was also used to invoke the spirits of the ancestors, especially at agricultural ceremonies. An interesting example is Fig. 76, its short legs resting on the base, long arms forming an oval shape, hands without wrists resting on the thighs, pendulous breasts. The pointed face has eyes set with cowries, ears carved as raised circles. On the vertical crest of the head and on the armlets and girdle, dried red berries are glued. A more simplified version (Fig. 165) has a weathered patina; the shape of the pointed face is repeated in the breasts and the legs extend the curvature of the arms.

Long staffs, called *daleu,* are mostly surmounted by a standing or sitting figure in a style similar to the larger statues, but because of the smaller size many of these statues (often cut off from the staff) have exquisite and refined execution (Fig. 169). The Abidjan museum calls these staffs *tefolopitian* and indicates that they were used for various purposes: in the Poro society's initiation ceremony connected with the land and in a dance performed to ward off evil influences (the dancer wearing a *kpelie* mask).

If we consider that the carvings of this tribe represent a high degree of plastic co-ordination, an entirely different concept has found realization in their magical statues, called *kafigueledio* (Fig. 167). Although the statue is carved roughly in wood, only the feet show this since the body and head are covered with a cloth, its surface incrusted, probably with sacrificial blood. The cloth is drawn together by a cord at the neck, and feathers are attached at the top of the head. The arms are movable, having metal and wooden "tools" fastened to them, the one at the right hand being curved. This statue was used in magic rituals, the figure's arm being pointed toward an intended victim.

Large statues representing hornbills (often seen also on masks) and used in the Lo society as symbols of fertility are the standing birds called *porpianong* (Fig. 168). They stand on a round base, which is often hollowed out to fit the head of the wearer. The long beak often rests on an exaggerated belly and the rectangu-

* A mask closely resembling these is in the Abidjan museum. It has an elongated forehead with twelve protrusions representing eyes—indicating that the wearer is able to see at night. The Abidjan museum identifies it as: "Ubi mask, from the area of the great forests south of Taï."

Senufo, Republic of the Ivory Coast

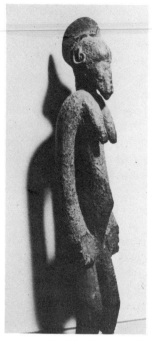

165. *Rhythm pounder*
(deble). *16½"*

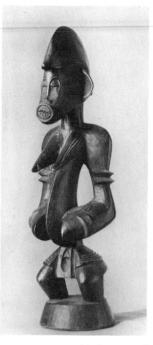

166. *Statue. 10"*

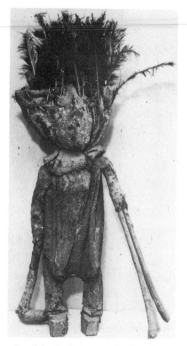

167. *Magical statue* (kafigueledio)
21"

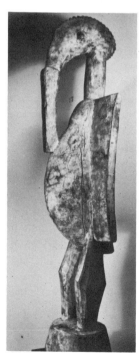

168. *Statue of a hornbill*
(porpianong). *22"*

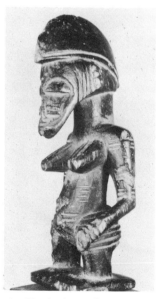

169. *Head of a staff* (daleu). *6"*

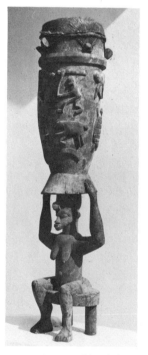

170. *Ritual drum*

lar wings are outstretched, mostly polychromed with round, painted ornamentations.

MASKS. The Senufo made many different types of masks, which could be divided into two large groups: face masks and helmet or hood masks.

The *face masks* or *kpelie* (also known as *kodelle* or *kulie*) represent ancestors. They are rather small in size (10 to 15 inches) and are joined to a costume that covers the wearer's whole body. Usually they are of extremely delicate workmanship compared with the large masks of the same tribe. They combine human and animal features, many having a pair of upturned horns, often combined with a pair of downturned horns. Some of them are surmounted by a bird or a figure and flanked by curving antelope horns. Most of them have leglike formations on either side of the chin, probably representing a bird's legs. There are usually three to four extensions at both sides, the symbolism of which is not fully understood yet. The mouth is usually projecting, sometimes with teeth showing. Fig. 172 has many of the features described above, plus arched eyebrows forming one pattern with the long, narrow nose. There are scarification marks on the forehead in relief, and it is surmounted by a row of palm nuts, symbolizing the profession of sculptors. There are also double-face masks, which are supposed to depict fertility. The masks were used in the Lo secret society, also at harvest festivals. The Poro society used them, too, in two dances called *korigo* and *koddalou*.

The same type of mask described above is often cast in brass, often having a dark patina. Usually not used in rituals, the majority of the brass versions are of more recent production.

Still within the face-mask category are those in which the human nose is elongated into a long bird's beak.

Probably under Baule influence are those masks which do not have "legs" and the flanking ornaments, and often have geometric ornamentation on the top or horns.

The next large group is the *helmet mask*. Of larger size (some 30 to 40 inches long), their outstanding feature is a crocodile jaw, giving a frightening impression, and in fact they were used in various ceremonies to cast out malevo-

lent spirits. Sometimes they are referred to as "firespitters" due to an old custom of placing a small piece of glowing coal into the muzzle and the dancer blowing through it.

There are two basic types having a crocodile jaw: one with long antelope horns and the other without horns, both having been used in the Korubla society: (1) Fig. 173 has the long, curved antelope horns with spiral grooves. The jaw is open although the teeth cannot be seen. On top are a chameleon and a bird with beak, flanked by the horns. There is also a small round cup on the forehead. The horns of a warthog issue from both sides of the jaw or from the front of the jaw, or both sets of horns are combined on the same mask. Usually the large pointed teeth are separated, but sometimes the lower and upper teeth are carved together, the jaw thus forming a rectangular cage. A human element is indicated on the face (see also Fig. 171) by a long, wedge-shaped nose, arched eyebrows, pointed ears in lozenge shape. In *Les Senoufo,* Holas calls these masks *waniougo* ("recalling the chaotic conditions of the primordial universe"). (2) Fig. 171 illustrates the second type, combining human and animal elements, but without the long horns.* In this group belongs also the *double helmet mask,* which has a central hood and on both sides open jaws, pointed teeth, curved double boar's tusks protruding from the sides of the jaws and on top of them.

Other masks definitely attempt to represent a given animal (omitting human features) such as a baboon or a hyena.† Fig. 66 has a large, open jaw with broad teeth inside. There is a ridge on the forehead and a chameleon forms the crest. There are examples in which the double helmet mask has at one side the hyena jaw and on the other side a jaw with pointed teeth.

Another helmet mask called *deguele* covers the head completely, the rim resting on the shoulders. Some examples have two square openings for the eyes (Fig. 174), others a

* Often the horn of a bushbuck filled with magical substance is placed in a hole in the forehead, giving the wearer power over an enemy from a distance.

† These masks, also known as *korubla,* may represent the sacred hyena of legend and were used at funerals.

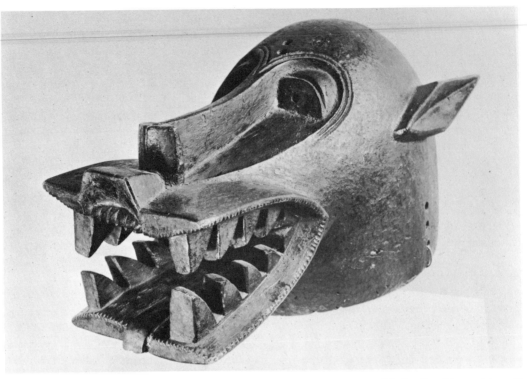

171. *Mask, Korubla society.* 16"

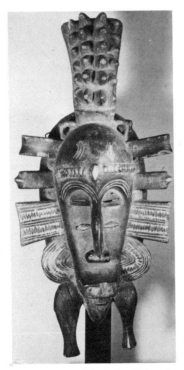

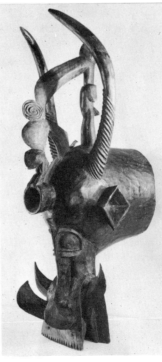

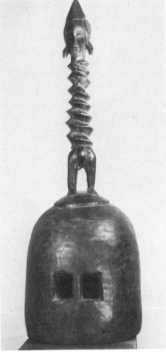

172. *Mask* (kpelie). 14" 173. *Mask, Korubla society.* 29" 174. *Mask* (deguele). 14"

larger square or rectangular opening for the face. This type is surmounted by an armless female figure with a crested coiffure, her body made of rows of rings or carved in a spiral, some having prominent pointed breasts.

HEADDRESSES. One is known as *kwonro*, a wicker or wood cap surmounted either by a board that is flat (round or angular) and has openwork with a lizard in the middle or by a much larger board with openwork consisting of multiple motifs such as figures, animals, and other designs.

Entirely different is the so-called "bovine" hemispherical headpiece, its base hollowed out to form a cap. One example has a square form, with eyes and other features making a human face, and two large horns. The legs of this horned face stand on the front of the cap. In another example the casque has in front a huge wooden crescent (appearing like a wide, flat horn) with a stylized human face in the middle, the cap surmounted by an equestrian figure in the center of the crescent shape.

Another caplike headdress is Fig. 175, which has two horns, a pair of ears on both sides, and ten round protrusions (only five can be seen in the illustration).

An unusual headdress is made completely of cowrie shells, with a superstructure and a 5-foot-long "tail" (Huet has fine photographs of them). Part of the headdress is the beak of a bird, which comes down over the face of the wearer.

OTHER SCULPTURE. The heddle pulleys of the Senufo differ from those of the Baule and Guro in that they often use an animal head with long beak as motif.

Senufo doors are larger than Dogon doors, often 5 feet high. They have relief carvings with a center sun motif. The other motifs most often used are face-mask designs, human figures, and animals (mostly lizards), each of them having a symbolic meaning. Doors were used for the dwellings of the chief or notables or for shrines.

The ritual drums of the Senufo are either on four short legs or are supported by a sitting figure (Fig. 170). The drum itself is decorated in relief with the same type of emblematic carvings as the doors.

The Senufo, particularly in the Korhogo region, also made containers for holding magical substances and preventive medicines. Often they have four legs, with a lid that resembles a smaller version of the *kpelie* mask.

Unusual are the wooden "flying birds" (*kono*) with a smaller identical bird above, supported on a twisted wire. The wings are outstretched with two holes. The tail is splayed, with legs and feet below, the body pierced through with a round hole into which a pole is attached. At ancestral rites (*kurli*) two dancers held this pole in the air.

DAN (YAKOBA)

The Dan people called themselves Danpome ("Dan-speaking people"). Masks similar to those classified below were also used in the upper part of the Republic of Guinea and in

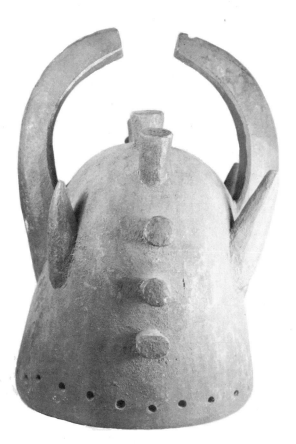

175. Headdress, Senufo, Rep. of the Ivory Coast
30½"

Liberia. And the Dan have themselves adopted the style of the roughly carved Guere masks.

The range and development of style forms in this region, particularly in MASKS, has inspired extensive studies. Since Vandenhoute's research is based on field study and covers the largest area, we shall adopt his classification:

(1) The *classic* Dan style is characterized by an idealized realism of the human face, executed usually in a smooth, polished manner, with high, domed forehead, sensitively carved mouth, sometimes inset with human, animal, or metal teeth, eyes either completely round (Fig. 80), slits (Fig. 82), or rectangular. Some masks have a hairdo and some a beard woven of black raffia or hair. Others have one or more incised grooves on the rim of the mask, a stylized representation of the tattoo marks of the Diomande tribe. Or the face is stylized into two flat planes with eyes at the meeting of the planes of the brows and cheeks.

(2) Masks with beaklike mouth may have a movable lower jaw (Fig. 148) or be covered with hair.

(3) The *southern* Dan style is characterized by more stylized forms. A vertical scarification mark on the forehead is often continued on the nose; the pointed chin and the forehead are flatter than classical Dan. The eyes are slanted or carved as slits.

(4) The *Dan-Guere* substyle includes three main mask types. First, and most amazing, cubistic constructions in which the dominant angularity, mostly consisting of triangular patterns, is strongly contrasted with secondary round shapes. The mask in Fig. 58, although Geh, is a good illustration of this type: the cheeks, nose, and eyes form triangular shapes contrasting with the curving forehead and circular mouth. In Fig. 81 the nose, mouth, and cheeks are triangular, the forehead and eyes round. (These two examples illustrate again the basic interplay of round and angular shapes in African art.) The second type of Dan-Guere mask has a pointed chin, protruding, tubular eyes, and carved ornaments on the forehead, a stylization of small antelope horns. The third type is characterized by a naturalistic rendering of Negroid features (Fig. 59).

(5) The so-called *Flanpleu* style is named after a village which developed a style marked by heavy eyelids, protruding mouth, tilted upper lip, bulging forehead, and small antelope-horn ornament.

In the region of Man, human HEADS in terra cotta, with head feathers.

Two tribes living in the Dan region should be mentioned. One is the Tura mountain people, makers of Dan-type masks of lesser technical perfection for use in the ancestor cult. Each Tura mask has a name denoting its particular role in the ceremonies. The other tribe is the Mau, living in the vicinity of Touba, who also adopted the Dan style, but they covered a mask completely or partially with red cloth (as in Fig. 149), using a narrow band of aluminum to outline the eyes.

GUERE-OUOBE (NGERE-WOBE)

MASKS. Although we classify the following masks under Guere-Ouobe, other tribes, such as the Niabwa and the Bete, also used them.

Holas discusses the difference between the sophisticated, refined art of the people of the sun-drenched savannah and the aggressive, brutal art of the deep forest regions in the west, bordering Liberia. Most Guere-Ouobe masks were created to frighten, having the gaping jaw of a wild beast, tubular eyes, a strong, flat triangular nose (Fig. 44). Leopard's teeth, porcupine quills, and empty shotgun cartridges were used for the Guere masks known as *te gla*. These additions were signs of the warrior class, and by extension symbolized strength and masculinity. Some Guere masks have a vertical scar on the forehead (Fig. 162), some a white line drawn at the level of the eyes. Each mask was designed for a precise purpose; the function of the *zoroa gla*, for example, was the collection of food for the elders of the village. Today, under changed social conditions, many Guere-Ouobe masks are used for entertainment.

A type of Guere-Ouobe portrait mask has the most realistic Negroid features to be found in African masks.

STATUES. Guere-type statues (identified by Schwab as Kra, Bassa, and Gio from the hin-

terland of Liberia) are characterized by bulbous forms for the legs and arms, the arms separate from the body. Many have highly developed, pendulous breasts, a neck composed of ringlike forms, and a face that resembles some Dan masks, often with a painted white strip covering the eyes. Most of these statues have a raffia hairdo attached to the top of the head, and another cloth attached around the waist covering the sexual parts.

The Guere of the Guiglo region (also the Gio of Liberia) make brass casts of small figurines (from 5 to 8 inches high): figures with outstretched arms, mothers (most having highly developed breasts) with baby on the back or holding a child by the hand), male figures in various positions (Figs. 153 and 154).

GURO (GOURO)

No statues are known.

Their masks have long, narrow, human faces with refined features; long, narrow nose, oval eyes, prominent forehead, chin with frequent beardlike extension. The hairdo is often carved in elaborate geometrical patterns, surmounted by horns (Fig. 83) or a totem animal.* In some the nose forms an animal-like beak, similar to those of the Poro society. Rather well known is the *zamble* mask combining the features of hyena, crocodile, and antelope (Fig. 43). Masks of this type are usually worn by two dancers, one mask representing the male, the other the female. They are enthusiastically applauded by the villagers when they appear. Most of them are polychromed.

Guro heddle pulleys have great beauty (Fig. 161), the heads carved on them having the elongated, long-nosed face used on many of the face masks.

EBRIE (ALANGUA) *and* ATIE (ATYE)

Standing and seated statues (Figs. 176 and 177) with bulbous arms and legs show strong Baule influence, but they are very marked by their distinctive style. Usually the arms are

* The Dakar museum has a very unusual example of this type. The face is like that in Fig. 83, but a triangular mass has been carved on the top of the head and into this a large bunch of feathers has been inserted.

176. *Standing figure, Ebrie (Alangua), Rep. of the Ivory Coast. 9½"*

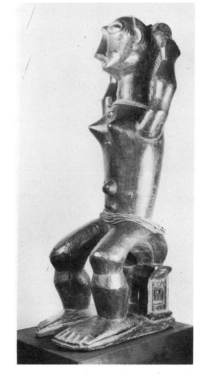

177. *Seated figure, Ebrie (Alangua), Rep. of the Ivory Coast. 18"*

raised to touch the head; often the hairdo is geometric. What is unusual is that the relief scarification marks are achieved by insertion of small wooden plugs into the carving. Representing the forces of female fecundity, these statues were used in rituals to make these forces work.

This type of statue was known under the tribal name of Alangua, based upon an earlier Musée de Trocadéro reference; it is now more appropriate to attribute them to the people living on the border of the lagoon Ebrié, partly Atie, partly Ebrie.

AGNI (ANYI)

This is a small tribe living on the coastal areas of the Republic of the Ivory Coast next to the Ashanti, and the fact that they specialized in terra-cotta funerary figures is probably because of Ashanti influence. The best known are those found in Krinjabo (Fig. 178): a seated man with elongated neck formed of rings (perhaps a choker) and long, slitted eyes; some are bearded, with a flat circular hat, hands stretched out in front. There are also female fig-

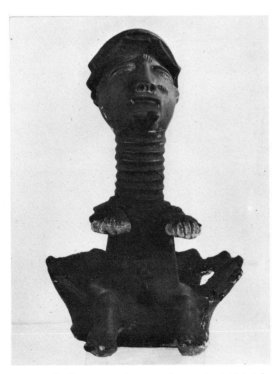

178. *Terra-cotta funerary figure, Agni, Krinjabo region, Rep. of the Ivory Coast. 16"*

ures, some only heads, the hair in the form of a number of small protuberances or arranged in tresses. In others the body is like a column, with outstretched arms. There are also wood carvings very similar in style to those of the Baule tribe, except that the faces are rather flat, the necks formed of small rings, and the carvings painted black, white, or red, and decorated with earrings, necklaces, etc. Couples seeking fertility made offerings to these statues.

BETE

The Bete live in the region around Gagnoa, and although they have produced masks with human features, their ancestor-cult statue is rather unusual. The standing ancestor-cult statue has a cone-shaped head with a crest having incisions. The massive cylindrical neck is nearly as thick as the head itself; the arms held out from the body are short, showing the palms of the hands; the legs are heavy. Most unusual are the rich scarification marks, lozenge-shaped, covering the whole torso and also the thighs.

The Bete masks are characterized by an elongated, rectangular shape, with hornlike points carved around the mouth, prominent domed forehead, pierced oval eyes, short nose. There are also masks composed of half-human, half-animal features (similar to the Ouobe masks), representing spirits of nature and threatening spirits that had to be appeased by sacrifices.

REPUBLIC OF THE UPPER VOLTA (IVORY COAST)

BOBO

The Bobo tribe (numbering about 300,000) are surrounded on the east by the Mossi, on the south by the Senufo and the Lobi, on the west by the Bambara, and on the north by the Dogon. Although this tribe has produced a very marked and distinguished artistic style of its own, certain influences of the neighboring tribes can be detected.

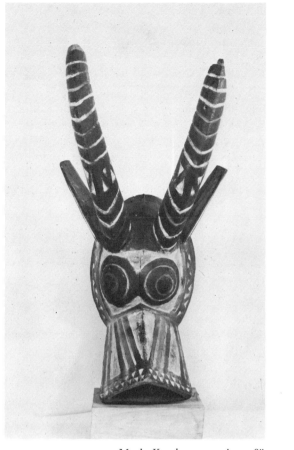

179. *Mask, Koudougou region. 18"*

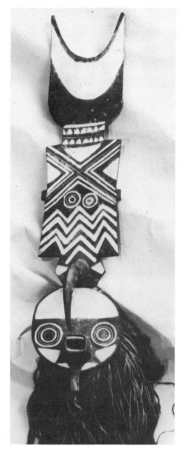

180. *Mask with superstructure*
40"

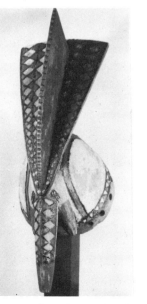

181. *Bird mask, Koudougou*
region. 14"

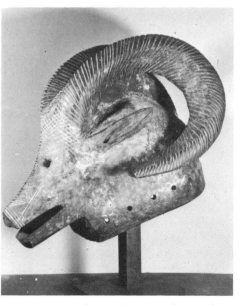

182. *Horned-animal mask, Bobo-Dioulasso*
district. 15" x 20"

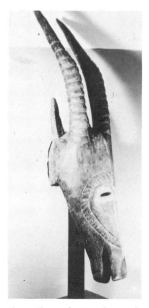

183. *Horned-animal mask,*
Bobo-Dioulasso district. 39"

Perhaps best known among their masks are those with planklike, polychromed (red, white, dark brown, black) superstructures (Fig. 180), similar in concept to some Mossi and also to some Dogon masks with planks.* The concentric rings that indicate the eyes occur also on their animal masks. These masks were used by a group of dancers (as Huet has shown) at agricultural rituals in the spring and at the beginning of the farming season. Less well known are the masks of similar style without superstructures (Fig. 48).

The next large group of masks, mostly from the Koudougou region, represents animals, many with square or triangular jaws (Fig. 179).† Their bird masks (Fig. 181), with beaks of various lengths, are highly abstracted and stylized, and also polychromed.

Different in design are the animal masks from the region around Bobo-Dioulasso, where the Bobo-Fing and Bobo-Dioula live. A hood-like structure fits over the top of the head, the mask face covering the face of the wearer (Fig. 183), or completely covers the head (Fig. 182). There are also (in the Dakar museum) massive rams' heads with heavy horns and buffalo masks with horns turned upward in semicircles.

The plank construction idea is also carried out in the mask called "the bird of the night," but the plank is used horizontally. In the middle of the plank is a triangular shape with concentric round eyes and a round hole for the nose, above which the beak of a bird protrudes. This part functions as the face of the mask, and the two side parts of the plank represent the wings of the bird.

An unusual stool is attributed to this tribe (Fig. 186), the head showing strong Bambara

* Two other types of masks with superstructures in the Dakar museum are identified as Gourma-Foulce and Duahigouya, from the Aribinda region. One has a roughly carved face, with an elaborate superstructure with a pierced effect (about four times the size of the face), painted brown and decorated with white linear patterns. The second type has as the base a human face with beaklike nose, surmounted by a figure (again about four times the size of the mask) similar to the Mossi mask in Fig. 184.

† The Dakar museum has a similar, polychromed mask that is particularly striking because of its elegance and daring construction. The face is the same, but instead of horns a thin superstructure (about 3 to 5 inches wide and 8 feet long) rises from the middle of the head, with zigzag edges.

influence. There is a similar stool, but with three legs, in the Musée de l'Homme, called *nani*, attributed to Bobo-Ule.

LOBI

This tribe lives in the northern part of the Republic of the Ivory Coast and the southern part of Upper Volta. The Lobi have produced mostly roughly carved figures, some without feet, standing on a round base, some with rather bulbous forms. These statues were used by soothsayers and by the leaders of the family cult.

Also stools similar to Fig. 186, mainly three-legged with a human or animal head.

MOSSI

Very close to the structure of the Bobo mask is the Mossi dance mask used by the female Wango society, except that the face is more simplified and abstracted, with a bold concave surface, the middle of which has a straight vertical line with notched triangular cuts; the eyes are pierced also in a triangular pattern. Many have flat planks painted with geometric patterns, often five to seven times the size of the mask itself, reaching 6 feet, some having small heads carved on the top, some with long horns only. Fig. 184 shows one with a figure on the top, a concept also adopted by the Dogon. These masks were used at burial and agricultural rites.

There is also a headdress like a small cap (Fig. 185) the side of which shows some Bobo influence. There are similar headdresses surmounted by an animal, usually an antelope.

KORUMBA

This tribe lives between the Mossi and the Dogon in the Aribinda region. They produced a very unusual antelope head (Fig. 187), mostly polychromed, representing only the neck, the head, and the horns (often combined with the ears). At the end of mourning, it was fastened to the head and used to drive away the soul of the deceased, who might harm the living.

The Korumba also have headpieces with abstract superstructures.

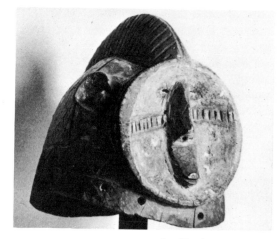

185. *Headgear, Mossi. 7"*

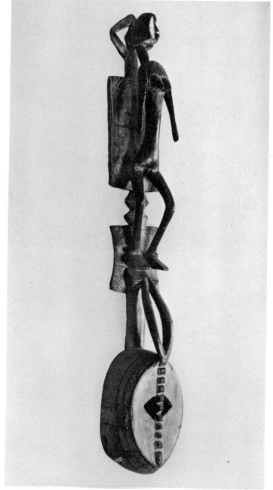

184. *Mask with figure as superstructure, Wango society, Mossi. 43"*

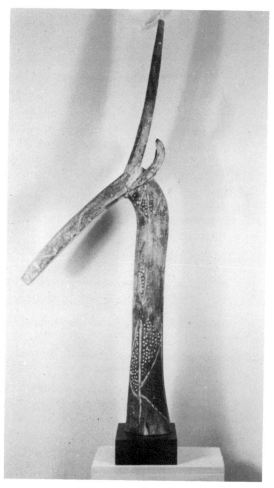

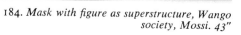

186. *Stool, Bobo-Bambara. 6" x 13"*

187. *Antelope headdress, Korumba. 41"*

GHANA
(GOLD COAST)

Ghana is composed of three sections: the southern region, with Accra the main city and capital of the country; the middle section of the Ashanti, with Kumasi the main city; and the Northern Territories.

ASHANTI

The Ashanti- and Akan-speaking people were organized into a confederacy about 1700. Their Golden Stool was then introduced by one of their rulers to symbolize the "soul" of the nation, hence standing for the unity of the body and soul. They have an extremely complex social system centering around the queen mother's sacredness and the divine king. They also developed an elaborate system of symbolism in which number, design patterns, animals, etc., all have symbolic meanings of their own.

The art of Ashanti can be classified into two main groups: metalwork (casts of brass or gold using the lost-wax method and objects made of hammered metal sheets) and wood carvings.

METALWORK. Best known are the small brass figurines (usually measuring from 1 to 3 inches, with some larger ones mostly used by the chief and the king). Called *mrammuo*, they weighed the gold dust used as exchange before the Europeans introduced their currency. These small objects are executed with very fine craftsmanship and artistic care, and they constitute one of the finest series of small cast objects in the history of art. Fig. 101 only illustrates a very small portion of the available material, which can be broken down into four major categories:

(1) Human figures, single or as many as four together; also small masks (about 2 inches) such as Fig. 188. The human figurines depict scenes in a very vigorous manner, generally referring to some legend or proverb. Some examples: two old men meeting and shaking hands (known as Amoaka and Adu); man with sacrificial chicken; man holding barrel of gunpowder on his head and flint gun on his shoulders; mother carrying her child on her back.

(2) There are a great number of animal rep-resentations, each having a symbolic meaning: antelope, the supreme deity Nyame; snake, death; crocodile, scepticism; two crocodiles with one stomach, unity in diversity; lion, power; porcupine, fighting strength. There are birds and fish of great variety, some symbolizing total ownership.

(3) Inanimate objects such as weapons, stools, drums, lamps, gongs, fly whisks, shields, ceremonial swords, sandals, etc. Some objects were not modeled first in wax but were used to form a mold; after the original object was burned out, liquid metal was poured into the cavity. In this group: seeds, plants, claws of crabs, snails, etc.

(4) Geometric designs, each having a symbolic meaning, as Meyerowitz has indicated (*The Sacred State of the Akan*). A straight line indicates the life-giving ray of the sun and is a male symbol; a zigzag line means prudence, application of wisdom; an undulating line stands for the stream of life or for water. A crescent-moon shape is a female symbol; an encircled dot stands for fertility; a ring shape is male, a triangular shape female, etc. The swastika appears on some of them, symbolizing the solar wheel with its rays.

As to the actual weight value of each gold weight, we have no study yet. Attempts have been made by Abel to classify the geometric weights; he was able to establish that the basic unit was a grain, two of which resulted in a *ba* (0.146 grams); three forming another unit called *takou* (0.219 grams).

There are many recasts of old gold weights, the best indications of age being the great care and detail of the modeling, the deep groove between the very thin wax thread used, the thinness of the legs and arms, the great expressiveness of movement, and the very fine patina caused by wear.

Gold-dust boxes should be mentioned in connection with the gold weights. There are many in hammered metal, mostly in oval form, but there are others that are cast, which have a square form or an unusual cross form decorated by very thin wax thread placed on the flat surface of the lid (Fig. 193).

Ceremonial swords (Fig. 191), consisting of

iron blades and two round wooden pieces for grips, are often covered with very thin gold sheets. Often below the handle a cast object (some in brass, some in gold) is attached, as a rule representing an animal such as a crocodile, a lizard, a turtle, or a tortoise. These ceremonial swords are called *akrafena* or *akofena*, depending upon their function. Another type of ceremonial sword is cast completely of iron (Fig. 192) and has a snake for the handle, a blade with pierced effect, a lizard in the middle.* Other ceremonial objects cast in metal are umbrella handles (Fig. 194).

There are many highly elaborate gold ornaments with geometric patterns. The most important is "the soul-bearer's disk," a personal ornament used either on the body or on the dress. Many other gold ornaments are worn on the cap of the chief.† Gold casts also include small masks (similar to Fig. 158), rings, ankle rings, bracelets, etc.

Brass cast vessels known as *kuduo* are made in various shapes, but the round form shown in Fig. 190 is the most usual. This example has a grille beneath the vessel's main body; others have three legs, although some square *kuduo* have four. Often they are richly ornamented in bas-relief with birds, double crocodiles, etc. All of them have lids (mostly round) ornamented with a free-standing figure (Fig. 190 having an elephant) which was also used as a handle, or with groups of figures similar to the gold-weight figures, many of them standing for well-known proverbs. The original function of the *kuduo* was religious. The vessel was believed to contain *ntoro*, the inherited male soul-substance. By presenting an offering to the spirit in "the cup of souls," one was able to gain the good will of the soul, increasing one's sense of being protected and gaining the self-confidence needed for an undertaking.

* Similar ceremonial swords, some with double blades, are exhibited in the National Museum in Accra. The snake (or two intertwined snakes) emerges from a wooden handle with double globes (like the handle in Fig. 191), covered in gold foil. It is reported that these swords were used when loyalty was sworn to the chief.

† The Cultural Center museum in Kumasi has many of these gold ornaments, some made of small pieces of wood covered with thin sheets of gold.

Another type of round vessel, this time made of hammered sheets of brass, is the *forowa* (Fig. 189), a container of grease. This vessel is decorated with very fine incisions, mostly geometric, some with a chicken motif. Often the chicken's neck turns backward, representing the *sankofa* bird. These *forowa* vessels, some with lock and key, have a very delicate sense of proportion, recalling some of the metal vessels of the Shang dynasty of China.

WOOD CARVINGS. In *Religion and Art in Ashanti,* Rattray has illustrated thirty different styles of ceremonial stools, each having a name associated with a particular idea and function. They all have crescent-shaped seats and flat bases, the great difference occuring in the middle supporting structures. There are some with metal appliqué similar to the ceremonial chairs. Of two basic types, one was guarded at the shrine of the tribal ancestor and had a custodian who poured a libation upon the stool from a cup, hence feeding the ancestor. The other type (similar in style) was in common use (Fig. 47, the *nsebe'gwa* or "the amulet stool").

Ashanti chairs, often with footrest, are highly elaborate, the various styles resembling European chairs from different periods. Since the indigenous tradition all over Africa is the making of stools rather than chairs, we can assume that, as in the Batshioko tribe, these chairs are copies of European chairs probably imported during the days of the slave trade.

Rather naturalistically carved wood figures in various positions, such as drumming, were used to illustrate legends or stories. Rattray calls them the *mmoatia* or "fairy-tale" figures. *Esi manse* figures (Fig. 205) belong in this group. Although only a fragment, this example shows the great delicateness of the carving. In others, hair is attached to the head.

In great contrast to these naturalistic figures are the well-known carvings of the Ashanti labeled *akua'ba*. In the Twi language the word *akua* means a "child born on Wednesday" and *ba* means "child." The figurine, worn by women in the back of the waistcloth, had two functions: first, to insure a good birth and also to impart the beauty of the statue to the child and, second, to help a woman become preg-

Ashanti Metalwork, Ghana

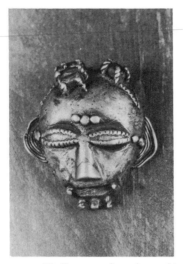

188. *Brass mask used as gold weight* (mrammuo). *2½"*

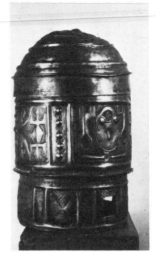

189. *Hammered-metal grease container* (forowa). *7"*

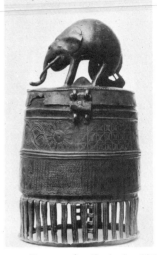

190. *Brass casket* (kuduo). *7½"*

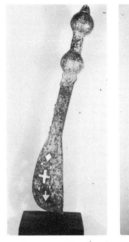

191. *Ceremonial sword* (akrafena). *17"*

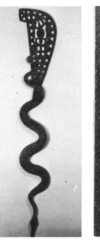

192. *Ceremonial sword. 40"*

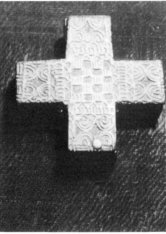

193. *Brass gold-dust box. 2½"*

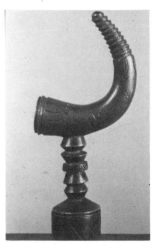

194. *Brass umbrella handle 6¼"*

Akua'ba Statues

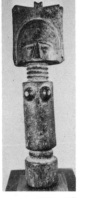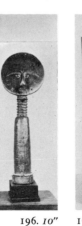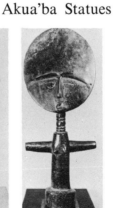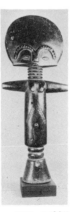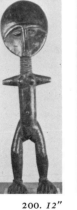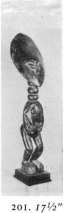

195. *12"* 196. *10"* 197. *15½"* 198. *11"* 199. *13½"* 200. *12"* 201. *17½"*

nant. A Ghanian writer, Antuban, indicates another use: When a child disappeared, the *akua'ba* statue was placed with food and silver coins at the edge of the forest to attract the malevolent spirit responsible; the spirit would then exchange the child for the statue. *Akua'ba* are now often known as "dolls," but only in the last twenty years, under European influence, have they become playthings.

Akua'ba statues (Figs. 195–201) have three basic forms: (1) Figs. 195, 196, and 197 all have columnar bodies, no legs, and no arms, though differing in the head shapes: Fig. 195 has a semiround head with an ornament around it; in Fig. 196 the head is a completely flat, round disk; in Fig. 197 the head is rectangular. Fig. 195 also has breasts. (2) This is the best-known type with columnar body, no legs, but with two outstretched arms and a round, flat head (Fig. 198). This type sometimes has an oval head. Fig. 199 resembles Fig. 198 except for the straight line at the bottom of the head and the two carved rings at the base. (3) Fig. 200 shows the type in which both legs are highly developed, a trend toward naturalism. Fig. 201 is rather unusual, with oval head, bent legs, arms set close to the body, and heavy rings at the neck.

In general the head of one of these figurines is a slightly convex disk, the highly stylized eyebrows forming an arch carved in relief with the long and narrow nose, nose and eyebrows sometimes of the same thickness. In many the head is set at an angle to the body similar to Cycladic figures. The incised eyes are round, oval, or lozenge-shaped. The mouth is usually very small and indicated by two vertical lines; often there is no mouth at all. There are finely incised scars marked on the face and often small holes are drilled around the rim of the head to hold small bead-rings. More rare are those with carved ears, into which metal earrings are sometimes placed. On the back of many figurines are engraved symbolic patterns similar to those of the geometric gold weights. The neck is usually round with three to eight rings. Frequently there are several rows of small bands of beads around the neck, the base, or looped through small holes drilled at the end of the outstretched arms. They vary in color—natural brown, weathered gray, mostly

the white wood stained black. (In a 1963 study by the writer an attempt was made to establish a connection between the *akua'ba* statues and the Egyptian *ankh* sign.)

Also among Ashanti wood carvings are a large number of combs, mostly with a flat head at the top (Fig. 203); and ceremonial staffs about 5 feet long, with one or two animals, a sitting figure, or other carving on the top, covered with gold foil.

POTTERY. In terra cotta there are funerary figures, sometimes only a head (Fig. 202 is a good example). At present large numbers are produced for trade.

They also produce black earthenware vessels with lids, each lid having a human head on the top.

BRON (BRONG, ABRON)

The Bron live north of the Ashanti. Except for two bronze masks (Fig. 204), very little is known of their work.

GRUNSHI (GOUROUNSI)

This tribe lives in the northern part of Ghana, having as their northern neighbors the Bobo and the Mossi. Perhaps the closeness to these tribes accounts for the Grunshi production of large, flat, planklike structures known as *nafana*, which have a strong abstract appearance. Most of them are polychromed. Fig. 207 has a basic triangular form, with a human face carved in bas-relief in the center. In other examples the lower triangular shape represents a human face, having two tubular protrusions for eyes and one for the mouth. Fig. 206 illustrates another type, with square designs used on the lower part and triangular designs on the horns. The majority of the *nafana* masks have inward-curving horns symbolizing the crescent moon (the female attribute). Some have a tall, open-work, rectangular superstructure with a circular projection symbolizing the sun (the male attribute). There are similar planklike structures in the Abidjan museum attributed to the Abron (Bron) of the Bondoukou area of the Republic of the Ivory Coast and in the Accra museum attributed to the Bedo from the region of Debango.

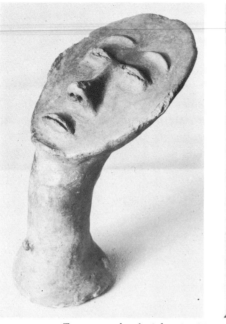

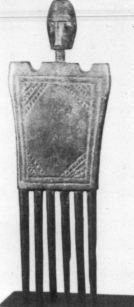

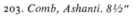

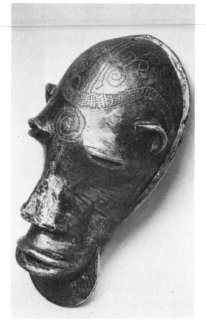

202. *Terra-cotta head, Ashanti. 28"*

203. *Comb, Ashanti. 8½"*

204. *Bronze mask, Bron. 6"*

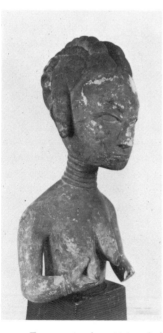

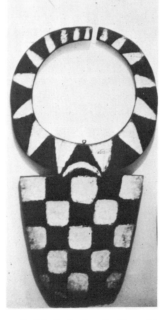

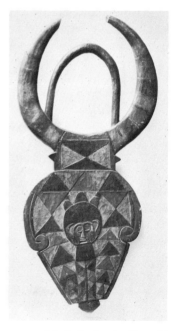

205. *Fragment of a statue (esi manse), Ashanti. 12"*

206. *Mask (nafana), Grunshi 55"*

207. *Mask (nafana), Grunshi 58"*

REPUBLIC OF TOGO (TOGO)

EWE

Clay figures, called *legba*, used as tribal or family fetish, phallic form, crest of cock feathers representing the spirit of fecundity and generative power, goat hair as beard. *Aklama* statues, roughly carved out of wood, representing the protective spirit. *Ibeji* twin fetishes (Fig. 36), for protection of survivor after death of twin. Animal figures in black clay. Copper figures in lost-wax technique, representing animals and small masks.

REPUBLIC OF DAHOMEY (DAHOMEY)

PORTO NOVO

This region of the Togo coast is the place of origin of many of the Ewe works. In addition: life-size royal statues characterized by a monumental naturalism; wood carvings in relief of decorative patterns with human and animal figures; large thrones supported by kneeling or erect human figures; bowls supported by human figures; animal figures recently produced.

YORUBA

The Yoruba live here but also in Togo and along the coast of Ghana. Since the majority, about three million, live in southwestern Nigeria, their art is discussed under Nigeria.

ABOMEY

Originating from the area of this city are: Small brass figurines, often in groups, in lost-wax technique, of recent production, mainly in a repeated, traditional pattern. Fine old wrought-iron and brass figures, now rare. Equestrian figure of the mythological god Obatala. *Legba* clay statues. Animal figures representing mythical gods and demons—alligator symbolizing the sun god, Lisa; lizard symbolizing the national god, Togbodonou.

Carved wood or clay wall reliefs composed of figures, animals, and plants.

Crude, massive, caplike masks, colored with commercial, imported colors (similar to Fig. 223).

Houseposts in the form of human figures.

FON

Statues with sword in hand, with animal head, or with arms outstretched. Animal-head masks surmounted by a human figure.

FEDERAL REPUBLIC OF NIGERIA (NIGERIA)

One of the most important characteristics in the art of Nigeria is that in spite of the tribal style differences, in general their carvings are more complex than the majority of African works. In Nigeria many figures are sitting, crouching, riding a horse, holding tools in their hands, and are often surrounded by groups of figures, a combination of human and animal representations. This complexity of representation reflects the complexity of the social order, rooted in a highly elaborate mythology and expressed through a large number of secret societies.

The Yoruba mythology, for instance, had a great number of gods and demigods. The highest god was Olorun, the owner of heaven, from which Obatala, the male, and Odudua, the female, deities emerged. The *orisha,* or demigods, personified natural forces or phenomena: Shango, lightning; Olokun, the sea (this god also became the representative of the Benin king, *Oba*); Olosa, the lagoon; Oko, farming and the harvest; Oya (one of the wives of Shango), rivers; Osanyin, healing; Shapona, small pox; Ogun, war; Oshosi, the hunter; Eshu, malevolence and uncertainty; Ifa, divination; Ibeji, the protection of twins, etc. To have an idea about the great number of *orisha* is helpful since each of them had a cult and often not one but many carved objects (see discussion of Ifa, pages 190 and 193) were used in them.

Nigerian secret societies were not only numerous but differed from the majority of African male societies; they did not serve merely to initiate the adolescent into the adult society but

were societies for adults as well, indicating civic and political rank (such as the Ogboni of the Yoruba).

Because of the complexity of the art of Nigeria, the following division is appropriate: the art products of early historical periods, classified by place; and the art products according to regions—the southern and the northern parts of Nigeria—classified by tribe.

Art Products of Early Historical Periods

IFE

Terra-cotta heads of naturalistic tendency, with fine incisions on the face, were discovered in 1910–12 by Leo Frobenius. In 1936–38 bronze heads (also a pure copper mask) with greenish patina, in a strong naturalistic style reminiscent of Roman heads, were excavated—nineteen pieces in all, of which sixteen are in the possession of the *Oni* (king) of Ife and one is in the British Museum (Fig. 26). The heads are mostly life-size, some smaller. In 1949 another series of terra-cotta human and animal heads were excavated in Abiri, near Ife. All the bronze heads were cast by the lost-wax technique, with technical delicacy that surpasses all other casting. Most of the bronze heads, similar in style to the terra-cotta heads, have fine parallel incisions covering the whole face, probably scarification marks. Rows of holes along the hairline on the forehead and the line of mustache and beard must have held human hair, a tradition that survived in the Ekoi (Cameroon) skin-covered heads.

To the Yoruba, Ife was the source and spiritual center of their nation. It had a flourishing culture long before Benin. Its position resembled that of Delphi in ancient Greece. It was the home of the Yoruba oracle. As early as 1172 the Benin elders are said to have applied to Ife for a ruler. Bronze casting was introduced into Benin from Ife during the reign of Benin *Oba* (king) Oguola (about 1280). However, although the earliest Benin works show the influence of Ife heads, the Benin artists rejected the classic, naturalistic Ife style. An extremely great variety of objects was produced in Benin differing from the unique nat-

uralistic head style of Ife and more in the prevailing West African tradition of rendering conceptual reality, resulting in an abstract quality.

In Ife a most accomplished artistic form and technique seems to have appeared without any slow development, at least according to our present knowledge, and to have come to an end just as suddenly, showing no survival or further development. We must suppose that such an eruption of a new style as that of Ife must have been the effect of foreign influence, probably a direct Mediterranean influence.

TADA *and* JEBBA

Only a few years ago the most astonishing bronzes were found in the Nigerian fishing village of Tada, on the Niger River. One was a 2-foot-high seated figure with a strong resemblance to the early Egyptian "scribe" statue (Fig. 29), and closer to the Ife bronzes than to other West African sculpture. Another figure with clasped hands is different in style and inferior in workmanship.* A third figure, called *gago* (Fig. 27), about 4 feet high, with a tunic similar to that of the Coptic Nubians or Egyptians of the first century, was found at Jebba. Another larger, nude figure was also found, along with a warrior statue.

With these discoveries new vistas open in the history of western Africa.

ESIE

Equally mysterious and exciting in implication are the 750 stone statues found in the sacred grove near Esie (Figs. 30 and 209), seventy miles northeast of Ife. Most of the figures are seated, some on a mushroom-type stool. They average 22 inches in height. Two types of faces can be distinguished: one, a northern type, with swelling forehead, straight nose, and pointed beard; the other, a Negroid type, with broad nose and thick lips. They show a highly developed, coherent style of their own, very different from the Ife semiclassic features. We may assume from the richness of facial expression that they were portraits.

* Both figures have been restored and are in the National Museum of Nigeria in Lagos.

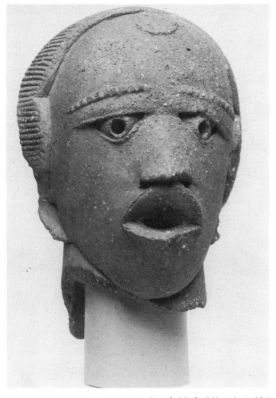

208. *Terra-cotta head, Nok, Nigeria. 7½″*

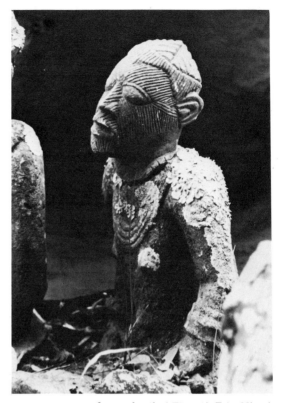

209. *Stone figure (detail of Fig. 30), Esie, Nigeria*

According to K. C. Murray (1951), these stone carvings are not more than 300 years old, and they might have been abandoned by the fugitives from the advancing Fulani about 120 years ago. Food offerings are still made to these statues at a yearly festival in March and permission of the images is asked to set fire to the bush for hunting purposes.

NOK

In the 1940's, at a depth of twenty-five feet, some terra-cotta heads were unearthed at Nok in the Northern Provinces (Fig. 208). Their estimated date is the latter half of the first millenium B.C. As yet we have no data for this culture and its possible connections with Nigerian archaeology.*

* The carvers of the *akwanshi,* monolithic stone figures that were found in the forest of the Cross River region, are also unknown. Now in the garden of the Lagos museum, they are phallic in form, with rounded tops representing the human head and with prominent navels. Some are 4 to 5 feet tall, and some have crudely incised indications of arms and hands or concentric circles engraved on them. (See *Cross River Monoliths* by Philip Allison.)

BENIN KINGDOM (BINI)

This is the best known among the Negro empires, discovered by the Portuguese in 1472 and described in documents by Dutch travelers as it was in 1668 and 1701.

The discovery of the Benin bronzes dates from 1897, when a British punitive expedition stripped the city of Benin of about 2,500 to 3,000 objects, which were carried to London. A Dutch traveler's description describes the city as it was in 1668 and expatiates on the splendor of the king's palace, where bronze plates decorated its rectangular pillars. This went unmentioned, however, in a later Dutch description (1701). The English in Benin found many buildings in ruins and the art objects scattered around or heaped in storerooms. What happened between 1668 and 1701 can only be conjectured. In all probability the decline of the slave trade and continuous tribal warfare contributed to the downfall of the kingdom.

In contrast to the extremely delicate execution of the plates, rough nail holes are found on

most. It is possible that originally the plates were mounted in grooved recesses on the pillars, without the use of nails, and that during one of the tribal invasions, probably between 1668 and 1701, the plates were ripped down; this would account for their damaged or broken condition. During the eighteenth century those plates must have been nailed up, later to be torn down again by other invaders and left in the state in which the British found them. Felix von Luschan's monumental work *Die Altertuemer von Benin* lists about 2,400 objects, mostly in museums. A representative collection of bronze and ivory pieces are at present very well exhibited in the Lagos museum (one of the African museums that concentrate on exhibiting with distinction objects of high quality rather than showing a quantity of mediocre or inferior pieces).

Some examples of the great variety of objects produced (in bronze and ivory) are given in Figs. 67 and 87–100. Benin art has given rise to a large literature; certain art periods have been established:

Archaic period	1149–1360
Old period	1360–1500
Great period	1500–1575
High period	1575–1648
New, flourishing period	1648–1691
Late period	1691–1819

Unfortunately, our limited space does not permit detailed descriptions of the great variety of artwork and the origin and use of each object. The casting was of a 2-to-3-millimeter thickness, a feat still unmatched by modern techniques. Also produced were steel tools so hard that they mystify modern steelmakers. It is calculated that with the advanced methods used today approximately six months of work would be needed to produce similar work. Von Luschan declares: "Cellini himself could not have molded better, nor anybody else before or after him."

Southern Area

YORUBA

The Yoruba people, with a population of over ten million (1963 census), extend into Dahomey, partly also into Ghana.

Their works of art can be divided into those used in the *orisha* cults and those used in secret societies.

ORISHA. Olokun, the god of the sea, is often represented in Benin art by a catfish. A representation of the Benin king *(Oba)* often has catfishlike appendages instead of legs. Ogun, the demigod of war, is symbolized by small brass cast figurines with spikes, called *edan* (Fig. 220), also used in the Ogboni society. Oya, the goddess of rivers (one of the wives of Shango), is a kneeling figure with exaggerated breasts (Fig. 84).

Eshu is sometimes called the Yoruba "devil" but in fact he was the divine trickster, having both good and bad qualities, corresponding to chance, the subject of the Ifa ceremony in which Eshu plays an important role. It was believed that it was Eshu who brought the Ifa cult to the Yoruba.

The art of the cult of Eshu has various forms. Conic mud pillars in phallic form were erected around which dances were performed. His image, mostly in profile, is carved on doors. A staff may have a handle consisting of a kneeling or standing figure or only a head. Fig. 210, with hairdo bent backward, has a strong phallic connotation. Our example is rather unusual because there is another head at the end of the curved hair. For the Ifa ceremony Eshu was represented by a small ivory head (Fig. 211) or by a head and torso carved in wood (Fig. 213) with cowrie shells hanging from its neck.

The *orisha* Ifa (not Ife) was the protector of the divination ceremony, which was conducted by a well-trained diviner (*babalawo*). According to the method of divination various implements were used:

(1) The bowl, called *adjelle-Ifa* or *adjelefa*, which contained sixteen palm nuts, is carved in a great variety of forms. Fig. 215 shows a dove as the supporting figure, Fig. 214 an equestrian figure with spear, but there are others with rooster, mother carrying a child on her back, fishes, drumming figure, kneeling woman offering a bowl, woman seated at a weaving stool, etc. Some also have a cover, attached by a hinge to the bowl. The sixteen palm nuts were thrown on the ground by the diviner, giving figurations called *odou;* developed from 256 basic

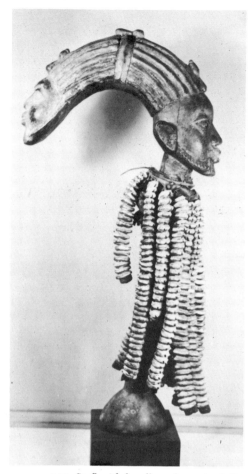

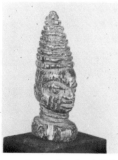

211. *Ivory head of Eshu (odousa).* 2½"

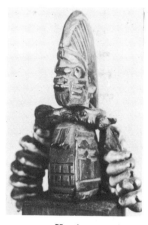

213. *Head of Eshu with cowrie shells (odousa).* 3½"

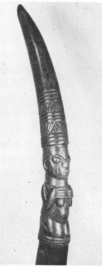

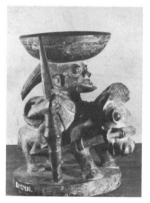

210. *Staff with handle and cowrie shells, Eshu cult.* 19"

212. *Ivory clapper (iroke).* 14"

214. *Bowl for Ifa divination (adjelefa).* 6"

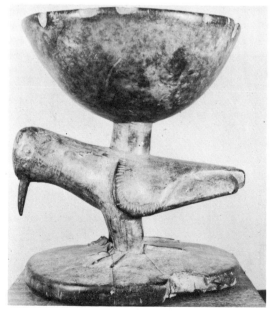

215. *Bowl for Ifa divination (adjelefa).* 6½"

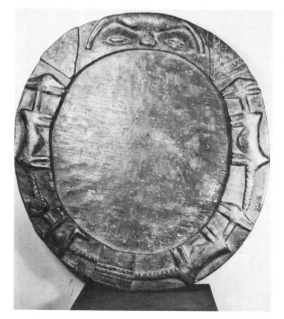

216. *Divination board (okoua-Ifa).* 15"

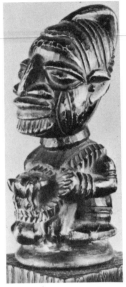

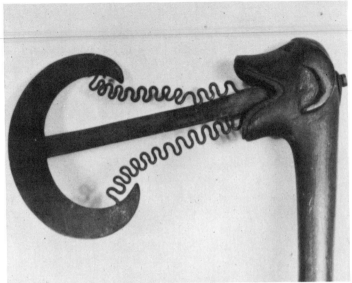

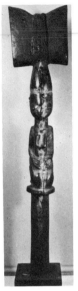

217. *Equestrian figure,*
Shango cult. 3"

218. *Head of a ceremonial axe, Shango cult. 16"*

219. *Shango*
staff (ose-
Shango). *23"*

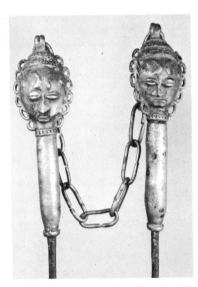

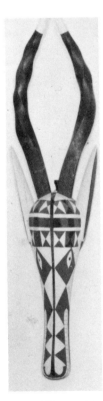

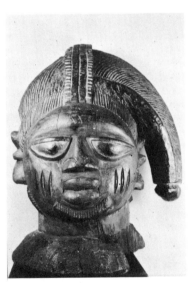

220. *Brass casts with spikes* (edan),
Ogboni society. 16"

222. *Headgear, Egongun society. 18"*

221. *Water-spirit*
mask (imole),
Ijebu Yoruba. 20"

designs are 1,680 formulas, evolved further into 4,056 designs, which the diviner was supposed to know.

(2) The next carved object used is the small ivory head of Eshu called *odousa* (Fig. 211), which was placed next to the divination board and used in the ceremony to appease the malevolence of Eshu.

(3) The divination board, called *okoua-Ifa* (Fig. 216), is carved in a round or rectangular shape (about 15 inches wide). Its border is always carved. The main figure is the head of Eshu, also various animals, couples copulating, interwoven with geometric designs. On this board white powder, often flour, was spread (white is sacred to Eshu) in which the *odou* were marked with the finger of the diviner.

(4) Before the divination began a clapper called *iroke*, usually made of an ivory horn, was used to call the attention of Eshu to the start of the ceremony. Fig. 212 is a kneeling figure. Some depict the head of Eshu, some only geometric designs.

(5) *Okwong-Ifa* is a carved box in a round or rectangular shape with geometric designs or figurines and having inside sections for holding clay, charcoal, limestone, and the powder of a red wood.

The *babalawo* performed his divination ritual every morning to foretell the day to come. He was also consulted by individuals wanting to know what course of action to take and by relatives of an expected child to find out whose grandfather or grandmother would return among the living in the child.

Shango is the *orisha* of lightning and also the legendary founder of the Yoruba nation. The Yoruba king (*Alafin*) himself traced his origin to this hero, who might have come from the east. Shango has many attributes and associations and accordingly different representations. The horse is connected with Shango in several ways, one legend linking him with the Hyksos, the Egyptian kings who first used horses in their warfare, and a Meroitic legend assumes Shango's relation to the king of Kush. Hence we have Shango portrayed as an equestrian figure alone (Fig. 217) or he is placed on the top of a mask (Fig. 224) surrounded by various figures, or he, on his horse holding spears,

forms the base for a bowl (Fig. 214). Another association is with Neolithic celts (polished stone chisels). When a great hurricane accompanied by lightning washed out from the ground such stone implements (left by prehistoric people), it was believed that they were sent by Shango, and for this reason he has another name, Jakuta, meaning "the thrower of stones," and the staff used in Shango ceremonies, known as *ose-Shango,* has a superstructure showing the double axe (Fig. 219). Shango is also associated with a ram spitting fire (connected with lightning); thus, an axe may have a carved ram's head (Fig. 218) with metal blade and undulating wire depicting this idea.*

Ibeji is the protective *orisha* of twins. The name derives from *ibi,* "first born," and *eji,* "two." Possibly accounting for the large number of Ibeji statues (Fig. 36) is the fact that in 1961 the twinning incidence among the Yoruba was 45 pairs of twins for 1,000 births as compared to 14 pairs among American Negroes and 9.9 in the United States in general. In contrast to the great diversity of attitudes toward twin birth (see Lagercrantz), the Yoruba welcome the birth of twins. Twins are considered more intelligent than others and thought to bring good luck, protecting the family. Twins are traditionally named Taimo (first born) and Kaide (second born) and believed to share one soul between them. If one of them dies, a statue is made to become the abode of the departed; hence, the surviving twin's half a soul is reunited with that of the deceased one. Most of the Ibeji statues are 10 inches tall and have bulging eyes, the pupils indicated by nails. The typical three-claw tribal scarification marks on both cheeks are often extended into a more elaborate design pattern. The face is sometimes so much rubbed with food (to feed the spirit residing in the statue) that the facial features are obliterated. The statues are often rubbed with red earth and the hair with indigo. Rows of colored beads may be looped on the neck, on the arms, etc. There is a marked uniformity in the over-all stylistic concept among all the Ibeji statues, but on close observation certain

* For further details, see the author's paper "Shango Sculpture" (1955).

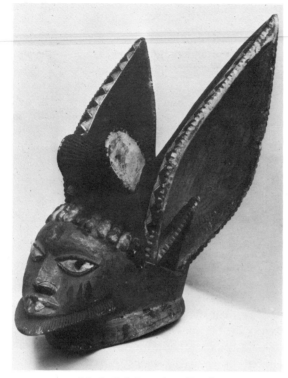

223. *Mask, Gelede society, Yoruba, Nigeria. 9″*

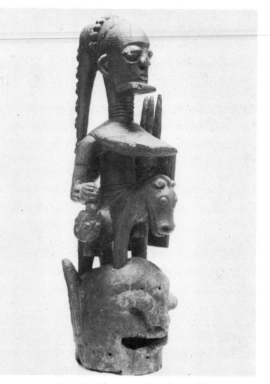

224. *Mask with equestrian figure, Shango cult, Yoruba, Nigeria. 40″*

differences reveal from which part of Yoruba-land each carving comes. Those from Oyo have a hairdo of multiple braids and are usually on a circular pedestal with rings around the base; they have the arms extended, hands placed against the thighs. Those of Ibji to the north: cross-hatched patterns on the base; Egba: the arms held akimbo; former Ijebu Province and Igboland: conic hairdo with braids, no marks on the base; former Abeokuta Province: round hairdo, strong naturalistic facial expression (see Nicol). The Lagos museum has an *ibeji* statue that is completely covered, except for the head, by a multicolored, patterned dress that is wider that the actual carving.

SECRET SOCIETIES. The Gelede society wore masks horizontally like a cap (Fig. 223). They usually have strong Negroid features, often a superstructure. As early as 1885 these masks were sold to Europeans. They show a use of commercial colors usually not found in African art. The chief deity of this society was Iyala (or Aiye), god of the earth and fertility and

the masks were used at the yearly fertility celebrations, also at the funeral of a member of this society. A very unusual carving used in the Gelede society has been mentioned to the author by Mr. Jacques Kerchache. Collected in the region of Adjohon, in Dahomey near the Nigerian border, this is a body-mask consisting of two enlarged breasts and prominent belly. This body-mask was carried on the chest by men performing dance rituals for female fertility.

The Egongun society also wore headgear on the top of the head. Fig. 222 has the traditional three claw marks of scarification on each cheek. The hairdo, similar to some Eshu work, has a phallic appearance. The Egongun society (mainly in the former province of Oyo) performed at a member's funeral by acting out the dead man's presence and talking in disguised voices. Frobenius indicates in *Das Unbekannt Afrika* that when sacrifices were made to the headgear the aim was to expiate a sin committed against the deceased. Masked members

appeared also at the founding of the town to promote its fertility.

Oro was a bullroarer's society and its main aim was to frighten the women. A slab of wood (sometimes decorated, sometimes with a figure in relief on it) was attached to a cord and swung around the head, emitting a noise. Similar bullroarer slabs have been used for the same purpose in Australia, Greece, Sumatra, etc.

The Ogboni society was composed mainly of noblemen, some documents indicating that it acted like the English House of Lords. Its role was social, political, and juridical, holding courts before which criminal cases were tried. Its insignia was the *edan* or *oreda,* usually brass casts upon iron spikes, often the two heads held together by a chain (Fig. 220). The *edan* had many uses. It was kept in the sanctuary of the society. When an enemy attached the city, this symbol was placed before the doors of the house to be protected. Great magical power was attached to it (because of the yellow metal); also it was believed to have an invigorating effect on its owner. The female *edan* was sent with a messenger as a sign of friendship, the male *edan* when the person approached was to account for a fault or offense. It was also used in the Ogun (war) cult.

The Yoruba of the Ibeju region lived along the coast and adopted water-spirit masks (*imole*) (Fig. 221) similar to those of the Ijaw. Mention must also be made of some remarkable bronze casts, several pieces of which were first published by Talbot in 1926, who identified them as Ijebu (Ode) Yoruba. These people, the earliest wave of Yoruba, under Osoula, the crown prince of Benin, conquered this territory around 1450.

A number of bronze casts, mostly in the British Museum, are identified as Lower Niger. There are various figures (one a hunter with an antelope over his shoulder), heads, groups of figurines, bells, bowls, and pendant plaques.

Farther east from the Ijebu Yoruba, not far from the coastal regions and below Benin City, live the Jekri and the Sobo. Fig. 225 is a wooden mask attributed to the Bini, although the style is rather different from the well-known Benin style. Some of these masks were found in Gwatto (or Gwato) south of Benin City; hence, it is possible to attribute them to the Jekri or to the Sobo.

The Yoruba style of Owo is very different from the usual one and may have certain resemblances to the Benin style, Benin being about sixty miles from Owo. Two magnificent carvings from this region represent a ram's head, or *osamasinmi* (Fig. 28), and a horned man's head (Fig. 227); both were used in the yam cult and were placed on the altars of the ancestors of chiefs. Sacrifices were made on festive occasions. (Note that the ram's horn is also used on Ibo *ikenga* statues, a case perhaps of outside influence.)

IBO (IGBO)

A large group of nearly seven million people, the Ibo are divided into northern Ibo (around Onitsha), southern Ibo (in what was Owerri Province), western Ibo, eastern Ibo (in the Cross River Region), and northeastern Ibo. Space limitation permits us to mention only the most important stylistic features.

STATUES. Among the Onitsha (northern) Ibo the best-known statuary is called *ikenga*. The name derives from *i-ke,* meaning "strength" or "power"; thus, *ikenga* means "place of strength." According to Talbot, this applies to "the part of the right arm from shoulder to elbow." When a man died, this part of an *ikenga* statue was broken off and buried with him.

There are various types of *ikenga* statues, but most of them have two curved horns symbolizing strength and vigor. Jeffreys, however, in his paper on the *ikenga,* suggests that the horns are ram's horns and that they might have a connection with the ram-headed Egyptian god Amen-Ra. Using Basden's (1921) and Talbot's (1932) descriptions, the following types of *ikenga* statues can be distinguished: (1) a head on a small base, with two horns (also in this category may be classified examples consisting of a base from which two horns protrude); (2) the body formed from a round block of wood, with two horns; (3) a block decorated with geometric shapes, the basic forms a head with horns, a pipe in the mouth

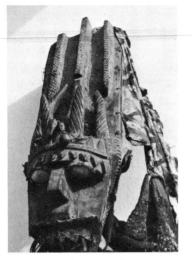

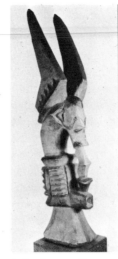

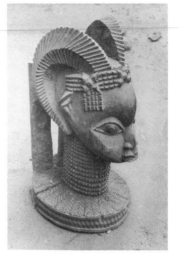

225. *Mask, Bini of Gwatto. 14"*

226. *Statue (ikenga), Ibo. 14"*

227. *Horned man's head, Yoruba, Owo region. 17"*

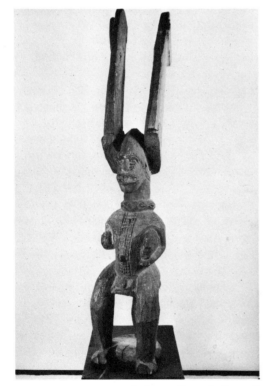

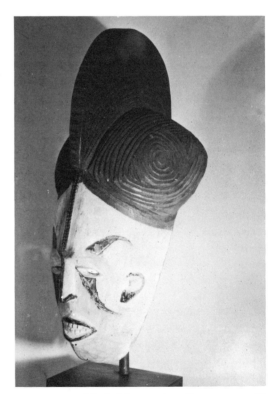

228. *Statue (ikenga), Ibo. 19"*

229. *Mask, Mmo society, Ibo. approx. 16"*

(Fig. 226); (4) a base with four heads, a single horn on each head; (5) the best-known type: a sitting figure holding a sword in his right hand, a severed head of the defeated enemy in his left hand, with horns attached to the figure's head (Fig. 228) (it is suggested that the severed head is linked with early head-hunting activities, as in the case of the Ekoi skin-covered heads); (6) very small *ikengas,* some roughly carved, some delicately, which were carried in the owner's pocket. Small figurines of the same type were also used by the diviner.

Like most of the Ibo carvings, *ikenga* statues are as a rule polychromes of white, black, and yellow (or ocher).

To the Ibo the *ikenga* statue embodied a protective spirit for worldly success, for achievement, a well-known motivating force among the Ibo. The statue was usually purchased when a young man moved into his own house. It was considered a house-protective statue and consulted before undertaking a new enterprise, before going on a journey or hunting, or in general for good luck. It was placed on the house altar. An interesting detail: Although the majority of African carvings were carved by professional carvers, they were consecrated by a "priest" before being used since they were implements in religio-magical rituals. *Ikenga* statues, however, were bought in market places and used in a house without the intervention of a magician; they were consecrated by the owner himself with palm wine and kola nuts.

The best-known statues of the southern Ibo are those that were used in the *ogbom* play honoring the earth deity, Ala, protector of human fertility. These carvings (Figs. 231–233), attached to basketwork worn on the head, consisted of: (1) a seated figure (some double figures); (2) a seated figure with raised arms holding a container; (3) a figure with a large head like a bust; (4) a figure holding a tray upon which a severed head is placed (perhaps a connection with the severed head of the *ikenga* statues). Most of the statues are black from deposits of soot since they were kept in the roof above the hearth when not in use.

Other Ibo carvings should also be mentioned: (1) Family ancestor figures, mostly from the Owerri region. Ranging in size from six feet to 10 inches, and usually polychromed, they are elongated, with bent arms, and have a variety of hairdos. They are placed either in family shrines or in larger village shrines. Prayers and sacrifices were offered to them to maintain the relationship with the spirits of the ancestors and to gain their good will for success. (2) Tall statues representing the masked maiden spirit (see below under masks). (3) Small carved objects representing animals or *ikenga*-type small figurines used by a diviner to forecast the future and discover which spirit has caused a sickness. (4) Small figurines, with elaborate hairdos, carved exclusively as dolls for young girls.

MASKS AND HEADDRESSES. The outstanding characteristic of the many Ibo masks is that they are painted chalk white, the color of the spirit. Often camwood red, orange or yellow, and pot black are also used. Masked dancers wore extremely elaborate costumes (sometimes ornamented with mirrors) and often their feet and hands were covered. Masks were used by secret societies for agricultural and funeral ceremonies.

The most widespread secret society among the northern Ibo was the Mmo. Dedicated to the cult of death, this society performed rites to induce a dead man's soul to go into the spiritual world, thus preventing him doing harm to the living. Members also functioned as a "police force," maintaining social order according to the old tradition. Another society, the Ozo, was composed of influential men who encouraged achievement. Another function was dedicated to the maiden spirit (*agbogho*). In the maiden-spirit ceremony three types of masks were used, all colored white, with design patterns: (1) a small face mask with design patterns around the eyes, mouth, or forehead, the mask being attached to the costume; (2) the well-known helmet mask (Fig. 229) that fitted the head like a cap, the mask itself covering the face; the crested top represents the actual hairdo of the Ibo woman, as Basden (1938) has shown; (3) the *nwanza* mask, similar in design to the second mask but made to be carried on top of the head as a headdress and

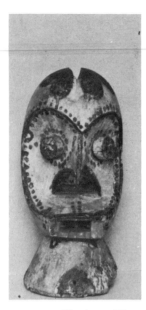

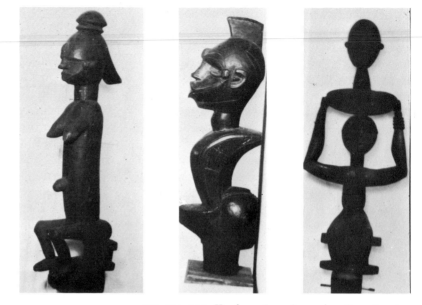

230. *Headgear, Ekpo society, Owerri region. 17"*

231, 232, 233. *Headgear for* ogbom *play, Owerri region*

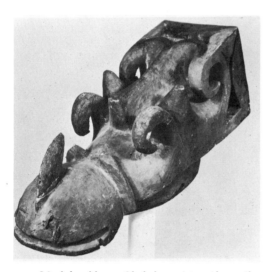

234. *Mask-headdress, Obukele society, Abuan Ibo 24"*

235. *Mask, eastern Ibo, Afikpo district*

236. *Mask (mba), eastern Ibo, Afikpo district*

strapped under the chin, with very complicated ornamentation on the hood. When these three masks were worn in the maiden-spirit ceremony, the male dancers wore artificial breasts attached to their knitted costumes (also done among the Batshioko in the Congo). These maskers also appeared at funerals and in a case

of adultery visited the offending man and demanded compensation for the husband.

Animal spirit headdresses *(ula onu),* worn on the forehead, also come from the northern region. They represent various animals, having beaks or horns. The unpierced eyes are often inlaid with mirrors. These carvings were not

used by dancers but by the runners who made announcements in the villages.

Around Afikpo and Ada, the eastern Ibo produced a large number of different types of masks: (1) One of the most interesting is the *mmaji (mmaubi* or *maji)* mask, its name deriving from the hatchet or knife used at the yam cutting. This mask (Fig. 103) was used at the beginning of the dry season. It has four cylindrical projections, believed to represent teeth, and a blade thrusting upward from the forehead. (2) A small mask, known as *mba* after the wood used, is similar in facial decoration to the maiden-spirit mask but is distinguished by a rectangular flat board rising vertically from the top of the mask (Fig. 236). These masks were used in plays depicting girls admiring themselves. Other masks from the same region, according to Starkweather, are: (3) The woodpecker mask *(otogho)*, the forehead of which forms a beak. (4) The he-goat mask *(mkpi)*, with small beak and horns. The last two derive from Ibo folklore; in their use they were also associated with human characteristics. (5) A mask representing the white man *(bekee)*. (6) *Ashali* masks worn by young boys at the Christmas parade. (7) A mask used by singers, the *okonkpo* mask, with flat face, square eyes, the forehead painted with geometric patterns. Another variant of this mask is the *igiri* mask.

The southern Ibo, around the towns of Bende and Aba in former Owerri Province, performed plays at yearly yam festivals as a ritual of the Ekpo society. Here the white-faced maiden-spirit masks were used, and also complete heads (Fig. 230), the base carved out to fit on the performer's head. There are also structures on which two such heads are mounted. The Abuan Ibo around the port of Degema, being close to the water, adopted the water-spirit mask (Fig. 234), which was used in the Obukele secret society.

The artwork of the western Ibo is strongly influenced by the Bini style, as best seen in the brasswork of Ika.

Mostly from the northern regions are DOORS carved in a hard wood (iroko), 4 feet in height, with geometric patterns engraved. They were set into the mud walls surrounding the compound of an important family.

IBIBIO

Located mainly in former Calabar Province, in southeastern Nigeria.

Among the western or Anang Ibibio, the Ekpo male society honors dead ancestors and enforces the law. This society uses a great number of masks, each with different stylistic features: (1) masks with a calm expression; (2) masks with a fierce expression (Fig. 237), supposed to represent the spirit of the underworld; (3) masks with great abstract design, the main emphasis on the eyes; (4) masks showing the ravages of skin and bone disease (possibly due to congenital syphilis); used in the Idiong society as well as the Ekpo; (5) horned masks with strong cubistic features, having also similarities to the Mmo society's white-faced masks (Fig. 238); (6) masks mostly black in color with horns, pierced eyes, sometimes with movable jaw (Fig. 240).

The statues of the Anang Ibibio have bulbous forms, open mouth, teeth showing (Fig. 241). Sometimes the arms are separated and nailed to the body; some sitting or standing figures with outstretched arms are used as marionettes in plays.

The southern Eket Ibibio use Ekpo society masks similar to those of the Anang Ibibio. Some of the oldest carvings in this province are the *ekpu* figures (Fig. 239), considered the ancestors of the tribe. K. C. Murray ("Arts and Crafts of Nigeria") has found about 1,200 pieces, though only 350 were not ruined; they can be dated as far back as about one hundred years.

The Efik or Riverain Ibibio produced skin-covered heads (see the Ekoi tribe under Cameroon).

Closely related to the Ibibio are the Ogoni, who created an extremely abstract mask in which the eyes and horns are predominant (Fig. 242). It was used in the Karikpo ceremony dedicated to the local deity and to agriculture.

IJAW (IJO)

Numbering about 150,000 people, the Ijaw live mainly in the creeks and mangrove swamps of the Niger Delta area. They depend upon the

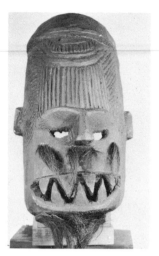

237. *Mask, Ekpo society, Anang Ibibio. 12"*

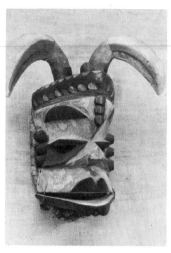

238. *Horned mask, Anang Ibibio. 14"*

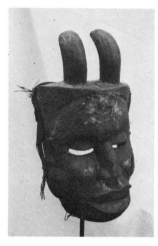

240. *Horned mask, with movable jaw, Anang Ibibio. 12"*

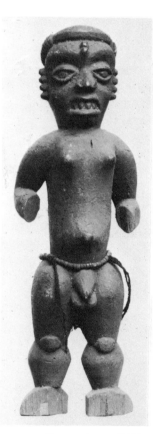

241. *Statue, Anang Ibibio*

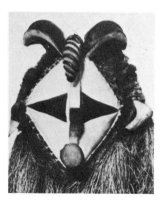

242. *Mask, Karikpo society, Ogoni*

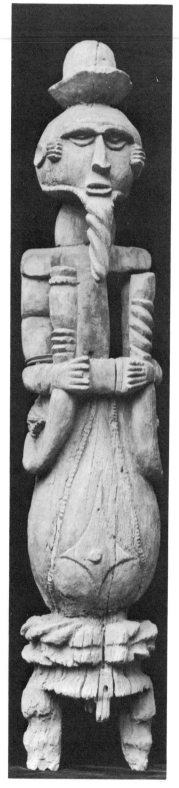

239. *Ancestor figure (ekpu), Eket Ibibio. 42"*

water for food and communication, but at the same time they fear inundation, bad fishing, etc. The cult of the water spirit (Imole) developed not only among the Ijaw of the Delta, but on the whole four-hundred-mile coastline, among the Yoruba of former Ijebu Province, the Ijaw of Mahim, Epe, and Okitipupa, ending with the Warri of the Delta and the Bamum of Duala (Fig. 259) in Cameroon.

The *imole* masks are either animal representations (Fig. 243) or have human faces combined with various animal features (Figs. 244 and 245). Actually the masks do not represent the spirit Imole but its servant, in the same way that crocodiles were considered messengers of river or lake deities. The masks were worn horizontally so that when the wearer walked in the water, the mask looked as if it were floating (Fig. 246). The use of the hippo mask (Fig. 243) is described by Chadwick, who relates that they were used in plays. Masked dancers were mock-attacked by nonmasked members of the society who overpowered those with masks, symbolically acting out man's wish to win over the spirit and keep it under his control.

A mask of great simplification, called *igbo,* with flat surface and inverted T for the nose (Fig. 247), was used by the Ijaw in the Sekiapu secret society.

The Ijaw also used a headdress formed of a human head (a cap below) with an elaborate superstructure and a headdress with a double head and a white surface.

Northern Area

The sculpture of northern Nigeria is less well known than that of the southern part. This is partly due to the fact that the majority of the inhabitants are Moslem and there are only small groups of non-Moslems (especially in the Niger-Benue confluence) who maintained their religious practices using carved objects. Although there is a literature on this region (Meek, Nadel, etc.), some with occasional illustrations of artwork, the publications of Murray in 1949 (on Idah masks) and of Sieber in 1961 shed more light on the tribal art of this region. Limited space permits us to mention only a few examples.

IGALA

A large number of masks: a large animal mask worn horizontally (similar to the Senufo firespitter type); a large Janus, hood-type mask with white faces and made to rest on the head (similar in construction to the Mmo mask, Fig. 229). Murray illustrated a hood-type mask, the hair, eyebrows, beard, etc., indicated by black and red *Abrus* seeds (Fig. 251). There is also a life-size bronze mask similar to the Benin masks, although larger than the usual Benin masks, and tiaralike headgear constructed with metal parts.

Statues with lozenge-shaped faces are rather roughly carved.

IDOMA

Heads with a stand, the face carved in two white concave shapes, recalling some of the Pangwe masks, with a coiffure made of cords. Rather large headgear combining the features of the crocodile and bush cow, another with a human face and a snake curled on the top. White-faced small masks similar to the Mmo small masks were probably imported from the Ibo and were used for popular entertainment.

NUPE

Most members of the Nupe tribe are Moslem. They work mostly in iron and brass, reportedly introduced by their legendary hero, Tsoede. Their mask called *ello-gara* is oval with two round eyes and a spike on the top (Fig. 250, presently in the Basel Museum).

JUKUN

The Jukun, who live on both sides of the Benue River on the Bauchi Plateau, have some of the most abstract headgear in the whole body of African art (Figs. 248 and 252). An oval, concave upper part is connected by a cylinder to a lower, smaller concave form, used as the cap. It was worn horizontally, the larger concave section facing up. This headgear was already illustrated by Frobenius in 1899 *(Die*

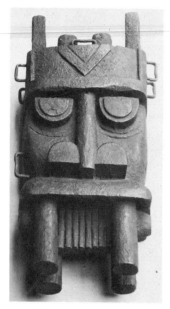

243. *Hippopotamus water-spirit mask* (imole). *18″*

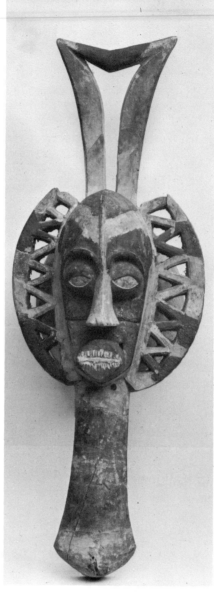

244. *Water-spirit mask* (imole). *26″*

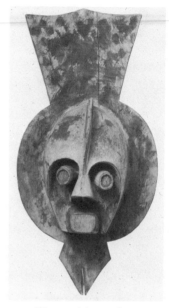

245. *Water-spirit mask* (imole) *15″*

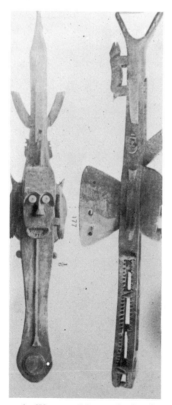

246. *Water-spirit mask* (imole) *(front and side views). 34″*

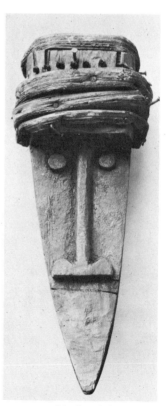

247. *Mask* (Igbo), *Sekiapu society. 18″*

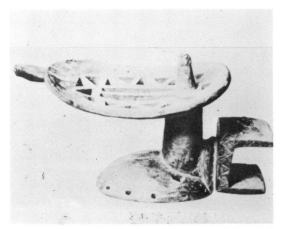

248. *Headgear* (aku maga), *Jukun. 20"*

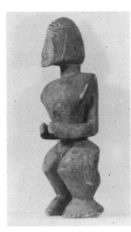

249. *Statue, Montol. 24"*

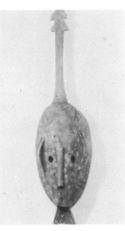

250. *Mask* (ello-gara), *Nupe. 60½"*

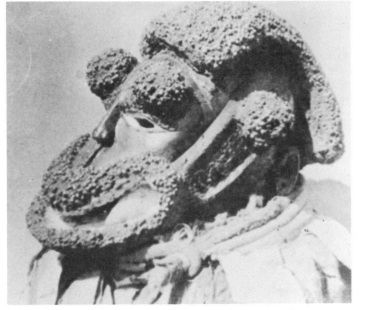

251. *Mask with seeds, Igala. 24"*

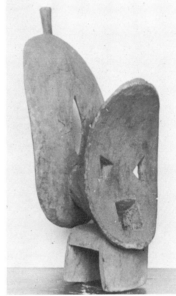

252. *Headgear* (aku maga), *Jukun 40"*

Masken und Geheimbunde Afrikas), and Meek saw one covered with red seeds. Called *aku maga*, it is the abode of a deity, and also of the spirit of a dead chief.

MONTOL

Also living on the Bauchi Plateau, the Montol have a mask made of fiber (as if woven). Their statuary (Fig. 249, in the Basel Museum) is remarkable for its strong plastic configuration. Usually the arms stand out from the body.

CHAMBA

The Chamba are situated east of the Jukun. Their statues are executed with great simplicity, although roughly carved. They are rather long in form. They have also monumental buffalo masks.

GOEMAI

Masks similar to the Jukun, but also masks with large jaws. Statues roughly carved, in strong columnar form, used in divination rituals.

TIV

The Tiv, who live on the border of the Benue River, have not produced a large body of artistic work. To be noted: a male figure with arms close to an elongated body, the male genital prominent.

REPUBLIC OF CAMEROON (CAMEROONS)

Four large style regions are to be distinguished in this territory: (1) *The Cross River region* (extending into Nigeria). Typical are the carved-wood heads in naturalistic style, covered with skin (Fig. 255). (2) *Grassland*. The statues, masks, and utensils of this region are free, elastic, and bold in execution, and sometimes on a grandiose scale, with an effect of strong vitality and a peasantlike lack of sophistication. (3) *The coastal region* or *forestland*. Smaller statues and masks. (4) *The northern area*. Very abstract work, completely different from other Cameroon styles.

Cross River Region

ANJANG (ANYANG)

Unique seated figures, head resting on the right hand; high, broad forehead, arched nose, open toothless mouth, protruding chin, the expression intense and brutal. Also skin-covered statues and masks with a savage expression.

BANJANG (BANYANGI)

Skin-covered, antelope-head masks.

BIFANKA (BIFANGFA)

A small tribe living in both Cameroon and Nigeria who, in addition to Ekoi-style skin-covered heads, produced seated figures, also skin-covered, with movable arms and legs (Fig. 253) and basketwork base as a cap. These statues, *m'chivie,* represent the deceased and were used by members of the family at funerary rites.

BOKI

Sculpture in human and animal form. Skin-covered heads.

EKOI

Skin-covered wooden heads and masks of a demonic naturalism in three sizes: smaller than life, life-size, and twice life-size. Earlier skins of slaves, later skins of antelopes, were used. Human hair went into the hairdo. It is presumed that all masks represented ancestors. They were used in burial ceremonies by the Egbo (or Ekpo) secret society (Fig. 255). Janus-type, two-faced masks, having mythological significance: one face (black) representing Father Heaven, the other (white or yellow) Mother Earth, black signifying male, white female.

Statues, rough in execution, that emphasize the expressive head. Also skin-covered seated figures.

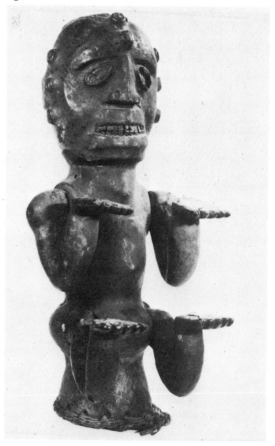

253. *Leather-covered figure with movable arms and legs* (m'chivie), *Bifanka, Cameroon. 13"*

Grassland

BANGWA

Some statues about 40 inches in height, of monumental construction. Mother-and-child groups. Large carved human heads. Animal sculpture. Roughly carved, dramatic female statues. Skin-covered heads. Seated figures holding bowls.

Large, dramatic masks in human and animal form.

Food bowls with lids carved in the form of animals.

BALI

Known for their clay pipe bowls, mainly derived from the Bamessing, Bamileke, Babungo, and Bamum tribes. There is great variety, the most common in the form of a seated human figure with oversize head (Fig. 257); several heads with arms and legs (Fig. 256); some with human body and animal head.

Masks in the form of animal heads (Fig. 254).

Footstools with human and animal figures as ornaments of supports.

Noteworthy for its graceful structure is a coal pan from this region (Fig. 260).

BAFUM

The products of Bafum are dramatic in effect. There are statues of both human and animal figures. Some heads have extremely high hairdos and flat, high foreheads. Some large figures are entirely encrusted with beads and cowries.

The masks are more important. Their exaggerated but original forms show an almost brutal force, mainly human in feature and sometimes surmounted by a human figure. Also animal forms with a bulky, expressive vitality worn over the head, the rim resting on the shoulders of the dancer.

BEKOM

Some life-size, naturalistic statues covered with pearls or metal plating, supporting thrones.

Monumental masks (some over 20 inches high) (Fig. 4) with half-open mouth, teeth distinctively carved, a high hair superstructure, sometimes with pierced effects, eyes framed by a lighter color than the mask itself. These masks are often classified under Bamum and Bamenda, and it is possible that they were used by all three tribes.

BAMILEKE

Since the publication of Lecoq's work, we have an abundant documentation of the artistic work of this tribe.

The most monumental wood carvings are the large houseposts; door and window frames carved with human and animal figures; benches and stools carved with human, animal, and geometrical designs; also stools and human figures (as well as calabashes) covered with multicolored beads; large drums with stands, representing human or animal figures. Carved figures representing the ancestors, also mother-and-child statues.

There are various masks carved of wood in human features, often combined with animal horns, also masks in animal-head forms. Headgear completely covered with cowrie shells, animal horns attached; also hoodlike cloth headgear covered with shells and beads.

They have one very fine ivory, called *mu po*, which is similar to Bafo ivory carving, with both hands at the chin. Pipes in cast brass.

BAMUM (BAMOUN)

Large figures encrusted with beads and cowries. Noteworthy elephant heads cast in bronze.

Dance masks in the form of a long head on a high neck, also in animal-head form (Fig. 86).

Footstools and thrones decorated and supported by animal or human figures (Fig. 262). Bowls in animal form, or carried by human figures. Some in strong, cubistic design; some soft and round in form.

A great variety of pipe bowls in clay and cast bronze (lost-wax) in the form of a seated figure with oversized head.

This tribe has an old tradition of covering dolls, animals, stools and bottles with multicolored beads, which has persisted to the present. Their masks and little figurines, both cast by

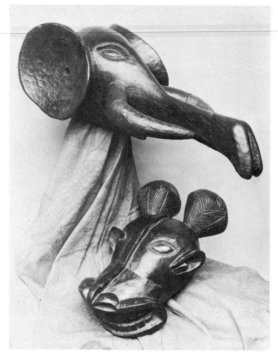

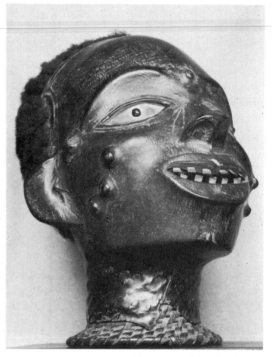

254. *Animal-head mask, Bali. 28"*
Animal-head mask, Bamessing. 18"

255. *Skin-covered head, Ekoi. 7"*

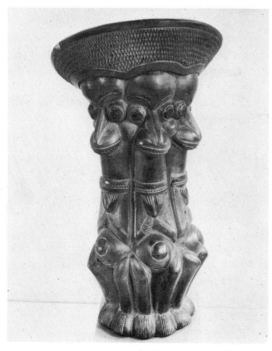

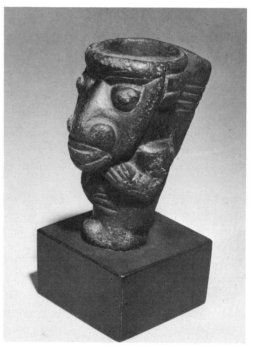

256. *Clay pipe, Bamileke. 12"*

257. *Clay pipe, Bamessing. 6"*

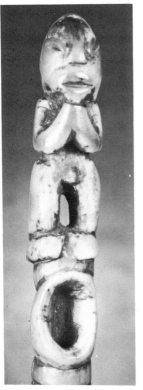

258. *Head of an ivory horn, Bafo. 4½"*

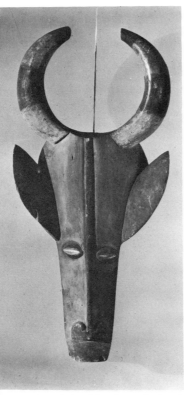

259. *Animal-head mask, Duala approx. 30"*

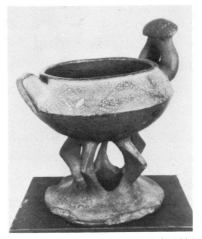

260. *Pottery coal pan, Bali. 8½"*

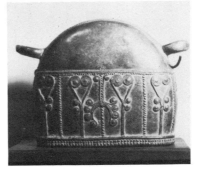

261. *Brass bell, Tikar. 5" x 5½"*

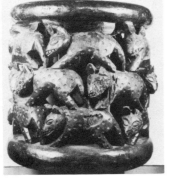

262. *Stool, Bamum. 13" (dia. 12½")*

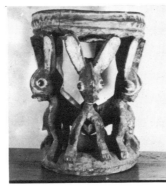

263. *Stool, Bameta. 12" (dia. 11½")*

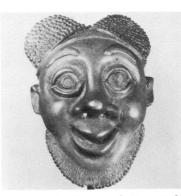

264. *Brass mask, Bamum. 8"*

the lost-wax process in brass, are now made mostly for the tourist trade (Fig. 264).

BABANKI

Although most of the tribes of the grassland produce highly elaborate stools, this tribe is known for stools carved from a large trunk of wood (often 16 inches in diameter), with animals, animal heads, and human figures carved all around. They also carve elephant tusks.

BASSA

Little known are the very interesting headdresses of this tribe, of which two (Figs. 267 and 268) are in the Stuttgart Museum. In *Afrikanische Plastik,* von Sydow attributes similar headdresses to the Lokjamba tribe of southern Cameroon.

BAMETA

Under this tribal name, the Stuttgart Museum has a charming stool supported by four rabbitlike animals (Fig. 263).

TIKAR

Masks carved of wood with a broad collar made of raffia, called *ngiga;* used in mask play, and reserved for men. The face forms a flat surface with outthrust cylindrical eyes, a cubistic oval for the mouth.

Also bronze-cast pipe bowls in the form of human and animal heads. Remarkable for its proportions and extremely fine ornamentation, cast by lost-wax technique, is a bell from this region (Fig. 261).

BAMESSING

Masks in the form of animal heads (Fig. 254). Pipe bowls of red clay in the form of a human face with bulging cheeks (Fig. 257).

Coastal Region or Forestland

BAFO

Individual and group figures (some double figures back to back), rather small, standing,

sitting, or crouching. The characteristic position of these statues—both hands held to the chin—is shown in the ivory carving in Fig. 258. There are also figures of birds and bird-headed masks, many polychromed.

BAKUNDU (BALUNG)

Janus-type, two-faced statues supported by six small figures. *Musongo* (or *mosongo*) figures, used when taking an oath. Figures are roughly carved.

Also skin-covered wooden heads.

DUALA

"Duala" is not a tribe name but designates an art style common to those living around the city Duala.

No statues, but a rich variety of polychrome masks, some animal-headed, some with horns (Fig. 259). Polychromed bovine masks used in the Ekongolo secret society, and also by the Bajong tribe.

Elaborate dance scepters and carvings for oar banks on pirogues (native boats).

NGOLO

Headdress-masks: human head resting on a high, conelike neck realized in a simple, naturalistic manner. Single- and two-faced masks, some with horns.

Wood panels carved in relief in cubistic style.

BAKOKO

Masks carved in hemispheres.

JABASSI

Figures in geometrical forms.

BATAUGA

Masks in human form.

MABEA

Both statues representing ancestor figures and masks are carved in long triangular shapes with two triangular eye openings.

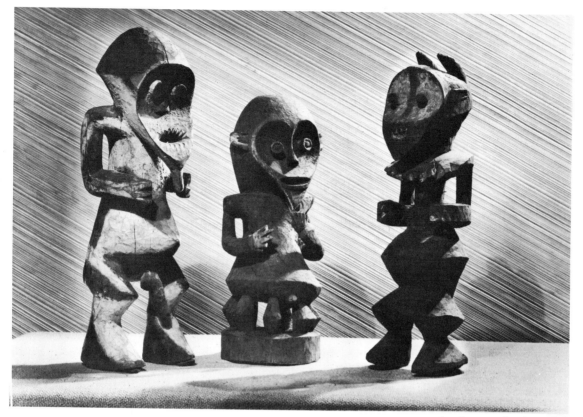

265. *Ancestor figurines, Kaka*

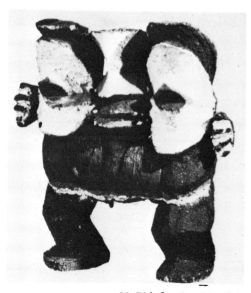

266. *Pith figurine, Mambila*

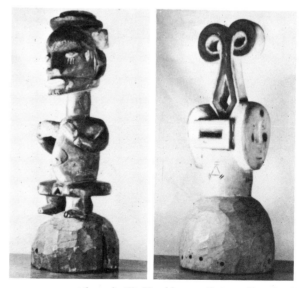

267 and 268. *Headdresses, Bassa. 26″ and 24″*

NGUMBA

Statues called *ngwun malanda*. Most have a head covered with feathers, head and body with metal appliqués; some have a pipe in the mouth. Kept in barrels as among the Pangwe. In times of sickness, offerings are presented.

BULE (BULU)

A subtribe of the Pangwe (described on pages 220 and 222).

Mostly masks in the form of a human face, some with horns. Geometrically formed human heads, mostly colored white and black.

JAUNDE

Pangwe-style, so-called "dancer" figures (similar to Fig. 280). *Akaba* sticks with carved human and animal figures.

Strongly marked masks: the surface is flat, the upper part round, the lower part square; the forehead domed; very long nose; eyes and mouth quadrangular holes.

Northern Area

Gebauer reveals the art products of three tribes in this area which have an astonishing abstract style of great expressiveness, extremely different from the artwork of their neighbors.

TIGONG

Funerary trumpets in form of human figures, with extremely abstracted face ending in a pointed beard, angular arms.

MAMBILA

Carved figures and masks composed of very bold, abstract shapes, painted with ocher and white chalk. The cow totem animal mask with its open jaw, worn horizontally over the head, is very similar in concept to the Senufo masks. Their light figures carved from cane pith (Fig. 266) recall in style some Bayaka figures.

KAKA

This tribe has produced perhaps the most astonishing carvings in this region, markedly similar to the small Warega statues, with zigzag legs, concave face, round eyes, the face ending in a pointed chin (Fig. 265).

REPUBLIC OF CHAD (FRENCH EQUATORIAL AFRICA)

SAO

Excavations undertaken by J. P. Lebeuf in the plains of the Lake Chad region brought to light a large number of pottery works attributed to the ancient Sao empire. Fig. 269, a good example, represents a "divinized" ancestor and came from the sanctuary at Tago. Bronze casts have also been found, among them a beautiful gazelle.

BAGIRMI

Fig. 270 was formerly attributed to the Bambara tribe, but, as Fagg has indicated, should be attributed to the Bagirmi of the Lake Chad region. These statues are supposed to represent dolls. (Note the interesting conceptual similarity with Ashanti *akua'ba* figures.)

GABON REPUBLIC REPUBLIC OF CONGO (FRENCH EQUATORIAL AFRICA)

Studies of this large territory are incomplete and sometimes contradictory.

In the south, in the Republic of Congo (formerly called Moyen or Middle Congo), bordering what was the Belgian Congo, the main tribes are: Bateke, Babembe, Ambete, Bavili, Bangiri, Bakwele, Kuyu. In the west and north, in Gabon, are: the Pangwe, M'Pongwe, Bakota, Nkomi, Eschira, Mitsogho, Balumbo, Machango, etc. (The Pangwe tribe extends into southern Cameroon as well.)

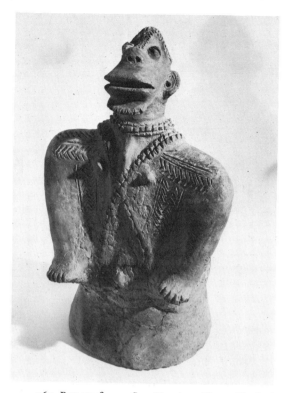

269. *Pottery figure, Sao Kingdom, Tago, Chad. 7"*

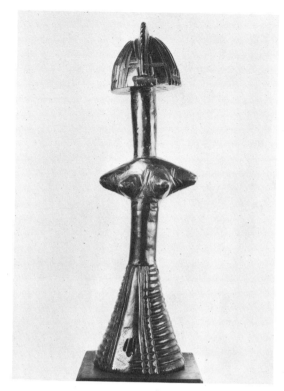

270. *Statue, Bagirmi, Chad. 9"*

ADOUMA (BADOUMA)

This tribe is located in the Ogowe (Ogooué) River region in Gabon. Remarkable are their masks (often identified as Okondje masks), with flat surface for face, domed forehead, and angular nose, an interesting interplay of flat, convex, and angular forms (Fig. 271). These masks are mostly polychromed, some with a painted design pattern. (Note the great similarity in plastic construction to the Toma mask in Fig. 147.)

AMBETE (MBETE)

The use of containers to hold the relics of a deceased person, a practice among the Bakota and Pangwe, is a custom among the Ambete also. A barrel-like container was made to hold the bone remnants, the lid carved in the form of a human head. Another type is a complete figure hollowed out with a "door" at the back of the statue, into which the relics were placed. The face is generally a lozenge shape, the body rather crudely carved, mostly painted white.

BABEMBE

A part of this tribe is located in the Democratic Republic of Congo and is called Babwende or Babuende. Their proximity to the Bakongo tribe accounts for the realism of facial expression in their sculpture and also for their use of shell or ivory inlay for the eyes, an adaptation of the Bakongo use of mirrors for eyes.

STATUES. This tribe is known mostly for its statues, which are not larger than 5 to 6 inches. Sometimes called *sibiti* figures, after the name of the principal village, the most characteristic feature is the rich scarification on the stomach, in curved and angular designs. They all have eyes inset with mirror, shell, or glass. The seated figure (Fig. 10) has a long, pointed beard (part of it broken off) stained in the same color as the headdress. Fig. 273 has pointed, protruding breasts (some figures have breasts of such proportion and shape that there is a phallic connotation), very large feet, flexed legs, arms held out in front (in all probability the woman held something, possibly a baby, as there are also figures with a child). Fig. 272

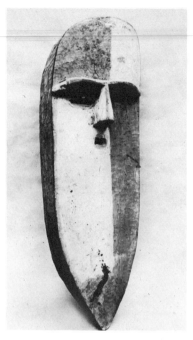

271. *Mask, Adouma. 6"*

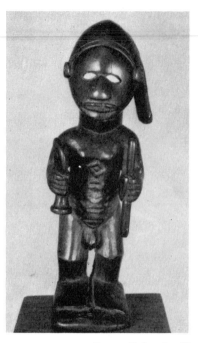

272. *Statue, Babembe. 6"*

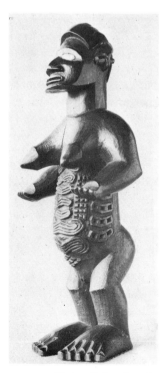

273. *Statue, Babembe. 5"*

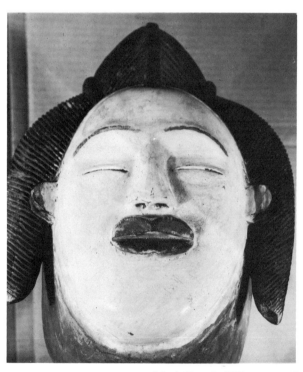

274. *Mask (duma), M'Pongwe. 15"*

stands on square base, has wide, plaited hair hanging down on one side (others have this feature also, but the braid hangs down the back of the head); he carries a knife in his right hand and a stick in his left (this is sometimes replaced by a calabash). These little statues are considered house-protective fetishes, representing ancestors, and it is reported that in case of fire the first thing saved is this statuette. Certain writers have assumed there was an Egyptian influence.

BAKHAMBA

Female and male statues with arms raised to the back of the head.

BAKOTA

The Bakota have lived in Gabon for a long time, between the Equator and the second parallel of latitude (north) and between the twelfth and sixteenth meridians of longitude, between the rivers Dja and Ogowe (a part of this same area being along the Ivindo River). They have as neighbors the Pangwe to the northwest and to the southeast the Bayanzi, and by extension the Bateke. They actually call themselves Ikota and their neighbors call them Mockora.

STATUES. What is known today as the Bakota reliquary (or funerary) figure was also made by many tribes, such as Adouma, Ondumbo, Obamba, Okanda, Abomba, etc. These figures (Figs. 21, 57, and 275) are carved of wood and covered with brass sheeting, sometimes a combination of copper and brass, and often have *repoussé* ornamental designs on various parts of the sheeting. The metal, covering only the face (with the exception of the Janus type), is bent on the side of the wood structure and is attached by native nails, often in form of large staples. The face is either concave (female) or convex (male), although sometimes only a domed forehead indicates maleness. In some examples (Fig. 57) metal strips decorate part of the face, either arranged in horizontal lines, or with copper and brass in alternate bands, or with the strips arranged in contrasting diagonal bands on four sections of the face.

(These metal-strip types are executed with great technical skill and are highly regarded by collectors.) Usually there is a medial ridge on the face, which is sometimes replaced by brass sheeting in cruciform shape laid over it. The eyes are indicated by copper rivets, metal roundlets, or semicircular metal pieces with rivets for pupils. The nose is usually a wedge-shaped triangle.

There are two criteria by which the Bakota figures can be classified. One is the size, the larger from 20 to 25 inches high, and the smaller from 10 to 15 inches. The second is the treatment of the extensions and both sides. Thus, the "open-form" type is shown in Fig. 57, where the semicircular top is independent from the side pieces. The "closed-form" type is shown in Fig. 275, where the top and side pieces form a closed line or an integrated unit. In the open-form type the top is either semicircular or an inverted crescent shape and may be considered as headdress. The side pieces vary greatly in shape, either a simple geometric shape or several combined together. Below the side pieces there are usually two projections bounded by strips of metal. The lower diamond-shaped lozenge is also found in various shapes, but basically the lozenge shape is maintained. This lower part is supposed to represent the body and upon this assumption von Sydow, in *Handbuch der Afrikanischen Plastik*, called this statue *Kopffusser* or "legged-head." (A similar construction can be seen in the Bakuba cups, Figs. 60 and 62.) Sometimes the lozenge form is partly covered with sheeting in *repoussé;* often it is missing or partly rotted away because of its contact with the organic material (the bones of the deceased) in the basket onto which the figure was fastened (Fig. 21). Frobenius shows a drawing by Brazza in which these baskets are placed next to each other in a sacred shed. Note that bone containers were also used by the Pangwe (Fig. 287), topped by a figure or a head.

There are various names ascribed to these figures. One source gives the name as *bangala* or *mbulu ngulu*, which would mean "the image of the dead." Anderson states, however, that in the Mbamba tribe they are not images standing symbolically for something else, but are in fact

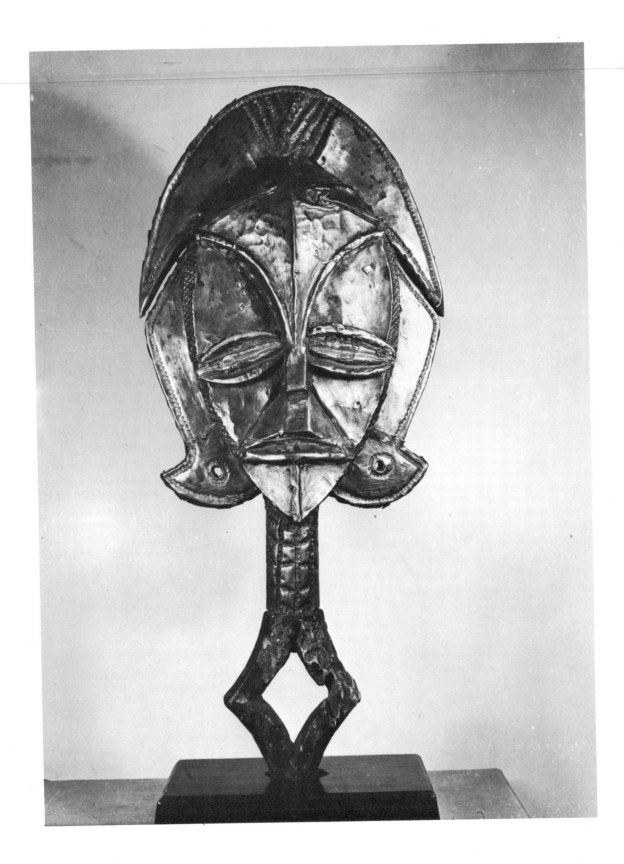

275. *Reliquary figure, Bakota, Gabon. 17"*

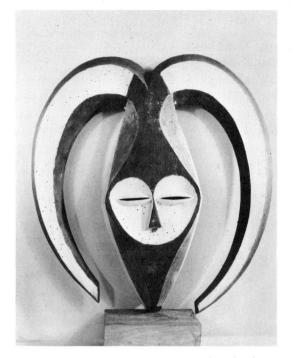

276. *Mask, Bakwele.* 17"

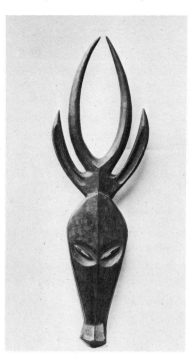

277. *Mask, Bakwele.* 38"

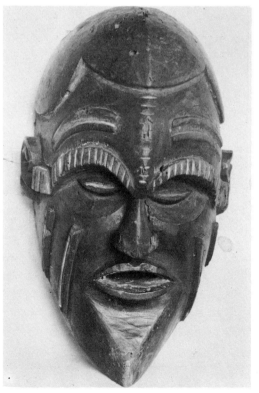

278. *Mask, Batanga.* 12"

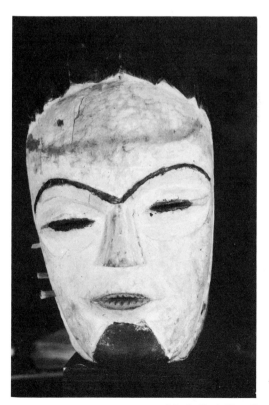

279. *Mask, Benjabi.* 12"

the deceased themselves. The Adouma and Ondumbo tribes called them *mbouti*. The museum in Ghent, Belgium, called them *lebulu n'goye* and the basket *kohan n'goya*. The difference in names is probably due to tribal language variations.

As to the meaning of the upper crescent or semicircular part, we have already indicated the possibility of its being a headdress, similar to the rendering of the actual coiffure of the M'Pongwe woman in M'Pongwe white-faced masks. Frobenius called it a solar-nimbus symbol, which could be connected with another assumption, namely that it was a halo standing for the radiation of the spirit, which actually took up its abode in the figure.

From the morphological point of view, these structures are rather unique in African art because of their two-dimensional frontal aspect, in contrast to the majority of African works, which are three-dimensional. Similarities could be found with two other tribes of the same general area, namely the Bateke flat pieces (Fig. 377) and the Bakwele frontal structures (Fig. 276)—to say nothing of the *akua'ba* statues (Figs. 195–201) of Ghana.*

We may mention two more types of works attributed to the Bakota. One, in von Sydow's book on the Heydt collection, is a four-legged figure with round body, arms in relief on the body, and the head carved in the same wood but similar in design to the typical Bakota figures. Another, shown by Raponda-Walker, is an unusual staff on the top of which stands a small figure in the style of the reliquary figures.

BAKWELE (BKUELA, BAKOUELE, KWELE)

This people live on the upper reaches of the Likouala River (the basin of the Alima River). Their masks are highly stylized: a white human face framed with a stained rim. Others have a hornlike ornament around the face (Fig. 276), perhaps suggesting the tusks of an elephant. There is a great similarity with some white-faced masks of the Pangwe, M'Pongwe, etc., their neighbors. This high degree of abstraction may be linked up also with the Bateke masks found in the Republic of

* For further study see the author's essay on the subject, "Bakota Funerary Figures" (1952).

Congo. There are other masks in which a trunklike protrusion starting from the forehead descends before and beyond the face reaching about three times the length of the mask. Another example, not in the flat style, is a triangular mask with a nose on the same form and a beaklike protuberance issuing from where the mouth might be, ending in what appear to be two horns. There are also animal masks (Fig. 277) very different in style.

BATANGA

Seated female statues. Also vividly colored masks (Fig. 278).

BATEKE

The Bateke live in both Congos. Their work is discussed under Democratic Republic of Congo.

BENJABI

Masks called *bakosi* (Fig. 279), with large white face, long black eyebrows, often fused with the nose in a strong black design.

GALOA

Pole statues with faces painted white (the features nearly identical to those of Fig. 279), sometimes with the pole carved into a body and two arms. (Although statues of this type in the Dakar museum are labeled Galoas from Cameroon, they are no doubt the work of the Galoa of Gabon.)

KUYU (BABOCHI)

Clublike polychrome wood carvings, used in snake ceremonial dances, called *kebe-kebe*, sometimes used as crest ornaments on masks.* Most are of very recent origin. With a few exceptions (such as Fig. 282), the artistic quality of these carvings is low and they lack sophistication.

* The Tropenmuseum in Amsterdam shows a double *kebe-kebe* placed on top of a human figure completely covered by a white cloth (similar to an Ekoi practice of placing a skin-covered head on top of the dancer's head, which like his body is covered with a cloth).

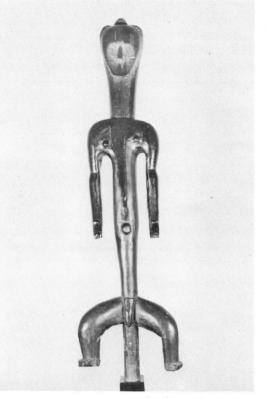

280. Statue, Pangwe. 23"

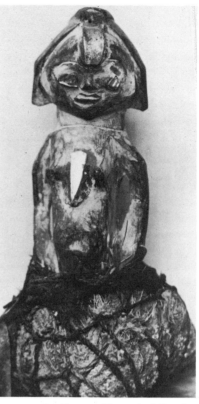

281. Statue with magical "bag,"
Mitsogho. 12"

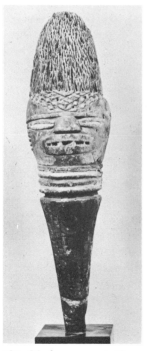

282. Mask ornament, Kuyu
24"

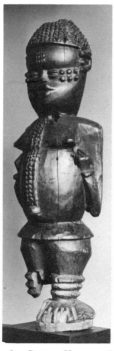

283. Statue, Kuyu. 27"

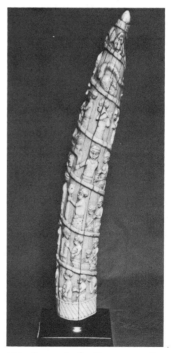

284. Ivory tusk, Loango region
14"

A few Kuyu statues are known (Fig. 283), some having rich scarification marks all over the body.

LOANGO

Loango is the name both of a region and of a seaport on the Atlantic in southernmost Republic of Congo. It has been mistakenly used by some authors as a tribal identification. The sculpture-producing tribes of this region include the Kakongo and the Basundi. Their sculptures are in the style of the Bakongo in the Democratic Republic of Congo, and the majority of the objects formerly attributed to Loango should be classified under Bakongo. There are many small ivory tusks in serpentine shapes, carved with figures in European dress, some carrying bundles and hammock. These carvings are produced for sale to foreigners at a price calculated on the number of figures in the carving (Fig. 284).

MITSOGHO

This tribe lives on the southern bank of the Ogowe River. Many of their statues have the features of the M'Pongwe mask. Remarkable, however, is a statue which is bound up in a "bag" made of burlap containing a magical substance, often (similar to the customs of many of the neighboring tribes) the relics of some deceased person. Fig. 281 has in addition pieces of glass glued into the eyes and also a piece of mirror glued on the chest (both Bakongo usages).

M'PONGWE

The M'Pongwe started their migration toward the estuary of Gabon and the delta of Ogowe around the tenth or twelfth century (Gautier). They are, according to Hauser, placed in the large ethnic group of Omyene, together with five other tribes. Anderson, however, has indicated that under this name about twenty tribes are known to exist (such as Nzabi, Lumbu, the Kuta of Zanaga, to which Himmelheber [1960] adds Okanda, Masango, Balumbo, etc.) Because of the long-established

denomination and the fact that the work of each tribe is difficult to distinguish, we shall maintain the M'Pongwe name. (A study by R. P. Gautier, published in 1950 by the Institut d'Études Centrafricaines in Brazzaville, is entitled *Étude historique sur les Mpongoues et tribus avoisinantes.*)

Best known are the small masks: face painted with white kaolin, pierced slits for eyes, red paint on lips, high-piled hairdo with two side forms (possibly braids) curving downward, the whole having an unusual Oriental appearance (Fig. 274). Often there are scarification marks carved in relief on the forehead, temples, and cheeks. These masks are known as *duma* or *mvudi*, words meaning "dance." The hairdo, as Kingsley has indicated, is a rendering of the M'Pongwe woman's coiffure, produced with great care, often using other materials to support the hair and often with long pins of hippo ivory inserted. Each of these masks represents a dead woman who, taking up abode in the mask, thus has returned from the land of the dead. They were used at burial ceremonies, in the ancestor cult, and in dances of the full moon. Sometimes they are called "ghost" or "specter" masks, white being the color of the spirit returning at night among the living (as Hall states in "Two Masks from French Equatorial Africa").

OSSYEBA

The Musée de l'Homme identifies under this name reliquary figures such as Fig. 285, but recently the Mahongoue (or Kota Mahangwe) tribe has been suggested and *m'boueti* given as a name for these figures. Neither tribal name, however, appears in the comprehensive *Carte Ethnographique* published in 1955 by the Institut d'Études Centrafricaines, nor is either indicated on the map published by Efraim Andersson in his study on the Kuta, although "Osiba" is mentioned in the text.

These figures resemble the Bakota figures (pages 213, 216) since they are carved in wood and covered with metal, and, as in the Bakota figures, baskets containing ancestral bones are attached to them. The forms are more simplified, however. The heads of these remarkable abstractions are large and do not have upper or

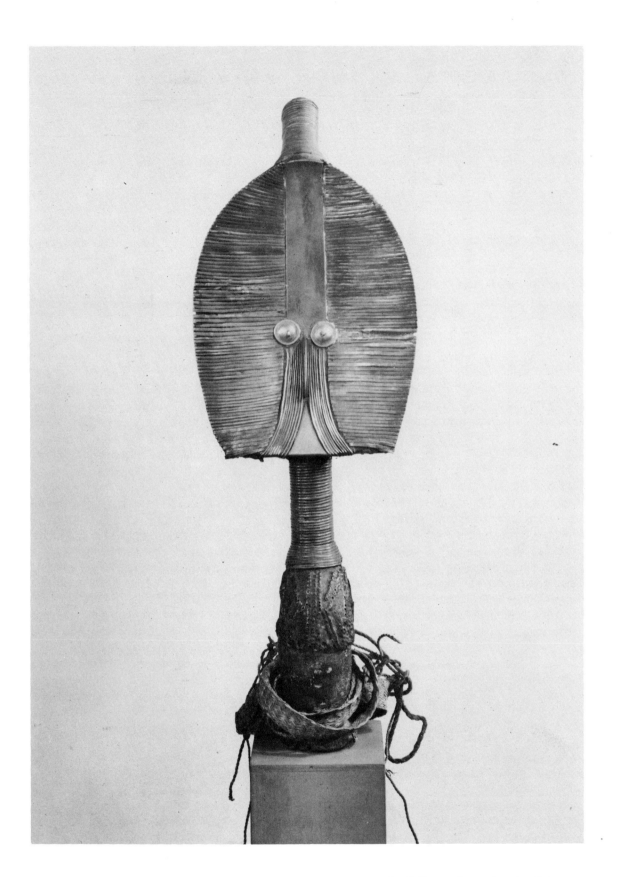

285. *Reliquary figure, Ossyeba, Gabon. 20"*

side pieces. They are covered with metal stripes and have a flat piece of hammered metal in the middle. The nose is indicated by a design made of metal stripes between the eyes, which are made of two round metal pieces. The metal stripes are usually placed horizontally (as in our illustration), but in others a section of the upper part of the head is formed by bent vertical stripes that interplay with the horizontal lines. The diminutive lozenge form of the base can be seen only from the side. These figures are rather rare, although twenty-three pieces were discovered in Gabon in 1967.

PANGWE (FANG)

In most French documents this tribe is called Pahouin, although this is said not to be an indigenous name. Other names used by authorities include Fang, Panwe, Fan, etc. They are said to have come from the Upper Nile region about 1834 and settled along the Ogowe River about 1860, spreading to the coastal regions about 1870. Another theory presumes a Sudanese origin—Haute-Sangha region—and dates their migration about 1800.

STATUES. The statuary of the Pangwe can be classified into three main groups: (1) heads on long necks (Fig. 12); in this category also belong the very unusual small heads (Fig. 286) about 2½ to 3 inches high, at present in the Musée de l'Homme; (2) half-figures (Fig. 75); (3) full figures, standing (Fig. 13) or seated. Carved with great simplicity, at the same time they exhibit a high degree of sophistication in the co-ordination of bulbous forms.

The neck is often a massive cylindrical form. The arms have various positions: hands clasped in front of the body (sometimes holding an object); held in front of the chest or attached to it; hands resting on the knees in the seated figures. The navel is often exaggerated into a cylindrical form. Legs are short, stunted. Usually there is a domed, wide forehead and the eyebrows often form arcs with the nose. The eyes are made of metal roundlets, often having a copper rivet for the pupil (in some examples the metal is missing, but the hole for the nail is visible). According to Raponda-Walker these metal eyes symbolize the all-seeing capacity of the statue. The mouths have

different expressions: in some the lips are closed and pressed, in some the teeth are showing. The hair is arranged in braids either falling down on the back of the head or swept back away from the neck.

An unusual type with outstretched legs (Fig. 280) is Pangwe but has been attributed to Jaunde, a tribe living to the northwest.

According to Alexandre and Binet, most of the statues represent the spirit of the original or tribal ancestor, Zambe (Nzame), and they play an important part in the ancestor cult. Junod, however, maintains that for the Pangwe himself, the statue has its own power apart from its relation to the ancestral spirit. A statue or a head was placed on a cylindrical barrel (made of the bark of the *Ficus*) in which from ten to fifteen craniums of the deceased were kept. Fig. 287 shows a container (in the Stuttgart Museum) with the head attached; other documentations indicate that a figure is seated on the rim of the barrel. Most of them have a long stick between the legs which goes into the barrel, and holds the statue in place. The statues are called *nskh bieri* (Junod calls them *byari*, others *bian malan*). The barrel is called *evora bieri*. The name of the cranium is *boo*, which derives from the verb *bo*, meaning "to do," indicating that the cranium is considered the seat of the capacity for action. The barrels with the statues or heads were kept in a special hut guarded by the elders of the family or tribe. This hut was also used by adolescents in their initiation ceremony so as to put them in touch with the ancestral spirit.

The statues, mostly carved in white wood, were rubbed with a mixture of copal, powdered charcoal, and palm oil, the copal giving a lacquer effect to the surface. There are rather rare pieces lacquered red, in which the powder of the *padouk,* a red wood, was used. Because the wood was usually not able to absorb all the oil rubbed into it, many statues have an oily surface.

There are other Pangwe figures, some up to 40 inches in size, called *niamondo*. These were kept with the *evora bieri* but were secretly stored away from the women. Some animal figures, such as elephants, boars, lizards, etc., were also carved and often hung from the community house. The Pangwe also molded clay

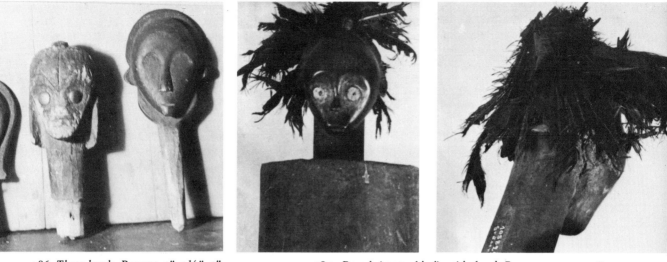

286. *Three heads, Pangwe. 2", 2½", 3"*

287. *Barrel* (evora bieri) *with head, Pangwe. approx. 25"*

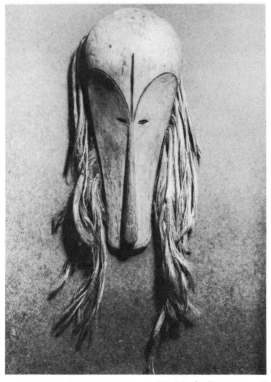

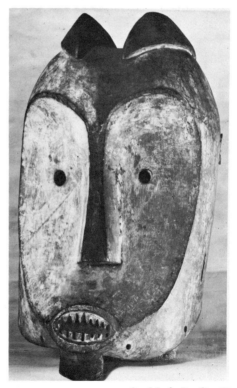

288. *Mask, Pangwe. 22"*

289. *Mask, Bavili. 16"*

figures (as Tessmann shows) 7 to 10 feet long, used in the *ngi* cult, which celebrated the cleansing effect of fire.

MASKS. The style of Pangwe masks is amazingly different from that of the statues. While a bulbous mass of forms in uniform color is the outstanding characteristic of the statues, the striking feature of the masks is a lineal design against the white surface of an oblong face. In Fig. 288, for example, the line of the arched eyebrows continues into the elongated line of the nose. On some masks the thickness of the eyebrow line is the same as that of the nose. In our example the nose is extended into the central ridge of the forehead, with small pierced eyes. Some masks have fiber for hair, some feathers; some are surmounted by a small figure. There are also four-faced helmet masks, each face a different size but all showing the same characteristics as the single-face mask.

Similar masks, but with a more accentuated concave surface for the face and with the mouth showing teeth, are attributed to the Bavili tribe and were used in secret societies (Fig. 289).

DEMOCRATIC REPUBLIC OF CONGO (BELGIAN CONGO)

The peoples of the former Belgian Congo have produced a great variety of statuary in wood, ivory, cloth, shells, and other materials, in a great range of color and design. Amazing artistic talent was shown by certain tribes (Bakuba and Baluba) and a great diversity of styles in individual tribes (the Bayaka had seven styles of masks alone). In general the styles show boldness in concept and execution. Because of this abundance of styles and the extent of the region (roughly a million square miles), varied classifications have been made by authorities.

In *Plastiek van Congo*, Professor Frans M. Olbrechts, the late director of the Musée Royal de l'Afrique Centrale in Tervueren, Belgium, distinguishes four major style regions:

(1) *Lower Congo,* including the Bakongo, Babuende, Bateke, Bayaka, Bambala, Basuku, Bapende, Babunda tribes;

(2) *Bakuba,* including the Bashilele, Basongo-Meno, Dengese, Bakete (or Basala Mpasu) tribes;

(3) *Baluba,* the Basonge, Balunda, Bena Kanioka, Batshioko, Wabembe tribes;

(4) *Northern,* including the Azande, Baboa, Bambole, Ngbandi, Ngbaka, Mangbetu, Bangala tribes.

The southern tribes, those below the fourth parallel (south), were the major art-producing peoples. Their figures have a wide range of attitudes, with opulent forms and subtle modeling.

The northern region, with twice the area, produced little in art. Such work as was produced is rigid in form and crude in execution, with the arms held away from the body and clumsily carved.

Here we shall limit ourselves to the simple enumeration of the major tribes and their most typical art works.

After thorough study of explorers' first-hand accounts, we have used the names adopted in the excellent book *Les Peuplades du Congo Belge, nom et situation géographique,* by J. Maes and O. Boone, published by the Musée Royal de l'Afrique Centrale. The tribal names given in parentheses are used by other authorities and include those adopted in the essay "Carte ethnique du Congo Belge et du Ruanda-Urundi" by Dr. O. Boone.

As already noted, the prefix *Ba* in many tribal names means "people." Thus Baluba means "the people of Luba." Since Luba is said to have been the name of a chief, this can be extended to mean "the people of the great chief Luba." The prefix *Ma, Mo,* or *Mu* signifies an individual. Maluba therefore means "member of the Baluba tribe."

Hyphenation has been proposed to simplify the nomenclature—Bu-Shongo, Wa-Rega, A-Zande, Ma-Ngbetu, etc. Most published material, however, uses the unhyphenated spellings, and for that reason we use them here.

AZANDE (ZANDE, BSANDE, BAZENDA, ZANDEH, ADYO, BADJO, IDIO, NIAM-NJAM)

Sande or *Sende* means "the earth." In the word *Azande* it means "the people who possess much land." This relates to their history as

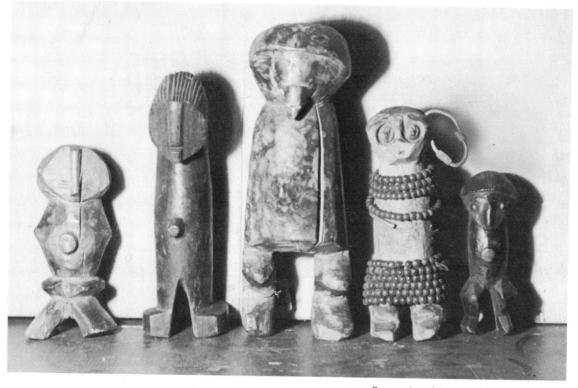

290. *Statues* (yanda), *Azande, Congo. 3″ to 5″*

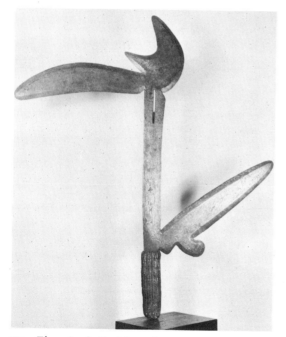

291. *Throwing-knife* (shongo), *Azande, Congo. 18″*

conquering warriors. They were famous for their iron throwing-knives in elaborate abstract designs (Fig. 291), also adopted by the Bakuba.

The Azande statues, generally known as *yanda*, were not well known and many of them were identified as Warega because of strong stylistic affinites. In 1956 a large collection was assembled in Belgium with definite local attributions, of which 250 were examined by Burssens. The majority are in wood, with some in clay. Between 3 and 10 inches high, they have archetypal, cylindrical bodies with phallic connotations (Fig. 290). More than half have no arms and a number of them are without legs. A statue with zigzag, stunted legs is known as *nazeze*. The head is in hemispherical form, the face (often without features) being made of two flat planes meeting at a medial ridge. Many have an accentuated, cylindrical navel. A statue without legs is known as *kudu;* some of these have arms. There are also small animal carvings. The statues were believed to have magical power, and many are covered with magical substance. They were used in the Mani secret society.

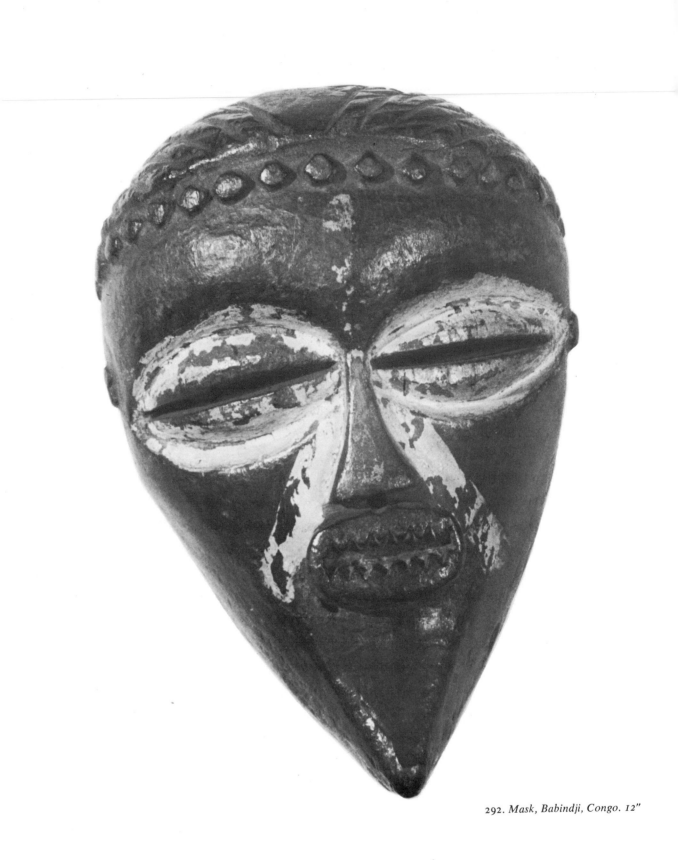

292. *Mask, Babindji, Congo. 12"*

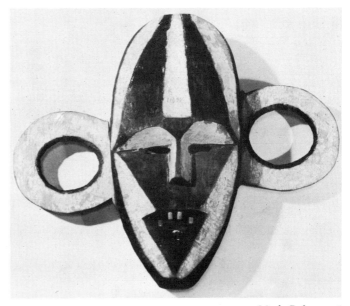

293. *Woven hood mask, Babindji. 13"*

294. *Mask, Baboa. 13"*

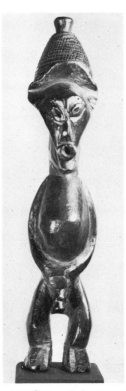

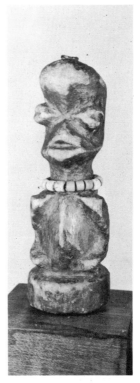

295. *Statue, Baboma. 5"*

296. *Statue, Bakete. 5"*

BABEMBA (WABEMBA—*different from* WABEMBE; *also called* WAWEMBA, BEMBA, AYEMBA, *etc.*)

This group lives in Zambia near the southeastern border of the Congo, south of Lake Tanganyika. The name means "the people of the lake."

Heads of male statues are flat and broadbearded. Seated female figures hold bowls. There are also "fetishsticks"; nonritual male and female figures in costumes, used as decorative objects; carved wooden heads.

Some masks are in the form of a human or animal head and are characterized by very small eyes; others in abstract forms.

Stools with supporting figures, similar to the Baluba stools.

BABINDJI

A group who live in the southern Congo near Angola.

A remarkable type of woven fiber mask, used as a hood, is very similar to some American Indian masks (Fig. 293). Another type, a wooden mask (sometimes polychrome), is characterized by a pointed chin and is carved in broad volumes (Fig. 292).

BABOA (ABABUA, ABABWA)

Masks with wood rings in place of ears, in striking black-and-white color contrasts. Polychrome masks of abstract design (Fig. 294).

BABOMA

Situated close to Lake Leopold.

The statues have an interesting and distinctive sculptural style, with a crownlike hairdo and curved arms with a sharp edge (Fig. 295).

BABUNDA

Small magical statues containing magical substance. Also a few mother-and-child groups.

Scepters with carved figures on the knobs.

BABUYE (BABUI), *see* WAGOMA.

BAHOLOHOLO (BAGUA, HOLOHOLO)

This is a small tribe living next to Lake Tanganyika, below the Wagoma-Babuye and having the Waruwa as western neighbors. There are two-faced half-figures with breasts on both sides. Another type of statue has a long stick in one hand and a hairdo consisting of three braids. Others show more marked Baluba influence in the hairdo, the face having thin slits incised for the eyes and the mouth. The body is somewhat naturalistically carved, with bulbous forms, as are the arms, which are separated from it.

BAHUANA (HUNGANA)

Mother-and-child statues. Masks, called *mahembe,* used at chiefs' weddings: two heavy horns arched back, low forehead, large round eyes, short flat nose.

Some unusual types of ivory carvings: one a stylized human-figure pendant shaped from a flat strip of ivory (Fig. 297); another, two human heads (Fig. 298); a third (Fig. 299), rather unusual, recalling the fertility goddesses from Cyprus (2500 B.C.). In contrast to the three flat ivory (and bone) carvings, are small ivory figurines, usually in a kneeling position (Fig. 300).

BAKETE (KETE)

These are southern neighbors of the Bakuba with whose statues and masks Bakete works are often classified.

The statues are marked by protruding eyes and a broad nose (Fig. 296).

The masks have eyes with a polychrome pattern; small, colored triangular patterns line the face. This characteristic can also be found in many masks of the Bakuba. The mask forms vary; some have V-shaped chin, with triangular patterns along the sides of the face (similar to Fig. 362). In 1924, in his book *Aniota-Kifwebe,* Maes attributed these masks to the Bakete and also to the Bapindi. In 1959 Sousberghe attributed them to the Bapende.

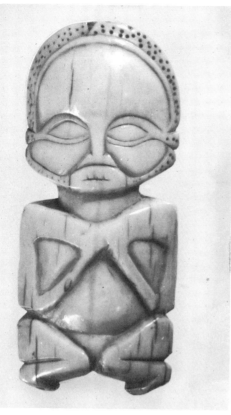

297. 2½″

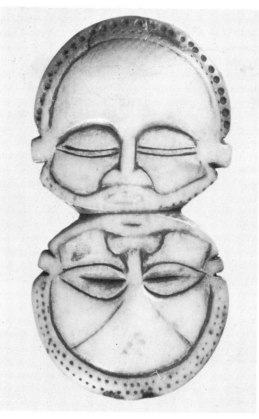

298. 2½″

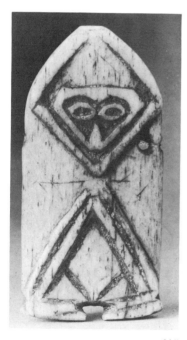

299. 2½″

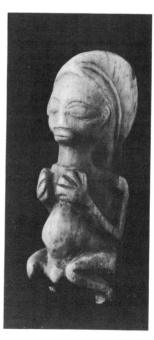

300. 2″

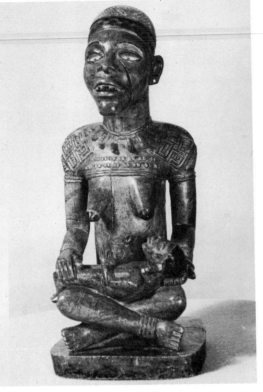

301. *Maternity statue.* 11"

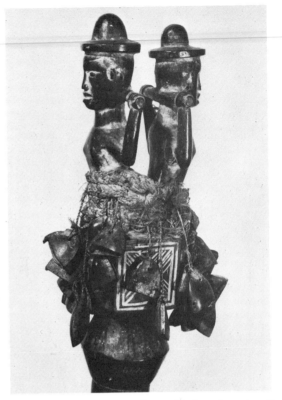

302. *Statue* (thafu malungu). *13"*

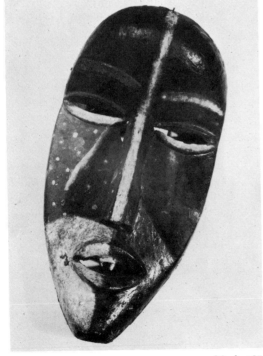

303. *Mask.* 18"

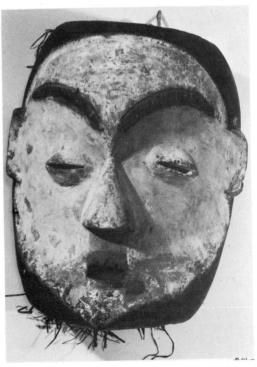

304. *Mask.* 11"

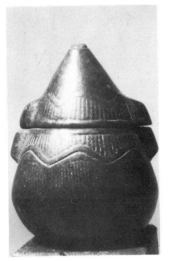 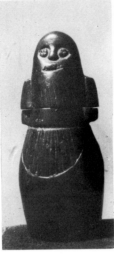 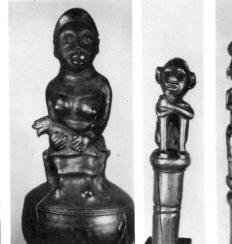

305. *Gunpowder container. 3"* 306. *Gunpowder container. 4"* 307. *Pottery with figure 17"* 308. *Head of a staff. 5½"* 309. *Head of a staff. 6"*

BAKONGO (KONGO)

This tribe is not to be confused with Bas-Congo (Lower Congo), in which they live. The regional name is Kongo; the tribal name Bakongo means "the people of Kongo." An individual tribesman is called Mukongo. A numerous people whose subtribes include the Basolongo (Mussurongo), Bawoyo, Basundi (both in the Mayombe region), Bambata, Bazombo, Bavili, and Bakuni. The attribution Mayombe frequently used for their work is incorrect. Mayombe (Mayumbe) is the name of one of the regions they inhabit.

STATUES. In a great variety of attitudes. Faces are flat-nosed and expressive and many have indications of teeth, sometimes filed down to a point. The Bakongo style is characterized by unusual realism.

The *konde, pezu, na moganga* fetishes from this region have been described under Magical Statues (page 58).

Of great beauty are the so-called "maternity statues" (Figs. 15 and 301) of women, kneeling or seated, holding children in their laps. The facial expression is naturalistic. Elaborate geometrical patterns occur on the pedestal or the body, where they may be mingled with fine scarification marks. The figures were used to ward off danger to mothers during delivery and to protect the health of the child. A maternity statue's effectiveness depended on the dignity of the figure and its youth (shown by the firmness of the breasts) and the jewelry which augmented its beauty and status.

Very unusual soapstone (steatite) statues, completely different from artwork found in the Bakongo region, are those of the subtribe Bamboma-Mussurongo found in the region of Noqui near Matadi, on the border of Congo and Angola. Verly has given valuable information about these statues which were created in a few basic types: a man sitting cross-legged resting his chin in his hand (called *fumani* or "the thinker"), or a man standing or crouching; a mother holding a child to her breast (Fig. 14); a figure kneeling, holding both hands before the face or shown as a drummer, etc.

The general name given to these statues is *mintadi* ("guardian"), representing the spirit of the departed. They were found in sacred cemeteries (*manene*) buried in the soft earth, which accounts for their good condition. The tradition probably can be dated back to the sixteenth century (Hindu refugees came to this region in 1561; thus there is possible Hindu influence). In 1695 the Luigi Pigorini Museum in Rome already had four such carvings.

A very unusual figure is the *thafu malungu*, representing Mbumba Luangu, a serpent spirit connected with the rainbow, and used by the Bakhimba men's secret society (Fig. 302). The objects hanging from it possessed magic. It was

credited with great power, the clan magician and his assistants devoting three weeks in the forest to its sanctification (see Bittremieux).

MASKS are not generally known; however, the Musée Royal de l'Afrique Centrale has two interesting specimens (Figs. 303 and 304), both from the Mayombe region.

OTHER SCULPTURE. Mention should be made of their very fine staffs, the top of which is either a kneeling figure (similar to the maternity figure) or a standing or sitting figure (Figs. 308 and 309). Rather unique are the gunpowder containers either in pure geometric form (Fig. 305) or with a carved head for the lid (Fig. 306). It may also be worth mentioning their pottery work (illustrated by Olbrechts in *Plastiek van Kongo*)—Fig. 307, for example, a seated female figure holding an animal in her lap.

BAKUBA (BUSHONGO)

According to Emil Torday, the name Bakuba is a Baluba word meaning "the people of the lightning," a probable paraphrase of the word *Bushongo,* which means "the people of the throwing-knife." The *shongo* was a weapon unknown to the Baluba until they came in contact with the Bushongo whose battle weapon must have struck them as having the effect of a lightning bolt. This name for the knife was later adopted by the Azande (Fig. 291). Though various names for this tribe are used by authorities, we follow the usage of the Musée Royale de l'Afrique Centrale, which prefers Bakuba.

We owe our knowledge of the Bushongo to the publications of Torday. Their line of 120 kings, called *Nyimi,* were held to be of divine origin. One of the most famous was the ninety-third king, Shamba Bolongongo (1600–1620 A.D.), who introduced the custom of carving a wooden image of the ruler. His statue is now in the British Museum (Fig. 2).

The Bakuba, blessed with favorable agricultural and climatic conditions, enjoyed a prosperity conducive to artistic activity and appreciation. Their villages were well organized and clean. Special sheds were provided for the artisans, whose work was greatly admired.

In spite of this unique appreciation of art, comparable only to that of the Baule tribe of the Republic of the Ivory Coast, most of the objects served a ritualistic purpose. Often a seemingly decorative, geometric pattern on an object had symbolic meaning.

STATUES. The royal statues, showing the king wearing a rectangular object on his head and seated on his haunches, were mounted on quadrangular pedestals. One hand is on his knee, the other holds a ritual sword. At the foot of the pedestal is an object emblematic of royal authority—a drum, an anvil, a cup, or a human or animal figure. These statues are the product of a court art similar, in its unique place in African art, to that of the Benin Kingdom. Technically refined, this sophisticated, conventional art form shows marked naturalistic tendencies. The royal attitude implies reflection and will power and aristocratic aloofness. We know of seventeen extant pieces and the names of twelve rulers are recorded. The figures vary little; apparently, the carving of the successors was modeled after the first.

Contrasted to the highly sophisticated royal portrait statues are roughly carved Bakuba figures, stronger in expression and vitality (Fig. 317). There are also wrought-iron figures, poorly executed, with oversize, flat hands, thought to date back to the sixteenth century, and divining instruments (*itombwa*) in the form of a stylized animal, with a long body flattened on the back, on which coinlike disks were rubbed during the divination (Fig. 1). Similar divination figures were made by the Bashilele, Bakongo, Basongo-Meno, and Bankutu tribes.

MASKS. Most commonly known in a very diversified output is the *bombo* mask used in initiation ceremonies: a helmetlike human head, with bulging forehead, small eyes, large nose, and chin extended by a beard (Fig. 316). A triangular-shaped ornament rests on the bridge of the nose; broad bands, encrusted with pearls, are set over eyes and nose; the closed mouth is often covered with a copper plate. Between eye and ear, cones are carved in relief. Other copper pieces, pearls, and cowrie shells may also stud the masks. They are thought to represent the aborigines now regarded as genii.

Bakuba Masks, Congo

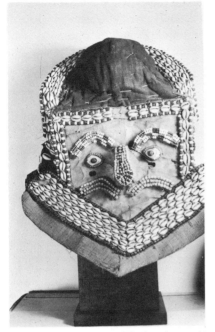

310. Mashamboy. *16"*

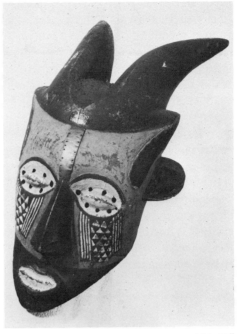

311. *27"*

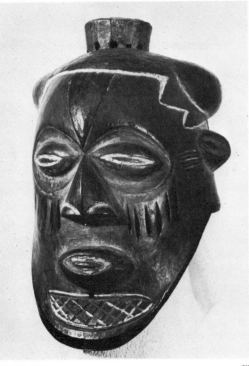

312. *16"*

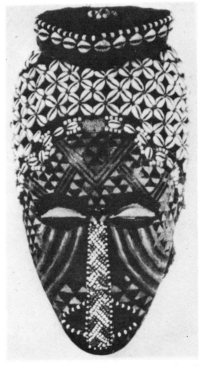

313. *14"*

The rich variety of Bakuba initiation masks may be seen in Figs. 3, 311, 312, 314, and 315.

Another mask, often attributed to the Baluba and Bena Lulua, has a triangular pattern over the whole face, shells and beads often marking the hairline, and raffia cloth in geometrical designs covering the wearer's head (Fig. 313).

The so-called *mashamboy* mask (Fig. 310) has a flat face made of antelope skin or metal plates. Wooden nose and ears and raffia beard are affixed to a webbed cloth base. Eyes, eyebrows, the framing of the face, and often the headdress are done in rows of beads and cowrie shells.* Tail-like ornaments on top are frequent. The *mashamboy* masks were supposedly worn by chiefs and other dignitaries to commemorate an ancient clan hero. According to Torday, Bo Kena, seventy-third king (*Nyimi*) of the Bushongo, invented this mask in 1350.

In *Aniota-Kifwebe,* Maes quotes Torday, and indicates that these were also called *mukenga* and *mukengo.* On Torday's last trip to the Congo, in 1912–14, they were worn by professional dancers. At these dances, women participated. Thus the sacred character of these masks had been completely lost and the masks had become props for public entertainment.

In the *mashamboy* masks, the use of fabric for the construction of the whole mask, leather for the face, wood for the nose and ears, and raffia, cowrie shells, and beads for ornamentation can be compared to the modern use of

nontraditional materials in collages and assemblages. Wood, stone, clay, metal, and ivory were the traditional materials in the art of both cultures—and in Western culture paint as well, a medium used by the African only for rock painting or for coloring their masks. The Cubists substituted printed and other materials for paint in order to make collages and experimented with a variety of materials in creating sculptural assemblages. In essence the *mashamboy* mask is an assemblage.

Extremely rare are the beautiful Bakuba ivory masks (about 5 inches in length) with reddish-brown or yellow-brown patina.

CUPS AND GOBLETS. The Bakuba love of form, knowledge of materials, skill in execution, and appreciation of quality are best seen in the number and variety of cups and goblets, mostly for drinking palm wine and restricted, among the Bashilele, to initiated men. There are reports—not confirmed—that these cups might have been used in the poison ordeal. Among the Bakuba, as among other African tribes, death was never attributed to natural causes but to malevolent spirits or to witchcraft. The person suspected of using witchcraft was required to drink poison from such a cup. If he vomited up the drink, he was declared innocent. On the other hand, his death proclaimed his guilt and constituted his punishment.

Some cups have handles, other are without. In both, the cups take the following forms: standing figures (Fig. 319) and kneeling figures (Fig. 320), the latter done in the Bushongo royal-statue style; human heads—some only the head, using the neck as a base (Fig. 318), some attached to one leg (Fig. 321), some to two legs (Figs. 60 and 62). Some are double-headed on a common neck base (Fig. 325). The facial expression is often of great beauty with a mysterious air of detachment, radiating an intense inner feeling (Fig. 318).

Another large group (also with and without handles) is of geometric design, done with great skill. If we remember that the African carver never traces a design but cuts directly into the wood, we wonder how he was able to cover a round surface with flawless balance, another tribute to his great artistry. These

* Because of the wide use of cowrie shells by tribes in the Congo, Mali, Cameroon, etc., in carvings and on ornamental girdles, it may be of interest to trace its development. The earliest known use of the cowrie shell in Africa was as a fertility symbol, probably because of its resemblance to the female sex organ. They were placed on girdles worn by maidens and marriageable women. In other lands the cowrie was identified with the Greek *porculus* (little pig), token animal of the fertility goddess, Aphrodite, and later with the concept of the Great Mother and the womb.

Cowrie shells were used as money. Ibn-Batuta and Cadamosto, who visited the Kingdom of Melle in 1353 and 1455, respectively, reported a cowrie shell currency. These shells are not indigenous to Africa, but were apparently imported from the Maldive Islands in the East Indies and spread by Egyptian traders to West Africa. The Egyptian six-cowrie basic unit of money survived in Nigeria until recently. The cowrie is still used in food markets for purchases under a British penny. Two hundred cowries are worth approximately three cents. Its use as money also made the cowrie a symbol of power; consequently, the more cowries on a mask the greater its power.

BAKUBA, Congo

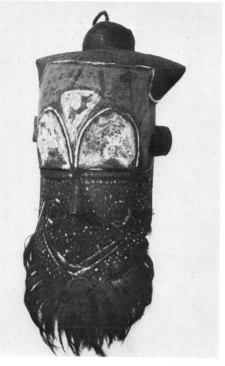

314. *Mask. 20"*

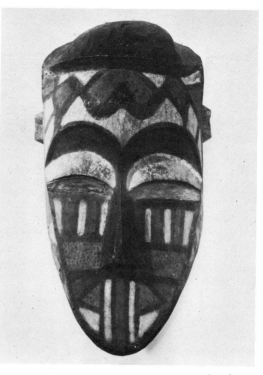

315. *Mask. 22"*

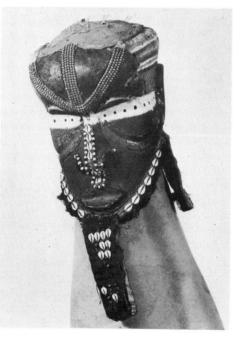

316. *Mask* (bombo). *13"*

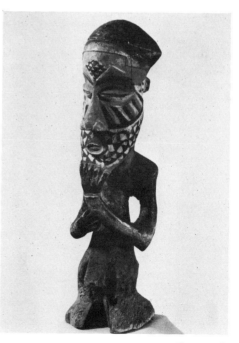

317. *Statue. 16"*

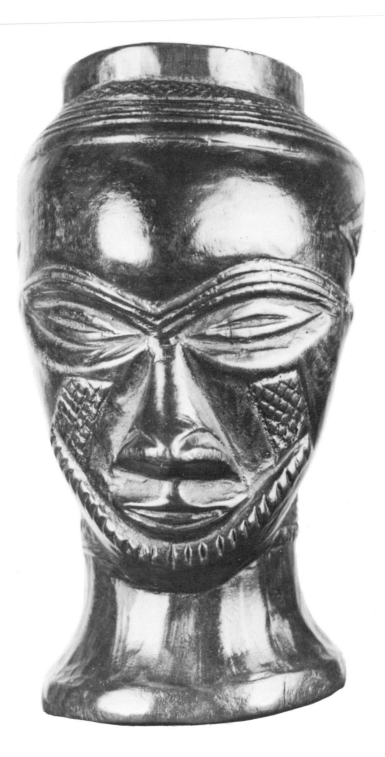

318. *Ceremonial cup, Bakuba, Congo. 6"*

Bakuba Ceremonial Cups, Congo

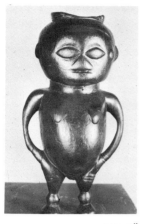

319. 9"

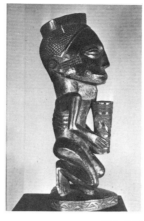

320. 11"

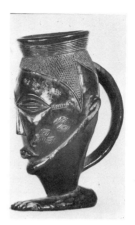

321. 10"

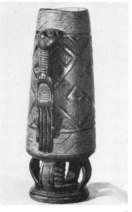

322. 9"

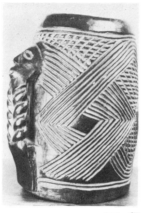

323. 6"

324. 7"

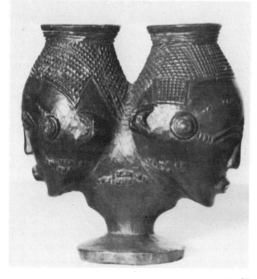

325. 6"

326. *Cup with ivory head and wood base.* 9"

"geometrical pattern" cups may carry no other ornament than the design (Fig. 324) or may have a handle like a head (Fig. 323) or like a hand (Fig. 322). Each design has its own name and specific meaning, based upon certain objects or symbolic ideas (moon, sun, animal forms, horns, cowrie shells, animal claws, etc.). Often they represent a royal insignia. The same is true of the designs on the raffia cloth.

The human-hand motif (also used on decorated drums) is often isolated. Sometimes the hand is half-closed, possibly commemorating an old custom of a warrior presenting the left hand of a slain enemy for admission into the Yolo secret society (Figs. 322 and 329).

A few cups are made of ivory. We know several made entirely of ivory, similar in style to Fig. 318, but a rather unusual one is Fig. 326, in which the head is carved in ivory and the lower part made of wood studded with round-headed copper nails, a handle on the back.*

In the same style tradition are the vases and ointment containers (some in crescent form) richly carved with geometrical patterns and used to hold the red *tukula* cosmetic powder (Figs. 327 and 328.)

Similar goblets, cups, and boxes are produced by the Bashilele, Bakongo, Bapende, Bambala, Basongo-Meno, and Baluba peoples.

A tufted CLOTH is woven of *minyoa* raffia, in geometric designs similar to those on the cups (Fig. 330).

OTHER OBJECTS include a circular stool with four flat, outward-curving supports (Fig. 332); pipes, the bowl decorated by engraved geometric patterns or a human-head carving (Fig. 335); spoons with carved head; carved-buffalo drinking horns (Fig. 333); wooden bells (Fig. 331). Also the well-known musical instrument *sanza* (Fig. 334), which consists of a hollow box with a metal spring attached to it. This type of "piano" is known all over the Congo (the Batshioko, for example, richly ornamented their own *sanza*). Headrests of great variety, some in very graceful geometric form (Fig. 336), some supported by figures similar to the Baluba headrests (Fig. 341). (Fig. 337 shows a widely known, highly decorated type

* For further details, see the author's essay "Bakuba Cups: An Essay on Style Classification" (1952).

of headrest, but this comes from the Makalanga tribe in Mashonaland, in Rhodesia.)

BAKWESE (KWESE)

Most statues are roughly carved, with angular shape, large eyes, and flat face.

BALUBA (LUBA, LOUBA, WALUBA, BULUBA; on old charts URUWA *from the name given them by Arabs*)

Inhabitants of southeastern Congo, also of Northern Rhodesia (now Zambia), the Baluba were formerly an independent state allied with the Lunda Kingdom, probably around the sixteenth century. The Baluba have a great variety of carvings, distinguished by emotional intensity. Refinement of execution is sometimes sacrificed for the sake of dramatic expression.

STATUES. Their magical statues are carved in hemispherical forms, the arms set close to the body, the head often round, and the eyes deep-set. There are also ancestor figures, characterized by elaborate scarification patterns on the body. Heads have a broad forehead and finely carved features, with an intricate hair pattern (Fig. 338). Some statues have the shoulder squared and the head also square on the neck (Fig. 339), suggesting great power. Composite figures also occur, such as a mother carrying her child or the *katatora* divining instrument (Fig. 340). The *katatora*, consisting of a human head surmounting an open rectangular form, was pushed back and forth on a flat surface by the diviner.

Unusual for African art is the kneeling or seated begging figure (*kabila ka vilie*) representing the protecting spirit of maternity, the hands holding up a *kabila* (wooden bowl) (Fig. 346). There are other variants of the same type of statue. One is a seated figure with rich scarification marks all over her body, elaborate plaited headdress, and a bowl between her legs, the lid of the bowl surmounted by the head of her child. The other is composed of two figures holding the bowl between them (Fig. 25). There is various information as to the use of this type of statuary. One source states that the bowl contained a white powder

BAKUBA UTENSILS, Congo

327. *Ointment box. 4"*

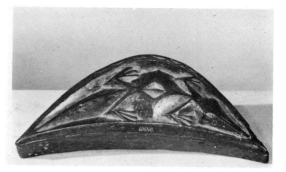

328. *Ointment box. 9" wide*

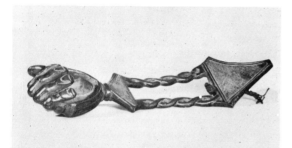

329. *Utensil in the form of a hand. 14" long*

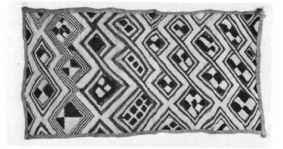

330. *Raffia cloth. 26" wide*

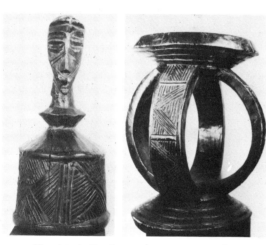

331. *Wooden bell. 9"* 332. *Stool. 12"*

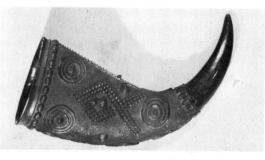

333. *Drinking horn. 10"*

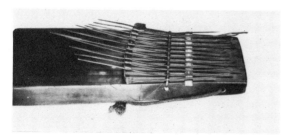

334. *Musical instrument* (sanza). *14" long*

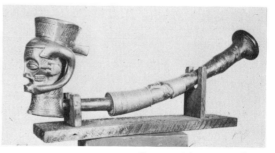

335. *Ceremonial pipe. 15" long*

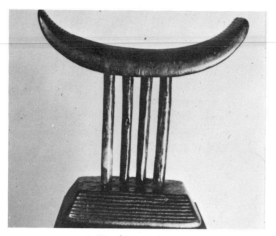

336. *Headrest, Bakuba, Congo. 4″ x 6″*

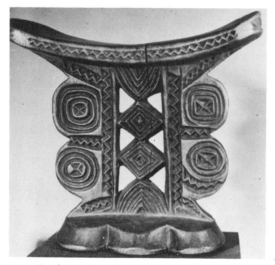

337. *Headrest, Makalanga, Mashonaland, Rhodesia.*
6½″ x 8″

(*mpenbe*) that was rubbed on the person seeking advice from the diviner. Another states that objects were placed in the bowl and thrown on the ground, the future forecast from the positions they took; this method was also used to determine the name of an unborn child. It is also reported that the white powder was used on the face of the diviner himself. Another source states that the mother-and-child combination was placed before the dwelling of a woman in childbirth, for which reason this statue was often called a "mendicant" figure.

The extremely rare, bowl-holding figures created at Buli (Fig. 351), with elongated faces carved with great expressive force, belong among the masterpieces of African art. Only

eight examples are known. This type of carving, however, also appears in the Buli stools (Fig. 8).

Less well known are the ivory carvings. Fig. 344 shows the typical Baluba facial characteristics, arms bent upward, the usual elaborate hairdo on the back of the head. Rather unusual is Fig. 345, a small torso of a woman with facial expression similar to the Buli figures of the same tribe; she holds a bowl and also has the complex coiffure on the back of the head.

MASKS. The *kifwebe* masks (formerly attributed to the Basonge tribe), used by the secret society of the same name, originated in this territory, according to recent research. However, Maes indicates that the name *kifwebe* was the name of the mask and was used in a dance called *makaye a kifwebe,* which means "the dance of the mask." He further indicates that this mask was used when the chief of the village died, or when a chief (*kalala*) was appointed, or when an important visitor arrived at the village. There is also a suggestion that the same mask might have been used on a large man-sized statute made of clay, wood, and fiber. The *kifwebe* masks vary a great deal but in general are characterized by impressive volumes and lineal patterns all over the face. Fig. 349 is the boldest type with large, angular nose forming one part with the crestlike hairdo, pierced eyes having what may be described as enlarged eyelids, the mouth (unique in African art) a bold, boxlike protrusion. There is another version of the same type with the square, boxlike mouth, but without the crestlike hairdo and the large eyelids. The second type (Fig. 350) is different because of its round shape, its emphasis on linear design patterns rather than on protruding nose and mouth. Others are two-faced, Janus types.

Entirely different (probably only two are known to exist) is the mask with curved horns shown in Fig. 19.

AMULETS. The Baluba have a unique animal-tooth carving (sometimes in ivory), called *mikisi mihasi* (Fig. 343), incorporating the spirit of a dead parent, the name of whom is often given to the protective amulet. It is worn on a cord around the neck or attached to the arm or the chief's baton, and it is often rubbed with oil to increase its potency, or a magical

BALUBA, Congo

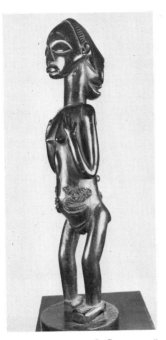

338. *Statue. 13"*

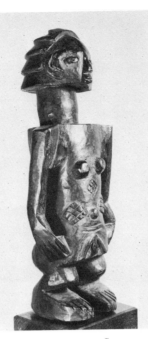

339. *Statue. 11"*

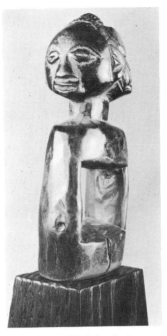

340. *Divining instrument
(katatora). 5"*

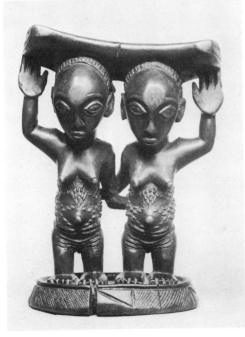

341. *Headrest. 6½"*

342. *Headrest. 7"*

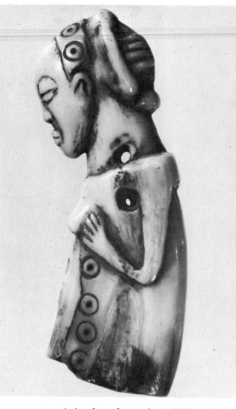

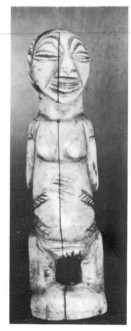

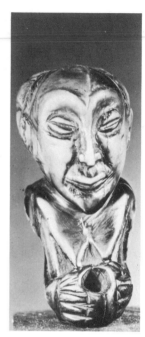

343. *Animal-tooth amulet* (mikisi mihasi). *3"*

344. *Ivory statue.* *5"* 345. *Ivory torso.* *2½"*

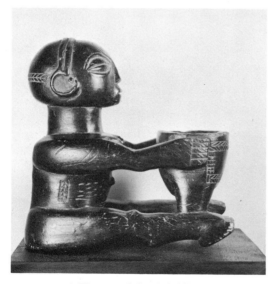

346. *Figure with bowl* (kabila ka vilie). *7½"*

347. *Ivory amulet.* *2"* 348. *Ivory torso.* *3½"*

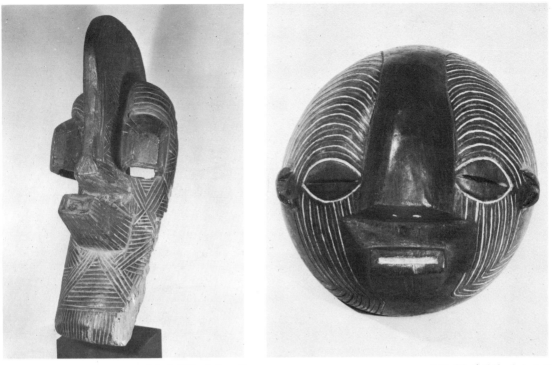

349. *Mask* (kifwebe). *17"*

350. *Mask* (kifwebe). *13"*

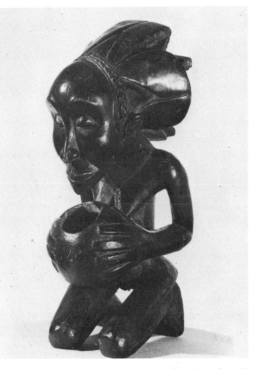

351. *Figure with bowl, Buli style. 18"*

substance is placed into the interior cavity. The circle-dot symbolic sign (noticed on many African ivory carvings, especially Warega), representing the sun and spiritual energy, is incised on the surface, also to increase the amulet's power.*

Fig. 347 is a much-worn, small ivory amulet with a hole in its neck. Fig. 348 is another protective amulet carved in ivory: a torso of a woman, the facial features obliterated from wear; the abdomen protrudes and a similar projection carved on the back is pierced to hold a cord.

STOOLS AND HEADRESTS. Their circular stools, carved from one tree trunk, are of high artistic merit. They are usually supported by a caryatid figure of a kneeling women or man (with large genital) or a woman or man standing, the seat resting on his or her head and also supported by upraised arms (Figs. 8 and 56). The coiffure, following the typical Baluba style, is arranged in double chignon, the body covered with elaborate cicatrice marks.

* For further details, see the author's paper "Circle-Dot Symbolic Sign on African Ivory Carvings" (1953).

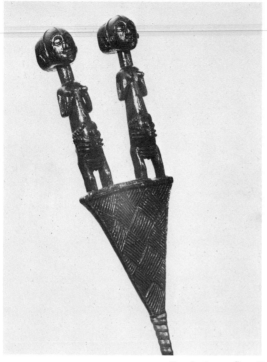

352. *Head of a staff. 41"*

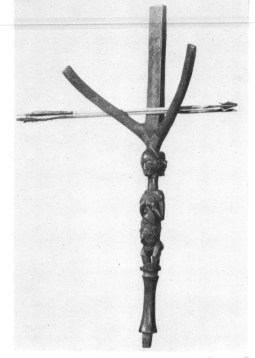

353. *Arrow quiver. 20"*

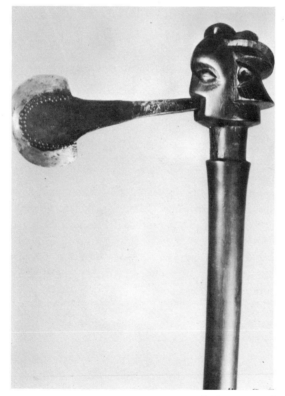

354. *Head of an axe. 15"*

The headrests, also of great variety, are similar to the stools. Fig. 341 shows double figures supporting a crescent-shaped form. Fig. 342 shows two sitting figures face to face, with elaborate, typical Baluba hairdos. Most of them have scarification marks all over the body. Some authorities explain these supporting figures by comparing them to the custom of a king sitting on the back of a slave.

OTHER SCULPTURE. Ceremonial staffs and scepters of very great variety and beauty (Figs. 9 and 352). Similar care is shown in adze and axe handles, with the blade inset like a tongue (Fig. 354), arrow quivers (Fig. 353), etc.

BALUNDA (ALUNDA, ARUND, MILUA, LUNDA)

Art similar to the neighboring Batshioko.

Their statues are unusual since they depict action: pounding a mortar (Fig. 355), smoking, drumming, etc. A characteristic of the statutes of this tribe is the carved headband (also to be noticed on some Batshioko masks).

Also, heads (*akish*) placed on small earthen mounds; clay figures in animal forms kept in straw huts. Hollow, carved wooden heads with elaborate hairdo.

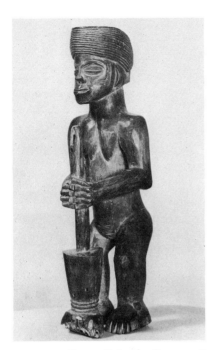

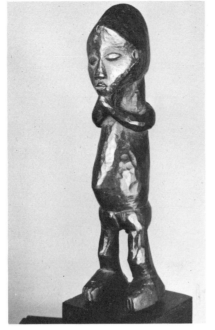

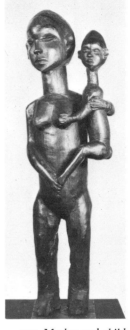

355. *Statue, Balunda, Congo. 12"* 356. *Statue, Bambala, Congo. 5"* 357. *Mother-and-child statue, Bambala, Congo 14"*

The masks have long hairdress carvings, round eyes, small nose, sharply cut lips, protruding chin similar to the Batshioko masks (Fig. 20).

A large variety of scepters with heads carved on the knob; tobacco mortars; whistles; combs; etc.

BALWALWA

The Balwalwa, a small tribe located in the southern Kasai region, are known for their masks: large, triangular, projecting nose; pierced slits for eyes with two cylindrical forms at the corners of each; protruding lips. The chin is another triangular shape, repeating the shape of the nose but in reverse.

BAMBALA (MBALA)

This tribe is sometimes called Ba-Babala or "the red people," the word *babala* meaning "red."

Bambala statues are characterized by stiff attitudes. Many have the hands on the chin (Fig. 356), like the Bayaka figures. The head is round, forehead domed, eyes small and oval. Among the large number of mother-and-child statues in African art, there is an unusual one made by this tribe in which the child is sitting on the hips of the mother (Fig. 357), the actual position in which she often carried the baby (as illustrated by Nuoffer). There are also seated maternity statues, seated drumming figures, and ancestor statues. The statues are reddened with *tukula* powder, also used on the body, from which custom the tribal name was probably derived.

Masks resemble those of the neighboring Bayaka.

There are also headrests supported on the arms of single or double figures.

BAMBOLE (MBOLE)

Although Olbrechts included this tribe among the northern Congolese, it lives slightly to the south of the other tribes, not far north of the Warega tribe. Its stylistic characteristics could be connected with Ngbandi (also Azande) features and also with the Warega. The manner in which the white faces (often

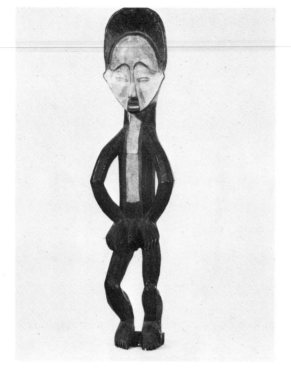

358. *Statue, Bambole, Congo. 28"*

with remnants of yellow color) of the statues
are carved, with concave surface, arched eye-
brows forming unity with the long and narrow
nose, reminds us of many of the Warega wood
masks and also of the masks of the Pangwe.
Fig. 358 shows one with arms akimbo, bent
legs, and rather elongated body, but there are
others that are more compact in their over-all
structure. These statues were used in the initia-
tion ceremonies of the Libwe secret society.

BAPENDE (PENDE)

The Bapende, numbering about 250,000,
live between the Bayaka and Batshioko tribes.
A distinction should be made between the Ba-
pende of the east (in the section known as Ka-
tundu) and those of the west; most of the
masks were produced in the east. Due to the
comprehensive work of L. de Sousberghe
(*L'Art Pende*), we are able to classify the art
production of the Bapende as follows:

MASKS. (1) The most important mask, made
of twigs, often ornamented with feathers,
formed into a large circular shape with two cir-

cular eyes (Fig. 359), is called *minganji* (also
gitenga). This is the mask which represents the
tribal ancestor, has magical power, and is also
used by the "policeman" at the circumcision
ceremony.

(2) Better known are the sensitively carved
masks called *mbuya* (Fig. 23); domed fore-
head, long stylized eyebrows, high cheekbones,
short broad nose (turned up), showing nostrils,
well-formed mouth in the lower part of the tri-
angle-shaped cheek, half-closed eyes; face
often painted red, with scarification marks;
hairdo made of black dyed raffia. The masks
were used on two occasions: first, when the ad-
olescent boys returned from the circumcision
ceremony from the enclosure to the village,
and, second, when they performed "plays."
Each mask has a name and represents a well-
known personality, such as a lazy person, a
young or old woman, a prostitute, clown,
etc., not more than three to five masks appear-
ing at one time.

Another version of the *mbuya* mask is shown
in Fig. 361, with the addition of a long wooden
"beard." Mostly associated with hunting, its
name is *muyombo* or *giwoyo*.

(3) A very unusual helmetlike mask comes
from the Kasai region, and unlike the very deli-
cately carved upturned nose of the *mbuya*, this
mask has a big, straight nose like a large finger.
An extended rim at the bottom rests on the
shoulder of the wearer (Fig. 360). This mask,
called *giphogo*, was kept in the hut of the chief
and was dedicated to the fertility of the people.
It was also used to cure the sick. The ailing
person lay on the ground and the masked per-
son jumped over him, thus exorcising the ma-
levolent spirit from his body. (A small ivory
mask was also used on this occasion, hung
around the neck of the sick as if to extend the
beneficial effect of the ceremony.)

(4) Another mask, called "little *giphogo*"
(also *phota*), is triangular and has the same type
of white design on the sides of the mask (Fig.
362). It is often surmounted by horns, the
knife of the chief, or a human standing figure.

(5) There is another helmetlike mask, very
close in concept to the Basuku masks (Fig.
374) but with a Bambala hairdo. This is called

BAPENDE, Congo

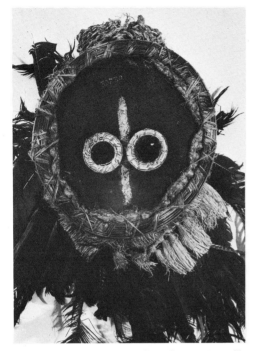

359. *Mask made of twigs and feathers* (minganji). 9"

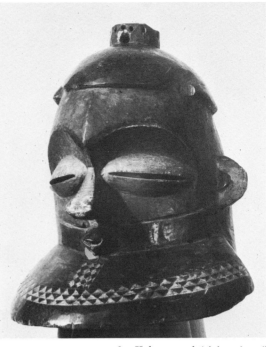

360. *Helmet mask* (giphogo). 11"

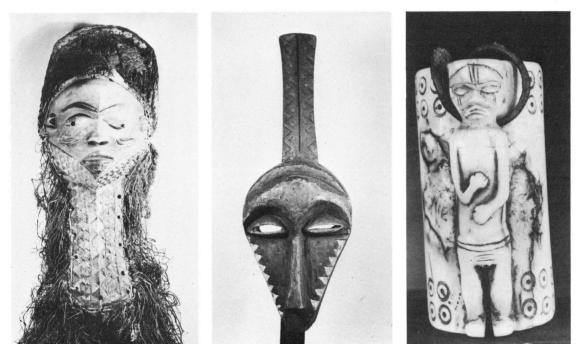

361. *Mask* (muyombo). 22" 362. *Mask* (phota). 13" 363. *Ivory powder container.* 3"

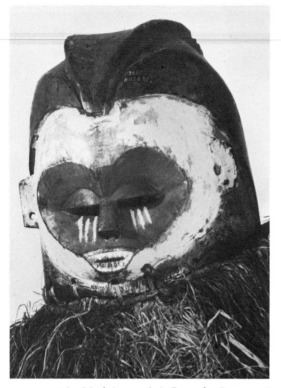

364. *Mask* (mayombo), *Bapende, Congo. 11"*

mayombo or *kiniungo* (Fig. 364). The small face has a symbolic "heart" shape painted white, with small, cut eyes, under each of which three vertical lines are incised (called *masoji*, meaning "tears").

(6) Another very well-known small ivory mask, in the style of the *mbuya* mask, is called *ikhoko* (Fig. 24), its primary role being that of a protective amulet suspended from the neck. As indicated above, it was given to the sick person. Some have the shape of the *muyombo* (with beard) and the three-pointed cap of the chief. These small masks are also carved of wood, grain of the palm tree, and bone, and some are cast into metal (mostly lead) by making an impression of the ivory mask in clay and pouring the metal into the resulting mold.

OTHER SCULPTURE. (1) Ivory whistles used also as pendants, some with carved human head (in the *mbuya* style), some with circle-dot ornamentation, and a number of them in old-fashioned key form. (2) Snuff or powder containers with standing figure (Fig. 363) and circle-dot ornamentation. (3) Free-standing ivory figures, rather rare, similar in style to the figure on the powder box. (4) Staffs of justice carved in wood, with head, standing figure, or geometric design for handle. (5) Wood stools and also chairs, the latter probably under Batshioko influence. (6) Adzes with carved head, the blade issuing from the mouth, similar in concept to the Baluba axe (Fig. 354). (7) The least interesting works of this tribe are the statues. Some have the head of the *mbuya* mask, giving an impression of representing a masked person, but the body is different in style from the face. It is as if the whole creative tradition of this people had centered upon mask making; perhaps this exclusive focus on one area of creativity was the key factor leading to the astonishing variety of the masks, each different in style, but each coherent within its own style configuration.

BASALAMPASU (BASALA MPASU, ASALAMPASU)

A small tribe north of the Balunda and west of the Bakete tribes, it has produced different types of masks. One is made of netting (similar to Fig. 293) with a superstructure of twigs. The second type is characterized by a heavy, domed, hemispherical forehead, with prominent triangular nose, pierced eyes in square or triangular form, pierced mouth (often rectangular) with teeth showing. (Some of these masks have metal sheeting.)

BASHILELE (LELE)

Closely related to the Bakuba; best known for their cups, especially those on a stem.

BASONGE (SONGYE, BAYEMBE, BASSONGO, WASONGA)

The name Basonge probably derives from Kasongo, one of the ancient great chiefs of the Baluba. Although the Basonge are relatives of the Baluba, their style differs appreciably.

STATUES. Carved with great force. Their hands rest on paunches filled with magical substance (Fig. 366). There are also busts in the same attitude; also figures without legs or arms

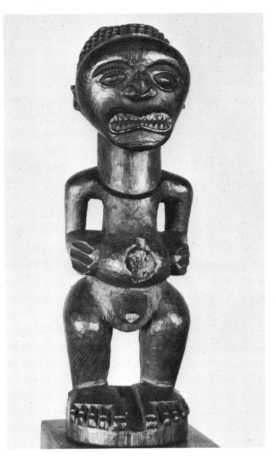

365. *Statue, Basonge, Congo. 7"*

366. *Horned statue, Basonge, Congo. 35"*

(Fig. 61). In the full figures the head is generally rounded in front and outstretched, the long neck often twisted, shoulders generally broad, feet large and flat on the pedestal. The statue may be covered with cloth, with varied objects —animal teeth, bits of wood, etc.—hanging from it (Fig. 366). The eyes are indicated in a variety of ways: buttonlike forms, concave shapes, perforations, cowrie shells. The head is often encrusted with metal pieces as decoration. These magical statues were used at changes of the moon.

According to Maes (*Aniota-Kifwebe*), these statues were also used as leopard fetishes, meaning that the medicine man possessing this statue was able to acquire power over an actual leopard and could command the animal to kill the person he chose. Many of the statues actually have a number of leopard teeth hanging on a leather band. In smaller figures the magi-

cal substance is often placed on the head in the form of an animal horn. Some have pointed, bearded chins.

The Basonge also have an unusual style of sculpture with large head and open mouth pinched together in the center to form a horizontal figure-eight design (Fig. 365).

Among the smallest (about 2 inches long) IVORY PIECES of West Africa are the Basonge whistles (Fig. 371), carved as a bearded male figure with circular patterns on the body. In spite of their small size and the gemlike feeling of the ivory, they have a remarkable monumental simplicity. Less well known are other ivory carvings of this tribe. Fig. 367 shows a male figure with neck composed of rings and with highly expressive facial features. Fig. 368 has the same type of neck but the long face has what appears to be a double beard, although the body has female sex indications. Very unu-

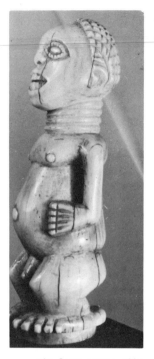

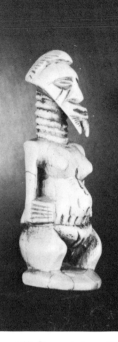

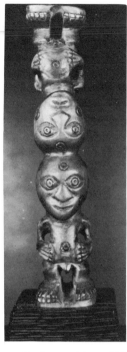

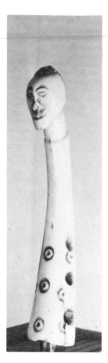

367. *Ivory statue.* 5½" 368. *Ivory statue.* 5½" 369. *Ivory statue.* 4½" 370. *Carved animal tooth.* 5"

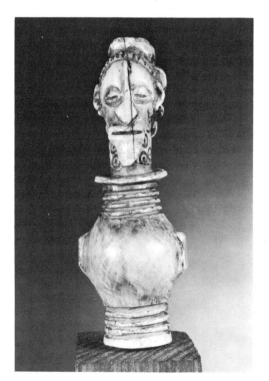

371. *Ivory whistle.* 4"

sual is Fig. 369, unusual not only for a Basonge ivory but for African statuary in general, because two figures are attached head to head, one on top of the other. This is not a unique piece, however; the Basel Museum has a similar one. Fig. 370, an animal tooth with a human head, decorated by the circle-dot sign, was used as part of a necklace with eight to ten other similarly carved teeth.

The Basonge *kifwebe* MASKS, modeled on those of the Baluba, have linear ornamentation in white. This becomes more dramatic when the mask is painted black (Fig. 350). A variation of these is the miter-shaped Basonge-Batempa masks, which have protruding, cylindrical eyes, no mouth.

There are also STOOLS with carved, supporting statues, similar to the Baluba stools.

BASONGO-MENO (SHOBWA)

Basongo means "people," *meno* "teeth"; thus Basongo-Meno, "the teeth people." The Basongo-Meno file their teeth to a triangular shape. They are also called Bankutshu, Bakutu, Batetela, Wafuluka, etc.

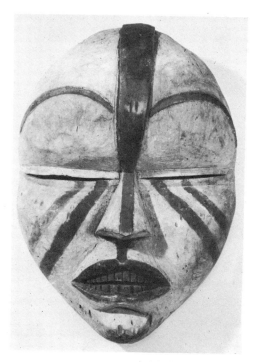

372. *Mask, Basundi. 17"*

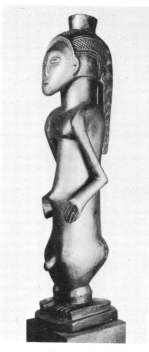

373. *Statue, Batabwa. 12"*

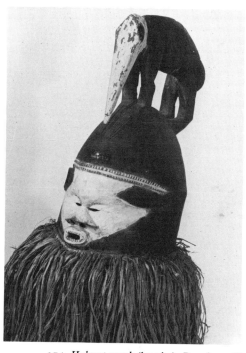

374. *Helmet mask* (hembe), *Basuku. 16"*

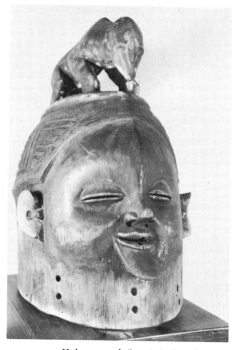

375. *Helmet mask* (hembe), *Basuku. 17"*

The statues are half-figures, exquisitely carved, down to the genitals, and set on round pedestals. The head is small in proportion. The hairdo is sometimes covered with cowrie shells. The trunk is very long, arms ending in large hands resting on the body, whose rigid attitude imparts an air of grandeur. Navel and abdomen are richly decorated with scarification marks. The head, too, has tattoo marks.

Basongo-Meno cups are in the form of a human head, similar to the Bakuba goblets, with hornlike hairdo.

BASUKU (SUKU)

The Basuku are sometimes confused with their western neighbors, the Bayakas.

Their two, hoodlike types of masks resemble Bayaka work. The type called *hembe* (Fig. 374) has an angular pattern concentrated on the forehead. The eyes are half closed. The whole, carved out of a single block of wood, is topped by a seated human figure, animal figure, or abstract design. Another *hembe* mask has the face compressed and has flaring ears and a small beard. The expression resembles that of Etruscan statues (Fig. 375).

BASUNDI (SUNDI, BAWOYO)

The Basundi tribe in the Mayombe region produced a very interesting mask (Fig. 372) for the Badunga secret society. This mask is over a foot high and has the features of some Dan masks from the Republic of the Ivory Coast. Usually painted white (sometimes with colored lines), probably indicating colors used in initiation ceremonies.

BATABWA (BAMARUNGU)

Statues attributed to this tribe may derive from the neighboring Baluba. Large heads with hemispherical, domed forehead with V-shaped tattooing, oval eyes. Some heads carry a horn containing magical substance, typical of the Basonge magical statues. A very unusual figure attributed to this tribe (Fig. 373) has a long braid descending on the back of the figure, with angular arms contrasting with the roundness of the body.

BATEKE (TEKE; *also called* M'TEKE *and* BAKONO)

The name of this tribe indicates its occupation—that is, trading—from *teke,* meaning "to buy." They live in the Stanley Pool area, in both Congo republics.

According to the study of the Teke by Hottot, the Teke people comprise the Fumu, Sisi, Bali, and Teo tribes, of which the Fumu and the Sisi are best known for their magical statues.

STATUES. Most of the statues have a helmetlike hairdo (Fig. 31) which looks sometimes like a hat and is the actual male hairdo (*mupani*), made by cutting both sides of the hair very short and letting the middle grow (some of the Fumu statues, however, have a round hairdo.) The face has incised furrows as scarification marks (*mabima*) and a beard (so does the headman or medicine man—it connotes excellence). Sometimes the eyes are made of European shirt-buttons (Fig. 376) to enhance the statue's mystical powers. Most have an abdominal cavity used to hold the magical substance called *bonga.* The statues with *bonga* are called *butti;* without *bonga* they are called *tege.* Often the magical substance is placed all around the body with a cloth as indicated in Fig. 378. The arms and hands are highly conventionalized, carved in right angles at the elbows and shoulders, or missing altogether. Legs are bent at the knees, similar to the position of the men in their *nkibi* dances.

The *bonga* is composed of various materials, but one of the main ingredients is a whitish clay called *mpieme,* which, for the Bateke, represents the bones of their ancestor, thus conveying protective power. Often it is mixed with the nail clippings or the hair of a venerated person, with leaves of specific plants, various parts of snakes or leopards, etc. According to the content of the *bonga,* the statues are used for various purposes: to insure success in an enterprise (hunting, trading, acquiring wives, etc.), to guard against disease, or for general personal protection.

The statues are kept as the personal property of the individual and placed in his hut, next to the fire, on the soft earth. The owner blows on *mpieme* powder to increase their

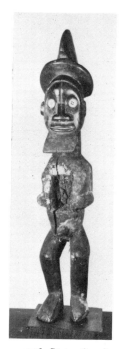

376. *Statue* (tege),
Bateke, Congo. 16"

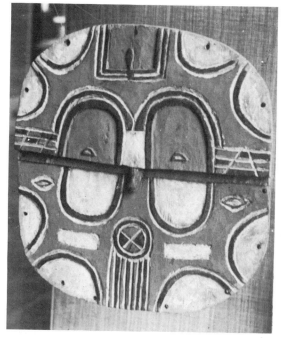

377. *Mask, Bateke, Congo. 14"*

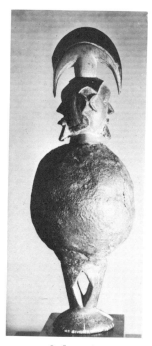

378. *Janus-type statue*
(butti), *Bateke, Congo*

power, but they are also used in groups in the Bumu male secret society. When the owner dies, the statues are buried with him.

There are also statues with two faces and double legs (Fig. 378); statues which do not have the cavity, called *nkiba;* sitting figures (also with helmetlike hairdo) with cavities, mostly carved by the Sisi.

MASKS. One of the most amazing masks in the whole of African art is the shieldlike mask of the Bateke (Fig. 377), with highly abstract polychrome patterns. Here again within one tribe we have highly naturalistic statues and completely abstract masks. It is perhaps worth noting that there is a conceptual affinity between this Bateke mask and those of the Bakwele (Fig. 276), a tribe living in the Republic of Congo to the north of the Bateke.

BATETELA (*see also* BASONGO-MENO)

Works of the Basonge style, but inferior in artistic quality, especially the masks.

Figures with hand on the accentuated navel or abdomen, filled with magical substance.

Also ivory carvings.

BATSHIOKO (TSHOKWE)

Although a section of this tribe lives in the Bakuba territory and another in southern Congo, the main body lives in Angola, and their works are discussed in the Angola section.

BAWONGO

This tribe belongs in the Bakuba stylistic complex. Ceremonial cups representing a full human figure (similar to Fig. 319) are often classified as Bawongo. The human-figure cups of this tribe are richly ornamented on the body and arms with scarification marks.

BAYAKA (YAKA)

Yaka or *yakala* means "males," "the strong ones," thus Bayaka, "the strong people."

STATUES. Distinction must be made between statues used among the eastern Bayaka and among the western Bayaka.

The statues of the eastern Bayaka are usually rather small in size. They have a long, clumsily carved nose, almost circular ears standing out from the rest of the face, two hands often either joined above the chest or

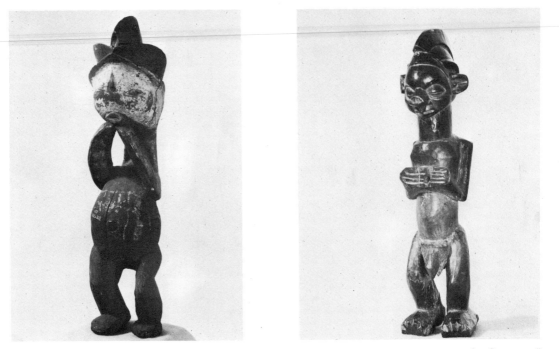

379. *Statue. 19"*

380. *Statue. 10"*

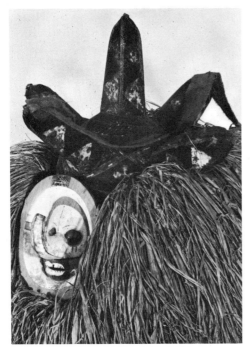

381. *Mask (nkisi). 16"*

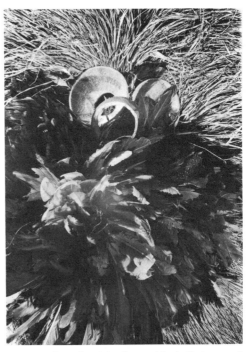

382. *Mask made of feathers with shell rings. 12"*

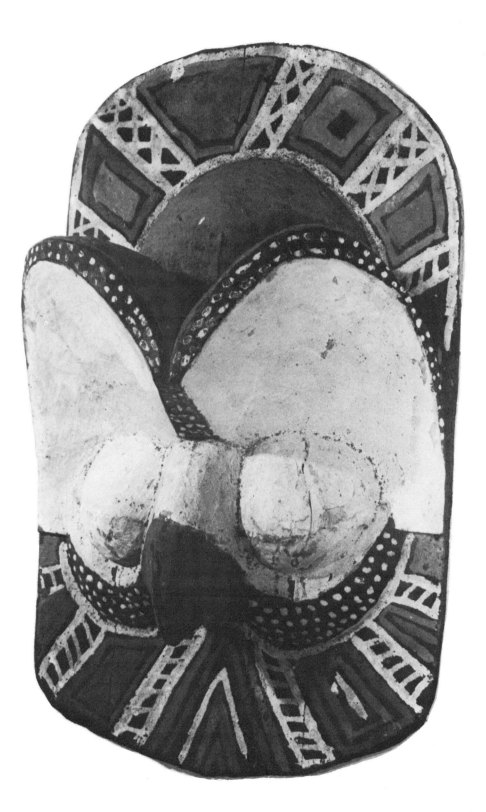

383. *Mask, Bayaka, Congo. 13"*

supporting the chin (Fig. 379); the hairdos or head coverings are not uniform, though circular and oblong forms are generally used. Some statues have little pouches hanging at the waist, or a small antelope horn tied to the neck, containing magical substance. Each of the smaller statues (up to 12 to 14 inches) has its own name and is used for a particular purpose. Some are painted with dots, and there is one called *mundele* ("the white man") with a European hat, which is painted white. The larger statues (up to 20 inches), called *mbonga* ("fear"), have a fierce look, pieces of metal attached to them, and were considered able to cure sleeping sickness.

The artwork of the western Bayaka is better known, particularly because of the deformation of the nose (Fig. 380), which on some masks is bent into an upward hook (Fig. 381). Usually the eyes protrude, the ears stand out, sometimes in block form. The forehead is often low and flat with vertical lines fusing with the bridge of the nose. The use of polychrome gives a forceful expression. Usually the body of a statue is roughly carved, with unshaped legs, some in strong cubistic form, some without feet. The arms are generally thin and curved, poorly developed, and not well integrated into the whole composition.

MASKS. The eastern Bayaka mask in Fig. 54 is called *kakunga* ("the chief") and is considered one of the important masks in the circumcision ceremony.

Other Bayaka masks are widely varied in style, although most of them are polychromed, some showing only traces of the color because of wear. Originally they all had a heavy raffia collar (or collarette), which, however, on many pieces has been removed.

The first main group of Bayaka masks is highly stylized. This type of mask (*nkisi*) has a long, upward-hooked nose, open mouth exposing two rows of teeth (Fig. 381). The face is often framed by a large, painted square or circle according to the sex represented by the mask. A long handle under the chin was held by the dancer. The mask is generally surmounted by a richly ornamented, abstract construction—sometimes resembling a Siamese pagoda; sometimes in animal shapes, made of twigs, covered with fiber cloth, and finally painted.

A variant is the broad-nosed *ndemba* mask, with round, protruding eyes and square, block-like ears (Fig. 51). Most are polychromed.

These two types of masks were used in initiation ceremonies of the Mukanda or Nkanda societies. At the conclusion of the initiation, the masks were held in front of the faces of the dancers.

A third type is made of woven raffia with a large raffia collar and feather headdress. The only marks identifying the human face are three white rings made of shells, so placed as to suggest eyes and mouth (Fig. 382). A fourth type is an immense, horned, fiber-cloth mask, used in war ceremonies. A fifth type has a flat surface with extremely abstract treatment of the eyes (Fig. 383). A sixth type is an animal mask (Fig. 384) very similar to the Duala masks from Cameroon.

OTHER SCULPTURE. The Bayaka also carved drums with a human head on top (Fig. 388); whistles (Fig. 387); combs and hairpins (Fig. 386); wooden panels with human and animal figures; ceremonial cups, the opening forming a graceful figure-eight (Fig. 385). The cups are supposed to have been used in marriage ceremonies, the bride drinking from one side and the bridegroom from the other to seal their union. Rather rare are the ivory carvings of this tribe (Fig. 389) with circle-dot pattern.

BAYANZI (BAYANSI, BABANGI)

Neighbors of the Bateke, part of this tribe also lives in the Republic of Congo. According to de Breaucorps, most of the statues are rather small (between 3 to 4 inches), though some measure from 10 to 12 inches. They are roughly carved with Z-shaped arms in bas-relief. Many of them are covered with magical cloth; some are double-faced. The very small ones are called *nshwo,* the larger *mpwo.* Both were used to prevent sickness and sterility in women, bring good hunting and fishing, etc. Fig. 390 is exceptional in its compact structure, but it shows the typical Bayansi hairdo, a reversed-cone shape protruding on the back of the head.

BAYAKA, Congo

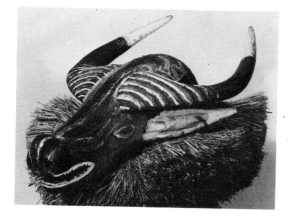

384. *Animal mask. 26"*

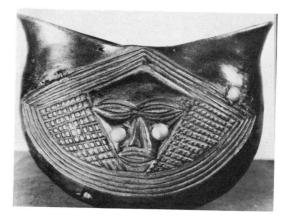

385. *Ceremonial cup. 4¼"*

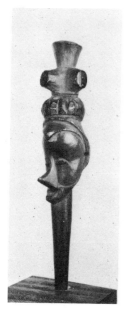

386. *Hairpin. 4"*

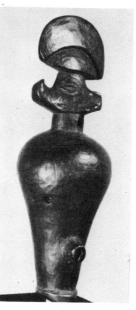

387. *Whistle. 5"*

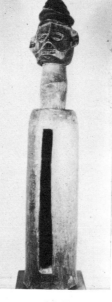

388. *Drum. 21"*

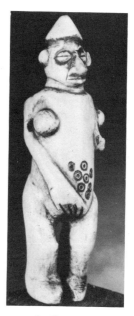

389. *Ivory statue. 4"*

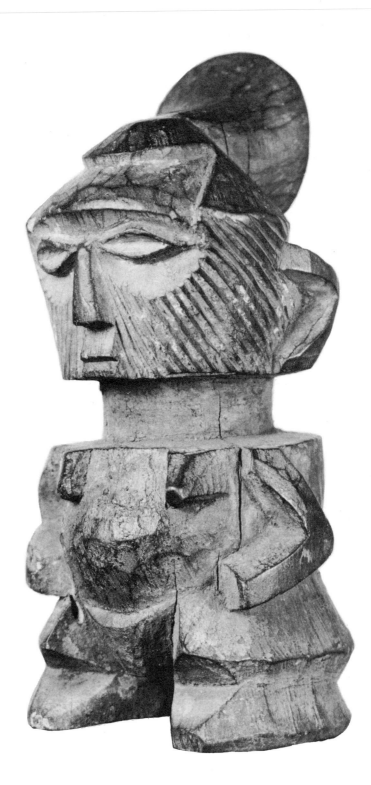

390. *Statue, Bayanzi, Congo. 6"*

BENA BIOMBO

Polychrome mask of monumental structure, with large eyes, small nose, and small circular mouth (Fig. 22).

BENA KOSH

Hood mask with bold, richly carved polychrome planes (Fig. 55).

BENA LULUA (LULUWA)

The name of this tribe derives from the name of the Lulua River, on which they live.

STATUES. The subjects are men, women, and mother-and-child groups, all with the same characteristics, and the majority about 8 to 10 inches high. Often there is an exaggerated umbilical hernia, or the navel is enlarged. The body is covered with elaborate and deep cicatrice marks in form of roundlets, V-shaped patterns, and other lineal designs, and many have a small loincloth. The head usually has a pointed projection, actually a hornlike, beaded headdress (Fig. 391). Some of the small male figures have a long, intricately braided beard. Many of them hold a straight staff in one hand and a calabash (or bowl) in the other hand, which contained magical powder or a potion, reportedly used during the rites after childbirth to insure the well-being of the baby. Extremely delicate are the mother-and-child carvings in which the body tapers to a point (Fig. 392) and the face is decorated by undulating cicatrice marks. It is possible that these statues were placed into another object. The male figures, called *lupfingu,* were supposed to represent chiefs and were used to bring success in hunting and to cure the sick.

Other figures are in crouching or squatting positions (Fig. 7) with raised hands resting on the neck and the oversize head. To balance the massive head, the feet are also oversize. It is said that this position corresponded to the burial form, and in all probability these statues represent ancestors. The very same statue exists also with a bowl on its head to hold magical powder, often with a lid attached to it by a leather band.

MASKS are rather rare. Fig. 393 shows an elaborate design pattern on the face, corresponding to the cicatrice marks on the faces of the statues. It is surmounted by a planklike structure with polychrome lineal design.

OTHER SCULPTURES. Drums; headrests supported by male figures, having the same scarification marks as the standing figures.

DENGESE (NDENGESE)

Northern neighbors of the Bakuba, the Dengese have been influenced by them, as can be noted in the head and hair formation of Fig. 394, which is probably a portrait figure of one of their sovereigns. The body is covered with rich scarification marks. There are other carvings known from this tribe, such as a standing figure with a cup on its head.

KANIOKA (BENA-KANIOKA, BEMA-KANIOKA, KANYOKA)

The name of this tribe means "the people of the snake." Neighbors of the Baluba, the Kanioka show many Baluba influences in their carvings.

Among their standing female figures, the most typical is in crouching position, the hands on the belly. Among the standing and seated male figures, a rather well-known example is a male drummer holding a long drum between his legs. There are also figures holding a bowl on the head; pipes in human-figure form.

Kanioka masks are of two types: One is colored black, the center painted in red, and has a white crest, domed forehead, cylindrical block for the mouth. The second type (there is one in the Hamburg museum) also has a domed forehead. The hairdo is hemispherical, the eyes slits. The lower part of the face is the most prominent feature, consisting entirely of a lozenge-shaped mouth with teeth.

MAMBUNDA

Although this tribe lives outside of the Congo territory in Barotseland in present-day Zambia (formerly Northern Rhodesia), their masks are rather noteworthy. The Mambunda

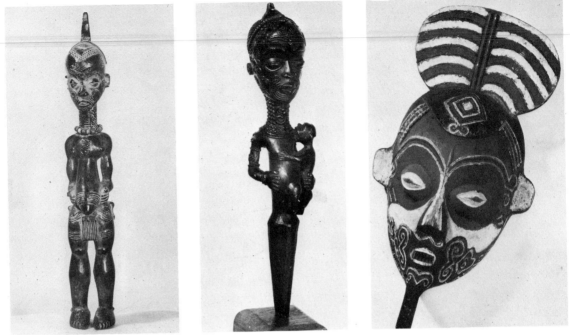

391. *Statue* (lupfingu), *Bena Lulua,*
Congo. 15"

392. *Mother-and-child statue,*
Bena Lulua, Congo. 15"

393. *Mask, Bena Lulua, Congo. 23"*

mask has a large domed forehead; puffed cheeks that are almost hemispherical (very similar to the Bamum masks); circular, pierced eyes; eyebrows indicated by parallel incised lines. The mouth is a rectangular box showing teeth (similar to the mouth structure of the *kifwebe* mask in Fig. 349). The hairdress is made of feathers. The mask was used mostly for entertainment purposes.

MANGBETU (MONGBUTU, MANGUTU)

This tribe lives in the northeast near the Sudan border.

The main characteristic of their carvings—statues (Fig. 395), jars, knives, musical instruments, wooden honey containers—is that the head on one of these works has an elongated cranium, probably due to Egyptian influence spread by the Khartum traders from up the Nile.

Their masterpiece is a clay beer mug, single- or double-headed, on which the face is highly stylized and the elongated head shows the tribal hairdo, a work comparable to Egyptian heads (Fig. 16).

NGBANDI

Northwest Congo.

In the previous printings of this book we discussed separately the various tribes which occupy the territory between the Ubangi and the Congo rivers under the tribal names of Bangala, Bwaka, Nkundo, and Ngbandi. Herman Burssens devoted two papers to the subject of this northern region of the Congo. In the first (1954) he indicated that the name Bangala is an over-all denomination used by many travelers, including such tribes as Ngombe, Ndoko, Ngbaka, Mbanza, and Ngbandi. In his second paper (1958) he considers that most of the sculptures of this region (they are rather rare) could be classified under "Ngbandi style." He places the following carved objects under this style. (Nevertheless many books make a distinction between works in the Ngbandi tribal style and those of Bangala, Ngbaka, and Ngombe tribal origins).

Statues, masks, and warriors' staffs are carved in human form, the foreheads having scarification marks in a vertical line. The statues have rather slim bodies; arms usually

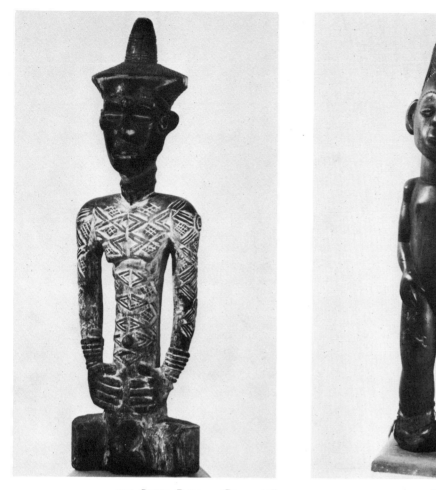

394. *Statue, Dengese, Congo. 20"* 395. *Statue, Mangbetu, Congo. 19"*

against the torso (Fig. 400) but occasionally separated (Fig. 396); legs slightly apart; hair indicated by triangular incisions. The masks have flat, oval faces; foreheads with typical marks; flat, oval eyes with white paint around them, making the masks rather stylized (Fig. 399). Warriors' staffs have heads like that in Fig. 397. Most of the statues and masks were used by the *bendo* (diviner) in magical ceremonies, although some ancestor-cult statues are also known.

WABEMBE (BEMBE, BABEMBE, CUABEMBE)

One of the rare eastern tribes (Wabembe—and its variant spellings—means "the people of the east") living in the mountainous area around the northern shore of Lake Tangan-

yika. Its interesting art style is characterized—as is the statuary of northern Congo in general—by geometrical face forms carried out further in cubistic treatment of the trunk and legs (close to the Warega style).

One of the characteristics of a Wabembe statue is that the face is shaped as a triangle, often with the mouth placed in the middle of the basic shape. Fig. 401 shows this and also an angular co-ordination of buttocks, belly, and arms, contrasting with the roundness of hairdo, ears, and large feet. Another, rather unusual example is Fig. 402, in which heavy legs are bent and the notches incised along the chin are repeated around the stomach. One hand holds the cheek and the other holds either an object or perhaps a braided beard. It is said that some of these figures were used on burial grounds.

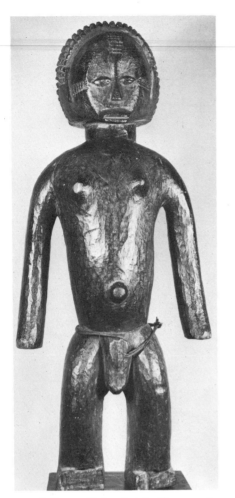

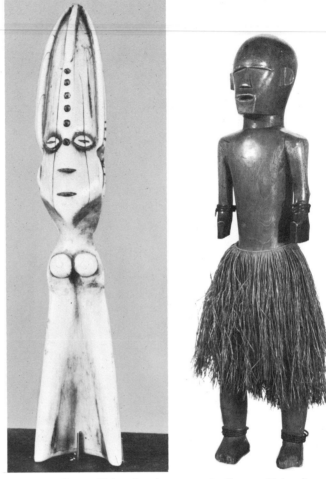

396. *Statue, Ngbandi style, Congo. 22"*

397. *Statue, Ngbandi style, Congo. 7"*

398. *Statue, Ngbandi style (Nkundo), Congo. 25"*

WADUMBO

Basing his attribution on documents, von Sydow (*Africanische Plastik*) labels Fig. 403 Wadumbo. (A similar statue is in the Berlin Museum.) The tribe is said to live in northern Congo. Our example is an extremely interesting figure from the aesthetic point of view, repeating a basic zigzag pattern in the arms and legs, and having uniform incisions on the rim of the face, a band of incisions from the breasts to the shoulders, and incisions across the upper thighs, including the pubic region. No eyes are indicated. Note that the left arm is longer than the right arm, and, in turn, the right leg is longer than the left leg.

WAGOMA (GOMA)

The Wagoma occupy a very small area at the northwestern end of Lake Tanganyika, with another small tribe, the Babuye, as their neighbors. Because the artwork of these two tribes is very similar, it is appropriate to classify their work as Wagoma-Babuye. The area of stylistic influence extends also into Wabembe (Babembe, Bembe) territory, so that Wagoma-Babuye carvings are often attributed to this neighboring tribe.

There are masks (Fig. 404) and shieldlike carvings (Fig. 405) which are remarkable for their abstract design, with great emphasis on the eyes, conic protrusion for the mouth. Prob-

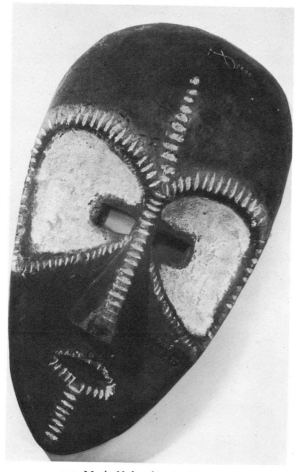

399. *Mask, Ngbandi style (Bwaka), Congo. 15"*

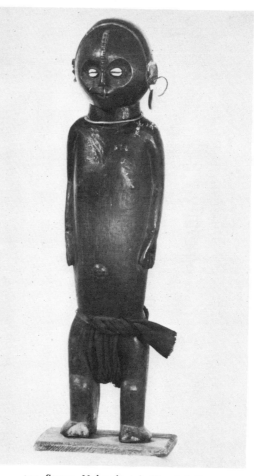

400. *Statue, Ngbandi style (Bwaka), Congo. 20"*

ably the shieldlike pieces are of more recent origin, although the style is rather old; prototypes can be found in the Paris, Frankfurt, and Leiden museums.

There is also a four-legged statue with a very large head, the facial expression in the same style as in the masks—two large concave surfaces with two round bulging eyes—and no body between legs and head. The same general structure is manifest in a headpiece, the legs replaced with a hollowed-out hemispherical cap below the two-faced head, often topped by feathers. Instead of recognizable features, the concave surface of the face is carved with an abstract cross design.

WAREGA (BALEGA)

The Warega are located south of the Equator between the second and fourth parallels and between the twenty-sixth and twenty-eighth meridians in the great equatorial forests of Elila and Ulindi, not far from the Lake Kivu region.

Although the art of the Warega belongs to the main stream of the African art tradition, from the morphological or plastic point of view, it belongs in a special class. Its monumental simplicity—often a reduction to the most basic indication of a human body or of the procreative organ—in spite of its size, shows a style very similar, and astonishingly

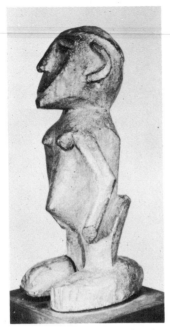

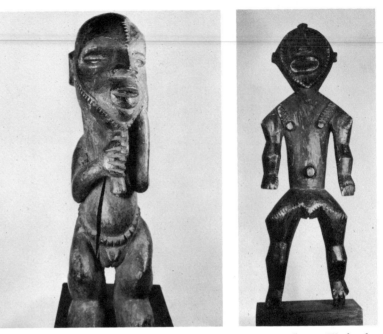

401. *Statue, Wabembe,*
Congo. 8"

402. *Statue, Wabembe, Congo. 14"*

403. *Statue, Wadumbo,*
Congo. 16"

parallel, to the sculpture in ivory, terra cotta, and stone of a large number of examples from the prehistoric and early historic periods. From 4000 B.C., especially during the period between 3000 and 2000 B.C., in the Aegean islands (Cyclades, Paros, etc.) and extending from Portugal (Idana Nova) to the Ukraine, and down to Tell Asmar in Mesopotamia, we find sculpture known as archetypal (see Neumann and Kuhn). Sculpture of this type uses the human body as a symbol to express a remarkable similarity between original structural components of the human psyche, genetic ideas, and fantasies, expressed in eternally recurrent (or inherited) primary forms and the configuration of shapes. Because of the use of primordial forms, associations with the essential parts of the human body, these sculptures (the Warega carvings among them) evoke in the onlooker the most fundamental emotional experience, the wondering astonishment of early infancy—being part of what Jung called the "collective unconscious"—carrying away the onlooker from visual and superficial surface reality into the realm of basic emotions, and perhaps abstract spirituality.

According to the latest anthropological stud-

ies (see Biebuyck's essays), the Warega had a complex social organization known as Bwami, which extended its function into religious, social, political, and economic fields with a complete hierarchy of eleven grades or degrees, with special ranks for both men and women, promotions following ritual ceremonies. Until the Belgian government abolished this organization in 1924 because of its great political power, nearly 80 per cent of the population belonged to the Bwami. The transmission of initiation objects of ivory and wood during ceremonies resulted in the acquisition of privileges (seniority, authority, etc.) and the maintenance of historical relationships and ritual clan bonds. The possession of the objects was kept secret (some grades had the right to keep only one or two objects), and most of them belonged to the Bwami society itself. Although the carvings were in themselves not objects directly related to the cult but symbols of social virtue, of rank and authority, they were based on the concept of ancestor worship and each ceremony expressed piety toward the ancestors. Many of the objects also have proverbs attached to them, which once served an educational purpose.

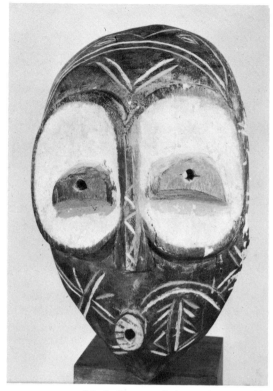

404. *Mask, Wagoma-Babuye, Congo. 11½"*

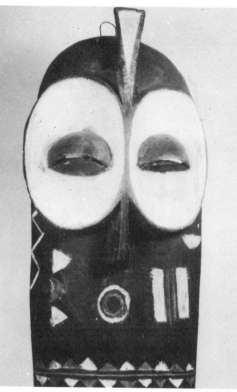

405. *Shieldlike carving,*
Wagoma-Babuye, Congo. 16½"

The Warega carved statues, figurines of animals, masks, and spoons, mainly in ivory but also in wood. In the history of African art, the Warega stand next to the Bini in the richness of ivory sculptures. Most of the carvings have individual names and their functions in grade ceremonies are known, as well as some of the proverbs attached to them.

There is an amazing richness and inventiveness in Warega carvings, in spite of the limitation of medium. They all have a monumental simplicity, a primordial strength, executed in a direct, unhesitant, unelaborate manner as if all the forms derived from an irresistible inner urge.

STATUES. If we take a series of Warega ivory statuettes ranging in size from 2 to 6 inches (Figs. 17, 18, 37, 406–422), we can see an interesting development in the treatment of the human form. These examples have been selected out of about forty known stylistic variations to show the main trends. In each type many examples are known; thus they are not unique but prototypes of the following:

(1) Legless statuettes: Figs. 37 and 406—phallic form; some have two faces. Fig. 407—head with pointed body. Fig. 408—body with no arms. Fig. 409—arms formed by hollowing out the body. Figs. 18 and 410—arms carved from the basic phallic form with hollow spaces between the arms and the body. Fig. 411—arms separate from the body.

(2) One- or two-legged statuettes: Fig. 412—only one leg (note the toes). Fig. 413—no arms, but the body indicated; also with head and two legs, without any hint of the body as such (Fig. 65). Fig. 414—one arm. Fig. 415—arms close to the body carved in relief. Fig. 416—arms separated by space from the body but forming part of it (same concept as Fig. 410). Figs. 17 and 417—short arms set close to the body (the lozenge shape of the head and the zigzag pattern of the legs and arms in Fig. 417 is a very frequent feature of Warega ivories). Fig. 418—arms completely separated from the body. Fig. 419—arms raised.

(3) Statuettes with multiple faces and bodies: Fig. 420—four faces, no legs. Fig. 421—

WAREGA IVORIES, Congo

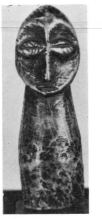 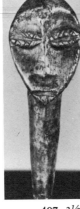 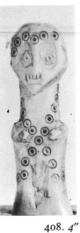 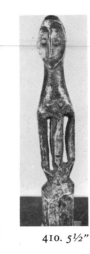

406. 4″ 407. 3½″ 408. 4″ 409. 4½″ 410. 5½″ 411. 4½″

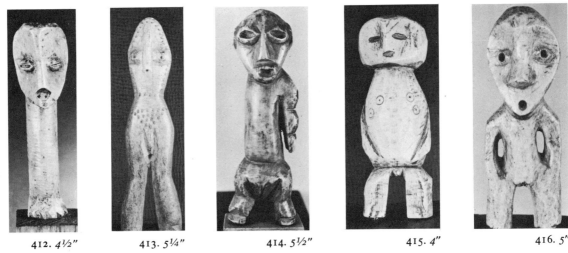

412. 4½″ 413. 5¼″ 414. 5½″ 415. 4″ 416. 5″

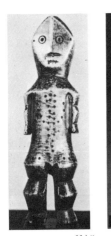 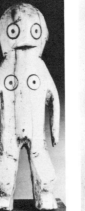 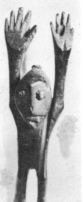 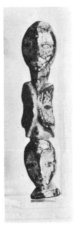 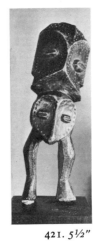 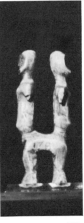

417. 6½″ 418. 5½″ 419. 420. 5½″ 421. 5½″ 422.

four faces with legs. Fig. 422—two separate bodies attached at the middle.

These descriptions are based on more than forty years of collecting and experiencing Warega ivories rather than on anthropological evidence. Although we do not know when and why these prototypes were created, if we assume that the simplest forms came first, a *stylistic evolution* seems to have occurred. (Note the similarity in the evolution of bodily forms among the Ashanti *akua'ba* statues shown in Figs. 195–201.) The ideology which gave birth to these forms is lost in the past. One of the fortunate facts in African art, however, is that because of the deeply rooted conservativism forms were repeated, basically unaltered, by many generations so that each carving could fulfill its traditional function. Thus, we can assume that, even though there has been some gradual change, the forms we observe today are similar to, or based upon the ancient tradition. This is also the reason that carvers of recent generations are unable to explain why those basic, genetic forms were created.

There is often a difference between what the physical statue presents to us and what is said about its function. For example, ethnologists have studied two Warega statues. A small statue is called *katembetembe*, meaning "little phallus," but the carving itself is *not* in phallic form. This statue was used by a woman in her initiation into a higher grade; when she wore the statue at her waist, it meant that she was untouchable (not to be seduced). In contrast, there is a statue in actual phallic form which was used as a sexual symbol in initiation dances but it is called *yango*, meaning "teaching" not "phallus." Of course, this kind of apparent contradiction has its own valid psychological basis, beyond the scope of the morphological study of the statues themselves.

Although we have information about the ritual use of Warega statues, we do not know the reason for the creation of the prototypes. We must assume that there was a very basic conceptual, underlying force, since plastic forms and their co-ordination represent modalities of thought and thought processes and at the same time are silent, unwritten documents of man's differential approaches to reality. If we take again the morphological evidence, as shown in our illustrations, we may advance the postulate that this series of ivory carvings may show in a symbolic manner the development of the human body, from conception (phallic form), through gestation (indicating how various limbs "grew" to the body), ending with the complete human body with two legs and two arms. (The statues in wood may also follow this sequence.)

The Warega also produced a large number of animal carvings (dogs, wild pigeons, chameleons, etc.), a proverb attached to each of them. For instance, the proverbial meaning of a dog is "he who goes slowly may arrive surer." These carvings were kept in the *mutulwa* basket, which contained initiatory objects when not being used for divination.

MASKS. The ivory and wood masks have great plastic beauty (see jacket and Fig. 423), the basic variable being the presence or absence of pierced eyes. Most of the masks originally had beards (*luzela*) made of fiber, by which they were sometimes carried. They were also carried in the hand, held against the chin, or placed in the ceremonial basket (*mutulwa*). On rare occasions one of the highest-grade officers was permitted to use a wood mask as guardian of his own house.

Warega ivory and bone SPOONS (Fig. 424) also have proverbial meanings. One is "hold your tongue in check." Another type of spoon (Fig. 425) is often attributed to the Warega, but is actually produced by the Babali tribe of the Aruwimi River district.

The Warega carvings at their best are among the great masterpieces of African art.

WARUWA (TEMBO)

This Baluba subtribe is also known as Warua, Urua, Uruwa, Uarua, Ouroua, because of the different versions used by Arab writers and carried over into early European maps of the region.

Statues conform to the Baluba types, except that they tend to be spherical.

WAZIMBA (BINJA)

Southern neighbors of the Warega. Wazimba art also has the strong abstract quality of such northeastern tribes as Wabembe, Warega, etc.

Large heads in nearly quadrangular form.

424. *Bone spoon, Warega, Congo. 6"* 425. *Ivory spoon, Babali, Congo. 6"*

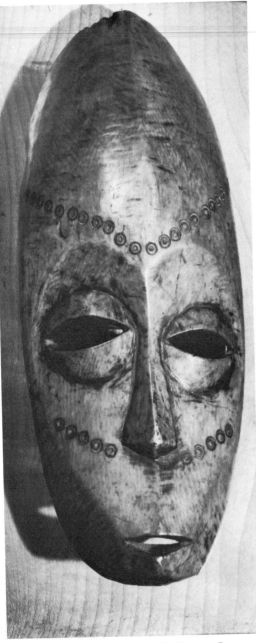

423. *Ivory mask, Warega, Congo. 7"*

The large forehead dominates the small face; small eyes (sometimes inlaid cowrie shells) are imbedded in large sockets; scarification marks cover the body. Also medicine figures. Their ivory statues, headrests supported by human figures, resemble those of the Warega.

The *kifwebe* mask (see Baluba) of the Wazimba has a forehead that merges with the nose and a protruding black ridge for the mouth.

ANGOLA

Northern Angola and the southern part of the Democratic Republic of Congo show a certain style unity which can be summed up as follows: There are *ancestor, demon,* and *totem* figures. These were carved immediately after a death to provide an abode for the spirit of the deceased. They were kept in special huts, and before each a wooden or clay plate or bowl was placed to hold food offerings.

Batshioko (Tshokwe)

This tribe is known in the literature under thirty-five different spellings, all based upon the name this people call themselves, *Kocokwe,* in plural *Tucokwe.* They number about 600,000 and live in the northern part of Angola and also in the southern part of the Congo, having as neighbors the Bapende, Balunda, etc. These people are known to have been great hunters (some statues have flint guns) and collectors of honey.

Since the publication of the comprehensive work on the art of this tribe by Bastin, we are able to classify their works into the following categories:

Masks. The most important mask, and rather fantastic in its appearance, is the great mask called *cikungo* (Fig. 432). Made of basket-

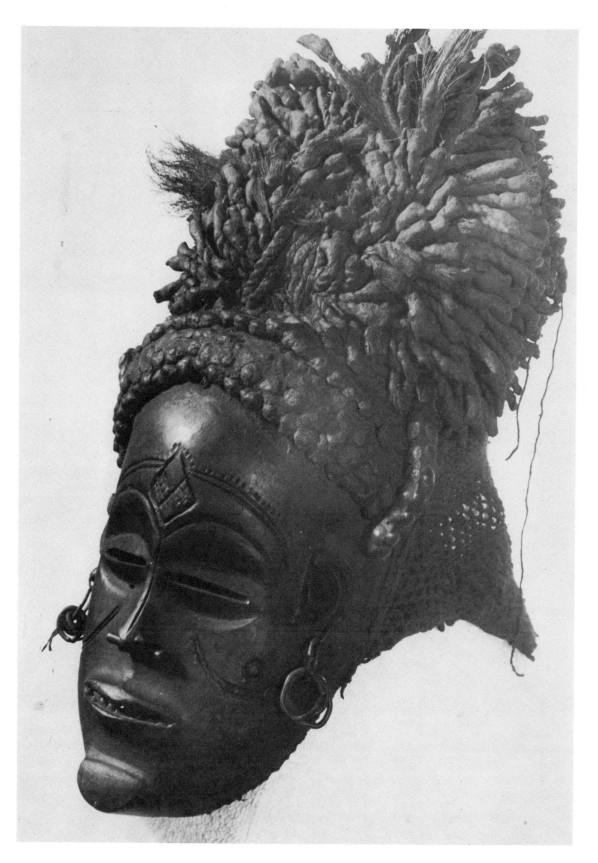

426. *Mask (pwo), Batshioko, Congo and Angola. 15"*

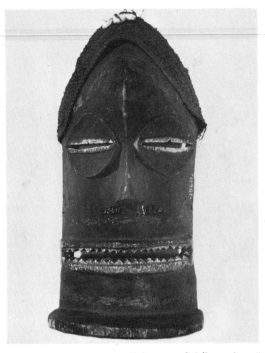

427. *Helmet mask* (cihongo). *10"*

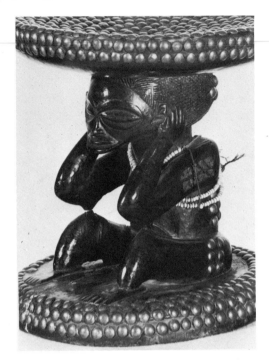

428. *Stool. 8"*

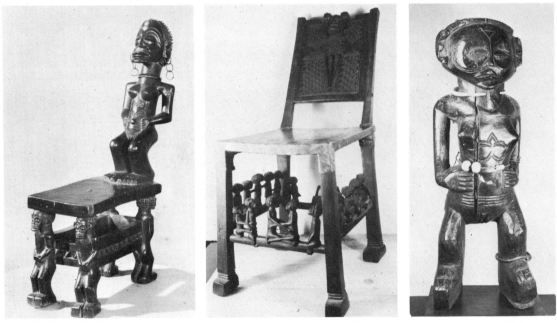

429. *Chair. 15"*

430. *Chair. 23"*

431. *Statue. 12"*

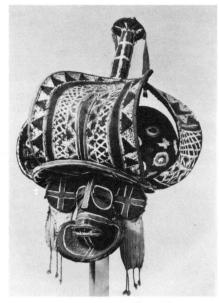

432. *Mask* (cikungo). *47"*

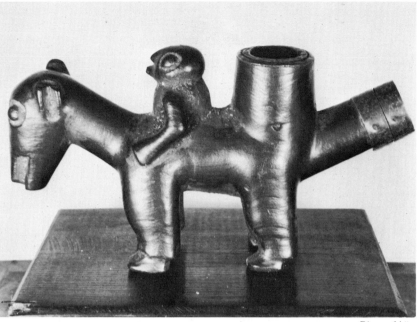

433. *Pipe. 5½"*

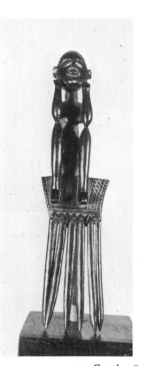

434. *Comb. 7"*

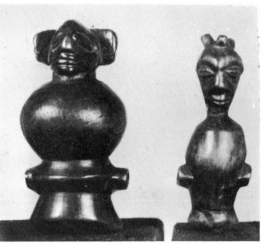

435. *Whistles. 3½" and 3"*

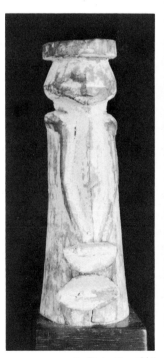

436. *Statuette. 4½"*

work, covered with burlap, and painted in white, blue, and red, this mask represents the ancestor of the earth. It was kept in the hut of the chief (it shows the hairdo of the chief) and appeared only if there was trouble during the initiation ceremony.

Similar in style but smaller is a mask called *kalelwa*. It played an important role in the circumcision ceremony since the person wearing the mask gave the signal for the departure and return of the adolescents to the village (after having spent about one to two years in the bush).

The initiated themselves also wore headgear (*ifuko*) with a visor to hide their faces.

A hoodlike mask (Fig. 427), called *cihongo*, was the symbol of wealth and considered a male mask. (A mask similar to our example exists in basketwork.)

Best known is the *pwo* mask, which symbolized the female ancestor. Carved in wood with tribal scarification marks and usually with raffia hair (Fig. 426), it was used by itinerant dancers dressed in a knotted costume to which they attached false breasts (as did Onitsha Ibo in their Mmo society dances, and also the Dogon). These masks have different hair arrangements. The hair in Fig. 426 is made of oiled vegetable fiber. The circular *cijingo* scarification marks are carved on the cheeks and a simplified version of the cruciform tribal mark, called *cingelyengelye* (better seen in Fig. 20), appears on the forehead. In Fig. 20, the carved headband known as *lenge* is similar to the Balunda hairdo (Fig. 355). The circular scarification marks (*cijingo*) symbolize the sun and male power. Although this mark is the typical symbol of the god Nzambi, there is probably some influence from the old Portuguese cross, which was similar to the cross of Malta. This mask shows also a net made of *minjiwa* fiber, which covered the neck and the body. It is interesting to note that the initiated had to learn the various dances in which *pwo* masks were used although they did not themselves wear these masks.

STATUES. We must mention first the magnificent head of a scepter (Fig. 11) showing the chief's headdress, which is repeated in a simplified manner on some standing figures. Bau-

mann in his book on the Lunda (Balunda) identified small wood carvings (Fig. 436) as amulets of hunters.

STOOLS AND CHAIRS constitute an important part of Batshioko art. The stools—with standing, crouching, or sitting human figures (Fig. 428) or animals supporting the seats—are carved from one block of wood. Others are more simple, but created in highly sophisticated proportions with geometric design patterns incised. Unusual are the chairs (probably a European influence as among the Ashanti), with quadrangular seats covered with stretched leather, the majority with backs. The legs, the backs, and the stretchers between the legs are all richly carved with small human and animal figures (Fig. 430), often representing scenes of tribal life: two men carrying a man in a hammock; circumcision ceremony; man with large male organ; etc. Very often the top part of the back of the chair is a highly refined carving of a head. There is another type (rather rare) in which the back is formed by a single figure (Fig. 429).

OTHER SCULPTURE. The Batshioko also made chief's staffs with single head, standing figure as handle; spatulas; fly whisks; powder holders; pipes (Fig. 433); combs with head or crouching figure (Fig. 434); whistles with the typical hairdo (Fig. 435); musical instruments called *cizanji* (similar to the *sanza*, (Fig. 334) known all over Africa; richly decorated drums and headrests (similar to Fig. 337).

LOVALE

Red and white clay human and animal figures. Masks with broad forehead, pointed chin, small eye slits.

KALUENA

Seated figure on a chair in the Batshioko tradition, but less tense in expression and utilizing smaller forms.

MINUNGO

Mukish masks similar to the Batshioko masks.

VIMBUNDU (MBUNDU)

Statues, with small head, very long body, and short, legless feet.

EASTERN AND SOUTHERN AFRICA

Although we have focused on the art of West and Central Africa, a short summary of the art production in the eastern and southern parts of the continent, based on the contribution of Ladislav Holy, may be helpful.

In *northern Sudan* the Omdurman tribe made doll figurines of various materials, and the Shilluk used part of a gourd to make round face masks with circular eyes. The Bari tribe's pole sculptures with pointed crowns are well known. They are roughly carved, slender figures, the arms joined to the sides.

The tomb figures of the Gato tribe in *Ethiopia* were made of thick tree trunks, the top carved into a human head with staring eyes.

From the region of the *eastern shore of Lake Tanganyika* come simply carved masks, with holes for eyes, made by the Ziba tribe. The Karagwe used wrought iron to produce astonishing animals of small size with curved horns. (Frobenius has given examples of these.) The wooden statues of the Jiji tribe are similar in style to the statuary of the northern Congo.

From *Tanzania* come slender wood figures made by the Zukuma tribe. The Nyamwezi produced chief's thrones with a human figure carved in relief on the high back. The Hehe tribe carved standing figures and staffs and also modeled clay animals. The Wakerewe tribe, who live on an island in Lake Victoria, produced roughly carved naturalistic figures with broad shoulders and arms next to the body.

Among the *northeastern Bantu* peoples, the Chaga tribe produced extremely interesting, highly stylized *nungu* clay figures and animals.

A tribe from the *coastal strip of the Indian Ocean,* the Shambala, produced figurines and stools carved in wood. The Zaramo tribe carved very small, abstract dolls in geometric shapes. The Mwera tribe made highly stylized antelopes and face masks, both with elongated horns.

In *eastern Africa* the artwork of the Makonde is best known (not to be confused with present-day production of ebony figurines). The most typical Makonde features, true of both face masks and standing figures, are the lip-plugged mouth and the enlarged ears. The faces of the masks are often scarified. There are a few very simple and expressive masks with stylistic similarities to the Warega wooden masks. Makonde helmet masks have strong, Negroid, portrait-like features, some with scarifications. The standing figures often have the arms separated from the body.

In *northern Mozambique* we find masks with or without scarification marks and heads with strong, Negroid features similar to the Makonde heads.

The Lozi (Barotse) tribe of *Zambia* are known for their food bowls, which have lids decorated with single or multiple animal carvings. The Babemba tribe of northern Zambia is discussed on page 226.

In *Rhodesia* the Zezuru tribe produced interesting, and rather complex, colored pottery.

In *southeastern Africa* the Nguni-Thonga carved awkward-looking ancestor figures (as did the Zulu).

The artwork of *South Africa* includes the Sotho tribe's expressive clay animals (some reminiscent of the Amlash bulls from Iran) and dolls with beadwork.

Maps

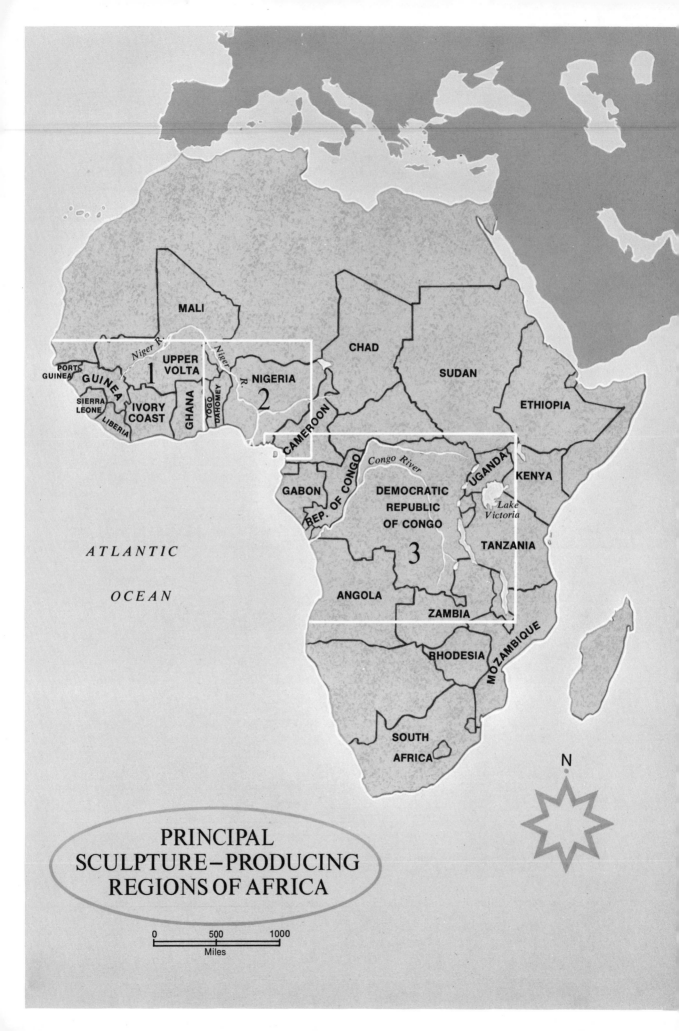

PRINCIPAL
SCULPTURE−PRODUCING
REGIONS OF AFRICA

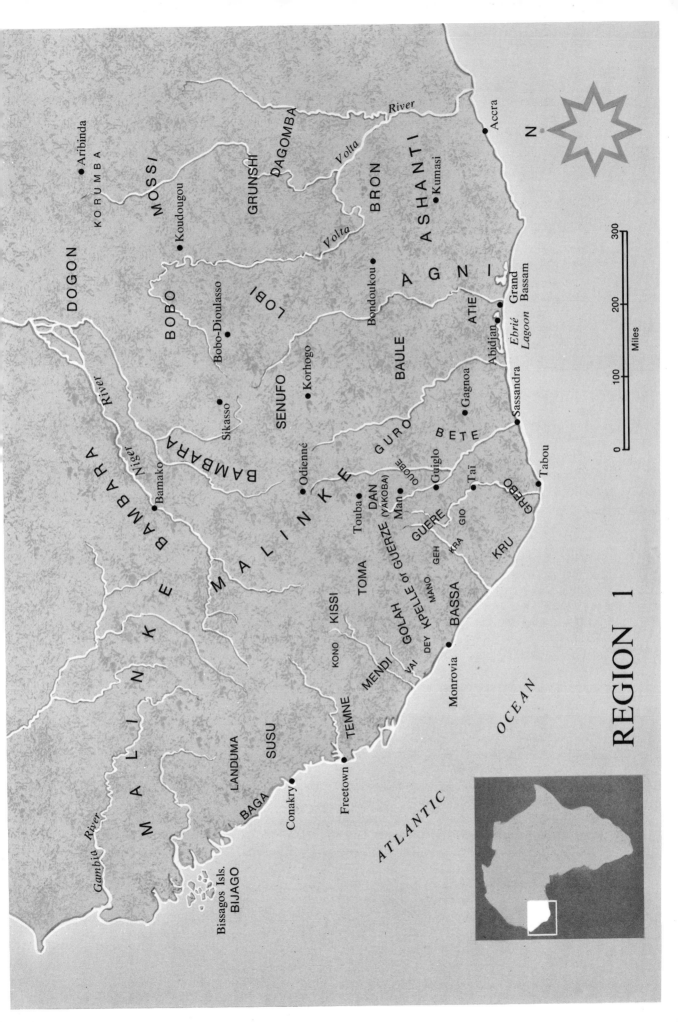

REGION 1

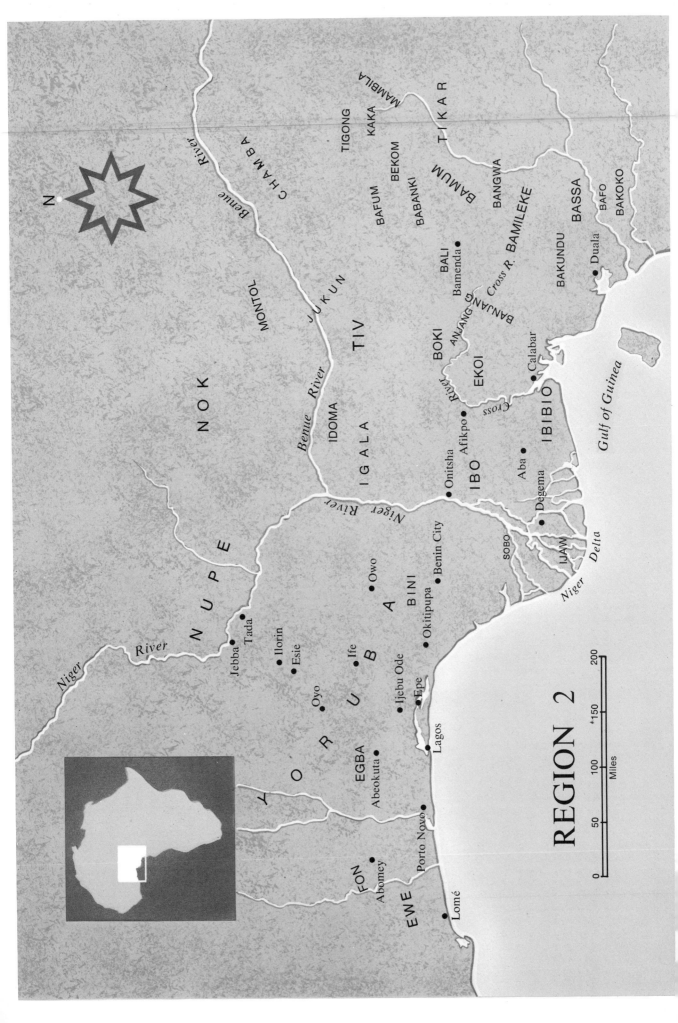

REGION 2

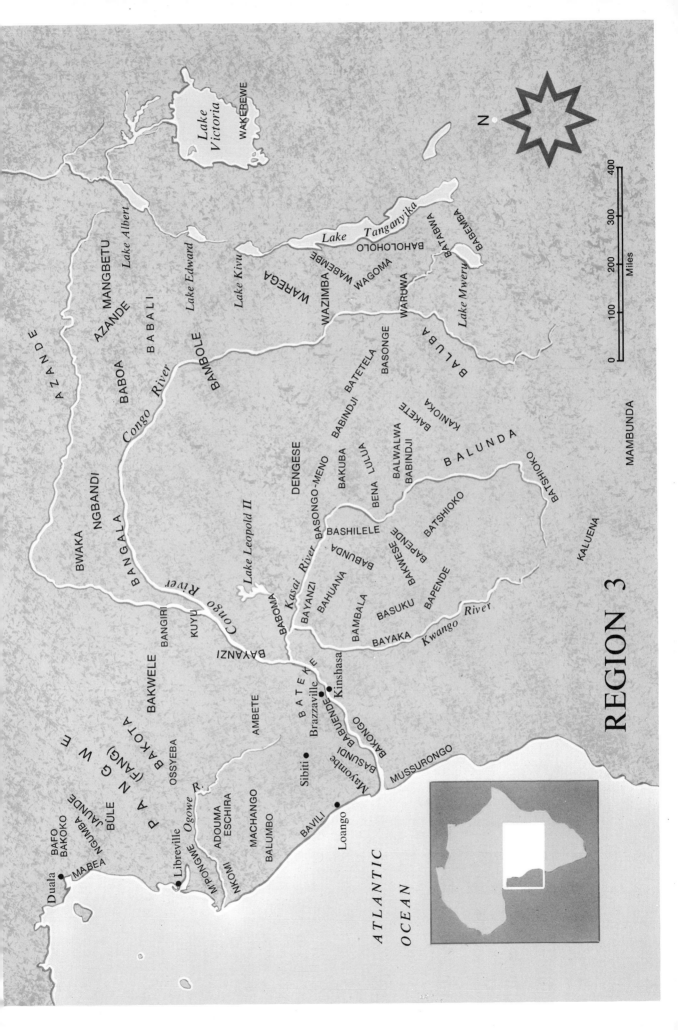

ATLANTIC
OCEAN

Lake
Victoria
WAKEREWE

Lake Albert

AZANDE MANGBETU
AZANDE
BABOA BABALI
BWAKA NGBANDI
BANGALA
BAMBOLE

Lake Edward

Lake Kivu

WAREGA
WAZIMBA WABEMBE
WAGOMA
WARUWA
BALUBA

Lake Tanganyika
BAHOLOHOLO BATABWA
BABEMBA

Lake Mweru

Congo River

BANGIRI
KUYU
BAKWELE
AMBETE
BATEKE

BAYANZI

Lake Leopold II

DENGESE
BASONGO-MENO
BASHILELE
BABUNDA
BAHUANA
BAMBALA
BAYANZI
BAYAKA

Kasai River

BAKUBA
BENA LULUA
BABINDJI
BASUKU

BABINDJI
BATETELA
BASONGE
BAKETE
KANIOKA
BALWALWA

BAPENDE
BAKWESE
BATSHIOKO
BAPENDE

BALUNDA
BATSHIOKO

KALUENA

River
Kwango River

MAMBUNDA

Congo River

BABOMA

BATEKE
Brazzaville
BABUENDE
Kinshasa
BASUNDI
BAKONGO
Mayombe
MUSSURONGO

PANGWE
BAKOTA (FANG)
OSSYEBA
Ogowe R.
ADOUMA
ESCHIRA
MACHANGO
BALUMBO

Sibiti

BAVILI
Loango

JAUNDE BULE
NGUMBA
BAFO BAKOKO
MABEA
Duala
M'PONGWE
NKOMI
Libreville

N

400
300
200
100
0
Miles

REGION 3

Bibliography

Bibliography

The following list contains only those books, articles, and catalogues which have been consulted in the preparation of this text and does not intend to be a comprehensive bibliography of African art or its related subjects. (For a more comprehensive listing consult *Bibliography of African Art* compiled by L. J. P. Gaskin and published in 1965 by the International African Institute in London.)

LADISLAS SEGY
PUBLICATIONS ON AFRICAN ART

Books

African Sculpture Speaks. New York, 1952, 1955, 1969; London, 1961.
African Sculpture. New York, 1958, 1959, 1960, 1962, 1964, 1965, 1967.
African Art Studies, Vol. I, New York, 1960.
Afrikanische Masken. To be published in Germany.

Papers

"A Neger Muveszetrol" ("About Negro Art"). *Az Urvezeto* (Budapest), May 8, 1930.
"Over Negerkunst" ("About Negro Art"). *Elsevier's* (Amsterdam), Vol. 42, No. 8, August, 1932. (6 pp., 4 ill.)
"Primitive Negro Art." *Art & Archeology* (Washington), Vol. 34, No. 3, May-June, 1933. (6 pp., 16 ill.)
"Stilgebiete der Elfenbeinküste" ("Style Regions of the Ivory Coast"). *Ethnologischer Anzeiger* (Stuttgart), Vol. III, No. 3, 1933. (3 pp., 14 ill.)
"Negro Sculpture in Interior Decoration." *The Studio* (London), 1934.
"Sur l'Art nègre" ("About Negro Art"). *La Terre et la Vie* (Paris), July, 1934. (5 pp., 4 ill.)

"The Term 'Negro Art' Is Essentially a Non-African Concept" and "The Different Styles of Masks of the Ivory Coast" (in co-operation with Mr. R. Michelet), in Nancy Cunard, ed., *Negro.* London, 1934.
"L'Art nègre et les musées" ("Negro Art and the Museums"). *Mouseion* (Office International des Musées, Paris), Vols. 25, 26, 1934. (5 pp., 4 ill.)
"African Sculpture and Cubism." *Gallery Magazine* (New York), December, 1950.
"The Significance of African Art." *Phylon* (Atlanta University, Atlanta, Ga.), Fourth Quarter, Vol. XII, No. 4, 1951. (7 pp.)
"Warega Ivories." *Zaire* (University of Louvain, Belgium), Vol. V, No. 10, December, 1951. (5 pp., 17 ill.)
"Bakuba Cups." *Midwest Journal* (Lincoln University, Jefferson City, Mo.), Vol. IV, No. 1, May, 1952. (23 pp., 36 ill.)
"The Future of African Art." *Midwest Journal* (Lincoln University, Jefferson City, Mo.), Vol. IV, No. 2, 1952. (14 pp., 10 ill.)
"Bakota Funerary Figures." *Zaire* (University of Louvain, Belgium), Vol. VI, No. 5, May, 1952. (11 pp., 13 ill.)
"Toward a New Historic Concept on Negro Africa." *Journal of Negro History* (Washington), Vol. 38, No. 1, January, 1953. (13 pp.)

281

"The Mask in African Dance." *Bulletin of Negro History* (Washington), Vol. 14, No. 5, February, 1953. (6 pp., 5 ill.)

"Circle-Dot Symbolic Sign on African Ivory Carvings." *Zaire* (University of Louvain, Belgium), Vol. VII, No. 1, February, 1953. (20 pp., 21 ill.)

"African Sculpture and Writing." *The Journal of Human Relations* (Central State College, Wilberforce, Ohio), Vol. 1, No. 3, Winter, 1953. (8 pp.)

"Initiation Ceremony and African Sculptures." *American Imago* (South Denis, Mass.), Vol. 10, No. 1, Spring, 1953. (25 pp.)

"Sculptures africaines et animisme" ("African Sculpture and Animism"). *Psyche: Revue internationale des sciences de l'homme et de psychanalyse* (Paris), No. 76, March, 1953. (11 pp.)

"African Sculpture and Animism." *The Journal of Human Relations* (Central State College, Wilberforce, Ohio), Autumn, 1953. (12 pp.)

"African Art: Its Culture." *Africa Is Here* (National Council of the Churches of Christ in the U.S.A., New York), 1953.

"African Names and Sculpture." *Acta Tropica* (Basel), Vol. X, No. 4, December, 1953. (18 pp., 8 ill.)

"Cérémonie d'initiation et sculptures africaines" ("Initiation Ceremony and African Sculpture"). *Psyche: Revue internationale des sciences de l'homme et de psychanalyse* (Paris), Nos. 88, 89, February, March, 1954. (23 pp.)

"African Snake Symbolism." *Archiv für Völkerkunde* (Museum für Völkerkunde, Vienna), Vol. IX, 1954. (13 pp., 9 ill.)

"Divers Aspects de l'étude de l'art africaine" ("Different Aspects of the Study of African Art"). *La Revue de Psychologie des Peuples* (Le Havre), Vol. IX, No. 2, 1954. (19 pp.)

"Masks from Liberia." *Liberia Today* (Washington), Vol. 3, No. 7, July, 1954.

"Art Appreciation: A Projection." *ETC., A Review of General Semantics* (Chicago), Vol. XII, No. 1, Fall, 1954. (10 pp.)

"Appréciation de l'art: Une Projection" ("Art Appreciation: A Projection"). *Psyche: Revue internationale des sciences de l'homme et de psychanalyse* (Paris), Autumn, 1954.

"Sculptures religieuses africaines" ("African Religious Sculpture"). *La Présence Africaine* (Paris), Autumn, 1954.

"Liberian Masks and Modern Art." *Liberia Today* (Washington), November, 1954.

"Masterpieces of African Art." *Arts Digest* (New York), November 1, 1954.

"Shango Sculptures." *Acta Tropica* (Basel), Vol. 12, No. 2, 1955. (35 pp., 18 ill.)

"Liberian Art: A Documentation for a Cultural Heritage for the Liberian People." *Liberia Today* (Washington), August, 1955.

"African Phallic Symbolism." *Zaire* (University of Louvain, Belgium), Vol. IX, No. 10, December, 1955. (29 pp., 7 ill.)

"L'Attitude de l'Africain à l'égard de la maladie: Ses Rapports avec la sculpture" ("The Attitude of the African in Relation to Illness: His Rapport with Sculpture"). *La Revue de Psychologie des Peuples* (Le Havre), XI, 3, 1956. (14 pp., 6 ill.)

"The Artistic Quality of African Sculpture." *Tribus* (Linden Museum, Stuttgart), Vol. 6, 1956. (19 pp.)

"Plastic Aspects of African Sculpture: The Theory of Tension." *ETC., A Review of General Semantics* (Chicago), Vol. XIV, No. 3, Spring, 1957. (14 pp., 5 ill.)

"The Carved Spirit." *Tomorrow* (New York), Vol. 5, No. 4, 1957. (5 pp., 12 ill.)

"The Significance of African Sculpture." *La Présence Africaine* (Paris), Vol. XIV, No. 15, June-September, 1957.

"Art Appreciation and Projection." *Impulse 1958, Annual of Contemporary Dance* (San Francisco), reprinted from *ETC.*

"Aspects of the Study of African Art." *Phylon* (Atlanta University, Atlanta, Ga.), Fourth Quarter, 1958. (16 pp.)

"The Meaning of African Sculpture." *The Journal of Human Relations* (Central State College, Wilberforce, Ohio), Vol. VIII, Nos. 3, 4, 1960. (14 pp., 9 ill.)

"Creativity and Guidance in the Fine Arts." *ETC., A Review of General Semantics* (Chicago), Summer, 1960. (16 pp.)

"African Art, Its Culture." *The Mooremack News* (New York), Summer, 1960.

"Aspects of African Art for the Museum." *Cahier d'Études Africaines* (Paris), No. 5, 1961. (4 pp.)

"African Sculpture and Cubism." *Criticism* (Wayne University, Detroit), Summer, 1962. (29 pp., 14 ill.)

"The Ashanti Akua'ba Statues as Archetype, and the Egyptian Ankh: A Theory of Morphological Assumptions." *Anthropos* (St. Augustin, Germany), Vol. 58, 1963. (26 pp., 15 ill.)

"The Phenomenological Approach to the Perception of Artworks." *The Centennial Review of Arts and Sciences* (Michigan State University, East Lansing), Vol. IX, No. 3, Summer, 1965. (30 pp., 9 ill.)

"Geometric Art and Aspects of Reality: A Phenomenological Approach." *The Centennial Review of Arts and Sciences* (Michigan State University, East Lansing), Vol. XI, No. 4, Fall, 1967. (40 pp., 15 ill.)

Film

Buma. ("African Sculpture Speaks") A short movie based upon research and story by Ladislas Segy; produced, written, and directed by Henry R. Cassirer; photographed and edited by Lewis Jacobs; music recorded in Africa by Arthur S. Alberts. Distributed by Encyclopaedia Britannica Films, Inc.

To Be Published

"Categories of Approaches to African Sculpture: A Phenomenological Study."
"On the Essence of Experience: A Phenomenological View of the Immediacy of the Relation Between Object and Subject."
"The Identity of the Self."
"Being and Creativity—the Identity of the Artist and the Mystical Participation: A Phenomenological Approach."
"Reality and Intuition: A Phenomenological Approach."

AFRICAN ART

Adam, L., *Primitive Art.* London, 1940.
Aderem, Oni of Ife, "Notes on the City of Ife." *Nigeria* (Lagos), No. 12, 1937.
Afrikanische Kunst in Nederland (catalogue). Leiden, 1947.
"Afrikanische Plastik." *Kunst Werkschiften* (Baden-Baden), Vol. XVII, 1951.
Allison, Philip, *Cross River Monoliths.* Lagos, 1968.
Apollinaire, G., "Avertissement." *Sculpture Nègre* (Paris), 1917.
Ars Exotica. Ghent, 1950.
L'Art de l'Afrique Noire. Festival Artistique, Besançon, July-October, 1958.
L'Art nègre du Congo Belge. Ghent, 1950.
L'Art nègre, source, évolution, expansion. Dakar and Paris, 1966.
Bacon, R. H., *Benin, the City of Blood.* London, 1897.
Bardon, Pierre, *Collection des masques d'or Baoule de l'IFAN.** Dakar, 1948.
Barnes, Dr. Albert, "Primitive Negro Sculpture and Its Influence on Modern Civilization." *Opportunity,* May, 1928.
Bascom, W. M., "The Legacy of an Unknown Nigerian Donatello." *The London News,* April, 1939.
Basler, Adolph, *L'Art chez les peuples primitives.* Paris, 1929.
Bastian, Adolf, *Der Fetisch an der Küste Guineas.* Berlin, 1884.
Bastin, Marie-Louise, *Art Décoratif Tshokwe.* Lisbon, 1961.
Baumann, H., "Benin." *Cahiers d'Art* (Paris), Nos. 3 5, 1930.
Bell, Clive, *Since Cézanne.* London, 1922.
Bibliography of African Art, compiled by L. J. P. Gaskin. London, 1965.
Blossfeldt, Willy, *Formen Afrikanische Plastik.* Stuttgart, 1961.
Boas, Franz, *Primitive Art.* Oslo, London, Cambridge, 1927.
Bodrigi, T., *Art in Africa.* New York, 1968.
Bossche, A. Vanden, "La Sculpture des masques Bapende." *Brousse* (Leopoldville), No. 1, 1950.
Bossche, Jean Vanden, "L'Art plastique chez les Bapende." *Brousse* (Leopoldville), No. 2, 1950.
Boulton, Laura C., *Bronze Artists of West Africa.* New York, 1935.
Burssens, Herman, "Sculptuur in Ngbandistijl. . . ." *Kongo-Overzee* (Antwerp), Vol. XXIV, Nos. 1–2, 1958.
———, "The So-called 'Bangala' and a Few

* Institut Français d'Afrique Noir.

Problems of Art-historical and Ethnological Order." *Kongo-Overzee* (Antwerp), Vol. XX, No. 3, 1954.

———, *Yanda-Beelden en Mani-Sekte bid de Azande.* Tervueren, 1962.

Carroll, K., *Yoruba Religious Carvings: Pagan and Christian Sculpture in Nigeria and Dahomey.* New York, 1967.

Casson, Stanley, "Negro Art." *The Listener* (London), May, 1933.

Chauvet, S., *Les Arts indigènes des colonies françaises.* Paris, 1924.

Clarke, J. D., "The Stone Figures of Esie." *Nigeria* (Lagos), No. 14, 1938.

Clouzot, H., and Level, A., *L'Art nègre et l'art océanien.* Paris, 1919.

Culin, S., *Primitive Negro Art.* New York, 1923.

Cunard, Nancy, ed., *Negro.* London, 1934.

Damase, Jacques, *Sculpture of the Tellem and the Dogon.* Paris, 1960.

Delafosse, Maurice, "Au Sujet des statutettes en pierre du Kissi." *Revue d'Ethnog. et de Sociol.* (Paris), March–April, 1914.

Delange, Jacqueline, *Art et Peuples de l'Afrique Noire.* Paris, 1967.

Duckworth, E. H., "Recent Archaeological Discoveries in the Ancient City of Ife." *Nigeria* (Lagos), No. 14, 1938.

Eberl-Elber, Ralph, "Die Masken der Männerbünde in Sierra Leone." *Ethnos* (Stockholm), No. 2, 1937.

Egharevba, J. V., "Art and Craft Works in the City of Benin." *Nigeria* (Lagos), No. 18, 1939.

Einstein, Carl, *Afrikanische Plastik.* Berlin, 1921.

———, "A Propos de l'Exposition de la Galerie Pigalle." *Documents* (Paris), No. 2, 1930.

———, *Negerplastik.* Munich, 1920.

Elisofon, E., and Fagg, W., *The Sculpture of Africa.* New York, 1958.

Esswein, H., "Masken." *Frankfurter Zeitung,* May 3, 1933.

Fagg, Bernard, "Pottery Figures from Northern Nigeria." *Africa* (London), January, 1945.

Fagg, William, "The Antiquities of Ife." *Magazine of Art* (Washington), April, 1950.

———, "L'Art nigerien avant Jésus-Christ." *L'Art Nègre* (Paris), 1951.

———, "De l'Art des Yoruba." *L'Art Nègre* (Paris), 1951.

———, *Tribes and Forms in African Art.* New York, 1965.

———, and List, H., *Nigerian Images.* New York, 1963.

Fried, Donald, "Masks." *Nigeria* (Lagos), No. 18, 1939.

Frobenius, Leo, *Kulturgeschichte Afrikas.* Frankfurt am Main, 1933.

———, *Die Masken und Geheimbünde Afrikas.* Halle, 1899.

———, *Das Unbekannte Afrika.* Munich, 1923.

Fry, Roger, *Vision and Design.* London, 1920.

Fuhrmann, E., *Afrika.* Munich, 1922.

Gaffe, René, *La Sculpture au Congo Belge.* Brussels, 1945.

Gaskell, W., "The Influence of Europe on Early Benin Art." *The Connoisseur* (London), June, 1902.

Gebauer, Paul, "Art of the British Cameroons," in *West African Art* (catalogue). Milwaukee, 1953.

Goldwater, Robert, ed., *Bambara Sculpture from the Western Sudan.* New York, 1960.

———, ed., *Senufo Sculpture from West Africa.* New York, 1963.

Gorer, Geoffrey, "Black Art." *The Listener* (London), August 14, 1935.

Grébert, F., "Arts en voie de disparition au Gabon." *Africa* (London), January, 1934.

Griaule, Marcel, *Folk Art of Black Africa.* New York, 1950.

———, *Masques Dogon.* Paris, 1938.

———, "Les Symboles des arts africaines." *L'Art Nègre* (Paris), 1951.

Guillaume, Paul, and Monro, Thomas, *Primitive Negro Sculpture.* London and New York, 1926.

Hagen, Dr. Karl, *Altertümer von Benin im Museum für Völkerkunde zu Hamburg.* Hamburg, 1898.

Hall, Henry Usher, *African Cups Embodying Human Forms.* Philadelphia, September, 1924.

———, *Examples of African Art.* Philadelphia, September, 1919.

———, *Great Benin Altar.* Philadelphia, June, 1922.

———, *An Ivory Standing Cup from Benin.* Philadelphia, December, 1926.

————, *A Large Drum from Benin*. Philadelphia, June, 1928.

————, *The Sherbo of Sierra Leone*. Philadelphia, 1938.

————, *Two Masks from French Equatorial Africa*. Philadelphia, December, 1947.

Hardy, Georges, *L'Art nègre*. Paris, 1927.

Harley, George W., *Masks as Agents of Social Control in Northeast Liberia*. Cambridge, Mass., 1950.

————, *Notes on the Poro in Liberia*. Cambridge, Mass., 1941.

Hassenstein, W., *Barbaren und Klassiker*. Munich, 1922.

Hefel, Annemarie, *Afrikanische Bronzen*. Vienna, 1948.

Herold, E., *Tribal Masks*. London, 1967.

Himmelheber, Hans, "Art et artistes Bakuba." *Brousse* (Leopoldville), No. 1, 1940.

————, *Die Dan*. Stuttgart, 1958.

————, *Negerkunst und Negerkünstler*. Brunswick, Germany, 1960.

————, *Negerkünstler*. Stuttgart, 1935.

Holas, B., "Une 'Genetrix' Baoule." *Acta Tropica* (Basel), Vol. 9, No. 3, 1952.

Holy, Ladislav, *Masks and Figures from Eastern and Southern Africa*. London, 1967.

Hooton, E. A., "Benin Antiquities in the Peabody Museum," in *Varia Africana, I*. Cambridge, Mass., 1917.

Horton, Robin, *Kalabari Sculpture*. Lagos, 1965.

Huet, M., and Fodeba, K., *Les Hommes de la dance*. Lausanne, 1954.

Hunt-Cooke, A., and Murray, K. C., "Dahomeyan Craft." *Nigeria* (Lagos), No. 10, 1937.

Karutz, R., *Die Afrikanische Hörnermasken*. Lübeck, 1901.

Kjersmeier, Carl, *African Negro Sculpture*. New York, 1948.

————, "Bambara Sculptures," in Nancy Cunard, ed., *Negro*. London, 1934.

————, *Centres de style de la sculpture négro africaine* (4 vols.). Paris, 1935–38.

Kochnitzky, Leon, *African Negro Sculpture*. New York, 1948.

Langlois, P., *Art Soudanais: Tribus Dogon*. Brussels and Lille, 1954.

Lavachery, Henry, "Apparente Évolution des masques dans la region de Man." *Bull. des Musées Royaux d'Art et d'Histoire* (Brussels), November-December, 1939.

————, "L'Art des noirs d'Afrique et son destin." *L'Art Nègre* (Paris), 1951.

————, "Essay on the Style in Statuary of the Belgian Congo," in Nancy Cunard, ed., *Negro*. London, 1934.

Lem, F. H., *Sculptures Soudanaises*. Paris, 1948.

————, "Variété et unité des traditions plastiques de l'Afrique noire." *L'Art Nègre* (Paris), 1951.

Leuzinger, E., *Africa, the Art of the Negro People*. New York, 1960.

Lindholm, Britt, "Les Portraits Baoule et leur base sociale." *Arstryck* (Göteborg), 1955–56.

Linton, Ralph, "Primitive Art." *Kenyon Review*, Fall, 1941.

Locke, Alain, "African Art, Classic Style." *American Magazine of Art*, May, 1935.

————, "Collection of Congo Art." *The Arts*, February, 1927.

————, *The Significance of African Art*. Baltimore, 1946.

Luquet, G. H., *L'Art primitif*. Paris, 1930.

Luschan, Felix von, *Die Altertümer von Benin* (3 vols.). Berlin, 1919.

————, *Die Karl Knorrsche Sammlung von Benin*. Stuttgart, 1901.

Maes, J., *Aniota-Kifwebe*. Antwerp, 1924.

————, *Fetischen of Toverbeelden uit Kongo*. Brussels, 1935.

————, "Les Figurines sculptées de Bas Congo." *Africa* (London), July, 1930.

————, "La Psychologie de l'art nègre." *Ipek* (Leipzig), 1926.

————, "Des Sources de l'art nègre." *Cahiers d'Art* (Paris), No. 6, 1930.

————, and Lavachery, H., *L'Art nègre*. Brussels, 1935.

Marquart, Joseph, *Die Benin-Sammlung des Reichsmuseums für Völkerkunde in Leiden*. Leiden, 1913.

Marquet, J. J., *Afrique, les civilisations noires*. Paris, 1963.

Meauze, P., *African Art*. New York, 1968.

Menzel, Brigitte, *Goldgewichte aus Ghana*. Berlin, 1968.

Meyerowitz, Eva L. R., "Ancient Nigerian Bronzes." *Burlington Magazine* (London), September-October, 1941.

————, "Bronzes and Terra-Cottas from Ife-

Ife." *Burlington Magazine* (London), October, 1939.

————, *The Sacred State of Akan*. London, 1951.

————, "Some Gold, Bronze and Brass Objects from Ashanti." *Burlington Magazine* (London), January, 1947.

————, "The Stone Figures of Esie in Nigeria." *Burlington Magazine* (London), February, 1943.

————, "Wood Carvings in the Yoruba Country Today." *Africa* (London), April, 1945.

Murray, K. C., "Arts and Crafts of Nigeria: Their Past and Future." *Africa* (London), October, 1945.

————, "Nigeria's First Exhibition of Antiquities." *Nigeria* (Lagos), No. 26, 1947.

Musée Vivant, Le (special issue). Paris, November, 1948.

Nuoffer, Oscar, *Africanische Plastik und die Gestaltung von Mutter und Kind*. Dresden, 1934.

Olbrechts, Frans M., "Contribution to the Study of the Chronology of African Plastic Arts." *Africa* (London), October, 1945.

————, *Plastiek van Kongo*. Antwerp, 1946.

Palmer, Sir Richard, "Ancient Nigerian Bronzes." *Burlington Magazine* (London), October, 1942.

Paulme, D., *Les Sculptures de l'Afrique Noire*. Paris, 1956.

Perier, G. D., *Les Arts populaires du Congo Belge*. Brussels, 1948.

Pitt-Rivers, L. G., *Antique Works of Art from Benin*. London, 1900.

Plass, Margaret W., *African Miniatures: Goldweights of the Ashanti*, New York, 1967.

Portier, A., and Poncetton, F., *Les Arts sauvages d'Afrique*. Paris, 1929.

Rachewitz, B., *Incontro con l'Arte Africana*. Milan, 1959.

Radin, P., and Sweeney, J. J., *African Folktales and Sculpture*. New York, 1952.

Ratton, Charles, "L'Or fétiche." *L'Art Nègre* (Paris), 1951.

Rattray, R. S., *Religion and Art in Ashanti*. Oxford, 1927.

Read, C. H., and Dalton, O. M., *Antiquities from the City of Benin . . .* London, 1899.

Roth, H. Ling, *Great Benin, Its Customs, Art and Horrors*. Halifax, 1903.

————, "Primitive Art from Benin." *Studio* (London), October, 1898.

Royal Anthropological Institute, *Traditional Art of the British Colonies*. London, 1949.

Sadler, Michael E., *Arts of West Africa*. Oxford, 1935.

Salmon, André, *L'Art nègre*. Paris, 1922.

————, "Negro Art." *Burlington Magazine* (London), April, 1920.

Schmalenbach, W., *African Art*. New York, 1954.

Schmeltz, J. V. E., "Neue Litteratur über Benin." *Intern. Archiv für Ethnologie*, Vol. 16, 1903.

Schneider-Lengyel, Ilse, *Die Welt der Maske*. Munich, 1934.

Sieber, Roy, *Sculpture of Northern Nigeria*. New York, 1961.

Sonolet, Louis, "L'Art dans l'Afrique Occidentale française." *Gazette des Beaux Arts* (Paris), July-December, 1923.

Sousberghe, L. de, *L'Art Pende*. Brussels, 1958.

Starkweather, Frank, *Traditional Igbo Art*. Ann Arbor, Mich., 1968.

Stephan, E., *Südseekunst*. Berlin, 1907.

Stevens, G. A., "The Future of African Art." *Africa* (London), April, 1930.

Struck, Bernard, "Die Chronologie der Benin Altertümer." *Zeitschrift für Ethnologie*, Vol. 1, LV, 1923.

Sweeney, James J., *African Negro Art* (catalogue). New York, 1935.

Sydow, Eckart von, "African Sculpture." *Africa* (London), April, 1928.

————, *Afrikanische Plastik*. Berlin, 1954.

————, *Ahnenkult und Ahnenbild der Naturvölker*. Berlin, 1924.

————, "Ancient and Modern Art in Benin City." *Africa* (London), January, 1938.

————, *Exotische Kunst, Afrika und Oceanien*. Leipzig, 1921.

————, *Handbuch der Afrikanischen Plastik*. Berlin, 1930.

————, *Kunst der Naturvölker: Sammlung Baron Eduard von der Heydt*. Berlin, 1932.

————, *Die Kunst der Naturvölker und der Vorzeit*. Berlin, 1923.

————, "Masques Janus de Cross River." *Documents* (Paris), No. 6, 1930.

Thornburn, J. W. A., "The City of Benin." *Nigeria* (Lagos), No. 10, 1937.

Torday, E., *The New Congo Collection*. Philadelphia, March, 1913.

Traditional Sculptures from the Colonies. London, 1951.

Trowell, M., *African Design*. New York, 1960.

———, *Classical African Sculpture*. New York, 1954.

Underwood, Leon, *Bronzes of West Africa*. London, 1949.

———, *Figures in Wood of West Africa*. London, 1948.

———, *Masks of West Africa*. London, 1948.

Utzinger, Rudolf, *Masken*. Berlin, 1922.

Vandenhoute, P. J. L., *Classification stylistique du masque Dan et Guéré de la Côte d'Ivoire Occidentale*. Leiden, 1948.

Vatican Exhibition, *The Arts in the Belgian Congo and Ruanda-Urundi*. Brussels, 1950.

Vatter, Ernst, *Religiöse Plastik der Naturvölker*. Frankfurt am Main, 1926.

Verger, Pierre, *Dieux d'Afrique*. Paris, 1954.

Verly, Robert, "La Statuaire de pierre du Bas Congo." *Zaire* (Louvain), Vol. IX, No. 5, May, 1955.

Walker Art Center, *Art of the Congo* (catalogue). Minneapolis, Minn., 1967.

Wassing, R.S., *African Art*. New York, 1968.

Webster, D. W., *Auction Catalogues, Nos. 2, 23, 24, 25, 26, 30, 31*. Bicester, England, 1899–1901.

Weyns, J., "Quelques Remarques au sujet de nos sculptures africaines." *Les Arts Plastiques* (Brussels), 1949.

Wingert, P. S., *The Sculpture of Negro Africa*. New York, 1950.

Zayas, M. de, *African Negro Art*. New York, 1916.

ANTHROPOLOGY

Abel, H., "Déchiffrement des poids à peser l'or en Côte d'Ivoire." *Jour. Soc. des Africanistes* (Paris), Vol. 22, No. 1, 1952.

Abrahamsson, Hans, *The Origin of Death*. No. III in the Studia Ethnographica Upsaliensia Series, Uppsala, 1951.

Alexandre, P., and Biner, J., *Le Groupe dit Pahouin*. Paris, 1958.

Andersson, Efraim, *Contribution à l'ethnographie des Kuta I*. No. VI in the Studia Eth-

nographica Upsaliensia Series, Uppsala, 1953.

Antuban, Kofi, *Ghana's Heritage of Culture*. Leipzig, 1963.

Armattoe, Dr. E. E. G., *The Golden Age of West African Civilization*. Londonderry, 1946.

Bardon, P., *Collection des masques d'or Baule de l'IFAN*. Dakar, 1948.

Basden, G. T., *Among the Ibos of Nigeria*. London, 1921.

———, *Niger Ibos*. London, 1938.

Bastian, Adolf, *Der Fetisch an der Küste Guineas*. Berlin, 1884.

Baumann, Hermann, *Lunde, Bei Bauern und Jägern in Inner-Angola*. Berlin, 1935.

———, "Die Mannbarkeitfeier bei den Tsokwe und Ihren Nachbaren." *Bassler Archiv* (Berlin), IV, 1, 1932.

———, *Les Peuples et les civilisations de l'Afrique*. Paris, 1948.

Beaucrops, Remi de, *Les Basongo de la Luniungu et de la Gobari*. Brussels, 1941.

———, *Les Bayansi du Bas-Kwilu*. Louvain, 1933.

Benedict, Ruth, *Patterns of Culture*. New York, 1934.

Bernatzik, H. A., *Geheimnisvolle Inseln Tropen-Afrikas*. Berlin, 1933.

———, *Im Reiche der Bidjogo*. Frankfurt am Main, 1960.

Bertossa, A., "Notes on the Warega Sculptures in the Archives of Völkerkunde Museum, Basel." November 13, 1954.

Biebuyck, D., "La Dégénérance de l'art chez les Balega." *Zaire* (Louvain), March, 1954.

———, "Function of a Lega Mask." *Intern. Arch. Ethnog.* (Amsterdam), Vol. 47, No. 11, 1954.

———, "Some Remarks on Segy's 'Warega Ivories.'" *Zaire* (Louvain), December, 1953.

———, "Superstructures of Secret Societies: The Problem of Various Social Organizations in the Kivu." *Folia Scientifica Africae Centralis*, Vol. 1, No. 3, 1955.

Bittremieux, Leo, *La Société secrète des Bakhimba au Mayombe*. Brussels, 1936.

Bohannan, Laura and Paul, *The Tiv of Central Nigeria*. London, 1953.

Boone, O., "Carte ethnique du Congo Belge et du Ruanda-Urundi." *Zaire* (Louvain), May, 1954.

British Museum, *Handbook to the Ethnographic Collections*. London, 1925.

Brown, S., "The Nomoli of Mende Country." *Africa* (London), January, 1948.

Bryk, Felix, *Dark Rapture: The Sex Life of the African Negro*. New York, 1939.

Burnier, Thomas, *Ames primitives*. Paris, 1922.

Burton, Sir R. F., *A Mission to Gelele, King of Dahomey* (2 vols.). London, 1893.

Chadwick, E. R., "A Hippo Play in Brass Division." *The Nigerian Field* (London), Vol. 18, No. 1, January, 1953.

Cureau, Dr. A., *Les Sociétés primitives de l'Afrique Equatoriale*. Paris, 1912.

Delafosse, Maurice, *Les Civilisations négro-africaines*. Paris, 1925.

———, *Les Nègres*. Paris, 1927.

Dennett, R. E., *At the Back of the Black Man's Mind*. London, 1906.

———, *Nigerian Studies: The Religions and Political System of the Yoruba*. London, 1910.

Ellis, A. B., *The Yoruba-Speaking People*. London, 1894.

Fage, J. D., *An Atlas of African History*. London, 1958.

Farrow, Stephan S., *Faith, Fancies and Fetish*. London, 1926.

Forde, Daryll, *The Yoruba-Speaking Peoples of South-Western Nigeria*. London, 1951.

———, Brown, P., and Armstrong, R. G., *The Nupe: Peoples of the Niger-Benue Confluence*. London, 1955.

———, and Jones, G. I., *The Ibo and Ibibio-Speaking Peoples of South-Eastern Nigeria*. London, 1950.

Frobenius, Leo, *Und Afrika Sprach*. Berlin, 1912.

Gautier, R. P., *Étude historique sur les Mpongoues et tribus avoisinantes*. Brazzaville, 1950.

Gerbrands, A. A., *Art as an Element of Culture, Especially in Negro-Africa*. Leiden, 1957.

Goldenweiser, Alexander A., *Anthropology, an Introduction to Primitive Cultures*. New York, 1937.

Gorer, G., *Africa Dances*. London, 1935.

Grébert, F., *Au Gabun*. Paris, 1948.

Griaule, M., "Les Savoirs des Dogon." *Jour. Soc. des Africanistes* (Paris), Vol. 22, 1962.

Gunn, Harold D., *Peoples of the Plateau Area of Northern Nigeria*. London, 1953.

Haardt, Georges-Marie, and Andouin-Dubreuil, Louis, *La Croisière Noire*. Paris, 1927.

Hardy, Georges, *Vue générale de l'histoire d'Afrique*. Paris, 1948.

Hauser, A., "Notes sur les Omyene du Bas Gabun." *Bull. IFAN* (Dakar), Ser. B. 3-4, July-October, 1954.

Hefel, A., "Der Afrikanische Gelbguss und seine Beziehungen zu den Mittermeerländern." *Wiener Beitrage* . . . (Vienna), 1943.

Herskovits, Melville J., *Dahomey, an Ancient West African Kingdom*. New York, 1938.

Holas, B., *Craft and Culture in the Ivory Coast*. Paris, 1968.

———, *Cultures matérielles de la Côte d'Ivoire*. Paris, 1960.

———, *Les Masques Kono*. Paris, 1952.

———, *Les Senoufo*. Paris, 1957.

———, *Les Toura*. Paris, 1962.

Hottot, R., "Take Fetishes." *Jour. Royal Anthr. Inst.* (London), Vol. 86, January-June, 1956.

Hubert H., "Magical Statues and Their Accessories Among the Eastern Bayaka and Their Neighbours (Belgian Congo)." *Anthropos* (Gribourg), Vol. 51, 1954.

Jacques, V., and Storms, E., "Notes sur l'Ethnographie de la Partie Orientale de l'Afrique Equatoriale." *Bull. Soc. Royale Anthropologie* (Brussels), Vol. V, 1886-87.

Jeffreys, M. D. W., "The Cowry Shell: A Study of Its History and Use in Nigeria." *Nigeria* (Lagos), September, 1938.

———, "Ikenga: The Ivory Ram-headed God." *African Studies* (Johannesburg), Vol. 13, No. 1, 1954.

Johnson, J., *The History of the Yorubas*. London, 1894.

Junod, H. A., *Moeurs et coutumes des Bantous* (3 vols.). Paris, 1936.

Kingsley, Mary, *Travels in West Africa*. London, 1897.

Kyerematen, A. A. Y., *Panoply of Ghana*. London, 1964.

Labouret, M. Henri, *Histoire des noirs d'Afrique*. Paris, 1950.

———, "Notes contributives a l'étude du peu-

ple Baoule." *Revue d'Ethnog. et de Sociol.* (Paris), March–April, 1914.

Lagercrantz, Sture, *Contribution to the Ethnography of Africa.* No. 1 in the Studia Ethnographica Upsaliensia Series, Uppsala, 1950.

———, "Der Donnerkeil im Afrikanische Volksglauben." *Ethnologiska Studier* (Göteborg), No. 10, 1940.

———, "Über Willkommene und Unwillkommende Zwillings in Afrika." *Ethnologiska Studier* (Göteborg), Nos. 12–13, 1941.

Laman, Karl, *The Kongo.* No. IV in the Studia Ethnographica Upsaliensia Series, Uppsala, 1953.

Latouche, John, *Congo.* New York, 1945.

Lebeuf, J. P., and Detournet, M., *La Civilisation du Tchad.* Paris, 1960.

Lecoq, R., *Les Bamileke.* Paris, 1953.

Leonard, A. G., *The Lower Niger and Its Tribes.* London, 1906.

Lietard, Capt. L., "Les Waregas." *Bull. Soc. Royale Belge de Géographie* (Brussels), 1923.

Lifchitz, D., and Paule, H., *Les Noms individuels chez les Dogon.* Dakar, 1954.

Lowie, Robert H., *An Introduction to Cultural Anthropology.* New York, 1934.

Lucas, O. K., *The Religion of the Yorubas.* Lagos, 1948.

Maes, Dr. J., *Notes sur les populations des bassins du Kasai, de la Lukanie, et du Lac Leopold II.* Brussels, 1924.

———, and Boone, O., *Les Peuplades du Congo Belge.* Brussels, 1935.

Malfante, Antonio, see Crone, G. R., ed. and trans., *The Voyages of Cadamosto and Other Documents on Western Africa in the Second Half of the Fifteenth Century.* London, 1937.

Malinowski, Bronislaw, *The Dynamics of Culture Change: An Inquiry into Race Relations in Africa.* New Haven, 1945.

Manoukian, Madeline, *Akan and Ga-Adangme Peoples of the Gold Coast.* London, 1950.

Marti, M. P., *Les Dogon.* Paris, 1957.

McCulloch, Merran, *The Peoples of Sierra Leone Protectorate.* London, 1950.

———, *The Southern Lunda and Related Peoples.* London, 1951.

Meek, C. K., *Tribal Studies in Northern Nigeria.* London, 1931.

Meek, R. E., *A Sudanese Kingdom.* New York, 1950.

Meyerowitz, Eva L. R., "Concepts of the Soul Among the Akan of the Gold Coast." *Africa* (London), January, 1951.

Michelet, Raymond, "African Empires and Civilizations," in Nancy Cunard, ed., *Negro.* London, 1934.

Miletto, Dr., "Notes sur les Ethnies de la région du Haute-Ogooue." Inst. d-Études Centrafricaines, Brazzaville.

Murdock, G. P., *Our Primitive Contemporaries.* New York, 1934.

Murray, K. C., "Idah Masks." *The Nigerian Field* (London), Vol. 14, No. 3, July, 1949.

———, "The Stone Images of Esie and Their Yearly Festival." *Nigeria* (Lagos), No. 37, 1951.

Nadel, S. F., *A Black Byzantium.* London, 1942.

———, *Nupe Religion.* London, 1954.

Nichol, D., "Twins in Yoruba-land." *West African Review* (London), September, 1957.

Paques, V., *Les Bambara.* Paris, 1954.

Paulme, Denise, *Les Gens du Riz, Kissi de Haute-Guinée française.* Paris, 1954.

Peschuel-Loesche, E., *Völkerkunde von Loango.* Stuttgart, 1907.

Pitt-Rivers Museum, *General Handbook.* Farnham, England, 1929.

Plancquaert, P., *Les Jaga et les Bayaka du Kwango.* Brussels, 1932.

Radcliffe-Brown, A. R., and Forde, Daryll, eds., *African Systems of Kinship and Marriage.* London, 1950.

Raponda-Walker, A., and Sillans, R., *Les Plantes utiles du Gabon.*

Rattray, R. S., *Ashanti.* Oxford, 1923.

Richard-Molard, J., *L'Afrique Occidentale française.* Paris, 1949.

Rop, A. de, "Les Statuettes Lilwa chez les Boyela." *Zaire* (Louvain), February, 1955.

Rütimeyer, L., "Über Westafrikanische Steinidole." *Intern. Archiv. für Ethnographie* (Leiden), Vol. XIV, 1901.

Schwab, George, *Tribes of the Liberian Hinterland.* Cambridge, Mass., 1947.

Seligman, C. G., *Les Races de l'Afrique.* Paris, 1935.

Shaw, Thurston, *The Study of Africa's Past.* London, 1946.

Sicard, Harold von, *Ngoma Lungundu*. No. V in the Studia Ethnographica Upsaliensia Series, Uppsala, 1952.

Söderberg, B., "Ancestor Guardian Figures and Ancestral Baskets Among the Bakuta." *Ethnos* (Stockholm), 1-2, 1956.

Talbot, (Mrs.) D. A., *Woman's Mysteries of a Primitive People, the Ibibios of Southern Nigeria*. London, 1915.

Talbot, P. A., *In the Shadow of the Bush*. London, 1912.

———, *The Peoples of Southern Nigeria* (3 vols.). Oxford, 1926.

———, *Tribes of the Niger-Delta*. London, 1932.

Tempels, Placide, *La Philosophie Bantoue*. Paris, 1949.

Tiarko Fourche, J. A., and Morlighem, H., *Les Communications des indigènes du Kasai avec les âmes des morts*. Brussels, 1939.

Torday, E., "The Influence of the Kingdom of Kongo in Central Africa." *Africa* (London), April, 1928.

———, and Joyce, T. A., *Notes ethnographiques sur les peuples communément appelés Bakuba, ainsi que sur les peuples apparentés, les Bushongo*. Brussels, 1910.

Warner, Esther, *New Song in a Strange Land*. Boston, 1948.

Weeks, John H., *Among the Primitive Bakongo*. Philadelphia, 1914.

Wieschoff, H. A., *Africa*. Philadelphia, 1945.

Woodson, Carter G., *African Heroes and Heroines*. Washington, 1944.

MYTH, MAGIC, RELIGION

Campbell, Joseph, *The Hero with a Thousand Faces*. New York, 1949.

Cendrars, Blaise, *Anthologie nègre*. Paris, 1927.

Diel, Paul, *La Divinité*. Paris, 1950.

Dieterlen, Germaine, *Les Ames des Dogon*. Paris, 1941.

———, *La Religion Bambara*. Paris, 1951.

Feuilloley, B. F., "Magic and Initiation in the Ubanghi-Shari," in Nancy Cunard, ed., *Negro*. London, 1934.

Frazer, James G., "The Magic Art" and "Taboo and the Perils of the Soul," in *The Golden Bough*. New York, 1926.

Gordon, Pierre, *Initiation sexuelle et évolution religieuse*. Paris, 1946.

Griaule, Marcel, *Dieu d'eau*. Paris, 1948.

Harper, "Notes on the Totemism of the Gold Coast." *Jour. of Anthropology* (London), No. 36, 1906.

Harrison, Jane E., *Ancient Art and Ritual*. New York, 1913–48.

Kaigh, Frederick, *Witchcraft and Magic in Africa*. London, 1947.

Kerharo, J., and Bouquet, A., *Sorciers, Féticheurs et guérisseurs de la Côte d'Ivoire—Haute Volta*. Paris, 1950.

Lavignotte, Henri, *L'Évur, croyance des Pahouins du Gabon*. Paris, 1936.

Le Roy, Mgr. A., *La Religion des primitifs*. Paris, 1911.

Malinowski, Bronislaw, *Magic, Science and Religion*. New York, 1948.

Marett, R. R., *Faith, Hope and Charity in Primitive Religion*. New York, 1932.

Potter, Charles F., *The Story of Religions*. New York, 1937.

Smith, E. W., ed., *African Ideas of God*. London, 1950.

Tauxier, L., *Religion, moeurs et coutumes des Agnis de la Côte d'Ivoire*. Paris, 1932.

Woodson, Carter G., *African Myth*. Washington, 1944.

Wundt, W., "Mythus und Religion," in *Völkerpsychologie*, Vol. II, Leipzig, 1906.

PSYCHOLOGY

Ankermann, Bernhard, *Totenkult und Seelenglauben bei den Afrikanischen Völker*. 1918.

Blondel, C., *La Mentalité primitive*. Paris, 1926.

Boas, Franz, *The Mind of Primitive Man*. New York, 1927.

Carrel, Alexis, *The Voyage to Lourdes*. New York, 1950.

Cotton, E. P., "The Mind of Primitive Man in West Africa." *Jour. of Applied Sociology*, Vol. IX, 1924.

Field, M. J., *Search for Security: An Ethno-Psychiatric Study of Rural Ghana*. Evanston, Ill., 1960.

Frazer, James G., "Totemism and Exogamy," in *The Golden Bough*. New York, 1926.

Freud, Sigmund, *Moses and Monotheism*. New York, 1947.

————, *Totem and Taboo*. New York, 1938.

Hartmann, George W., *Gestalt Psychology*. New York, 1935.

Hess, Jean, *L'Ame nègre*. Paris, 1899.

Lévy-Bruhl, L., *La Mentalité prélogique*. Paris, 1922.

Mueller-Freienfels, Richard, *Psychologie der Kunst*. Leipzig, 1912.

Parringer, G., *West African Psychology*. London, 1951.

Preuss, K. Th., *Die Geistige Kultur der Naturvölker*. Leipzig and Berlin, 1923.

Rank, Otto, *Art and Artist*. New York, 1932.

Rhine, J. B., *New Frontiers of Mind*. New York and Toronto, 1937.

Sydow, Eckart von, *Primitive Kunst und Psychoanalyse*. Leipzig, Vienna, Zurich, 1927.

Thorburn, John M., *Art and the Unconscious*. London, 1925.

Verworn, Max, *Zur Psychologie der Primitiven Kunst*. Jena, 1917.

ART APPRECIATION, PHILOSOPHY OF ART

Bergson, Henri, "La Perception du changement," in *Oeuvres Completes*. Geneva, 1921.

Buermeyer, Laurence, *The Aesthetic Experience*. Merion, Pa., 1924.

Cézanne, Paul, *Correspondence*. Paris, 1937.

Cladel, Judith, *Aristide Maillol, sa vie, son oeuvre, ses idées*. Paris, 1937.

Collingwood, R. G., *The Principles of Art*. Oxford, 1938.

Croce, Benedetto, *The Essence of the Aesthetic*. London, 1921.

Ducasse, Curt J., *Art, the Critics, and You*. New York, 1944.

Faure, Élie, *The Spirit of the Forms*. New York, 1937.

Hamlyn, D. W., *Sensation and Perception*. London, 1961.

Hartmann, G. W., *Gestalt Psychology*. New York, 1935.

Hayek, F. A., *The Sensory Order*. London, 1952.

Husserl, E., *Ideas: An Introduction to Pure Phenomenology*. London, 1931.

Jung, C. G., *Psyche and Symbol*. New York, 1958.

Köhler, W., *Gestalt Psychology*. New York, 1959.

Merleau-Ponty, M., *Phenomenology of Perception*. New York, 1962.

Riegl, Alois, *Stilfragen, Grundlegungen zu einer Geschichte der Ornamentik*. Berlin, 1893.

Scheltema, A. van, *Die Altnordische Kunst: Grundprobleme Vorhistorischer Kunstentwicklung*. Berlin, 1923.

Schopenhauer, A., *Die Welt als Wille und Vorstellung*. Leipzig, 1859.

Spearing, H. G., *The Childhood of Art, or the Ascent of Man*. New York, 1913.

Taine, A., *Philosophie de l'art*. Paris, 1901.

Vantongerloo, D., *L'Art et son avenir*. Antwerp, 1924.

Wittgenstein, L., *Tractatus Logico-Philosophicus*. London, 1922, 1961.

————, *Philosophical Investigations*. New York, 1953.

Worringer, Wilhelm, *Abstraktion und Einfühlung; ein Beitrag zur Stilpsychologie*. Munich, 1908.

COMPARATIVE MATERIAL

Buraud, Georges, *Les Masques*. Paris, 1948.

Clawson, H. Phelps, *By Their Works*. Buffalo, N.Y., 1941.

Fechheimer, Hedwig, *Die Plastik der Ägypter*. Berlin, 1923.

Goldwater, Robert J., *Primitivism in Modern Painting*. New York, 1938.

Gröber, Karl, *Kinderspielzeug aus alter Zeit*. Berlin, 1928.

Gunther, Erna, "Material Culture." *College Art Journal* (The Museum of Primitive Art), Spring, 1950.

Huggins, Willis N., and Jackson, J. G., *An Introduction to African Civilization*. New York, 1937.

Kahnweiler, D. H., "Negro Art and Cubism."

Horizon (London), December, 1948.

Kühn, Herbert, *Die Kunst Alt-Europas.* Stuttgart, 1954.

Kutscher, Gerd, "West-Afrika und die Moderne Kunst." *Bildende Kunst* (Berlin), November-December, 1947.

Münz, Ludwig, and Löwenfeld, Viktor, *Plastiche Arbeiten Blinder.* Brno, 1934.

Neumann, Erich, *The Great Mother: An Analysis of the Archetype.* New York, 1955.

Prinzhorn, Hans, *Bildnerei der Geisteskranken.* Berlin, 1922.

Rothschild, Lincoln, *Sculpture Through the Ages.* New York, 1942.

Shadbolt, Doris, "Our Relation to Primitive Art." *Canadian Art* (Ottawa), Vol. V, No. 1, 1947.

Teilhard de Chardin, Pierre, *The Phenomenon of Man.* New York, 1949.

Thoby, P., "Christ." *Aesculape* (Paris), 1933.

List of Illustrations

List of Illustrations

Photographs have been supplied by the collections listed or taken by the author unless otherwise credited.*

* Since the publication of the first edition of this book seventeen years ago, some previously listed collections have been dispersed on auction or sold privately and the present owner is unknown.
† Formerly Musée du Congo Belge.

* Formerly Institut Français d'Afrique Noir.

Index

Index

The main entries of tribal names are in capitals and small capitals. Page numbers for tribes and territories discussed in Part IV are in boldface type. Page numbers for illustrations are in italics.

ADDENDA TO
STYLE REGIONS

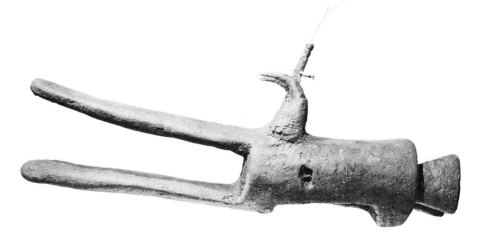

437. Headdress used in Komo society, Bambara, Mali. 34" long

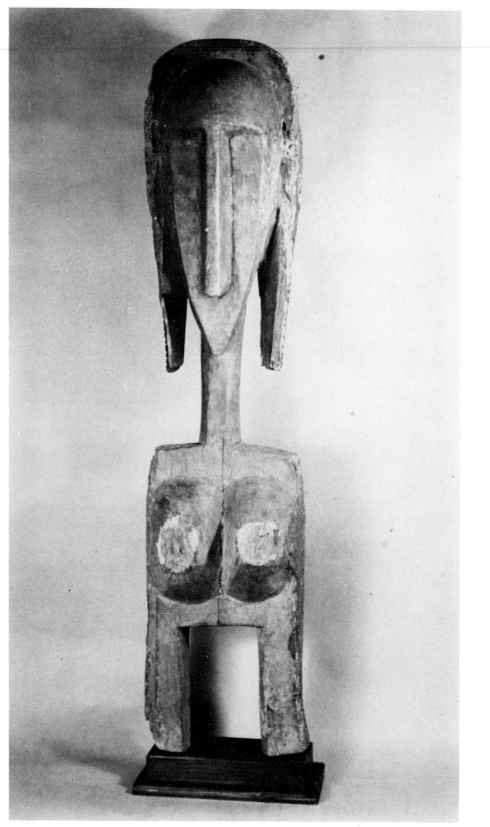

438. *Marionette* (merekun), *Bambara, Mali. 22"*

REPUBLIC OF MALI
(pp. 148-151)

BAMBARA

Fig. 437 is a headdress worn horizontally, used by the Komo society. It is covered with mud and sacrificial material, horns attached, mouth open. This mask was mentioned earlier (p. 150) but not illustrated.

We mentioned also the *merekun* marionette figure (p. 151). Fig. 438 shows one such marionette used in the Do performances.

Fig. 439 is a ceremonial wand with human head which the dancer carried over the shoulder.

DOGON (pp. 152-158)

Fig. 134 is an illustration of a typical granary door decorated with several rows of small figurines carved in relief. Less known are the doors carved with female breasts (Fig. 440) symbolically connecting human and grain fertility.

BOZO

This tribe of fishermen live at the confluence of the Bani and Niger rivers, around Mopti. They have very bold horned animal masks (Fig. 441) which they decorate with colored fabrics and metal appliques, in some respects similar to practices of the Bambara and Marka.

REPUBLIC OF GUINEA

BAGA (p. 158)

Under Fig. 140 we have illustrated a *nimba* fertility statue, a type less known is the so-called *nimba pefete* carvings (Fig. 442), having the same large breasts as the other *nimba* figures. This one was carried by the dancer above his head, the lower part of it and also its body completely covered with multicolored fabric. It was used at the girls' initiation ceremony.

Fig. 443 is a five-foot polychromed python, called *kakilamba,* also *banjonyi,* regarded as a reincarnation of an ancestor.

SIERRA LEONE

MENDI (p. 161)

Fig. 444 is a carefully executed *minsereh* statue. It has scarification marks on the shoulders and back. A necklace with pendent is carved in low relief. The head of this statue (Fig. 445) shows more clearly the hair style and rings on the neck typical of the Bundu helmet masks (Fig. 145). (Further details on this statue on page 161.)

LIBERIA

KRA-GIO (p. 163)

A rather unusual figure (Fig. 446) is tentatively identified as Kra or Gio. The highly unified structure of this carving, with its round shoulders and hips, is noteworthy.

Fig. 447 is a magical statue. The neck and forehead are covered with fabric and cowrie shells, and monkey hair is attached to the top.

BASSA

Fig. 448 is a mask with a domed forehead typical of this tribe.

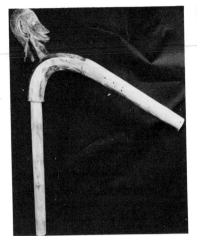

439. *Ceremonial wand, Bambara, Mali. 16"*

440. *Door, Dogon, Mali. 17 x 13"*

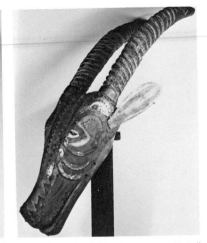

441. *Animal Mask, Bozo, Mali. 27"*

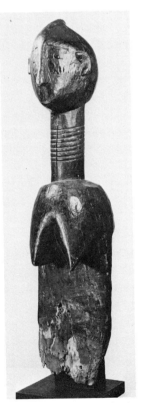

442. *Figure* (nimba pefete), *Baga, Guinea. 33"*

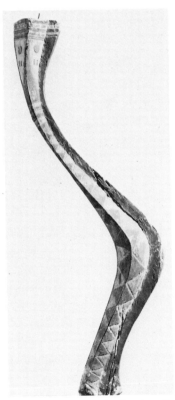

443. *Figure of a snake* (banjonyi), *Baga, Guinea. 54½"*

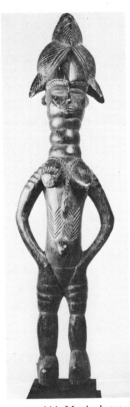

444. *Magical statue* (minsereh), *Mendi, Sierra Leone. 22"*

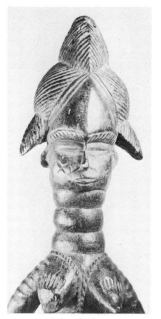

445. head of same statue

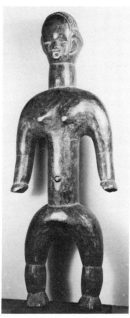

446. Figure, Kra-Gio, Libera. 17"

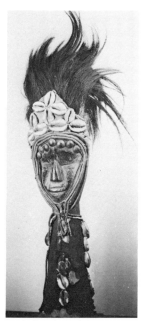

447. Magical statue, Kra, Liberia. 15"

IVORY COAST

BAULE (pp. 167-169)

Under Fig. 40 we have illustrated a *goli* mask with open jaw. There is however another type of similar style (Fig. 449) which has a massive structure and closed jaws.

It may be of interest to show (Fig. 450) that on our last trip to the Baule country we saw a dancer with a roughly carved mask, painted reddish brown with commercial color and topped by a superstructure of a woman entwined by a snake—all non-traditional characteristics.

SENUFO (pp. 171-175)

Under Fig. 173 we illustrated a helmet mask which, according to our investigations in Korhogo, was never used as "firespitter."

There is however a mask of similar style, known as *kagba* (Fig. 451), which was not used as a helmet (the neck has a diameter of only about five inches) but as an ornament on a tent-like structure under which the adolescent boys entered an enclosure for their initiation ceremonies. Fig. 452 is an extremely fragile rendition of the same style of mask (16 inches long and having a neck diameter of $2\frac{1}{3}$ inches) which was used as a head of a figure carved only with the neck. There are similar small masks (about 5 to 6 inches long) used as lids on round containers.

The helmet mask (Fig. 453) from the Northern Senufo region with heavy buffalo horn symbolism for procreative power has a height of 27 inches and a diameter of 9 inches. They were used by the initiated leaving the secret enclosure in the bush as evidence of their having acquired the male potency of adulthood.

We mentioned the *kono* birds (p. 175). They come in various sizes, some held by a stick. Fig. 454 is the smallest of this type (about 5 inches high).

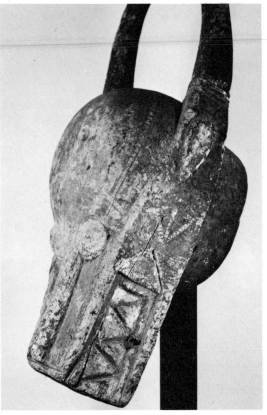

449. *Mask of bush-cow* (goli), *Baule, Ivory Coast. 30″*

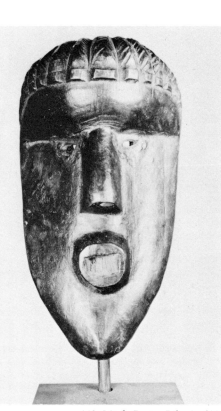

448. *Mask, Bassa, Liberia. 9½″*

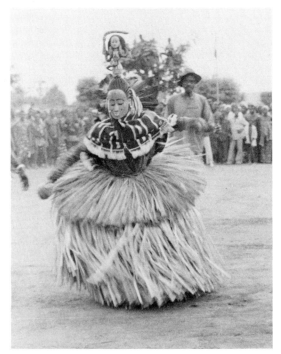

450. *Masked dancer in Sakassou, Ivory Coast.*

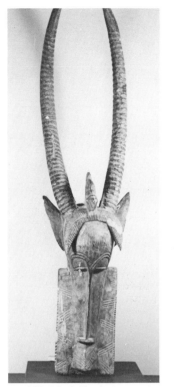

451. *Mask* (kagba), *Senufo,*
Ivory Coast. 30"

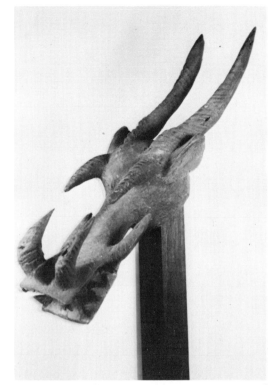

452. *Head of a statue, Senufo, Ivory Coast. 16"*

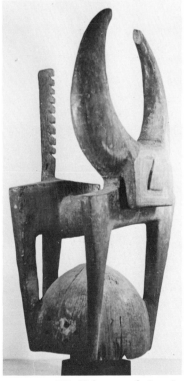

453. *Helmut mask, Senufo,*
Ivory Coast. 27"

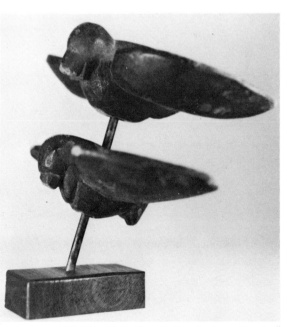

454. *Two birds* (kono), *Senufo, Ivory Coast. 5"*

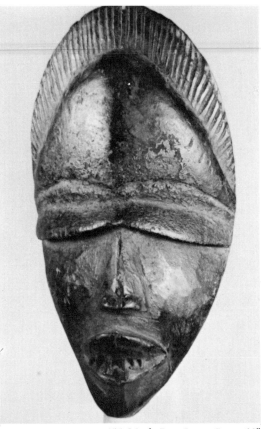

455. *Mask, Dan, Ivory Coast. 12"*

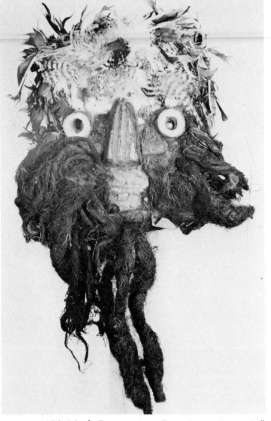

456. *Mask, Poro society, Bete, Ivory Coast. 11"*

DAN (pp. 175-176)

Our classification of the Dan masks into two main style trends, one with round eyes (Fig. 80) and one with slit eyes (Fig. 82) remains valid, but on our last trip to the Dan country we discovered one of great beauty with half-closed eyes (Fig. 455).

BETE (p. 178)

We have already indicated that this tribe produces masks similar to those of the Oube-Guere or Grebo tribes. Our Fig. 456 has the same tubular eyes, but it has additional material attached to it, such as feathers, pieces of textiles, and animal hair formed into a beard.

REPUBLIC OF THE UPPER VOLTA

BOBO (pp. 178-180)

Distinction must be made between the northern Bobo-Oule known today as Bwa and the southern Bobo-Fing. Our Fig. 179 is a mask called *laa* and Fig. 180 *doyo,* and both are from Bwa. Fig. 457 is an interesting combination of the head of *laa* and the superstructure of *doyo.* Fig. 458 is a Bobo-Fing semi-helmet mask with crested hair style representing the Do guardian spirit.

LOBI (p. 180)

We have already mentioned the roughly carved statues from this tribe. The thing of spe-

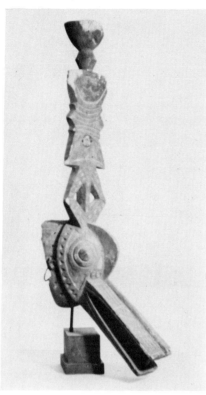

457. *Mask, Bwa (Bobo-Ouele),*
Upper Volta. 33"

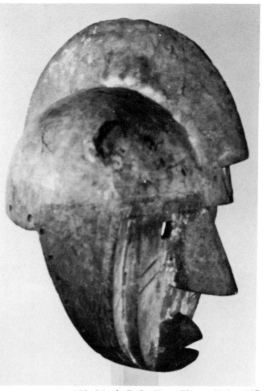

458. *Mask, Bobo Fing, Upper Volta. 17"*

cial interest about our next two illustrations is that these figures were actually sold to us by the local priest. Fig. 459 is a small statue attached to an iron bell having a spike by means of which it was placed in the tomb, the other (Fig. 460) has a movable head and once had (now missing) articulated arms.

Mossi (p. 180)

In 1972 I published a paper (see Additional Bibliography #1) in which I classified the Mossi "dolls" into 25 prototypes, ranging in size from five to seven inches. Fig. 461 illustrates only seven of them. They are all in the basic phallic form with prominent breasts, representing a rare example in the history of art of combined male and female characteristics. They were called *rad*

kamba (doll child), and they were given to female children to be handled and to stimulate mother behavior. But the fertility-inducing capacity attributed to them was their main function, manifest in the evidence that the girl kept the figurine until she gave birth to her first baby, and that a sterile woman carried it under her skirt in the hope of becoming pregnant.

GHANA (GOLD COAST)

Ashanti (pp. 182-185)

Fig. 205 shows the fragment of a maternity statue. Fig. 462 represents a more complete female sitting on a typical Ashanti stool. One

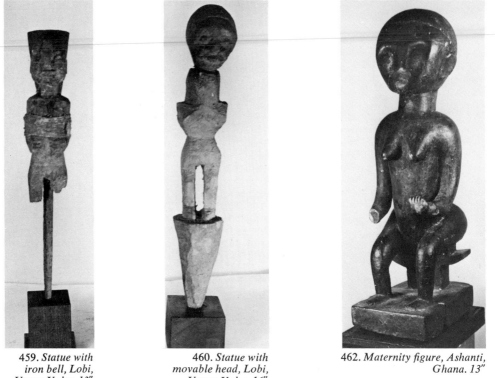

459. *Statue with iron bell, Lobi, Upper Volta. 13"*

460. *Statue with movable head, Lobi, Upper Volta. 16"*

462. *Maternity figure, Ashanti, Ghana. 13"*

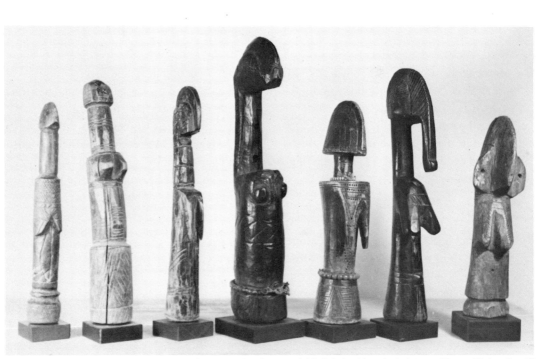

461. *Group of "dolls"* (rad kamba), *Mossi, Upper Volta. 5 to 7"*

A B C D E

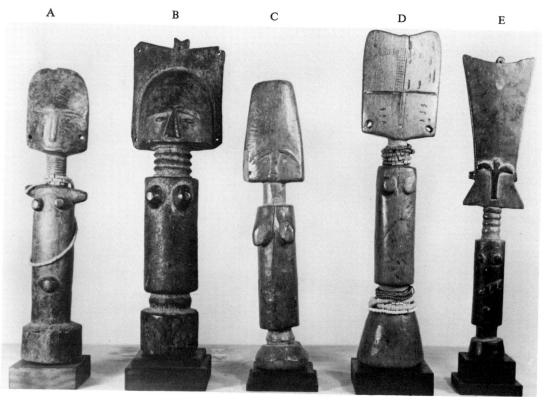

F G H I J K

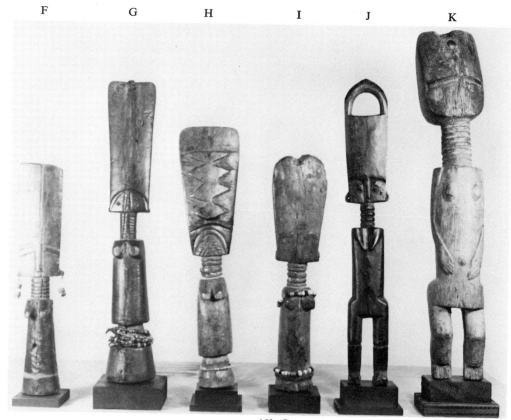

463. Group of Fertility figures, Fanti, Ghana. 8 to 12"

arm is broken, but the other is in the position in which it used to hold a small figure of a baby, which is carved separately, instead of from the same block of wood as Bakongo (Fig. 15) and Yoruba (Fig. 470). (Also frontispiece.)

Gurunshi (p. 185)

Fig. 206 shows a Gurunshi plank-like mask. We may add that those with round "horns" are considered to be male, those with crescent-shaped superstructure female. These masks were made by different tribes in a territory where they are neighbors. The Gurunshi tribe extends into the Upper Volta, the Nafara are partly in Ghana and partly on the Ivory Coast, the Kulango and Abron tribes who inhabit the Ivory Coast on the border of Ghana. The Nafana used these planks in the Bedu moon ceremony.

Fanti

Fanti are the southern neighbors of the Ashanti. Under Fig. 197 we included a statue with rectangular head which in fact is the style of the Fanti. Fig. 463 shows a great variety especially in the formation of the head. It is to be noted that "H" has no facial features. Similar to the *akua'ba* statues, the majority are legless,

the body in cylindrical from, and none of them have outstretched arms, hence adhering more closely to the basic phallic form. Similar again to the Ashanti figurines, they have strings of small beads, symbolic designs on the back, and very few have legs; only one "K" (almost unique) has arms carved in low relief on the body.

REPUBLIC OF DAHOMEY

Fon (p. 187)

The most amazing phenomenon to observe when traveling in the Fon territory is the widespread Legba cult. Usually in African villages the sanctuaries are hidden or visitors are not permitted to look at them, but in Dahomey in every compound next to the road under a shelter there is a heap of earth, the top of which is formed into a rough human face, and at the bottom, sometimes between crudely indicated legs, a wooden penis inserted (Fig. 464), upon which sacrificial blood or palm oil is poured. They are the protective *vodun* (similar to the Yoruba Orisha) of the villages, especially venerated by pregnant and sterile women.

464. *Fertility statue* (Legba), *Fon, Dahomey. about 25"*

465. *Heviosso staff* (mankpo), *Fon, Dahomey*. 23"

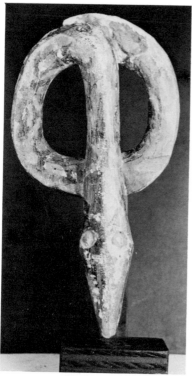

466. *Emblem of Dangbe, Fon, Dahomey*. 8"

Under Fig. 218 we illustrated a Shango staff. This however is from the Fon tribe. It is also used in their cult of the god of lightning, called here Heviosso. The staff is called *mankpo*. The ram's head (on Fig. 218) is sacred to the god. The serpentine metal is the symbol for the lightning, and the semi-circular blade represents the rainbow, similar to the Yoruba Oshumare, servant to Shango.

In Abomey, we visited the king Sagbadjou. Here we were able to acquire a *mankpo* (Fig. 465) covered with metal. It represents a mythological fish which refused to enter into a net, a symbol for the king Quedbadja.

In Ouida, the center of the Dangbe python cult, we found a sculptural representation (Fig. 466) of this very important local deity.

FEDERAL REPUBLIC OF NIGERIA

BINI (pp. 189-190)

Under this heading we discussed the court art of the Benin Kingdom, showing a number of bronzes and ivory carvings. There are, however, also wood sculptures of which one (Fig. 467) is similar to Fig. 96. The upper and lower parts as well as the nose of this wooden head are covered with hammered iron sheeting. The bronze heads were used by the king (Oba) on his altar, the wooden heads by the chiefs.

Outside the king's court the Bini people produced their own art. Fig. 225 illustrates one of their masks, but Fig. 468 represents a more typical prototype with highly stylized features.

Under Fig. 28 we illustrated a ram's head (known in Owo as *osamasnmi*) and a man's head with horns, both from the Owo region. Other ram's heads such as Fig. 469 are known as *uhumwelao* among the Bini chiefs, but are also attributed to the Ishan and Sobo tribes. Similar to their usage in Owo, they were placed on the ancestor's altars, and offerings were made to them. Our example has a slot in the back used to hold an invocation rattle.

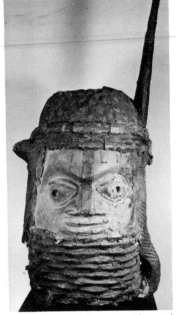

467. *Head* (wood) *with metal
sheeting, Benin Kingdom,
Nigeria. 21"*

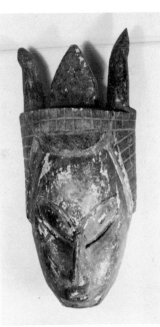

468. *Mask, Bini, Nigeria. 14"*

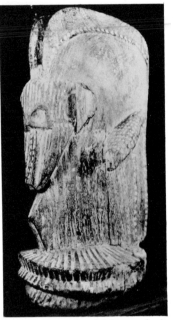

469. *Ram's head* (uhumwelao),
Bini, Nigeria. 15"

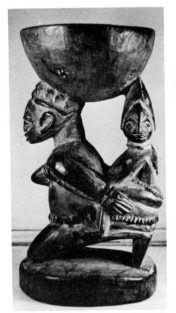

470. *Ifa Bowl* (adjelefa),
Yoruba, Nigeria. 10"

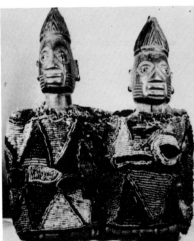

471. *Twin statues* (ibeji), *Yoruba,
Nigeria. 11 x 14"*

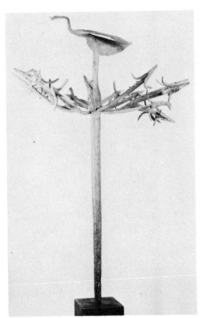

472. *Herbalist's staff* (opa Osanyin),
Yoruba, Nigeria. 16"

A B C D E F G

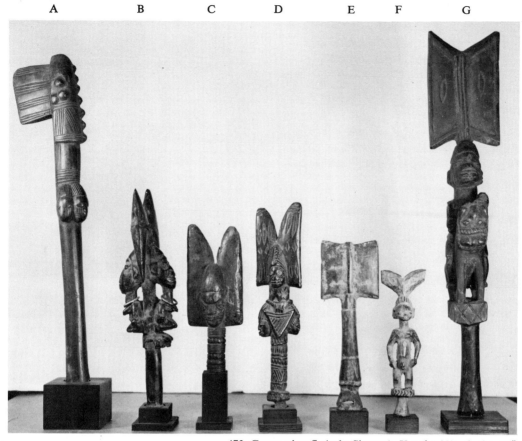

473. *Group of staffs* (oshe Shango), *Yoruba, Nigeria. 8 to 21"*

YORUBA (p. 190)

Under the Orisha cult we mentioned several ritual objects used in the ceremonies. *IFA:* Most of the utensils were represented by illustrations including two bowls (Figs. 214, 215). But the mother and child is such a widespread motif that an illustration (Fig. 470) is appropriate. *IBEJI:* We used only one illustration (Fig. 36), but in a paper by the author (see Additional Bibliography #2) he classified 15 prototypes and 21 different coiffures. Perhaps the most striking fact—already mentioned—is that a particular statue (often two or three) is covered with a multicolored bead garment, sometimes made of cowrie shells, such as Fig. 471. *OSANYIN:* This is the Orisha of the herbalist or traditional healer, and before he starts to prescribe medication he puts a wrought iron staff (Opa Osanyin) into the earth (Fig. 472). There is a large bird surrounded by smaller ones, the large representing the witch who caused the sickness, and hence it must be appeased before healing can take place. (See Additional Bibliography #3.) *SHANGO:* Under Fig. 219 a dance wand (Oshe Shango) is illustrated. But there are a great many variations of these cult objects, and Fig. 473 shows only seven of them. "A" is a rather unusual variation with only one axe-blade and three heads similar in type to the head of "C". "B" shows two figures back to back, and "G" shows Shango as an equestrian figure topped by a rectangular double axe. Fig. 474 is a bowl held by a kneeling figure to contain the kola nuts used

in sacrifices. This carving actually comes from a Shango temple, and of special documentary interest is the fact that there is a snake around the neck of the figure representing Oshumare, the Orisha of rainbow, the servant of Shango, and on the base a double axe is carved in relief. *ERINLE:* This is a river deity. Fig. 475 shows a pottery head burnished with indigo. It was used as a lid for an Erinle vessel in which water and stones from the river were kept, being changed every sixteen days.

Ibo (pp. 195-199)

We have already shown two types of Ikenga statutes (Figs. 226, 228). However, the very rich variety of these statues justifies two additional examples. Fig. 476 is an extremely compact carving with the head partly emerging between the horns. Fig. 477 from the Okoba group has a very abstract design. To round out our documentation on the Ibo we add Fig. 478, a typical statue from this tribe, and a girl's head (Fig. 479) used as a headdress in the Ekkpe play.

Ibibio (p. 199)

We have already illustrated several types of masks from this tribe (Fig. 63 which is not Ibo but Ibibio, Figs. 237, 238, 240), but Fig. 480 shows a different style, very naturalistic (comparable to Fig. 59, Dan-Guere) with strong negroid features, and also a movable jaw.

Northern Area of Nigeria
(p. 201)

This area includes the tribes living in the Niger-Benue confluence, partly in the Bauchi plateau and further south in the Adamawa province, neighboring Cameroon.

An extremely interesting phenomenon emerged in the last few years when products of this region began to appear on the art market. There is a unity and coherence in the style-trend of the carvings from the Chamba, Mumuye, Waja, Mama and Mambila tribes.

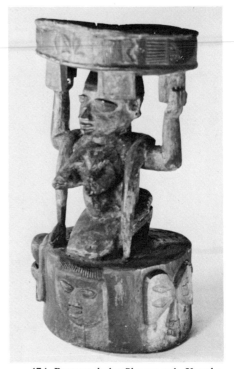

474. *Receptacle for Shango cult, Yoruba, Nigeria. 15″*

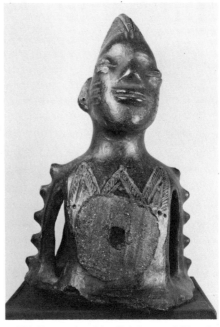

475. *Pottery head for Erinle vessel, Yoruba, Nigeria. 13″*

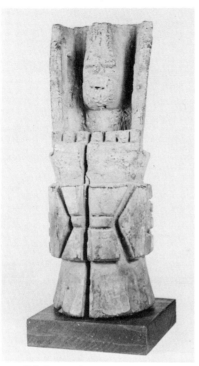

476. *Statue* (ikenga), *Ibo, Nigeria. 9"*

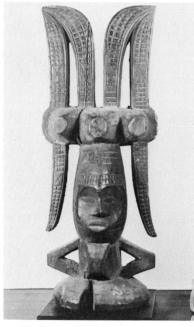

477. *Statue* (ikenga), *Ibo, Nigeria. 11"*

This style is extremely different from the rest of Nigerian art, and for that matter unique in the whole panorama of West African art. It can be characterized as highly simplified, semi-abstract, having an archetypal spontaneity, bursting freely into bold and daring volumes. But in spite of the primordial quality, there is a sophistication and strong respect for the tribal style discipline.

MONTOL (p. 203)

Although it belongs in the Northern Nigerian territory, its rather naturalistic trend (Fig. 481) makes it different from the semi-abstract trend of this region.

CHAMBA (p. 203)

This tribe is represented with a monumental buffalo mask (Fig. 482) already mentioned in the text. Most of the statues attributed to this tribe are from the Mumuye.

MUMUYE

Mumuye tribe of the southern Adamawa province. There is an immediacy in the primary simplicity of these statues (Fig. 483). The body and arms are elongated. The arms although separated from the body mostly follow the cylindrical curvature of the body. There is a great variety of style, the head usually disproportionately small, but each having a different facial expression. On many the nose is horizontally pierced (the Waja statues have the same characteristic). The legs are stunted, often in zig-zag form, and on many the navel is exaggerated. These statues were kept with the feet next to the skull of the ancestor, a reason why on many of them the heels are rotted away. They were used on many occasions for worshiping ancestors, for taking oath, for healing the sick, for greeting visitors, etc. Fig. 484 is a mask from this tribe, extremely bold, with horns, open jaw, a cross of raised relief on the face, and engraved circles for eyes.

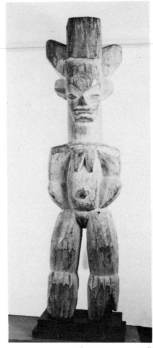

478. *Statue, Ibo, Nigeria. 22"*

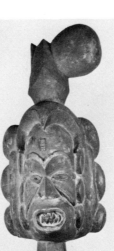

479. *Headdress used in Ekkpe play, Ibo, Nigeria. 16"*

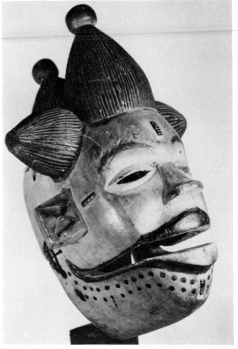

480. *Mask, Ibibio, Nigeria. 9"*

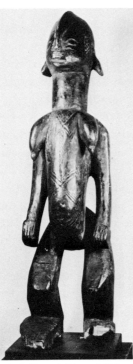

481. *Statue, Montol, Nigeria. 22"*

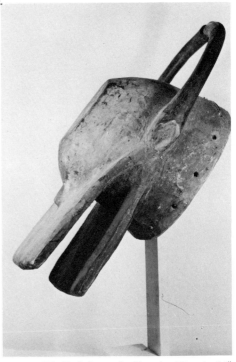

482. *Buffalo mask, Chamba, Nigeria. 26"*

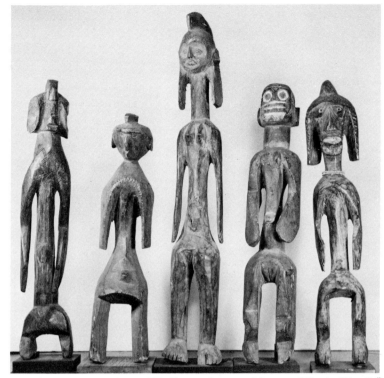

483. *Group of statues, Mumuye, Nigeria. 17 to 24"*

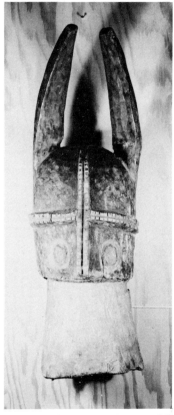

484. *Mask, Mumuye, Nigeria. 23"*

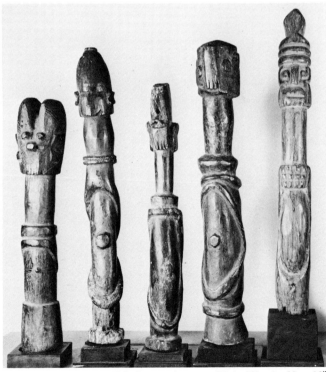

485. *Group of statues, Waja, Nigeria. 15 to 18"*

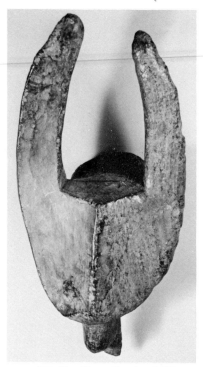

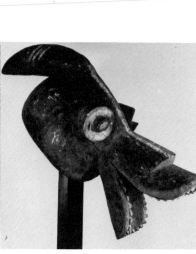

487. *Mask, Mambila, Nigeria. 17"*

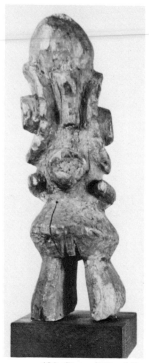

486. *Headdress* (kambon), *Mama,*
Nigeria. 17"

488. *Statue, Mambila,*
Nigeria. 7"

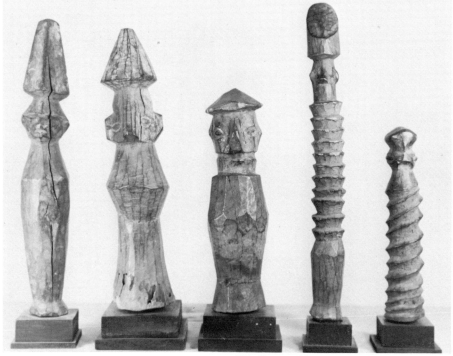

489. *Group of Statues, Bayaka, Zaire. 8 to 12"*

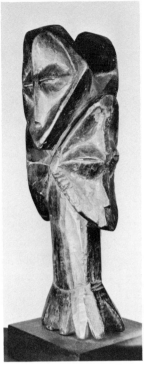

490. *Statue, Warega, Zaire.*
11"

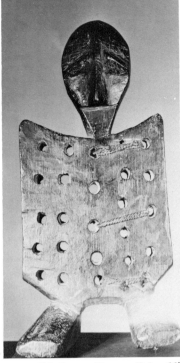

491. *Statue, Warega, Zaire. 10"*

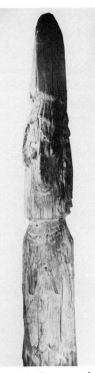

492. *Grave marker,*
Gato, Ethiopia. 40"

WAJA and WURKUM

The Waja and Wurkum tribes live further north on the Bauchi Plateau. Fig. 485 shows a number of their statues in pillar-like (phallic) form without legs, the arms carved in diamond shape in low relief on the body. They all have pierced noses and most of them protruding navels. The faces are only summarily executed. These statues were kept in huts and were used to heal the sick and to celebrate harvest festivities.

MAMA

The Mama tribe lives at the southern escarpment of the Jos Plateau. The dancers have wooden headdresses, called *kambon,* representing bush cow or antelope (Fig. 486), which they carry over the top of their heads so that the masks look upwards. These were used by the Ubawaru society at the agricultural cyclic festivities and also at funerals.

MAMBILA (p. 210)

This tribe was classified under Cameroon because a portion of it lives in this country. But since the larger portion lives in the southern part of the Adamawa province, and since their bold style belongs to the Niger-Benue style complex, we include our illustration here. Fig. 487 is an animal mask with a horn and wide open mouth. It was used at sowing and harvesting rituals. Fig. 488 shows a rather surrealistic small (7-inch) statue, which sometimes is attributed to the Bangwa of the Cameroon (p. 205) with large eyes at the sides of the head. These small statuettes were attached to the palm tree to guard the proper sapping of the tree.

ZAIRE

Compared to the rich new carvings coming from Mali, Nigeria, etc., there is less abundance in additional material from Zaire.

BAYAKA (pp. 251-254)

A type of carving not yet reported is illustrated in Fig. 489 which shows a very unified phallic form (average 10 inches high), probably used in the fertility cult. The unique ring and spiral carving on the last two examples are notable.

WAREGA (pp. 261-265)

In our earlier presentation we paid special attention to the small ivory carvings and wood and ivory masks. Here we add two wooden carvings. Fig. 490 is similar to Fig. 420 in the use of multiple heads, but Fig. 491 is rather unusual, having a flat body with 25 holes in it and a double head.

EASTERN AND SOUTHERN AFRICA
(p. 271)

Unfortunately we lack the proper illustrative material. But one of the great surprises on our trip to Ethiopia was the grave markers of the Gato tribe (Fig. 492), which we include because they fit into the West African tradition, being in some respects reminiscent of the Dogon style. In fact the Gato and Konzo animistic tribes lived isolated from the Coptic tradition. What is of interest is that these statues in phallic form were used on the burial ground, establishing a connection between ancestor and fertility cults.

Additional Bibliography

Additional Bibliography

1. Segy, Ladislas, "The Mossi doll." An Archetypal Fertility Figure. *Tribus*. Linden Museum fur Volkerkunde. Stuttgart, Germany, No. 21, November, 1972.

2. ———, "The Yoruba Ibeji Statue." *Acta Tropica,* Review of Tropical Science. Basel, Vol. 27, No. 2, 1970.

3. ———, "The African Attitude toward Sickness. Its Relation to Sculpture." *Acta Tropica.* Basel, Vol. 31, No. 4, March, 1975.

4. ———, "The Ecology of Dogon Sculpture." *Ethnologische Zeitschrift*. Zurich, No. 1, June, 1975.

5. ———, "A Sculpture from Mopti. A phenomenological investigation into the plastic aspect and meaning of an African carving of undetermined style." *Archiv fur Volkerkunde.* Wien, No. 26, 1972.

6. ———, "Masks of Black Africa. Their function and meaning." (272 ill.) Dover Publications, New York, 1975.

List of Additional Illustrations

List of Additional Illustrations

Unless otherwise credited, all objects from the author's private collection or from the Segy Gallery, New York. Photographs by the author.

1821